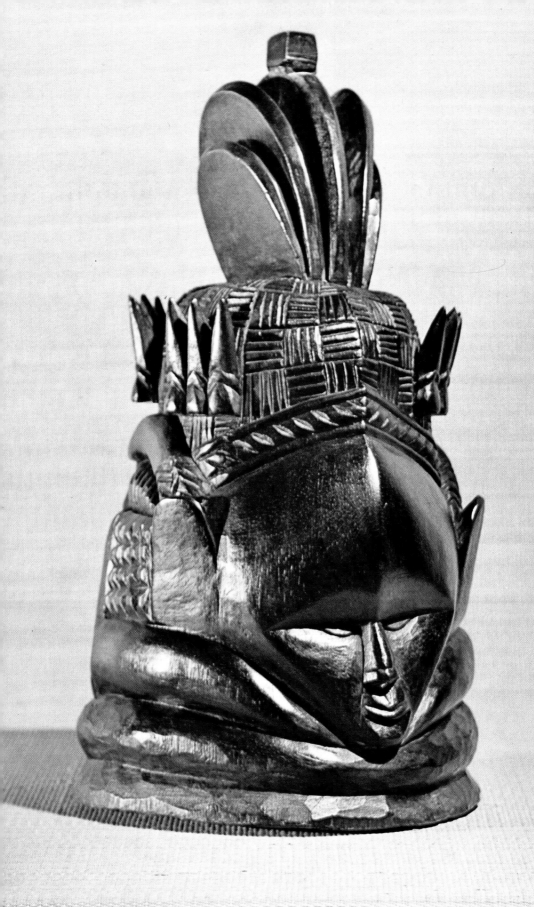

EDITED BY *Anthony Forge*

Primitive Art & Society

Published for
The Wenner-Gren Foundation for Anthropological Research Inc.
by Oxford University Press

London · 1973 · New York

Oxford University Press, Ely House, London W.1.

GLASGOW NEW YORK TORONTO MELBOURNE WELLINGTON
CAPE TOWN IBADAN NAIROBI DAR ES SALAAM LUSAKA ADDIS ABABA
DELHI BOMBAY CALCUTTA MADRAS KARACHI LAHORE DACCA
KUALA LUMPUR SINGAPORE HONG KONG TOKYO

ISBN 0 19 212953 8

Set by Filmtype Services Ltd. and printed in
Great Britain at The University Press, Oxford

Preface

Raymond Firth

Problems of primitive art have interested anthropologists for nearly a century. Stolpe's attempt to define regional styles of ornament in Polynesia, Holmes's demonstration of ways in which technical process might produce ornament in American Indian basketry, and Haddon's analyses of decorative design in New Guinea were early explorations in the field. But such studies, like the more general comparative work of Haddon, Grosse, and Boas, were concerned mainly with detailed description of form, or with broad problems of style, origin, and development of design. They focused, for instance, on the relation of conventionalization in art to the 'realistic' forms of the natural world, and the 'meaning' of art forms interpreted in the light of principles of evolution or diffusion. Explanations of pattern provided by the people among whom the art was produced were given attention, as in Boas's study of northwest coast Indian totem poles. The general setting of artistic products might be painstakingly indicated, as in Hamilton's elaborate account of Maori 'art workmanship'. But only slowly did it come to be realized that primitive art could not be understood without systematic examination of the structure of social relationships and concepts of the specific societies in which it was produced.

Early efforts of this kind were tentative. Eckhart von Sydow, under Freudian stimulus, tried to interpret primitive art in terms of its sexual components. Leonhard Adam gave some brief observations on the 'social implications' of primitive art in terms of recruitment of artists, economic aspects, ceremonialism, and – understandably in view of his own training as a lawyer – property rights. My own presentation of New Guinea art material in its social context owed much to the interest of William Gaunt and his colleagues of *The Studio* in providing at least some background to these exotic objects. From another angle, the highly original study by Julius Lips of how Africans and other 'primitive' peoples of the time represented white men was a lesson in cultural relativism which prompted Malinowski's definition of anthropology as 'the science of the sense of humour'.

The interest of artists and art critics in primitive art since the early years of the present century may have encouraged anthropologists in their belief in the seriousness of their study, but it may have even held back systematic inquiry into the internal significance of the material – that is, in terms of the values of the people who produced it. On the one hand, attention was focused on the formal characteristics of African or Melanesian sculptures irrespective of the social conditions in which they

emerged. On the other hand, where a social content was imputed it tended to be some attribution of magical or religious meaning, often based on the most slender evidence. Characteristic of such views was the attitude of Hermann Bahr in elucidating Expressionism, that primitive art is primitive man's response to his fear of nature. Driven by fear of nature and seeking refuge within himself, he is freed by art, which allows him to convert depth into plane surface and so turn the threat of nature away from himself. Segy has a similar view. The many exhibitions of primitive art which have taken place since the 'thirties, taken in conjunction with *Les Demoiselles d'Avignon* and its successors, certainly helped to establish the validity of the art forms for general culture – a validity which has been threatened though not destroyed by the activities of commercial art dealers and the producers who try to meet their market. But they did little to explain the relation of the art to society in any but the broadest terms. Dialogue between artists and anthropologists had been rare – one of the first interdisciplinary discussions being among Edmund Leach, Leon Underwood, and Roland Penrose in 1949, and another in a conference sponsored by the Royal Anthropological Institute in 1957.

In the last decade or so the pace of inquiry into the significance of primitive art has quickened, and artists, art historians, art critics, have all been involved. But it has not been common for anthropologists to engage in sustained discussion with such other specialists on this topic. So in 1966 talks between Anthony Forge and myself from the Department of Anthropology of the London School of Economics, and Robert Goldwater and Douglas Newton from the Museum of Primitive Art, in New York, resulted in a plan for a conference on Primitive Art and Society. This plan was adopted by the Wenner-Gren Foundation for Anthropological Research, and with the advice and help of Mrs. Lita Osmundsen, Research Director of the Foundation, we were able to hold the conference in the stimulating atmosphere of Burg Wartenstein, from 27 June to 5 July 1967.

The focus of the conference was anthropological, that is, we adopted essentially a comparative point of view which was prepared to consider art in any social context. And though the title of the conference specified 'primitive' art, in that the major field intended was the plastic arts of cultures without writing, it was explained that we felt it essential to admit for illustration material from any type of aesthetic situation or society. Our main concern was theoretical analysis, not ethnographic description. So, not only were we prepared to be broadminded about illustrative examples in argument, we stated in advance that as well as specific studies from particular societies, more speculative studies would also be welcome, provided they were sociologically oriented. We also deliberately sought the help of scholars outside the anthropological discipline, including those in art history and philosophy. If our discussions were

far-ranging and many of our conclusions were tentative, we regarded this as preferable to restricting our intellectual analysis. We did not shrink from tackling even such basic questions as: What is it that we call art? What does art do in society? What criteria of judgement can be best used in evaluating art? – as well as such more straightforward questions as the relation of art to ceremony, or the place of artists in society. Only a fraction of the discussions of the conference can appear in this book, but it is our belief that their effects will emerge over a wide range of scholarly products as time goes on.

As I was the anthropologist on whom fell the responsibility for most of the initial arrangements, it has seemed appropriate that I should write this brief preface. In it I would like to thank my colleagues: Robert Goldwater for his scholarly wisdom and work as co-chairman of the conference;* Douglas Newton for his planning help (a field trip to New Guinea prevented his attendance); Will Jones for his philosophical comments and questions to anthropologists and art historians alike; Warren d'Azevedo and Anthony Forge for serving as *rapporteurs* to the conference. I would also like to put on record the appreciation of the organizers for the enthusiasm and co-operation of the members of the conference; and their gratitude to Anthony Forge for his patient indefatigable handling of the conference papers in the editing of this book, amid evitable and inevitable delays. A very special note of thanks is due to the Wenner-Gren Foundation and to Lita Osmundsen for their warm support of this experiment in interdisciplinary exploration of ideas.

*Much to our regret Robert Goldwater died in March 1973.

Contents

List of Illustrations

Line drawings and diagrams are not listed here

Introduction

Anthony Forge

The place of the arts in anthropology has a curious history. For the pioneers in the actual observation of non-European peoples, such as Haddon and Boas, the plastic arts not only had a substantial place in their reports but also came, especially in these two cases, to be objects of intensive specialized studies. Yet with the next generation of anthropologists the study of art virtually ceased, the development and intensification of fieldwork techniques, particularly associated with Malinowski, led paradoxically to a narrowing of the field considered suitable for investigation. Further, as the emphasis on the importance of fieldwork for those studying social anthropology grew, the study of the arts and technology came to be considered a museum preserve and little or no funds were available for field investigation. At most, all that was considered necessary was a collecting expedition of a few months. This split between the developing social anthropology of the university departments and the museum based study of objects was certainly most acute in England, but was also very influential in America, France, and Holland. It hardly affected the German speaking countries because social or cultural anthropology had no impact there until after the Second World War. In Austria particularly however, art, was studied as an index of presumed past diffusion rather than as a subject in its own right, fieldwork was not much emphasized and most studies were based on museum collections. The assumptions behind these diffusionist studies were, of course, that the motifs and styles of an art were enshrined in ancestral practice and were somehow unchanging so that similar or identical motifs and stylistic resemblances infallibly indicated some past contact between the cultures concerned. This tradition survives in a much more sophisticated form in the work of Schmitz (1963) and of Fraser and his students (1968). Other museum based studies, including comparatively short but frequent field investigations, were concerned with the problems of the artist, both from the point of view of his technique and more especially with the extent to which he could be said to have a style of his own or was merely the skilled executant of an ancestral unchanging tribal style. Himmelheber (e.g. 1935 and 1960) and Fagg (e.g. 1963) have both contributed distinguished work in this field for many years; their work and that of others, mainly in West Africa, have left no doubt that

individual artists do have personal styles and that these involve
change in the tribal style. Gerbrands' work on the Asmat (1966)
shows clearly that such individual variation is by no means
restricted to complex stratified societies such as are common in
West Africa but also occurs among very small-scale unstratified
neolithic communities such as those of New Guinea.

From the 1920s to the 1960s social and cultural anthropology
were making great advances in theory and analysis as well as
in the techniques of investigation but virtually ignoring art,
while the museum based studies were concerned with documen-
tation and stylistic comparison and made no theoretical con-
tribution. During this period the consciousness and appreciation
of primitive art in western Europe was rapidly expanding both
indirectly through the works of modern artists, such as Picasso
and Braque, who had been early influenced by it and directly
through exhibitions of primitive art and the interests of the
surrealists. The impact of primitive art on the artists and the
change in taste and vision in Europe and America is definitively
documented and analysed in Goldwater (1938) and cannot be
treated here. What is interesting is that social anthropology, with
the notable exception of Firth (e.g. 1936), was ignoring precisely
that aspect of non-European culture which the anthropologists'
own culture found most stimulating. Much of the writing about
primitive art of this period, and indeed later, was concerned
with meaning. Critics and dilettantes freely recorded their own
reactions to pieces, assuming, often without question, that the
pieces must have been made to produce that reaction. Since
most anthropologists were uninterested, they were able to
produce no alternative set of meanings and such procedures
were accepted without opposition. The modern artists were on
the whole not concerned with meanings. They accepted the
carvings that came their way as interesting and exciting in terms
of form, basically as *objets trouvés*, on the same level as drift-
wood and other naturally occurring interesting shapes.

The question as to how far it is possible to discern the meaning
attached to a work of art produced by another culture, or even
by a distant epoch of our own, remains subject to debate. Most
anthropologists would suggest that it is impossible for a member
of culture A to know with any certainty the meaning of a work
produced in culture B unless he has had considerable experience
of that culture. There seems little evidence of genuine universal
symbols in the plastic arts or indeed in any other medium of
communication. Although it is obvious that the human body,
its parts, and its functions are a source of many powerful
symbols in ritual as well as art in most human societies, and that
this may provide a basis for impact cross-culturally, the beholder

will interpret what he sees in terms of the body symbolism of
his own culture, which may be very different from that of the
creator's culture except at the crudest level (see Leach, Chapter
12). If this pessimistic conclusion is justified there seems little
chance of establishing for prehistoric or now destroyed primitive
cultures any iconography that will enable the meanings of these
long dead masters to be accurately translated into verbal terms.

The studies of style in primitive art have naturally tended to
draw on the techniques developed by art historians. Since the
Second World War there has been a time dimension added to
such studies. Most particularly in West Africa and the Americas,
but eventually no doubt all over the world, excavation and
detailed studies of old material preserved by the on-going culture
have led to studies of stylistic change through time exactly
similar to those of European art history. (Sieber's paper, Chapter
5, is a distinguished example of the sort of meticulous work
necessary.) This extra concern with the past has in some cases
had the unfortunate effect of intensifying the division between
stylistic studies on the one hand and social anthropological
concern with the society as a total and existing system on the
other.

While the study of style, both individual and 'tribal',
continues to remain, in the main, museum based, certain workers
are developing from these studies into other fields, e.g. the
personality of the artist (Fischer, 1962), and the stereotype of the
artists held by the society (d'Azevedo, 1966), while an on the
whole successful attempt to measure and quantify stylistic
variation, in terms of the dimensions and proportions of the
works themselves, has been undertaken by Schefold (1966),
although the author interprets the variation he establishes in
terms of a rather crude diffusionist model. Despite this large
amount of varied activity and the increasing detail and precision
of the studies, purely stylistic studies have so far failed to find
any new theoretical framework. They seem often to be concerned
with reducing the material on primitive art to the terms made
familiar by art historians in western European civilization,
using categories such as sculpture, masks, painting, etc., as if
these were automatically the categories which all artists must
use. Further, although the swing from the old idea of rigid tribal
styles absolutely maintained to the realization of the contribu-
tion of individual artists has undoubtedly been most productive,
there is a tendency to ignore the problems of the relationship
between the individual and collective styles. It seems obvious
from the evidence available that all art systems, no matter how
tied up with ancestral sanction and ritual functions, provide
both stylistic limits, culturally determined but capable of

change through innovation, and at the same time considerable freedom in selection of elements and in stylistic variation available to the artist working within these limits. Holm's (1965) excellent study of the techniques of style on the northwest coast of America shows clearly the range of available choice to each artist working within what is, at first sight, a very formal and rigidly controlled style, as well as documenting diachronic stylistic change.

If the only continuing tradition of the study of primitive art, that based in museums, has recently emphasized the importance of the individual artist and rejected to some extent the concept of art as a standardized production of the culture, the reawakening of interest in the rest of anthropology in the subject of art has been very largely linked to just that standardized component that the museum men have tended to reject in their own studies. There have been, since the war, several approaches from different points of departure, mostly by social anthropologists or those familiar with and capable of handling social (or cultural) anthropological techniques and methods; these various approaches all owe something to the recent impact of linguistic theory on anthropology, but nevertheless they remain to date separate in the sorts of material they study and the aims of their analyses. At this early stage it is sometimes difficult to see how they could possibly ever be reconciled, yet between them there are clearly the outlines for an analysis of visual material as independent systems and of the relationship between such systems and other cultural systems.

In America there has grown up a group of analytical techniques, largely so far used on archaeological material, often referred to as iconics. There does not seem to be any agreed definition of this word, certainly it sometimes carries a heavier load of meaning than the straightforward use made of it by Nancy Munn in this volume (Munn, Chapter 11, n. 1). Analyses of this type often apply methods not unlike those of componential analysis to classes of objects or graphic signs with a view to discovering the principles on which their ordering is based. Sturtevant, for instance, has used it to describe the manufacture and design of Seminole clothing (1967). The aim of the analysis is to produce a 'grammar', often presented as a flow chart, which provides complete instructions on how to produce the class of objects under consideration; the analogy being with rules for sentence production in a language. Sturtevant and others have shown that such an analysis can provide an orderly description of change by the introduction of new stages, and by reordering the relationship between stages. But as yet most of these models remain descriptive, the element of meaning is not included.

The success of iconics in demonstrating that classes of human production can be analysed and shown to be systematic, has also aroused interest among certain archaeologists, as well as those concerned with material culture. These studies not only eschew any concern with the meaning of the objects they consider, but they also ignore any aesthetic aspect. Indeed, the whole iconics group has a somewhat puritanical approach. Nevertheless, with the amount of work being done in this field it seems likely that these problems will have to be faced. W. Watt, although not being concerned with aesthetics, is embarked on a fundamental study of the problems of translation between a visual system and a verbal system – language. His interest is in the theoretical problem rather than the class of objects he is analysing – Texas cattle brands. Only two of a planned three volumes have so far appeared (Watt, 1966 and 1967), but the issues raised and the questions of correspondence between the two systems are of importance in the analysis of any system of graphic signs and how it is generated.

In systems such as those of cattle brands, the reduction of ambiguity is an obvious prerequisite if the system is to perform its limited functions effectively. But however important reduction of ambiguity may be in sign systems that are required to communicate specific information, one needs a more complex linguistic model, one capable of coping with poetry and puns, if linguistic analogies are to be successfully used in the analysis of art. Of the contributors to this volume, all those concerned with the analysis of meaning in the context of the art of a single culture (Munn, d'Azevedo, Bateson, Forge) emphasize the essentially ambiguous nature of the symbols they discuss (words such as polysemous and multivocal have been used by other authorities) and it seems clear that the impact of art and its effectiveness as communication particularly perhaps in a ritual context depends very much on precisely this ambiguity. The power of the symbols or groups of symbols to make reference to contexts and rituals other than the one in which they are presently appearing is perhaps the most vital part of their effectiveness, especially when reinforced by beauty and mystery. That there is no necessary cross-cultural connection in ranges of meaning of even the simplest graphic elements is also apparent. Compare for instance the meanings of the circle in Walbiri art reported by Munn (1962 and Chapter 11) and the meanings of the same element in Abelam art (Forge, Chapter 10). There is virtually no overlap between the two ranges of meaning.

The study of ritual as well as of myth has been revolutionized within the last decade by the idea that the content of ritual, and indeed of many other items of culture, can be analysed and shown

to have structure and, further, that this structure has meaning in terms of the cosmology of the society concerned and correspondence with other structures of that society. So far the analysis of ritual acts and verbal usage has progressed further than has the analysis of the visual components of ritual, but such evidence as there is suggests that visual systems used in ritual contexts are not just illustrations of what is being said or done, but are self-contained systems of communication acting directly on the beholder (d'Azevedo and Munn, Chapters 8 and 11; Forge, 1966). Such art systems are not subordinated to language, giving a simple graphic presentation of what is being said. They appear to act independently from, but in combination with, words, ritual acts, myth, etc.; if this is indeed so, the failure of some experts for instance Mountford in his study of Arnhemland ritual paintings (1956), to find a secure iconography in their analyses, that is, a complete and one for one correspondence between the visual system and words, becomes understandable. It has also been realized that in considering art in non-European societies not only may our categories be inapplicable, but that body decorations, face-painting, head-dresses, and all sorts of ephemeral constructions, may well form an essential part of the cultural visual system that includes works of art in our more narrowly defined terms. Indeed, some cultures devoid of art in the sculpture and painting sense possess rich visual systems of great aesthetic powers, such as the complex system of body-painting from the Nuba hills described by Faris (1972) or the face-painting and head-dress styles of the Mount Hagen region (Strathern, 1971). There seems every reason to suppose that such systems are, in indigenous terms, every bit as important aesthetically and ritually as objects that fall within the traditional classification 'art' of civilization. This whole question is tackled by Paulme (Chapter 2).

The view of art as a symbolic system involves two changes in traditional approaches to art. First, what is included in the body of material to be considered has greatly expanded, often including natural objects as well as man-made products. Second, the search for meaning is no longer a matter of simple translation, each object standing for one thing, 'being' a statue of a war god or a painting of a tree spirit, this scene illustrating an episode in a myth. In primitive art, art objects are rarely representations *of* anything, rather they seem to be *about* relationships. Even single figures or masks carry on them attributes, some in themselves ambiguous, whose interrelationship provides 'meaning' additional to that of the object itself (e.g. d'Azevedo, Chapter 8; Thompson, 1969).

The symbolic system approach has in its analysis of art itself

much the same objective as the iconic. A coherent body of art from a single culture is analysed into its basic elements of form, with the aim of discovering the rules of their combination and apposition, but meaning is recorded at every level from a wide range of informants both artists and beholders of the art. On this view art becomes a system of multiple reference, not only relating disparate things but increasing the supernatural power of the focus of a ceremony by referring in visual terms to other occasions when the same elements are used in different combinations.

The problem of how people internalize such systems and hence can be affected by them has hardly been tackled, although Munn (1962) is an exception and shows clearly that the sets of meanings for each graphic element are, among the Walbiri, learnt by children watching their mothers tell stories which they illustrate by drawing in the sand. The accessibility of such systems to the anthropologist or other outside observer remains a problem. Most work so far, as indeed much of the work on the interpretation of myth and ritual, has been based on the explanatory power of the proposed analysis (Occam's razor) and indeed, since for the systems to work effectively it is supposed that their operation is not totally conscious to members of the culture concerned, it is difficult to see what other sorts of proof are available (see Bateson and Jones, Chapters 13 and 14).

A similar approach, although deriving from other sources, has been tried on the analysis of western European cave art by Leroi-Gourhan (1965). His method is fundamentally structuralist in that he considers the meaning of the cave paintings and engravings to reside in the relationship between the various elements, in this case animals, signs, humans, etc., rather than in each element itself. Although his suggestions have led to some controversy they seem to offer the most hopeful approach yet to bodies of art devoid of social context, or even the vaguest hint of meaning. Problems of 'proof' are, of course, even more acute in such studies.

The training of the artist has long been recognized as a subject of the greatest importance in the anthropology of art, the factors that influence him and the choices or lack of them left to him by the society of which he is a member have been far too sparsely reported (but see Firth, Dockstader, d'Azevedo, and Bateson, Chapters 3, 7, 8, and 13). Similarly the importance of materials and techniques has often been emphasized but little reported (Kooijman, Chapter 6). The economic aspect of art production and use and the creation of exchange value (Firth, Dark, and d'Azevedo, Chapters 3, 4, and 8) also requires much more extensive recording. All these tasks are basically anthropological.

The information required can only be gathered by extensive field work and the use of anthropological techniques setting the art in its social context and viewing the art as an essentially social product, for which there is a demand from the society as a whole. The problem of the relationship between the artists and their societies, between the individual and the collective constantly came up in discussion at the conference at which the papers in this volume were first presented. It was obvious that the freedom of the artists to innovate, the width of the band of permissible stylistic variation, was greater in some societies than others. It also varied within societies according to the use to which the object was to be put. For instance art used to express high status might be freer in its attempt to convey magnificence and power than art used as a focus of an ancestrally sanctioned ritual. Whatever the degree of variation however both the individual and collective factors were present in all societies. Even at the borders of art, in the making of Tikopia headrests, for example (Firth, Chapter 3), although the maker may do what he likes, he knows that appreciation of his fellows will be gained by producing certain types.

Architecture is, of course, the art in which the artist as an individual ceases to exist, at least in the sort of societies we were considering, and it is unfortunate that we had no paper specifically on the subject, although it is mentioned in Dark, Firth, and Forge. This art, often very highly charged with value and meaning for the society concerned, is essentially a social art truly devoid of artists yet none the less an effective form of communication (Cunningham, 1964; Forge, 1966). Architecture without architects is one pole of the continuum, the other being our own culture's conception of the completely free artist communicating through the intensity with which he expresses his own individual values. In the conference discussions it was apparent that the art of the societies under consideration was concerned precisely with points of tension both in the conceptual schemes of the society and in terms of its political and religious structure. Art seemed not only to be used to show the possession of power, as in regalia, but actually to be a source of power in itself, both individual and collective. Leach makes these points taking art to be a special case of that ritual concern with inter-categories, the analysis of which has done so much to transform recent anthropological approaches to religious phenomena. One of the simplest but most universal sources of power in the supernatural sense seems to be the combination of male and female symbols.

Another question that constantly recurred in our discussions was whether there could be any way of delimiting art from other

productive activities. It was obvious that any sort of gallery based conception from our own culture was inadequate and that there are, in fact, no 'artless' societies. The transformation and elaboration of the human body is certainly universal and must surely be relevant to any system of visual communication such as art (Paulme, Chapter 2). Firth's paper discusses the whole question of the boundaries of art in the detailed consideration of a coherent body of material, a unique and extremely important contribution to this basically insoluble problem. We were again forced back on to an empirical method; the analyst of any art had to take into account and include in his analysis anything that was visually relevant to the art producers and consumers concerned, and disregard, as far as he was able, any of his own ideas about what is or is not art. Although it was intended that the conference should include only anthropologists and should be about specifically anthropological approaches to art – there were, for instance, no psychoanalysts – we were very fortunate in having Will Jones at first as a listener and then as a contributor. His paper records some of our difficulties and confusions, and although we all agreed that it was not possible or even desirable to try to define art, there is little doubt that our basic assumptions and preconceptions about the subject we were discussing were various, but that we came to a much clearer and conscious understanding not only of each other's assumptions but also of our own.

It is of course impossible in an introduction such as this to summarize all the discussions. As they proceeded they opened up more and more subjects for consideration, so that the conference ended with more questions than it had had at the beginning, undoubtedly the sign of a successful conference. One major issue that most of the participants approached very gingerly was aesthetics. There seemed general agreement with Goldwater's view that the aesthetic is concerned with power, with the heightened impact of a perfect object whether it be beautiful, ugly, or frightening. But whether there is a universal human aesthetic remained a matter of faith, those who believed in a basic, presumably genetic, set of responses to certain forms, proportions, and so on were as unable to prove their case as those who did not were able to disprove it.

There is no doubt that with the reawakened interest in art among university anthropologists the split between them and the museum men will be reduced. Encouraged by the recent successes in the analysis of myth, ritual, cognitive systems, and the like, social and cultural anthropologists are turning their models ultimately derived from linguistics on the whole range of human expressive behaviour. It seems certain that we may expect

new theoretical approaches to the study of plastic arts, some pre-
liminary hypotheses for these developments are indeed to be
found in this book. I, at any rate, shall be very surprised if the
anthropological study of art does not in the next decade take an
important place in social and cultural anthropology, and
certainly, if the analysis of art as systematic communication is
successful, affect not only anthropological theory but also
psychology and linguistics.

REFERENCES

d'Azevedo, W. L., 'The Artist Archetype in Gola Culture', Preprint no. 14,
 University of Nevada, 1966.
Cunningham, C., 'Order in the Atoni House', *Bijdragen tot de Taal-, Land-,
 en Volkenkunde,* vol. 120, pp. 34–68, Leiden, 1964.
Fagg, W., *Nigerian Images,* London, 1963.
Faris, J. C., *Nuba Personal Art,* London, 1972.
Firth, R., *Art and Life in New Guinea,* London, 1936.
Fischer, E., 'Künstler der Dan, die Bildhauer Tame, Si, Tompieme und Son,
 ihr Wesen und ihr Werk', *Baessler Archiv,* Neue Folge, vol. X, 1962.
Forge, A., 'Art and Environment in the Sepik' in *Proceedings of the
 Anthropological Institute for 1965,* London, 1966.
Fraser, D., *et al, Early Chinese Art and the Pacific Basin,* New York, 1968.
Gerbrands, A. A., *Wow-ipits: Eight Woodcarvers from Amanamkai,* The
 Hague, 1966.
Goldwater, R. J., *Primitivism in Modern Painting,* New York, 1938.
Himmelheber, H., *Negerkünstler,* Stuttgart, 1935.
Himmelheber, H., *Negerkunst und Negerkünstler,* Braunschweig, 1960.
Holm, B., *Northwest Coast Indian Art: An Analysis of Form,* Seattle and
 London, 1965.
Hymes, D., 'Linguistic Models in Archaeology' (mimeographed) n.d.,
 Clare Hall, Cambridge (1969).
Leroi-Gourhan, A., *Préhistoire de l'art occidentale,* Paris, 1965.
Mountford, C. P., *Records of the American-Australian Scientific Expedition
 to Arnhemland, vol. 1, Art, Myth and Symbolism,* Melbourne, 1956.
Munn, N. D., 'Walbiri Graphic Signs: An Analysis', *American Anthropologist,*
 vol. 64, 1962.
Schefold, R., 'Versuch einer Stilanalyse der Aufhängehaken vom Mittleren
 Sepik in Neu-Guinea', *Basler Beiträge zur Ethnologie,* Band 5, 1966.
Schmitz, C. A., *Wantoat,* Leiden, 1963.
Strathern, A. and M., *Self-Decoration in Mount Hagen,* London, 1971.
Sturtevant. W. C., 'Seminole Men's Clothing', in J. Helm (ed.), *Essays on the
 Verbal and Visual Arts,* Seattle and London, 1967.
Thompson, R., 'Abatan: A Master Potter of the Ègbádò Yorùbá', in Daniel
 Biebuyck (ed.), *Tradition and Creativity in Tribal Art,* Berkeley, 1969.
Watt, W., *Morphology of the Nevada Cattlebrands and their Blasons,*
 Parts I and II: Part I, U.S. Department of Commerce, National Bureau of
 Standards Report 9050, 1966; Part II, Carnegie-Mellon University,
 Pittsburgh, 1967.

CHAPTER 1 Art History and Anthropology:
Some Comparisons of Methodology

Robert Goldwater

These observations are set down by one initially trained in the
methods of the history of western art rather than in the disciplines
of anthropology. Having first approached the study of the
primitive arts through an investigation of the interest they held
for the artists of our own society in the twentieth century, I was
less concerned with their position in their own societies than in
the influence they had had upon others, i.e. in the analysis of a
modern acculturative process based on the 'artistic artefacts' of
certain primitive cultures. This inevitably led to an interest in
the works themselves, and primitive art being at that time out-
side the purview of academic art history, I attempted to apply
some of the same methods to its classification and understanding.
Since then I have dealt with museum collections. Never having
done field work, my contact with primitive art is through objects
no longer in use and my knowledge of primitive societies is only
indirect. Therefore these few informal considerations on com-
parative methodology cannot have an entirely comprehensive or
systematic character; they must be limited to the ways in which
the framework of the investigation, collating, analysis, and judge-
ment of more conventional art history and the study of primitive
art seem to have evolved.

The information needed for an understanding of primitive art
and the methods of acquiring it have been discussed by those who
have worked in the field. In the long run the kind of information
required for the understanding of the role of the arts in any
society is of the same sort (whatever aspect of artist or audience
one is concerned with), and art historian and anthropologist must
in the end base their conclusions upon similar evidence. In no
instance is the information ever complete, and in every instance
it must attempt to transcribe into the incompatible medium of
words experiences that, whatever their individual or social
radiation of meaning, begin as directly visual. Fundamentally
then, the study of art in any society should be carried out in
essentially similar ways. Nevertheless, since the mutual aware-
ness of their respective disciplines and methods by art historians
and anthropologists is comparatively recent, and their conscious
collaboration even more so, and since for the reasons of their own
histories, and quite apart from the differences imposed by the
material, the emphases of the two disciplines have been very
different, it may be useful to compare some of the modes of

thought they have employed to order and to understand the information available.

It is generally assumed that the chief distinction in the subjects of the anthropologist concerned with art and of the art historian is to be found in the relative distance of the societies they study: the latter examines art in cultures that are part of his own tradition, while the former must deal with arts that function in cultures so different from his own that he may even be forced to inquire whether art as he knows it exists at all. Even the most sociologically-minded art historian, by definition, takes the existence of the arts for granted, while the anthropologist, partly by definition, but also partly because of the traditional accidents of his discipline, raises the question of the origin and nature of their existence. Add to these differences of information and of attitude the circumstance that the historian has written documents to compare with the visual evidence, while the anthropologist at best has only oral information and tradition, and the methodological gap would seem enormous. Nevertheless, at the risk of suppressing details that must vary even within each discipline, I would suggest that they have evolved in very similar ways.

It is obvious that the past is not the present and that the historian, although dealing with a more familiar tradition, must reconstitute, or attempt to reconstitute, a situation that is never complete, and some of whose elements are unknown to him. On the basis of the evidence, he makes certain factual suppositions. And since cultural attitudes change rapidly, even the recent past can be foreign to his natural modes of understanding his own present, especially in the interpretation of visual material. But such circumstances are only relative, and are hardly enough to force a similarity with the difficult problems inherent in the understanding of the arts of non-literate cultures – even granting that the historian's written sources often shed little or no light upon the direct impact and comprehension that the arts of another period had in their own time.

And yet despite these undoubted divergences, it may be enlightening to notice some of the methods art history has employed in dealing with periods in the western past and to recognize how they have evolved, because that methodological development seems at least in part to have been repeated in a series of approaches to primitive art.

The parallel is especially striking if one examines the historiography of medieval art. As others (notably Firth and Fagg) have noted, the Middle Ages offer a propitious comparison for the treatment of primitive art on several counts: medieval, and especially Romanesque and pre-Romanesque art is a compara-

tively recent field of investigation; the overwhelming preponderance of the art was 'functionally determined', being either religious or ceremonial in use and intention; and most of the representational works of art, whether painting or sculpture, like most works of primitive art, offer varying degrees of non-naturalistic stylization which by our own traditional standards are at the very least more 'expressive' or 'imaginative' than 'beautiful'. Here, as in the primitive arts, it was the apparently purely technical causes of an evolving or declining naturalism that were first investigated, largely in the narrow terms of the development or loss of skills alone, with the assumption (stated or assumed) that where skills were adequate naturalism would ensue, since it was the normal artistic goal. Thus the look of early medieval art was explained by the loss of Roman techniques and there was great interest in the minute tracing of the changes in Romanesque and Gothic figure sculpture as an unbroken, linear, and so-to-speak teleological development. Problems of iconography were treated separately, as if the religious subject-matter was an abstraction unrelated to its particular embodiment, so that one could change without the other. As a consequence of this separation, the more difficult, but still crucial questions of the origins and implications of expressive form were only tackled later (as with the use of Riegl's concepts for the early Middle Ages, or the significance of the cult of the Virgin in the development of the Gothic style), just as they are only now beginning to be broached as problems central to the understanding of the arts in primitive society.

It is not surprising that in the handling of the problems of style the methods employed in organizing the material have progressed in a strikingly similar sequence. First of all in terms of representation interest understandably proceeded from the more to the less familiar, the most highly stylized forms were considered only in their supposed developmental relationship to more naturalistic ones – coming before or after. Parallel with this attitude, and somehow separate from it, the earliest concerns were also, in both disciplines, with the description and limitation of local styles. A bewildering mass of undifferentiated material had to be set in some graspable order, and this was achieved by the establishment of static focal points. It was necessary to localize and describe individual schools of early medieval manuscript illumination, the masons' ateliers at Notre-Dame and Chartres, or the Florentine and Venetian styles of the fourteenth century. In the same way it has been necessary first of all to distinguish Bakuba from Baluba and Bena Lulua, or Ibo from Ijo and Ibibio, and it is presently important to distinguish the various local tribal and village styles in the Cameroons or along the Sepik. At this

stage of information and understanding the separate character of the local style seems most significant. Since the job at hand is descriptive recognition it is qualities of type that are emphasized in order to give a cohesive and discrete character to each local style. Differences are underscored, and all works tend to be divided up as exclusive productions of recognized centres whose character is known, and such schematic allocations inevitably tend to play down works ('hybrid', or, more lately 'non-nuclear') whose atypical character make them more difficult to place. What is more, the descriptions and the consequent allocations, at first tend to be made almost entirely on the basis of what can be described as external characteristics. There are such details as the shape of an ear-lobe, the outline of an eye, the incisions that stand for the human hair, or the striations in the surface of an antelope horn – generally elements of a certain minimal stylization about which objective agreement among outside observers seem most easily reached.

Art historians named this method after the nineteenth-century historian Morelli, who was the first to employ it in systematic detail. The Morellian approach, which in the interest of accurate observation divides the work into small and separate parts, necessarily tends to isolate individual details from their contexts, and to concentrate almost entirely on elements of representation and the degree of their stylization. It tends to ignore those aspects of the work's total impact – rhythm, interrelationship and sequence, and overall formal concepts – that are more fundamental to expressive meaning. It is a method that is useful in heightening the focus of attention by fragmentation, and that in its desire to define style through circumscribed detail paradoxically concentrates on small elements of skill and accuracy which are, precisely, those that can be borrowed the most easily. But in striving for analytic clarity it tends to overlook the larger, more basically structural factors that give a work its synthetic character, factors that are inimitable because they have to do with attitudes as well as skills and are ultimately dependent on its social setting. The limitations of the Morellian method have long been recognized by art historians, and notice taken of those other qualities, more difficult to convey through verbal definition, which must nevertheless be accounted for. The description of primitive art has for some time now been at the Morellian stage. Franz Olbrechts employed the Morellian details as exclusive indicators of stylistic definition in his book on Congo art, where his purpose was precisely to arrive at a stylistic breakdown by making exclusive distinctions. This was a pioneering work in the treatment of primitive art, but to an art historian it came as a surprise to find Olbrechts in 1946 explaining his

methodology as new and inclusive. It is a method that almost certainly will be incorporated into more penetrating approaches to stylistic differentiation.

It is perhaps also legitimate to follow the implications of the methodological parallel somewhat further. As has been mentioned, the first step seems always to be the establishment of strict style areas, and in recent years great strides have been made along these lines in both Africa and the Pacific. There is no doubt that this compartmentalization is at least in part a reflection of the character of the material itself (i.e. that 'nuclear' styles do exist and do have some sort of paradigmatic influence), and that this is perhaps more especially true for primitive art, based as it is upon relatively small social agglomerations. But if one may judge by the art historical precedent there is a tendency at this stage of classification, due not to the evidence but to the manner of its formulation, to over-emphasize the highly individual character of separate styles and to tie them too tightly to particular localities. Material, social, and religious contexts (i.e. techniques and function), closed and static in nature, are found to explain why such a style must belong to such a place. But once ease has been established in the definition and repartition of the available material, familiarity permits a relaxation of vision, probably truer and more internal to the art, and it begins to be possible to see variations of type and intermediaries of style. At this point the existence of peripheral contacts must be acknowledged, and the so-called transitional style (which has as much, or as little validity whether it is defined geographically or temporally) is seen to have widespread existence. This at least has been the progression in the art historical analysis of those regional styles in which personalities are largely unknown. The evolution of our stylistic recognition of primitive art is likely to be similar, and it thus seems fair to suggest that with the necessary differences (and these will of course vary from area to area as well) the discussion will move away from the traditional insistence on strict tribal or village attribution, and that in the future purity of style types will have a good deal less categorizing importance.

The question of influences from outside the cultural circle of the style then arises, and the nature of the propitious circumstances in which they become effective. 'La forme voyage seule', Denise Paulme has written, concerning the spread of Dan mask forms. Despite extreme functionalist objections this may indeed be the case in certain instances, but why do they occur? (There is no need here to raise the more basic problem of classic diffusionism and motive hunting; it is only the more localized contacts that are under discussion.) Here it would seem proper to invoke

the role familiarly applied by anthropologists in other areas, bu
perhaps too little considered in the problems of artistic contacts
influence is rarely imposed; it more generally occurs in respons
to need or desire. In artistic matters what looks like push i
actually pull (although the unwanted push may of course b
taking place at another more material level of force or domina
tion) and is effective only in so far as useful absorption is possibl
Such assimilation may be formal or iconographical, or a mixtur
of the two, and if one is willing to grant that form is in itsel
expressive (and not just skill or decoration – see below) then th
two can hardly be separated, and only a division of emphasi
need be made between formal and functional alteration.

Some reflection upon the concepts developed in western ar
history may also be useful in developing a terminology fo
dealing with all those problems usually lumped together unde
the heading of aesthetics. In fact the term itself raises problems
It usually points to those aspects of art that are left after function
ritual or otherwise, iconography and meaning – if these ca
indeed be distinguished – are separated out. It is sometimes mad
to include skill, or the self-consciousness (on the part of th
artists), or the admiration (on the part of the audience) for skill
but only in so far as that skill is employed for the purposes o
arrangement and design and not in so far as it is devoted to th
accurate making of traditional forms. Thus aesthetics as used i
most discussions of primitive art may be said to apply to what i
the discussions of our own art would be called its 'abstract
aspects, i.e. those having to do with the pleasing distribution o
formal elements. In a way that one suspects has a good deal to d
with our own subjective (and historically very recent) bias, ar
awareness of this kind seems to be one of the central concern
of most of those who have dealt with the role of art in primitiv
societies.

Primitive art is of course generally described as functional
and the ways in which it participates in the practical, ceremonial
and ritual concerns of its society are stressed. Indeed thi
'functional' role is often emphasized to the point of making it a
defining factor which sets apart the primitive from the arts i
other societies. But such an emphasis, far from denying th
assumption of an isolated 'aesthetics' which determines th
presence or absence of 'art' seems rather to confirm it. It is tru
that one of the first questions that attracts investigators i
whether what is called 'art for art's sake' is present as a separate
interest for either artist or public. Since this phrase has by now
come to mean the narcissistic preoccupation with 'art' divorced
from all the other concerns of society and the individual's role
within that society (hardly its original meaning) the answer in

almost all instances is predictably in the negative. This is hardly surprising; what is surprising is that the problem seems to have such attraction, since (quite apart from modern western society – and even here its existence as it is now defined may be argued) it is certainly the rare exception among historic cultures – if indeed it can be said to exist at all.

Nevertheless the view of 'art' that initially compelled the question remains: namely, that there is something called the aesthetic faculty, or the aesthetic reaction, which responds to works of art which are in every respect functional, as if a certain aspect of them were divorced from function. The question, as it is put, suggests that this is the case, and that the functional work of art is constituted by the joining of two separate and diverse attitudes – the one in the broadest sense utilitarian, the other free-floating and self-satisfying – which generally exist independently but have been brought together for this particular occasion. This is often expressed by some such phrases as 'an undecorated log would do just as well for the ritual purpose at hand, but . . .,' or, 'although there is no need for anything but a simple covering to hide the wearer so that the mask may have the full power it possesses or symbolizes, nevertheless . . .,' suggesting that any 'aesthetic' character the figure or the mask possesses is an entirely separable element. This tends to reduce the particular formal character of the functioning object to the level of decoration, which can be added or omitted at will without in any way affecting the nature or the mode of its function, i.e. its representational, symbolic, or magical role. (Although the treasures of the medieval cathedrals are evidence enough that even decoration alone, and the skill, the effort, the marshalling of resources that its presence implies, affect the power and efficacy of a ceremonial or religious object.)

Here once again the parallel of art historical thinking may be invoked. Of course the evolution of that thinking, itself influenced by an increasing consciousness of non-western art, has already been partially followed, or paralleled in the analysis of primitive art. Today no one would think of invoking the simple standard of 'beauty' for the goal intended by the primitive artist, although a century ago this was frequently done, and his success or failure (which was thought of as collective rather than individual) measured by it. There are two basic reasons for the abandonment of such a standard.

One reason will immediately be clear. 'Beauty' is a measure developed by a culture external to primitive societies and therefore not applicable to any such society. Even granting that the recognition of feeling it describes may be found outside the classical tradition, it will not be aroused by objects of corres-

ponding appearance. So to invoke it is an elementary ethnocentric error, obvious today, although not always so in the past. The same applies to the closely related standard of naturalism which is immediately recognized as applicable to only a few tribal cultures and even to these with changes (Ife is the outstanding example), and altogether inapplicable to most.

But more is involved here than a simple acknowledgement that different cultures employ varying measures of an unvarying aesthetic response. What is in effect recognized is that beauty and naturalism are not generalized concepts which can be either overlaid or omitted at will from previously imagined functional objects, changing their 'aesthetic' aspect but not their function. The presence or absence of these qualities, in part determined by role, but also affecting that role by the impact they have, is an essential and primary aspect of these objects – as basic as their material substance or their iconographical character. Thus such qualities are not only reflections of function, but are themselves functional. (I am referring to qualities found generally in the art of a given culture, or during a time-span within that culture, and not to the relative success of individual objects.) We acknowledge this when we recognize that where we see a naturalism altered (as in the middle period of the art of Benin, and also in the Lower Niger Bronze Industry (?)) or an expressionism softened (as in later Maori works) the broader character of the culture is also changing. This suggests that the search for a primitive aesthetics, which implies qualities of pure arrangement and design and the satisfaction of self-contained order, will at the very best be inconclusive in its results.

The faulty implications buried in the use of the word 'aesthetic' have been noted before by others.[1] Although the noun 'beauty', with its Hellenic connotations, is now generally avoided, Vandenhoute notes that its adjectival form is common in the descriptions and definitions of primitive arts of quite diverse character. He observes further that 'aesthetic' is employed as a synonym for 'beautiful', and the aesthetic experience taken to be the awareness of forms and arrangements considered to be beautiful. As long as it is so restricted, he says, 'it will be difficult or even impossible to justify the use of the word "aesthetic" in an ethnological study. . . .'

This point would apply to studies of the arts well outside the range of ethnology, and in making it Vandenhoute is actually invoking the evolution of art historical concepts. 'Aesthetic experience,' he writes, 'includes a quantity of other aspects, e.g. the experience of ugliness, of horror, of the hateful, of surprise, of the comic, the tragic, the religious . . .,' and here he is calling on the history of the 'science of aesthetics', whose two-hundred

year evolution has in large part been an attempt to keep pace, not only with an expanding range of contemporary art, but an increasing knowledge of the arts of all societies – and not the least the primitive. Ever since the eighteenth century recognition of the sublime as both different from beauty and a proper goal for the arts, the study of historical art has increasingly been compelled to acknowledge the diversity of different types of art, and even more the incommensurate qualities of different periods of art. If this is true for the various periods of an historical tradition, how much more true for contrasting cultures. But once the term 'aesthetic' has been broadened in this fashion and given such diversity of reference, one must question whether it retains much of its usefulness.

Its employment may in fact still be misleading in its implications. For even if it is now allowed that 'aesthetic' refers to a wide range of artistic intentions (thought out or not) on the part of the maker of an object, and a corresponding spectrum of responses on the part of his audience, it still seems to refer to the secondary characteristics of a 'functional work of art', aesthetic aspects that are not only different, but less essential to it than its functional role. But is this in fact the case, can the separation of these two facets of art be justified as anything more than a temporary analytic device?

Here the precedent of art historical method is of less assistance. Robert Redfield remarks with some irony:

It is so often said that the art of a people expresses that people that I hesitate to deny it. . . . Among both art historians and anthropologists there have been those who have seen art styles as expression in concrete form of the thought and feeling that pervades and characterizes a whole culture. . . . But I should not expect to derive much valid understanding of a primitive world view from the art style of that people (Redfield, 1959).

Redfield's scepticism may be justified; even the social historian of art, who often reasons deductively from society to art, rarely reasons inductively from art to society. But one must note that his description still puts aesthetics in a secondary role: the world view first, art later as its illustration.

But it is also possible that the arts must be seen in a different relation to society, not as illustrations, but as primary documents. A religious sculpture may indeed seem to follow up and exemplify ideas and attitudes already in force. But it must not be forgotten that it also has behind it other earlier sculptures from which it largely takes its particular character. This character, or style, not only conveys a message, but more than this in itself embodies a message or a meaning and one that is essentially untranslatable. (Philosophers such as Suzanne Langer have belatedly come to

acknowledge 'symbolic form'; artists have always known that in this direct and elementary sense the medium is the message.) As George Kubler has written, 'Anthropological conclusions about a culture do not automatically account for the art of that culture' (1961). Art is thus its own model at least as much as it is a demonstration (in both the literal and the figurative senses) of ideas first elaborated elsewhere. A work, or a series of works, exists in this way not only for its creator, but also for its audience, whose vision it forms, so that its initial reality precedes and embodies ideas and feelings at least as much as it illustrates them. If this is so, then art is a primary document in a culture, and as such cannot be explained out of the other elements of that culture any more than they can be explained by it.

NOTES

1. See the discussions in Smith, 1961, and more especially Vandenhoute, 1961.

REFERENCES

Kubler, G., 'Rival Approaches to American Antiquity' in *Three Regions of Primitive Art*, New York 1961.
Olbrechts, F., *Plastik van Congo*, Antwerp, 1946.
Redfield, R., 'Art and Icon' in *Aspects of Primitive Art*, New York, 1959.
Smith, M. W. (ed.), *The Artist in Tribal Society*, London, 1961.
Vandenhoute, P. S., Comment on *Methods of Studying Ethnological Art*, by H. Hasselberger, *Current Anthropology*, vol. 2, 1961, p. 374.

CHAPTER 2 Adornment and Nudity
in Tropical Africa

Denise Paulme

Translated by Judith Djamour

It would, nowadays, be difficult to maintain successfully the
proposition that a society, however impoverished economically,
can be quite devoid of artistic tradition. Even when the conditions
of life are wretched, the members of the community have some
aesthetic criteria and leisure hours when they can indulge in
contemplation and in pleasures unrelated to the satisfaction of
immediate needs.

This capacity to recognize and to appreciate what one must call
beauty has long been denied to the pygmies of the Congo forest –
to cite only one example: it was alleged that their ceaseless
wanderings did not allow them this luxury. It was only after the
first sound recordings in the field that we came to realize that
they had not only an admirable music but also that they had a
feeling for ritual which made a return from the hunt the equi-
valent of a great musical drama, whose several movements follow
and balance one another in an ever-growing crescendo which
culminates in a final apotheosis. More recently, a record has
shown that among these pygmies, story tellers, in a series of brief
sequences, mime the principal scenes of a plot familiar to their
audience and play the parts of several characters. The interest of
the audience is focused on his acting, his intonations, his mime –
this is already theatre.[1]

It used to be contended that the plastic arts, painting and
sculpture, could flourish only among sedentary peoples, since
the wandering existence of cattle herders could not allow the
production of such works of art. Similar statements were
advanced by armchair scholars and museum curators who had
in mind collections of exhibits which could not include perishable
objects or ephemeral decorations. Marcel Mauss (although he
himself never carried out ethnographic field work) forcefully
denounced this prejudice; he stressed the importance of those
ephemeral works of art which often reveal the whole aesthetics
of a society: earth drawings, paintings on the outside walls of
dwellings, soon wiped out by the rain; or fragile frameworks
which are made of a complex of branches covered with bark or
cloth, and which are erected for one single day: the Yembe of the
Congo, for example, who work neither wood, stone, nor ivory,
erect immense *emumu* which derive from the tower and the

palanquin, exhibit them for a moment, then burn them in a ballet-like finale. Again, there are statues of dried earth, variegated in vivid colours, to which the young initiates are solemnly presented on the morning of their ordeal. Erected for a specific occasion, which they will not outlive, these figures, once the ceremony is over, stand abandoned and soon crumble in a heap of mud under the eyes of indifferent passers-by. No one will come again to gaze upon them. This deliberately transient character of a work of art is found in many African societies. Nor has the practice always been unknown in the western world; a recent renewal of interest in the Renaissance festivals has enabled us to envisage their splendour from the descriptions and engravings of the period.[2]

It is, however, on a more modest art form which I should like now to dwell: body adornment, which is the first in time of the plastic arts.

Bodily ornamentation is the point of departure. The first object to have been decorated was the human form, and more particularly the male body. Man in society has always striven to add on to himself some item of beauty and to make it part of himself (Mauss, 1947).

Ornamentation is universal, while to consider it a luxury is an idea peculiar to civilized man: everything points to clothing as an outcome of adornment, not to adornment as the result of a desire to complete and embellish clothing. It is only when man saw himself alienated from nature, when he experienced the complex feeling in which embarrassment certainly plays a greater part than pride (and which Genesis has made the consequence of original sin), that he felt compelled to represent himself other than he was at the time of his birth. Those parts of tropical Africa which have not been subject to the influence of Islam, have remained to a large extent, until recent times, unaffected by this change in the relation between man and nature. Nakedness is not an object of general condemnation; it is assessed by other criteria. Dress is one of the marks of prestige by which the noble or the rich are differentiated from most people, as among the Hausa. Dress can also distinguish the married from the single: in Benin, for example, the young men went about naked and were entitled to wear clothes only after obtaining the king's permission to do so at the time of their wedding. Among the Ashanti, silks and cottons have designs which identify the origin, social status, and sex of the bearer; in earlier times all new designs were the property of the king who either reserved them for his own use or else made a gift of them to those whom he wished to honour.

The first ornaments which man used were perhaps taken from the animals which he had just slain. The Bushmen, until very

recently, used to make cuts in the backs and arms of young boys and to rub the wounds with burnt flesh in order to give them the strength and agility of game. Generally, hunting peoples have retained a marked preference for adornments taken from animals.

Even when societies have developed they have not, in Africa, entirely severed all links with their prehistory. This continuity, so long broken off in western societies, is especially manifested in rites concerned with re-establishing links with the most remote past, with mythical times antedating all history. There are several present-day ceremonies reminiscent of those depicted on the rock paintings of the Fezzan or of southern Africa. I shall cite only one example: Hampate Ba has been able to interpret frescoes of the Tassili from the Bovinian era by comparing them with the traditional initiation rites of the Fulani herders which he himself witnessed in 1913, and with the annual ceremony of the *lotori,* during which there are lustrations of men and cattle, for cattle are not only a source of wealth for the Fulani, but also their 'kin'. This kinship is expressed in the symbolic relations between the four Fulani clans, the four main colours of the coats of cattle (yellow, red, black, and white), the four elements, and the four points of the compass (Hampate Ba and Dieterlen, 1966).

Following the sort of precedence with which nature, in this respect, endows the males of the species, African peoples often reserve for men the most astonishing and vivid ornamentation, particularly during the ceremonies which precede marriage. Among the Coniagui of Guinea, the privilege of wearing immense crests in the shape of a cocks-comb is reserved for young men for whom (as for the Gallinacea) it is a symbol of potency and beauty. The climax of the great festival which every year brings together the scattered tribes of the Bororo Fulbe of the Niger is the extra-ordinary ceremony of the *gerewol,* the beauty contest in the course of which young men vie with each other in most ingenious ways in preparation for their parade before the girls. This dance cannot but recall the rivalry in animal herds during the mating period. All the resources of the art of seduction are brought into play on this occasion. The body is surrendered to the refinements of painting and finery; in the course of the festival, the young men in line look like sumptuous and mobile figures of gods; their faces, shining with butter, are painted red and the corners of their blackened mouths show designs of dotted triangles; tall ostrich feathers tower over the banks of cowries which encircle their heads while rams' beards, rows of chains, of beads, and of rings frame faces whose gaze is lost in the distance; the neck and bust are polished as though they were precious wood and adorned with multiple rows of beads, of leather pendants, of cowries, and

of metal discs which are also seen on the dyed and embroidered loincloths. A deep chant is intoned by the young men who sway as they stand, their feet close together; they are wide-eyed, and fix their lips in the obligatory grimace of a broad smile while their faces remain impassive, since the eyes and teeth are important attributes of male beauty (Brandt, 1956).[3]

Nomads who go from waterhole to waterhole cannot express their passionate love of the beautiful in the creation of durable objects; apart from dances and songs, they can only show it in the adornment of the body.

As is the case in the animal world, ornamentation tends rather to emphasize than to conceal the differences between the sexes; it so happens that what we call, improperly, a *cache-sexe* is a garment which sometimes appears to be intended to draw attention to that part of the body. It is of course true that, what to us is only an ornament might be a protection against invisible dangers. The penis sheaths of the Somba hunters in northern Dahomey are intended to guard the wearer against the spells which an animal he has just killed might still be capable of casting. The crucial parts of the body, the apertures and the joints, must be protected; the labret inserted in the upper or lower lip (mainly of women) is both adornment and protection.

Animals are born adorned; man has to adorn himself. Animals indulge in mating display only intermittently because the sexual instinct occurs only in certain given conditions and only during some weeks of the year. At first sight it would seem that nothing should prevent men (who are not subject to such cycles) from permanently wearing what they consider to be objects capable of arousing admiration or desire. However, everyday life does not encourage the refinements of coquetry; moreover, though it is true that adornment is in origin closely linked to the sexual instinct, it is not exclusively related to it. Every human being, however wretchedly he lives, owns some ornament which he sets aside for formal occasions; every society has special moments when it requires each of its members not only to show himself to his best advantage, but also in the fullest splendour he can attain.

The wish to allure is always present, but the community (because the manifestations of that desire might give rise to imbalance and to disorder) allows it to express itself to the full only during special days of ceremony. Society cannot control desire, but at least it is able to manifest its will to guide it in the same way as nature does with the first arousal of the sexual instinct among animals. Better still, the mere exteriorization of a physiological need, by definition strictly personal, is transformed into the very mainspring of a collective exaltation which allows

1 A Coniagui initiate, Guinea.
Photo Monique Gessain

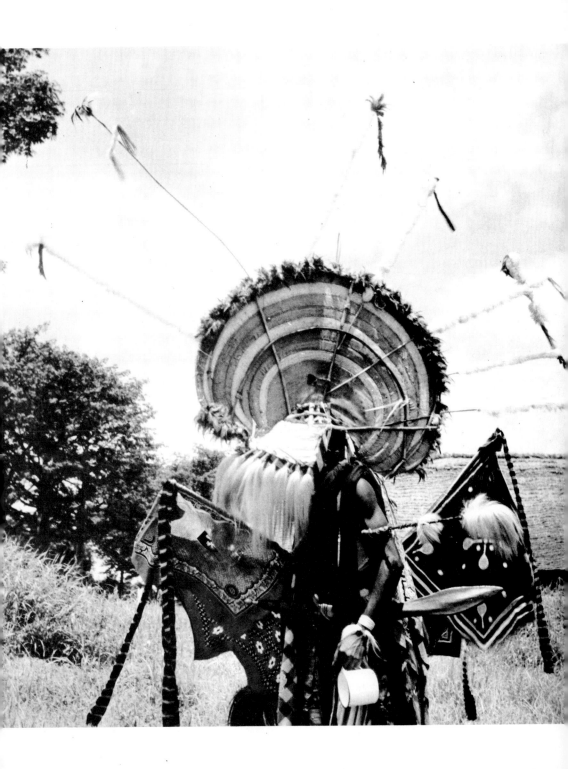

the whole community to participate in cosmic life. Thus we can no more look upon the ornamentation worn on such an occasion as expressive exclusively of the desire to appear alluring than we can identify the festival itself with the release of erotic impulses ordinarily kept under control.

In many societies, body markings and adornment serve to emphasize forcefully the differences between man and beast. The Bafia of the Cameroon explain ear-piercing and tooth-filing: 'Otherwise we would look like pigs or like chimpanzees.' Other peoples will say that these same mutilations are due to their wish to identify themselves more closely with their totemic animal.

Even outside the sacred period of ceremonials, ornamentation still plays a somewhat formal role in social life. It serves to emphasize that the community is one entity, by distinguishing it from neighbouring groups and by assigning to each one its proper place. In many African societies (also in Oceania and among the American Indians) finery and body markings are ordered in a veritable complex of signs which almost amount to a language. This language, as all languages, has value and efficacy only within the framework of conventions that are fixed and recognized by everyone. In this case, too, it cannot be left to individual whims. Ornaments are almost never without social significance: some are obliged to wear them while others are forbidden their use.

Some of these signs are aimed at enabling members of the same ethnic group to identify one another. They must, therefore, have an obligatory character; it is important that they be indelible and not easily counterfeited. This is why body markings such as tattooing and, among the Negroes on whose black skin the tattooings would not be easily visible, scarifications are preferred to mere ornamentation. The representatives of authority and of tradition always supervise the actual making of the markings. There is a right as well as a duty to be scarified, and no one would relinquish or avoid it; among the Nuer six long scars on the fore-head indicate that a young man has joined the ranks of the adults. Among the Tiv of Nigeria scarifications differ not only between tribes, but also with age: those known as *abaji* mark mature adults while young men are entitled only to the ornamentation known as *akusa,* achieved by the use of fingernails. When they are about fourteen years old the Kabre boys of Togo acquire the name of *efalu* and are then subjected to their first scarifications; three years later, at about seventeen, the *efalu* becomes *espa* and the young man's head is shaved in public; but it is only when he reaches the age of twenty and graduates to the rank of *kondo* that he acquires all the markings which signify that he has become an active member of the group. Body markings may indicate

membership of a religious sect, of a special cult, or even of a secular association, such as that of the Bafia 'ravishers of women' whose members sport two hippopotamus teeth around their neck. A body marking may indicate personal or kinship status: among the Bambara of Mali, uncircumcised boys have their heads shaved with the exception of a tuft of hair running from the forehead to the back of the neck, while a blacksmith's children exhibit the additional embellishment of two rings of hair intended to represent the forge.

In most African societies, a little girl, a pubescent girl, a young bride, a mother, a woman who has lost her child, and a widow, are identifiable by their particular hair styles; and must wear distinctive ornaments. Little Bambara girls have their hair shaved with the exception of a single plait across the head, which at a later stage is replaced by two plaits on either side. A Kikuyu woman shows that she is married by retaining only a small tuft of hair at the nape of the neck. The Herero woman, when she bears a child, fastens on her head some sort of diadem made of iron beads mounted on a leather band; as soon as the Dyola woman of Casamance is aware that she is pregnant, she discards her belt of glass beads in favour of a girdle ornamented with grasses and fruit. As for widows, they are always deemed unclean and are obliged to wear special apparel, which varies with the duration of their widowhood. On the day of her husband's funeral, the Ashanti widow used to rub a powder made from red bark on her face, arms, and legs; her usual clothes were replaced by a skirt made of vegetable fibres, and across her bosom she arranged garlands of *asunai* flowers; on her head was a crown also made of the same flowers, the name of which means 'tears'; from her elbows dangled knotted palm fibres which swayed during the dance in honour of the departed, a dance in the course of which the performers chanted plaintively, 'If we had wings we would fly up to him.' Finally, scarifications and tattooings often allow members of the same clan to identify one another: these markings are then combined with tribal signs and personal ornamentation.

We find that everywhere aesthetic considerations influence hair style. The hair is sometimes arranged on a concealed wooden or fibre framework. The *gossi* of the wealthy Senegalese women, to which young unmarried girls had no right (any more than they had the right to wear the headscarf used by married women on their everyday outings – to go about uncovered could cause their husbands to die), required them to wear sisal plaits upon which were fixed amulets as well as gold drops firmly stitched on (but which they nowadays prefer to fasten on a coif of black velvet fixed on a hair bun; the coif can thus be easily taken off). Before

going to sleep, a woman will tie a scarf firmly around her head in order to protect the masterpiece. When she gets up she uses a candle to burn any obtrusive bits of sisal, then freshens up her head-dress with a mixture of kerosene and soot.

Wigs and hair pieces are not exclusive to women. Men of the Pende of Congo-Kinshasa dress their hair with a number of small plaits, abundantly anointed with palm oil and soot, and dyed red with clay. The hair above the forehead is cut short and straight, forming a fringe, under which a band of palm fronds is inserted to make it *bouffant*; at the back, the hair is allowed to fall full length, recalling the thatched roofs of the local huts. Women's tresses, coated with vegetable fat, become rigid; they are weighed down with brightly coloured drops: seeds, shells, or imported beads. The Eshira women of the Gabon slide in long bone or wooden needles.

From the few instances just cited, it is clear that some body markings are permanent: they are those which express the enduring – or at least irreversible – characteristics of an individual, such as tribal or clan membership, or admission to adult status; the others – often, the style of head-dress – indicate a transitory stage: virginity, marriage, or widowhood.

It is not always easy to interpret these adornments: the penis sheath, the only form of clothing of the Coniagui of Guinea, is made of basketry and fantastically elongated; it is decorated with coloured designs and embellished with pompons of wool. The penis sheath may be worn because of an admittedly genuine sense of prudishness, but it also fulfils the secret yearning to draw all eyes. Is it not adornment as well as protection against the evil eye?

Again, when a little girl, in nearly every community, is given a belt made of blue grass or porcelain beads as soon as she begins to walk, is the belt not as much ornamentation as it is a talisman? Throughout her life she will wear this first trinket, and into it she will slip her first *cache-sexe,* a strip of cotton the ends of which fall loosely. The young girl will look to her parents as well as to the generosity of her suitors to lengthen her belt; when she walks, the jingle of the beads concealed under her dress, is said to excite male passion.

Ringing ornaments provide protection: the sound of a toddler's ankle bell will not only allow adults to locate a baby, but will also avert the evil emanations which threaten a still frail life; the small bell rings at every movement, attracting attention. Similarly, the bells made of fruit husks, of shells, of snake vertebrae, and nowadays of discs cut from tin cans, whether they be fastened to the wrist, to the calf, or to the ankle, punctuate with their clanging the rhythms of the dances.

2 Dancer, near Beni, Kivu, Eastern Zaïre. *Éditions Hoa-Qui*

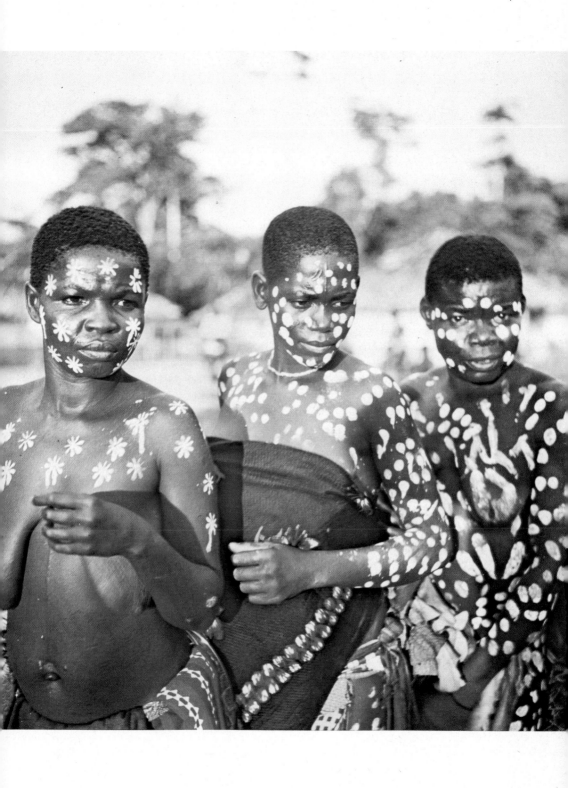

It is obvious that the more complex the everyday ornamentation the more information it provides about the wearer, and the more sharply it identifies him within the society. The question we might well ask is whether it is really necessary to have such a precise system of reference in communities which are so small in number that everybody knows everybody and each is aware of his own status *vis-à-vis* everyone else. Perhaps the problem is more complex: if a person were to identify another who is neither adorned nor tattooed, he would be identifying him according to criteria which are only superficial, which are perhaps not rightly his, which he might have wrongfully arrogated to himself, and which might cause the wearer to deceive and the onlooker to be deceived. It is safer to rely on markings imprinted on the flesh, since these markings serve the purpose not only of defining the person who exhibits them, but also of anchoring him to his own true self. Indeed, we should not forget that an individual is defined almost exclusively – even in his own eyes – by the position he occupies in his community, by his relationship to the world of the ancestors and of the spirits, to those who have died and those yet unborn. Of this collectivity, the community at any one moment is only a transient manifestation. Such a system (often very rigid) allows little individual initiative; it cannot satisfy all the aspirations which finery betrays.

One of these aspirations is, in fact, the wish to stand out from others, to present an inimitable, a unique appearance. This is a yearning present in all men; when it is relegated to a position of secondary importance, as in agricultural communities, it is because the development of adornment has been primarily to serve social ends. The societies of tropical Africa are in general little inclined to allow men to glory in their individual prowesses, and especially to allocate to themselves a position which is not based on established privilege. Nevertheless, able hunters, or conquering warriors are nearly always distinguished by some visible mark.

Among the Bété of the West Ivory Coast, nowadays coffee planters but formerly exclusively concerned with hunting and waging war, I was unable to discover even a trace of aesthetic activity as commonly defined in western society: they have neither sculpture (the few Bété masks are but feeble imitations of Guéré masks), painting, nor pottery; they do not engage either in basketry or in weaving. The village men spend most of their time in the narration of past exploits and in playing a war game (which resembles our own game of draughts and for which they use bamboo strips driven into the ground). Their only known festivals were war ceremonials, involving gunfire, etc. These

were staged before the departure of an expedition, on its victorious return, and, finally, at the funeral of a warrior. The first traveller to have observed the Bété, at the turn of this century, has described their dances:

Armed with guns, the natives kneel behind a chief who, after many bizarre chants are repeated by the choir, leads them in a furious charge against an imaginary foe only to halt them abruptly after the first few steps, and then repeat the performance. In another dance they gallop in single file, winding their way among the audience, about the trees or huts, and fiercely brandishing their guns while emitting blood-curdling cries (Thomann, 1903, p. 174).

The drums accompanied these triumphal dances (nowadays forgotten) with beats which tirelessly underlined the conquering warriors' praise poems. Every warrior worthy of the name had his own praise poem invented after his first exploit to herald his first victorious return. Sometimes, on the other hand, the praise song was created by a musician who would improvise the formula on his instrument in the course of the feast held to celebrate the warrior's prowess. Such a praise song would be endlessly proclaimed by beating of drum and taken up from mouth to mouth; it would soon become famous and carry the renown of the warrior throughout the length and breadth of the region. When a man killed an enemy he won the right to wear a necklace of *sabo* bark; he who wore the greatest number of these necklaces was a hero, a *kpañõ* (from *kpane* = war).

In bygone days every village had its Bagnon (*kpañõ*), who was its source of honour and of pride, its idol; he was chosen from among the most handsome men, his bearing was proud and haughty, women admired him without restraint . . . he used to select his numerous wives from the ranks of the most beautiful women born into the leading families . . . he had a guard of honour and everyone would contrive to pamper him.[4]

How could one fail to be struck by the stress a Bété places on virile beauty and by the attributes which he enumerates? Indeed, can one allege that the Bété are wholly lacking in artistic tradition when the entire village saw in its conquering hero the incarnation of an ideal in which physical and moral virtues seem indissolubly linked?

A man presents an image to himself and to others simultaneously: apparel and appearance are very closely related,* as are *parare* and *parere* in Latin. He who claims that the wearing of apparel serves the purpose only of reflecting what one is in reality (that is, either one's social status or even one's individual achievements) ill understands human psychology. Side by side

* *parure* and *paraître* is the original contrast made by the author (ed.).

with the rigid system which regulates the use of ornamentation and at the same time gives it a significance clear to all, there exists everywhere some tolerance of coquetry.

By observing and imitating animal behaviour, man has aroused, developed, and enriched his reflex of self-adornment; what started as a function of the sexual instinct and of imitation became charged with a multitude of meanings which might give rise to conflicting interpretations. This primary, almost biological, motivation provided the plain theme about which rapidly clustered an infinite number of psychological variations. Just as the complex of elements which belongs to the system of social references served the purpose of anchoring a member of the community in the human setting and of compelling him to identify himself with the role assigned to him, so did the individual's additional ornamentation cause him not only to appear to others, but also to become in his own eyes the character he had chosen to represent. A man puts on a disguise to show himself as the person he wishes he were; it is not an idle game, since he may eventually become that person. Pride of self may be a reprehensible fault, but we cannot ignore its role in personality development any more than we can forget that adornment is one of the ways in which this feeling can express itself.

Young Kissi initiate, High
Guinea

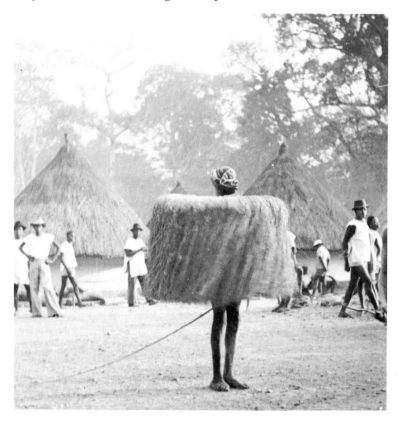

But it comes to pass that in this game of appearances, what is real and even what remains possible in social terms do not suffice. There are some individuals who are confusedly aware that they have progressed beyond the position ascribed to them, who are no longer able to be content with their allotted station; although they may not be aware of it, they yearn to be other than they in fact are. They want to be endowed with prestige, to be invested with exceptional powers, and so to escape from their everyday humdrum existence. This longing for change can find satisfaction in ornamentation. The world of bygone days, the world which is apprehended in dream life and cannot be reached by ordinary ways, this is the world which men attempt to reach through their dances. A man puts on an animal skin, adds a mask made in its image, and thus becomes the animal. When an ancestor or a bush spirit has indicated a wish to be represented or incarnated, a living being obeys the command and in so doing gives shelter to a wandering soul and momentarily acquires its powers. When a man wears a mask he is able to restore the loss of energy which his real self has suffered by being torn away from its deep roots. The mask is usually a personal creation, it is the outcome of a private inspiration, sometimes of possession; it is the mysterious injunction given from the world to which it belongs and with which it provides an indispensable communication.

There are African societies which have never worked either wood or stone; there are no blacksmiths in the villages and men have to seek elsewhere the few necessary tools. In these villages, during the festivities for the initiation rites of boys, the latter present an unrecognizable appearance with their skulls and bodies entirely painted with ochre and lime. The desired effect is identical with that produced by the wearing of a mask, the actors are no longer themselves: as a matter of fact, the disguise cannot be detached from its wearer. Similar cases have been reported in Australia, where body painting of symbolic value exists side by side with masks that are mere hoods of bark. I was present at more than one initiation ceremony among the Kissi of upper Guinea, where the smallest of the boys, chosen for their ability, exhibit red and white geometrical designs which stand out on the brown skin of their faces and on their shaven heads. The effect is breathtaking. A board placed on the shoulders of the 'mask' supports raffia fibres which form a circular fringe falling to the calves; the wearer shakes the fringe with a continuous shrugging of the shoulders; he walks on bent legs and drags a long wand with which he holds the curious at bay. The latter dare not come too near for the wand is said to be poisoned and contact with it to inflict leprosy. The other initiates are entirely naked, but their bodies and heads are whitened with

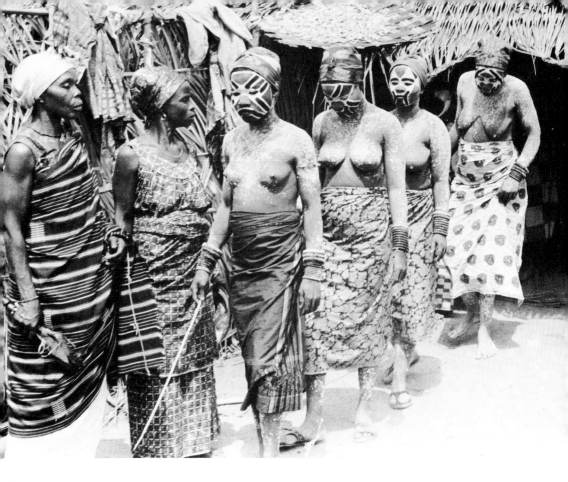

clay, for white is the colour of the other world. They hold in their hands the paraphernalia of the dance, such as wooden guns; their movements, dictated by the rhythms beaten on a wooden drum, are reminiscent of gymnastic or para-military exercises.

The dance is a waking dream, and in the course of the dream the mask is more real than the creature of flesh which acts only as its support. When a person dons a mask, when he disappears beneath the robe made of fibre or of cloth which is the complementary apparel and which renders the wearer unrecognizable, he does not surrender his own fluid and fleeting personality; rather, he rediscovers within himself his own enduring essence. In such a case ornamentation does not mean the superimposition of some object on to one's outer aspect; on the contrary, it means divesting oneself of externals. It also means effacing oneself before something more powerful and more durable than oneself, allowing the invisible to be apprehended by all eyes, giving a body to the insubstantial, attracting to the community the benefits which flow from the public visitation of supernatural beings; further, these beings, once propitiated, will not now cause any injury. The dance of the gods is not performed merely for the pleasure of the spectacle, nor for the temporary ecstasy engendered by the metamorphosis of the dancers; its purpose is

to bring back some order into the world of the living, to regenerate in an enduring manner the vital forces which animate it, to inspire it anew. The actor in this cosmic drama will also emerge renewed, more able to bear, after being bathed in incomparable grandeur, the petty tyrannies of everyday living.

NOTES

1. Record, *The Music of the Ba Benzele Pygmies,* Unesco Collection, Barenreiter-Musicaphon, BM 30 L 2303.
2. *Les Fêtes de la Renaissance* and *Fêtes et cérémonies du temps de Charles-Quint,* both Paris, 1956.
3. Record, *Nomades du Niger,* OCORA, Ocr. 29.
4. Serele Seri, M.S., p. 279. See also Paulme, 1962, p. 85.

REFERENCES

Brandt, H. *Les Nomades du soleil,* Lausanne, 1956.
Hampate Ba, A., and G. Dieterlen, 'Les Fresques d'époque bovidienne du Tassili N'Ajjer et les traditions des Peul: hypothèses d'interpretation', *Journal de la société des Africanistes,* vol. XXXVI, 1966, pp. 141–57.
Mauss, M., *Manuel d'ethnographie,* Paris, 1947.
Paulme, D., *Une Société de Côte d'Ivoire hier et aujourd'hui: Les Bété,* Paris, 1962.
Serele Seri, J., 'Daloa et la race Bété', Diplome de L'École des Hautes Études (unpub.).
Thomann, G., 'De Sassandra à Séguéla', *Journal des voyages,* vol. xiv, 1903.

CHAPTER 3 Tikopia Art and Society

Raymond Firth

Most studies of primitive art heretofore have concentrated on
cultures and aesthetic spheres in which the art could be described
as 'rich' in character. The Tikopia offer a contrast to such studies.
Generalizations about art in the broadest sense have often
stressed its expressive function, its role as a material sign of ideas
and emotions held collectively or manifested individually by
different members of a particular society. For Lethaby 'art is
man's thought expressed in his handwork' (1949, p. 1). For
Hinks and others it is the 'concrete expression of abstract ideas'
(1935, p. 2), and so on. Art crystallizes aspirations and indicates
consciousness of a particular era of national life. Different eras
have their own particular method of aesthetic expression, a
product of the traditions of art workmanship and the 'national
equation of the moment' (Lethaby, p. 2). So the recognition of
periods of art can be coincident with the recognition of periods
of general development. Among the complex set of forces which
becomes manifest in the art of a particular society at a particular
period not only the aesthetic structure but also the social struc-
ture is held to be involved. Arnold Hauser (1952, pp. 35–9)
connects a geometric style of neolithic peasantry, for example,
with a uniformity of organization, stable institutions, an auto-
cratic form of government, and a very largely religiously oriented
outlook on life. Such art, he thinks, is conventional, solid, stable,
and inflexible, even invariable, in its form.

These are merely samples of well-known views, some of them
clearly exaggerated, which try to give some kind of explanation
in social terms to the variation which appears in the character of
art in different societies and at different periods. Sometimes a
further factor is added, the degree to which the society itself is
subject to change and development. Lethaby holds that periods
of art have coincided with crests of general development, and
emphasizes that the most important characteristic of art, apart
from individual artistic genius, is its continuity and response to
change (1949, p. 2).

THE POVERTY OF
TIKOPIA GRAPHIC
ART

In the light of such views the Tikopia pose a problem. Evidence
from their tradition and from observations on the state of their
society over more than a century indicates that despite conflict
and occasional violence the form of their society may be regarded
as relatively stable. Again, their institution of chieftainship and

the great respect shown to their chiefs, whose orders on critical occasions have until recent times been carried out without question, allow their form of government to be categorized as relatively autocratic. In the pagan conditions which obtained until recently their outlook on life, with their elaborate ritual cycles and complex pantheon of spirits to whom prayers, offering, and libations were made, was religiously oriented to a high degree. Yet fascinating as all this has been, to an anthropologist interested in primitive art their culture has been disconcertingly barren. Their plastic arts traditionally and in recent times have been relatively undeveloped, simple in form and often poor in quality of workmanship. Their chiefs were not a leisured class but they did command some patronage; they and some other senior men in the community have been able to employ craftsmen of skill to make sea-going canoes, wooden bowls, clubs, dance bats of a reasonable degree of efficiency. Such things were ornamented, but very simply. The craftsmen responsible were recompensed for their effort and skill. But the emphasis has been upon securing effective working implements rather than objects of particular aesthetic interest. Plastic art as such in Tikopia has had no commercial value, that is, artist as distinct from craftsman has had no material reward and no special social status. In Tikopia fine craftsmanship has had some social approval but this has been primarily related to the technical workmanship and utilitarian elements of the product rather than to its aesthetic effect. Yet all this in itself would not necessarily inhibit the production of art objects of high quality. In some primitive societies men have produced 'high art' apparently irrespective of material recognition or perhaps even of status recognition of their aesthetic efforts. More important, perhaps, is the lack of any great degree of competitiveness in the craft sphere, of that emulative striving for excellence which might lead to a search for more effective, more striking, modes of presentation.

Is one to conclude, however, that the Tikopia, lacking any developed plastic art, have lacked also any degree of sophistication in thought, feeling, or abstract ideas? My answer is decidedly in the negative.

In many primitive societies art appears to be selective. In Tikopia, while plastic art has been relatively undeveloped, upon music and associated arts of poetry and dance the Tikopia have focused a great deal of attention. It is true that in the field of poetry and dance in particular their aesthetic expression may be described as robust rather than refined, but in these fields they cannot be said to lack either sensibility or abstract ideas. In music, poetry, and dance Tikopia seem to have developed a very considerable range of variation and elaborate articulation,

with many nuances of form and expression. They also seem to
have associated these aesthetic products much more closely with
the organization of their society, with the expression of social
bonds and status differences, than their creations in the field of
the plastic arts.

What I am arguing is not novel, but perhaps needs restating –
that a community which has been remote and very isolated for a
long period may develop its aesthetic tradition differentially. It
may lack certain kinds of aesthetic creation, or concentrate on
one sphere to the neglect of others, without necessarily lacking a
general vitality, capacity for abstract thought, aesthetic sensi-
bility, and interest in new ideas and experiences.

But a second question – is the lack of Tikopia plastic art due to a
deficiency in the conceptual handling of solid form, to an absence
of a specifically sculptural art tradition, or to some repressive
influences in the society (comparable to the Muslim ban on
religious iconography)? – is more difficult, perhaps impossible,
to answer.

In the sphere of plastic and graphic expression Tikopia offers
a case of almost minimal art. Painting and drawing generally and
their analogues in bodily decoration have had very limited scope.
Bark-cloth is sometimes dyed orange with turmeric, though
never painted; pandanus mats may be given a border of chevrons
and allied design; tattooing has traditionally been applied in a
limited range of naturalistic and geometric designs to the human
body (Firth, 1936; 1947); white flowers are worn in ears and
round the neck; beads, traditionally black or white, and later
coloured from European sources, were strung round necks and
wrists. But all these decorative elements, though very important
to Tikopia as social indexes, were relatively minor as contri-
butions to aesthetic production in any comparative sense. Minor
also, though of potential interest to students of comparative
design, are the elaborate systematic 'geometrical' variations in
Tikopia string figures (Firth and Maude, 1968).

Tikopia sculpture has been confined almost entirely to wood-
work. On a small scale, neck pendants and wrist ornaments were
constructed of clam shell, pearl shell, or horn (turtle shell).
Pleasant in their simple shape, these too showed little aesthetic
development. The greatest range of variation has been in the
production of objects from wood. But almost none of these can
be regarded as objects of primarily aesthetic interest in their
manufacture. Possible exceptions were figures, conventionally
described as birds (Pl. 1), set as decoration on temple ridgepole
or canoe of the Fangarere chief. But even these had a strong ritual
connotation and might be regarded as essentially symbolic
presentations with religious orientation rather than primarily art

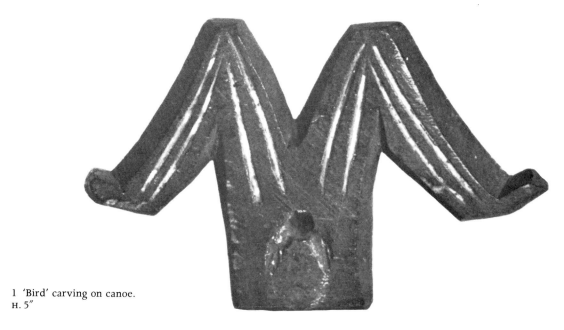

1 'Bird' carving on canoe.
H. 5″

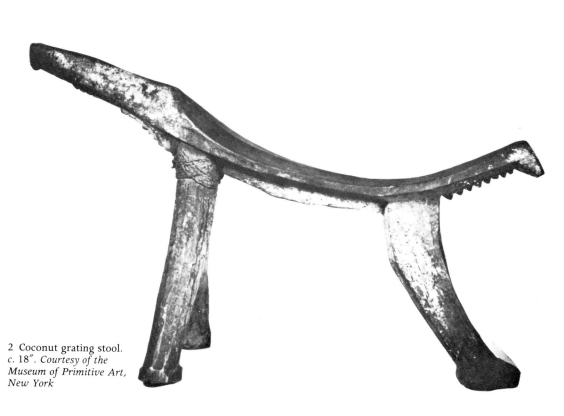

2 Coconut grating stool.
c. 18″. *Courtesy of the*
Museum of Primitive Art,
New York

objects (Firth, 1960). Only the decorative elements such as the rows of notches (*fakatara*) on many wooden objects, or the incised outline drawings of fish on house-posts, have had a non-utilitarian, elaborative, putatively aesthetic role (Pls. 2 and 3). The only painting applied to woodwork was a white clayey kind of stone sometimes roughly smeared on for general effect of contrast (Firth 1967, Pl. 1a).

In woodwork the Tikopia have had a strong craft tradition. There has been no very specific system of instruction or apprenticeship in woodworking, but a fair amount of empirical information has been passed on, particularly from father to son or grandfather to grandson. But by no means every Tikopia is a woodcarver; this is certainly one society where *not* every man is a 'natural artist'. Woodcarvers have tended to be professional specialists – not devoting all their time to the work but making it a definite occupation, sometimes on commissioned jobs. There has been some tendency to role aggregation – men skilled in wood-working have often been expert fishermen and dancers too. (One lineage in particular in recent times, that of Avakofe, has had a special reputation in these fields.)

The work of the woodcarvers has been pragmatic and tech-nically effective. Manual dexterity has been admired but traditional forms have been given high value and scope for invention has been relatively limited. In canoes, bowls, dance bats, and most other objects of wood, experiment either in form or in ornament seems to have been extremely restricted. In myths and other traditional tales the author is unknown. But, as with songs and string figure designs, many wooden objects are labelled as items of named personal authorship. All the major items of recent workmanship, such as canoes and bowls, can have their maker identified not only by those who commissioned the work, but also by other people at large. This is not basically a matter of style recognition. The construction of such important objects is a matter of social interest and consequently the maker is borne in memory. Again, the Tikopia prize things which re-mind them of their ancestors, and often identify wooden objects as formerly the property of ancestors. In such a case they also may attribute the object to the workmanship of the ancestor concerned, crediting him with the reputation of a noted crafts-man. This personalization of the manufacture of wooden objects, though possibly apocryphal, does mean that some elements of status are involved in the construction. But the status factor does not seem to have been strong enough and pointed enough to have resulted in stimulating any very specific aesthetic achieve-ment.

The form of Tikopia wooden objects has been fairly closely

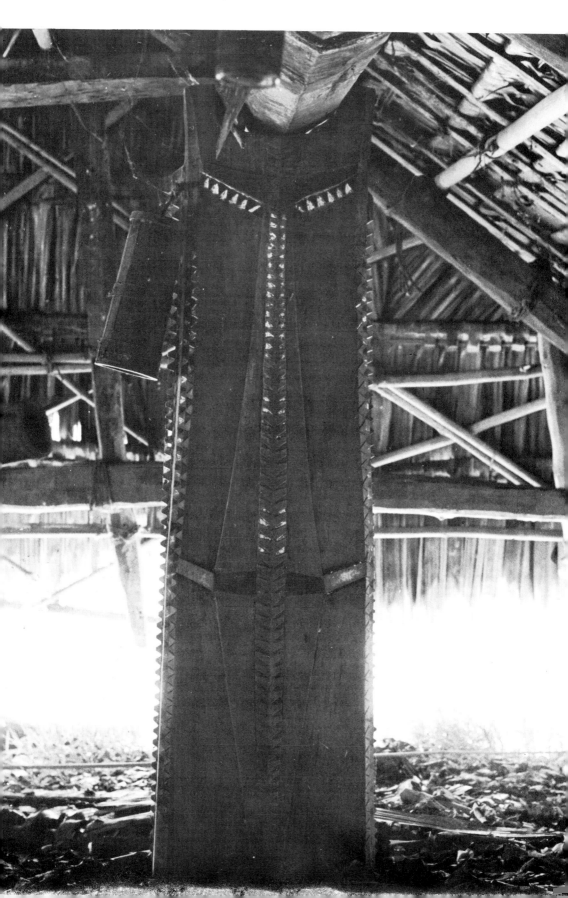

ornament on house-
Raniniu temple, 1966.
rg Photo

determined by their function. In general shape, line, and proportion Tikopia bowls, turmeric ovens, netting needles, or clubs offer few surprises. Many of their forms can be considered tasteful by western critics. Their simple notched-row ornament diversifies but does not radically modify their functional outline.

Traditionally the Tikopia had nothing in the field of anthropomorphic figure sculpture. Unlike some other Polynesian peoples, they seem to have found it quite simple to symbolize their gods by stones of natural shape or structural members of buildings such as house-posts and rafters, whose primary purpose was to serve an architectural need. In Tikopia temples, house-posts were traditionally symbolic. But they were adorned with very little ornamentation – occasionally a fish design or a series of rough notches – and the aesthetic handling of a post was almost irrelevant to its symbolic role. This does not entitle one to say that the Tikopia lack abstract ideas or powers of conceptualization. On the contrary, it may be argued that their power of conceptualization has been such that it has needed no stimulus of any quasi-representational kind. As with some 'higher' religions, they needed no graven images to assist them in the worship of their gods. Distressing though this lack of anthropomorphic iconography may seem from the aesthetic point of view, the Tikopia were able to invest their crude, functional items with strong symbolic value.

It is difficult to give reasons for this lack of Tikopia aesthetic achievement in sculpture and lack of interest in aesthetic possibility of working in wood when they had canoes, bowls, and other objects with which to demonstrate their skill. It may perhaps reflect the absence of an artistic tradition dating back to the colonization of their island. It is feasible (if tradition has any relevance here) that their ancestors arrived in driblets, perhaps mainly as castaways, and may have carried with them no memory and technique of fine craftsmanship and artistic invention. But if tradition is to be believed (and it is supported by a little other evidence – Firth, 1961), there has been ample time for individual artistic impulses to develop and express themselves in some overt cultural form. Such indeed seems to have taken place in the musical and allied fields. The lack of tradition then is not a sufficient explanation. I cannot point to any simple set of factors which seems to be involved here. Tikopia preoccupation with ritual and social institutions in a non-iconographic milieu may have tended to militate against the devotion of elaborate time to aesthetic achievement. Relevant also perhaps is an attitude of acceptance of convention, of a notion of standardized shapes for objects of major cultural interest, and an unwillingness to incur criticism by departing from recognized standards.

TIKOPIA HEADRESTS But some aesthetic interest, if only embryonic, emerges in a domestic context. In the production of headrests the Tikopia seem to have shown much less inhibition than in other fields of sculpture, much more freedom of individual expression. One may speculate that in this field, where the objects are of a highly personal character, traditional form is on the whole less important, and initiative and aesthetic interest can find play. This hypothesis is the reverse of a common view, that whereas religion provides a stimulus to 'high' art, the domestic field is one of convention and lack of experiment.

I do not wish here to magnify the idea of variation in a small sector of Tikopia woodwork into the notion of a very serious field of personal artistic expression. But the problem of such individual expression is of interest – if only because of Hauser's generalization that the geometric style of the autocratic, stable type of society is relatively invariant. Evidence from Tikopia shows that such a statement needs clarification and modification.

During my first visit to Tikopia in 1928–9 I was struck by the wide range of variation to be seen in Tikopia wooden headrests. I collected about two dozen examples of these headrests, and on my second visit to Tikopia decided to investigate more closely this matter of variation. Further examples collected in 1952, and again in 1966,[1] demonstrated still more the range of variation in style of these relatively simple articles of furniture. Moreover, I was able to obtain, though not easily, some Tikopia opinions on the significance of this variation.

TECHNICAL AND
SOCIAL BACKGROUND The Tikopia have two major types of headrests, differentiated as part of what may be termed the 'cultural signatures' which marked sex division in that society. One type is a soft bundle of bark-cloth resembling a European pillow, but rolled and not stuffed. It is used by women and small children of both sexes. The other type, cut out of wood and the subject of discussion here, is used by men and adolescent males. In methods of dress, carrying loads and seating, conformity to the recognized sex pattern is very high, even from the earliest years. But whereas children follow these sex patterns from the time they begin to wear clothing, in the use of headrests small male children are assimilated to the resting pattern of the women who tend them. In this connection it is probably relevant that the use of the bark-cloth pillow is a pattern which makes no demands on bodily skill, whereas use of a male type headrest normally requires some little care to keep it upright. A wooden headrest is less comfortable than a bark-cloth pillow, and Tikopia sometimes attribute bumps or indentations in the head to the use of such headrests from an early age. But until recent years male status

required the use of such a headrest. (In modern times some men have been ready to use more ordinary types of pillow.) But though traditionally a male Tikopia would not use a bark-cloth pillow, the use of a properly constructed headrest was optional, not mandatory. An upturned bowl or a billet of wood was equally appropriate and was commonly used in huts in the orchards where often no ordinary headrest was available. (In 1952 I noted that a rectangular block of wood which had drifted ashore, apparently from some Japanese war vessel, had been used as a headrest by a Tikopia family.)

Headrests of any kind are termed *urunga,* and wooden head-rests are commonly known as *urunga nga tangata* (headrests of men). They are often made from fairly hard wood such as *fetau* (*Calophyllum inophyllum*), but softer timbers such as those of breadfruit, *Plumeria, poumuri,* and *afatea* may also be used. An average headrest weighs about two lb. The tool ordinarily used in cutting out a headrest, as for other woodwork, is a small adze with a European plane iron as a blade; a piece of coral rock is used as a rasp to rub down the rough edges of the wood. Making a headrest is not highly restricted but may be done by any man of ordinary skill. The opinion was expressed to me that to make a headrest is not difficult. 'Any man picks up a piece of wood and hews out his headrest.' Some men, however, tend to specialize in this work and turn out headrests in their spare time – one woodworker I knew had made thirteen over about twenty years. But any man who wishes may try his hand, and many headrests are clearly amateur jobs. One I saw (of ordinary single-foot type) had been made by a boy. Though not specifically encouraged to work in wood, male children are allowed to exercise initiative in this field, and may be helped by a father or other kinsman. One exception to all this is the most delicate type of headrest with high 'wings' and lashed legs (Fig. 19). This is usually made by a professional woodcarver, who constructs also canoes, bowls, etc. as commissioned items.

HEADREST STYLES I do not find the classification of styles in these Tikopia headrests at all easy. Tikopia themselves, including the woodcarvers, used simple descriptive categories such as 'solid block' type (*urunga potu rakau*), 'holed' type (*urunga fakafotu*), 'legged' type (*urunga fai vae*), etc., and I have broadly followed their divisions. But these are very rough. Three main criteria may be identified – general shape, principle of construction, and supporting or ancillary details. From a sample of forty headrests I examined, about a dozen styles may be recognized, though some are sub-divided by the Tikopia themselves. These are illustrated in simplified form by the accompanying sketches. The simplest,

Fig. 1

Fig. 2

Fig. 3

Fig. 4

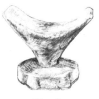

Fig. 5

Fig. 1, is a wooden block, usually hollowed slightly to take the neck and back of the head. Developing from this are various shapes, retaining the form of the block but removing some material to provide a neck platform and/or feet. Fig. 2 illustrates one of these. A further development, Fig. 3, is to cut a hole from side to side through the middle of the block. This hole may be of varying size. If it is comparatively large, then the amount of material remaining at the base of the block as the foot platform is thin and the side pieces assume almost the form of legs (Fig. 14). Instead of cutting the hole through the centre of the block, material may be cut away through the base so as to alter the particular style though not the general form. An instance of this is cutting a large groove longitudinally at the base of the block and shaping the remainder so that the result is rather like a wooden shoe with a V-shaped hole underneath (Fig. 4). Another style is not to cut through the base of the block but to cut around the sides in such a way that a solid central pillar remains with a base platform or foot. Stylistically, three types may be recognized here: one, Fig. 5, deeply cut into the central column at the base to form a Y-shaped headrest; another leaving the central column in a bulbous shape, Fig. 6; and still another, in which the central column is rectangular, Fig. 7 (said by one informant in 1952 to be a modern style) (see Pls. 4 and 5). The major alternative to the single column support is to provide the headrest with two legs. Here again there are several different styles. In one, the most common, the base of the block is cut out in approximately rectangular form so that the legs form two relatively straight columns (Figs. 8–12 in various forms). Another style is similar except that the central space is triangular, not rectangular, and thus gives a different shape to the legs (Fig. 13). (Examples of both of these, as also of a couple of other two-legged varieties, were identified in 1952 as of traditional style.) Still another style, Fig. 14, may be classified as either a much extended version of Fig. 3 or as a variety with two legs joined together at the base by a platform. (This latter was the classification into which it was put by Tikopia themselves.) Another associated type (Fig. 15, Pl. 6), has a bar hewn out of the solid adjoining the two legs. In all the types described so far the headrest has been cut completely out of the solid. But in one further type, Fig. 19, the headrest is composite. It is made up of three sections, the top section where the head lies and two legs attached by coconut sinnet lashings to this. A normal distinguishing mark of this type of headrest is that one leg is straight and the other is forked with two feet, but a stylistic variant in one example I saw had both legs forked. (Naturalistic prototypes are shown in Figs. 17 and 18).

What can be said about the origination and relationships of

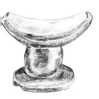

Fig. 6

these styles, with particular reference to the relation between individual and social factors involved? It must be said at once that at the ordinary anthropological level of inquiry, granted the imperfections of field technique, I could obtain little direct information from the Tikopia themselves on this question. For any systematic answer to this question we must rely primarily on indirect evidence, even speculation. But one thing is clear – that this range of styles in Tikopia headrests is not primarily of overt symbolic significance. How far is it due to variations in taste among headrest makers or users?

THE DEMAND FOR HEADRESTS

The most general element in the Tikopia demand for headrests has been the wish for a pillow of the kind prescribed by custom for men. Yet despite the permissive attitude towards wooden headrest style, and the relative ease with which any man can cut one out for himself in rough form, there has been a strong differentiation in demand between individual pieces.

Fig. 7

One component of this demand has been interest in workmanship as such. But this has often been commingled with interest in a particular design. A man might wish to have something of greater comfort or utility than the ordinary. Pa Panapa, a well-known maker of headrests, made one of a solid block, hollowed out at top and sides and about five inches broad at the flat base. He was very proud of this. He said it was his own design and that his idea was that there should be three ways in which it could be used, each giving a different height to the head: upright, sideways, and upside down – when the straight base would give rather more height. This headrest was much praised by one of his friends, he said, who wanted him to make one like it. I doubt if he did.

Fig. 8

I was told in 1952 that sometimes a well-known carver was commissioned to make a specified kind of headrest. The client would go along with a basket of food to proffer his request, and then when the headrest was ready he would go to collect it bearing a gift of food, with three or four pieces of bark-cloth in payment. (No pandanus mat was given; this was a reciprocation for more weighty objects.) Alternatively, a man might wish for a certain headrest which he had seen in the carver's home, and bear it off – with or without reciprocation. Pa Panapa told me how a man of rank from the other side of the island came over to visit him one evening with a basket of food, slept in his house and then said to him, 'Uncle [mother's brother], I am going with this headrest,' and took it, unchallenged. Another headrest was in use by Pa Panapa in his house when an adopted son of his came and slept there one night. As he left the next day he took the headrest with him, saying nothing to anyone. A search was

Fig. 9

Fig. 10

Fig. 11

Fig. 12

Fig. 13

Fig. 14

made and it was finally located. The man stoutly objected to giving it back, saying that he wanted to keep it, as a memorial of his 'father', the maker; so he was allowed to retain it. Altogether eight of Pa Panapa's headrests were borne off by kinsmen, in each case by someone whose relation to him was such that he could carry off such property with impunity.

A component in the demand, then, has often been not so much an interest in workmanship or design of a headrest as in an object associated with the personality of the maker or the user. A rather subtle balance may be involved here. When a kinsman bears off a headrest from the house of the maker, alleging that he wishes a personal memento, is this because he is moved primarily by affection, or is using kinship sentiment to cover his acquisitive spirit? After all, it can be argued, the woodworker can always make himself another one.

But the non-utilitarian interpretation is supported by the general Tikopia evaluation of the place of headrests in their cultural scheme. A headrest (whether made by the owner or not) is 'the valuable property of man'. It can be used as a weapon on occasion – if a thief is heard at night in the house the householder may take the headrest from under his neck and hurl it at him. But principally it has a peculiar association with its owner's personality since it pillows his head, the most important part of the body, which it is forbidden to a man's children to touch. Though not taboo, the headrest of a householder ordinarily is handled by others with discretion, as a piece of his private property. As a consequence of this, a man's headrest tends to be one of the items of his property most commonly buried with him. A headrest is 'the death property of this land; when a man dies, he is pillowed upon it. After a man has slept constantly upon it, when he is put into the ground, his head is laid upon it, then he is wrapped up and buried.' One of Pa Panapa's headrests, for example, was taken by Pae Avakofe, in his day the most respected senior man of rank in Tikopia, and a 'grandfather' of his; this headrest was buried with the old man when he died.

But since the headrest has been so closely associated with the personality of the user, it can serve as a very convenient memorial to him, if it is preserved by his kin after his death. Hence sometimes a conflict of sentiment occurs. Some relatives argue for interring the dead man's headrest with him, with the idea that he should not be separated from what he was so intimately linked with in life. Others argue for keeping it in the house as a visible reminder of him. I was shown one valued headrest, made by my informant's brother, a noted craftsman of the Avakofe lineage, with the words, 'This headrest is a token of sentiment (*tau arofa*); the headrest of our father the chief' (long deceased).

Fig. 15

Another headrest, of type 3, was said to have been made by a
great-grandfather of the Ariki Taumako and his kinsman Pa
Fatumaru, and to have been used in turn by the chief's grand-
father and father. The latter left it as an heirloom to his 'son' Pa
Fatumaru with the words, 'This is our headrest. It shall remain for
you as your headrest.' It was a token of affection between 'father'
and 'son' said Pa Fatumaru to me; he obviously prized it greatly.
A man's eldest son usually decides at his burial whether the
headrest is to be interred with the corpse or not.

So, there is a distinct non-utilitarian element in the appraisal
of Tikopia headrests. But this has a sentimental, rather than an
aesthetic, base. That headrests preserved as memorials or buried
as intimate property seem usually to have been examples of
relatively fine workmanship does not invalidate this stress upon
the sentimental aspect.

One further element in the demand for headrests has been the
association of a special style with men of rank. The headrests
with high wings, though not restricted to chiefs, have been
regarded as being particularly appropriate for use by chiefs or
by other men of high rank.[2] The construction of such a headrest
is a job of considerable skill and delicacy, and examples of this
style seem always to have been relatively rare in Tikopia.
According to one informant, himself a skilled carpenter, in 1952
only one man, Pa Nukutapu of Avakofe lineage, then knew how
to make such headrests, though every man knew how to make
ordinary headrests. I think this was an exaggeration, but it
illustrates the particular value attached to this design.

Fig. 16

There are then several distinct elements recognizable in the
Tikopia appraisal of their headrests: design; quality of craftsman-
ship; personal association with elder kinsman, or with men of
rank. Aesthetic elements seem to have been present in the con-
struction and evaluation, but in any individual case I found these
almost impossible to separate out from the other factors in the
situation.

Fig. 17

Tikopia recognition of differences in the value of headrests
was exemplified by differences in the rates at which they were
willing to exchange headrests with me. For most of the two dozen
headrests which I collected on my first expedition I paid a
standard rate of nine fishhooks each. But for a few older examples,
heirlooms, the owners refused to accept such a price (or knowing
this in advance I offered more); I paid ten fishhooks, a pipe, a
belt, and even in one case a plane iron which the Tikopia regarded
as extremely valuable. By 1952 the exchange rate had become
about three times as great in fishhooks.[3] In 1966, at the request of
the people themselves, fishhooks and other trade goods were
abandoned altogether, and exchange was conducted in money.

Fig. 18

Here the price range for a headrest was between about six shillings and ten shillings dependent upon the quality. In no case was any price differential asked for on account of the headrest being of better *design* than others.

THE MAKER'S ATTITUDE TO DESIGN

Having considered the consumer's view of headrests, we now look at the maker's view. When a Tikopia who is not a woodcarver by vocation makes himself a headrest, it is usually either a roughly shaped block of wood or a simple, single-footed design. But when a woodcarver of experience makes such an object his attitude is rather different. He may be guided by the interest of a client in having a headrest of a particular type, in which case his aim is primarily to produce a headrest of good workmanship in accordance with the request. A craftsman who is in the habit of making headrests for other men in this way tends to work in a recognized style. Other men later may identify headrests as his workmanship by such style, and I observed some cases of such identification.[4] But the craftsman may also be motivated by experimental interest, as Pa Panapa described, seeking a design which is novel or a variant which seems more satisfactory to him. It was said, too, that a craftsman hopes to make something by which he will be remembered and so tries to invent a new style which people can point to and link with his name: 'This is the headrest of So-and-so.'

I could obtain from craftsmen no detailed reasons why they chose to work with one design rather than another. I did not actually sit down with a carver while he was making a headrest, though I did talk with craftsmen while they were making canoes, wooden bowls, and ritual objects, and with headrest makers at

4 Pillared type of headrest

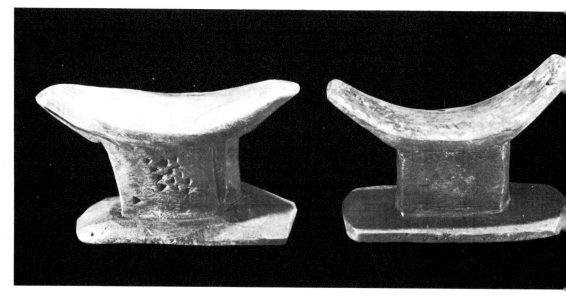

other times. In answer to a question as to why he chose to make a headrest with one foot rather than with two, one craftsman said:

It is there in my desire. It carves according to the thought. Like you Europeans, one seeks skill. A man who has found his thought is a man of firm mind. Like you [he continued, referring to me], we say you are of firm mind because you are skilled in writing. Because thought is confused one seeks that one may be firm.

He was describing by this the process of a craftsman debating with himself, considering alternatives and rejecting them until he has found the design which suits his fancy. I could get from few Tikopia any overt expression that one kind of design was regarded as being better than any others, or even that they themselves had any definite preferences. But craftsmen did say that amateurs, men simply making headrests for themselves, would keep to the styles known as 'billet of wood' – that is, a simple wooden block – or 'single-footed', which are not difficult to carve. When asked about differences in style, craftsmen were apt to reply always, 'It is the thought of the man. The styles are all equally good.' Pa Motuata, a man of taste and judgement in most affairs, but not a craftsman in wood, described Fig. 2 as 'bad' – but added that some men liked it. I found that while craftsmen were usually ready to differentiate good and bad workmanship, they did not stand out more than ordinary men as judges of design.

 I got the most detailed description of the craftsman's attitude from Pa Panapa, in speaking of the headrest he adapted from a solid block (see above). Of the originality of this he was proud. He said, 'I sought an idea and as I went on and on it parted and turned round [crystallized] to cut out a single platform.' He also

illared type of headrest

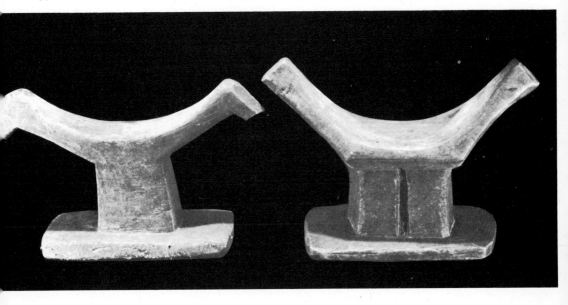

6 Headrest with bar. H. 9″

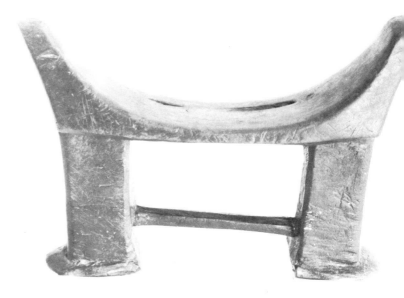

had the idea that if he wished he could cut away part of the body of the block and round it off into a foot. But he decided to keep it as it was, partly to serve the needs of different men on different occasions. But he also gave another reason for not carving out this headrest further – that his good headrests were carried off by kinsmen or friends, and he thought that if he made this one as a mere 'billet of wood' no one would be tempted. He said also that by this time his working adze had become very worn!

SPECULATIVE INTERPRETATION

This is about as far as I could go in the time available in direct consultation with woodcarvers in the assignment of reasons why different types of headrests were made. Indirectly, however, at a more speculative level one may examine further the problem of headrest styles.

The first point to make is that the description of parts of a headrest involves no special terms peculiar to woodcarving. The terms used are ordinary words from other fields of experience, utilizing in particular names for parts of the human body. (This is a convention which Europeans also commonly follow.) So the 'foot' of a headrest and its 'body' are known by the Tikopia equivalent of these terms, as they are applied also to animals and human beings. The platform on which the head is laid is known as the *marae*, a term used ordinarily for an open space for assembly – it conveys the notion of breadth and flatness. The ends of the platform, what we might call the 'ears' of the headrest, are known by the Tikopia as 'ends' or 'noses'. (The term which when applied to a human face is translated as nose is used by the Tikopia to indicate a much wider range of protuberances, as with ourselves in English, e.g. the nose of a boat.) There is then a

vague analogy between the headrest and the human body or, more accurately, headrest and human body are regarded as showing certain characteristics of shape in common.

With this anthropomorphic analogy in mind, attention can be drawn to the fact that fairly clearcut distinctions exist between Tikopia domestic wooden objects according to the number of legs or feet which they display. At one end of the scale are ordinary food bowls and nearly all bowls of other kinds, e.g. for turmeric or coconut cream manufacture, which have no separate legs at all, but rest upon a single solid base. In more abstract classification this type might be said to be supported by one leg or foot, especially if the base is shaped. Most headrests have one leg or two legs. At the other end of the scale, four legs constitute the support of a special kind of bowl, the kava bowl, which was used for religious occasions alone; the heavy, low, flat stool used primarily as a seat by an expert engaged in turmeric filtration or occasionally by a chief or other man of rank on a more casual occasion was supported likewise. So, four legs were reserved for bowls and stools of ritual or semi-ritual use, while two legs and one leg – or no legs at all – were most characteristic of headrests and objects of personal, non-ritual association. Intermediate between these two classes of objects were certain others of more complex character. The coconut grating stool (Pl. 2) had one leg together with the seat and projection for attaching the grater carved out of the solid, while another leg was lashed on. This second leg, however, was forked so that the stool had two legs but three feet.

To some extent the differences in type of support can be linked with different requirements for stability. The low seat used by the expert in turmeric filtration required to be absolutely steady. Hence four legs gave it the required stability. The coconut cream stool needed to be firm but could to some extent be supported by the legs of the person seated upon it – since when at work he faced forward with one leg on either side, his feet being in line with the two feet of the stool. Stability enough for the work was thus assured by three wooden and two human feet. With headrests, provided that the base platform was reasonably steady, one or two feet were adequate – and two feet seems to have been a traditional style.

But stability was not the sole requirement – the four inward-sloping legs of the kava bowl were no more efficient, possibly rather less stable, than the solid, legless, flat base of an ordinary bowl for coconut cream. Differentiation for ritual emphasis would seem to be the reason for this special style; so also in the case of headrests with three feet (Figs. 16–19). These may be slightly more stable than the headrests with two feet or one foot, but the

difference cannot be great. This design of headrest is clearly structurally closely related to the coconut cream stool. In its principle of support it is thus aligned with an object which raises a man more than does any other seat in Tikopia. Associated with this particular design of headrest, then, is the notion of *elevation,* a notion which is carried through further by the very high slender 'wings'. It is thus no surprise to find that this type of headrest is regarded as particularly appropriate to chiefs and men of rank, who in many contexts are more elevated than ordinary men. In terms of legs then one can see a rough scale: four legs, ritual; three legs, social status; two legs, one leg, or no legs, ordinary domestic affairs. The scale is not perfect because three legs includes the coconut grating stool which serves a domestic purpose – but such stools are also commonly used by chiefs in general assembly and so have a kind of associated status.

I have said that there is no overt symbolism in the design of Tikopia headrests. One type of headrest (Pl. 5), which was specifically said to be a recent style invented by a well-known woodcarver, seems to me to have a distinct resemblance in form to the design of the 'sacred bird' carving which used to be set upon the canoes of the Ariki Fangarere (Pl. 1). But this resemblance was not recognized by my informants.

Fig. 19

In reviewing the material on Tikopia headrests the following points can be made:

(a) The ornamentation on these headrests is simple and crude compared with the elaborate carving on many examples of New Guinea headrests. But the variety of styles is considerable, even surprising, for such a small community, and apparently much greater than for other Polynesian small island communities of analogous cultural development (cf. Burrows, 1937, pp. 121–2; MacGregor, 1937, p. 124).

(b) Although the styles illustrated by these headrests apparently combined both traditional and modern features, all the examples quoted were contemporary, i.e. of recent manufacture. Even in 1966 none was regarded as of an archaic type not normally to be reproduced nowadays. In other words, the manufacture of these headrests represented a living tradition not an archaic survival.

(c) The objects illustrated can be placed in a design sequence which might indicate a logical scheme of development. From the simplest wood block type there could develop either the pillared support with its variations or the pierced type with its free legs. From this latter a further development could be the composite type of refined headrest platform with attenuated side 'wings', necessitating for symmetry delicate legs which could not be safely cut from the solid but had to be separately made and attached.

(d) But such a sequence is quite hypothetical as regards any of the examples here illustrated. The block type may have been, and probably was, due to the inertia of the carver in not wishing to go to the trouble of cutting a more delicate support. The pierced type may have been initially purposeful or may have been due to the omission of the last stage of cutting out legs. Some headrests with three legs are not composite but have clearly taken advantage of the natural shape of the timber (Figs. 17, 18).

What we are dealing with in the range of Tikopia headrests, then, seems to be a field for the exercise of relatively free design interest. Some social factors do give certain designs a special appeal, but the influence of these factors is not overt. The result is that from a field of design untrammelled by many ritual or overtly symbolic rules, the Tikopia craftsman has produced a series of headrest styles in which a combination of cultural pattern and individual fantasy has been at work. Alternate stylistic principles of removal of the solid from the sides of a block to leave a central pillar, or removal of the centre of a block to leave supports at the sides, are regarded as equally good solutions to a problem of production of a pattern from a wooden block, and even retention of the solid block shape in itself is regarded as permissible. What is striking is the versatility of

invention in this 'free market' for design of such a simple, mundane instrument.

Are these Tikopia headrests to be considered as art, if only as 'minimal art'? I think so. In essence, aesthetic experience is the recognition, with affect, of relationship between elements of form. Art is that product which, in expressing formal relationships either directly or symbolically, communicates or evokes such aesthetic experience. Whether art can be solely in the private experience of creator or observer is arguable – for an anthropologist it would seem that relevant data should embody some element of public recognition.

But for anthropologists, art has historically been considered primarily as a conventional field involving objects or actions in which the formal elements were a matter of strong public attention. Moreover, anthropological interest has focused mainly on 'primitive' cultural objects of striking design, often elaborated with ornament and often of ritual use and highly symbolic. Masks have probably been the high point of interest in this field. But art can also imply the scrutiny of relations of form in a broader sense. Meaning is regarded as obtainable in a more general, less culture-bound way by the observer's perceptive construction and the affect related to this.

Here I have been distinguishing in effect between art as an observer's relation to material, as a producer's relation, and as a consumer's relation. These all cannot be assumed necessarily to coincide, and I would argue that the definition of art is not necessarily to be found in any one of them alone. Part of the problem in anthropological studies of art, which particularly involve an analytical culture-comparative standpoint, is to examine the relationship between these aspects of art definition. The difficulty is that for much of the field surveyed by the anthropologist only the observer is apt to be highly articulate. For producer and immediate consumer there may be non-explicit relations of form which the observer can hope to elucidate only inferentially.

Sometimes all three standpoints may be combined. In my view the surrealists, however defective their theory of art in some directions, were right about classifying their 'found objects' as art. Here an observer discovers for himself in his environment an object with a set of elements so disposed that for him they constitute a pattern with symbolic or emotional content. From the apparent irrelevance of such external objects the observer has constituted himself a producer of relationships and a primary consumer of art. In a way this is a return to Clive Bell's notion of 'significant form', but at another level.

In line with modern conceptions, art may be regarded as a kind of communication, but from the everyday common sense point of view a communication in a code which may be difficult to comprehend.

At first sight Tikopia headrests have a minimal element of communication. Superficially the meaning of their design is non-symbolic. They seem to involve no 'other order of cultural fact' (Forge, 1965, p. 23) such as ritual or myth; and they imply status factors only to a very limited degree. What they seem to indicate is, in Herbert Read's words, an innate drive to pattern, superficial aesthetic values so simple that they can be reduced to skill (Read, 1961, pp. 17–19). But the variation in their design is expressive for the maker. As Tikopia craftsmen themselves have indicated, the forms in which they couch their craftsmanship are not irrelevant to them and it is not their skill alone which matters to them. Apart from the technical relevance of the different designs – the degree of physical comfort they offer, the social status they indicate – the maker shows his preference on a basis of what is plausibly recognizable as taste, with aesthetic components, however concealed. Also at a low level, but recognizable, there is differential interest on the part of consumers. The men who command or take away the maker's headrests prefer one style to another, though the reasons they may state for this are often obscure.

In an attempt to understand the communication implicit in the variety of forms of Tikopia headrests one becomes concerned with the categories in which Tikopia arrange the objects of their natural and social universe. Our anthropological techniques are still so relatively unsubtle that one can do little more than speculate here. But among the categories which appear to be of concern for the Tikopia in this field are those which relate body parts and posture to social status. Physical positions seen in contrast between standing, sitting, kneeling, lying are relevant for the interpretation of social positions.[5] Relevant also is the interposition of an object between body and ground according to one's position. If a Tikopia is standing or walking, traditionally he wears no foot covering. If he kneels it may be also on bare ground. But if he sits in any situation of social significance politeness demands that he be given a mat or some coconut frond or a block of wood, upturned bowl or a stool to sit upon. If he lies down his head should not only be supported but also kept off the ground by a headrest. Differentiated social values are also involved in these different types of contact and the part of the body concerned. The sole of the foot, commonly in direct contact with the ground, is that part of the body to which the most abject apology can be directed. The knee may be also the site of a gesture

of apology. But not so the fundament or the head.

The form which the headrest may bear is not very finely oriented towards bodily features and social differences, but there is a broad relationship. In the headrest code recumbency demands head support. A simple block of wood may stand for firewood, or hewing into a betel mortar or other manufactured object. It may serve as a headrest, but it is of neutral or low status. A guest is not offered a rough block of wood for his head if a shaped headrest is available. The shaping of a headrest has then some social significance. It has little or no technical function in relation to coiffure, although in former times male Tikopia wore their hair long, except in mourning. More broadly, wooden headrests in general stand for men in domestic roles. Taboo as to head, when prone they may be objects of sympathy to others of the household and kin group. Headrests represent then 'tokens of affection' of a high order. In the very considerable latitude in headrest shaping, no significant value attaches very precisely to the different shapes. But, broadly, refinement of technique and elaboration of base-support convey association with higher status.

Briefly my argument here is: Tikopia craftsmen have some aesthetic interest in sculpture, if only at a low level of development. This did not emerge in the field of their religious art, possibly because of the competing demands of ritual for time and energy and perhaps also because the Tikopia conceptual apparatus did not demand iconographic material. In some sculptural fields, e.g. production of wooden bowls, functional requirements tended to dictate considerable variation. In the field of headrests the functional demands were simple. But the domestic situation was relatively free for experiment, and the peculiar associations of headrest with the head as personality symbol, with bodily posture, and with social status promoted an awareness of individuality which stimulated the inventive potentialities of the craftsmen.

Much may be made of the relation of art to ambiguities in experience. But the element of art in Tikopia headrests seems to be related not so much to expression of *ambiguities* in social status as to a statement in very generalized allusive terms of formally recognized *differences* in social status. One of the major expressions involved is the special position of men as distinguished from women – the latter have only rough packages of bark-cloth as headrests and by convention never use the shaped man's headrest. Male headrests are always of wood, the material associated in canoes, bowls, house construction, and other fields especially with male activity. Moreover, the range of forms within which headrests are conceived is one in which attention

may be focused to a considerable degree upon 'feet' or 'legs' as means of support. This in turn is linked with the social differentiation of male position on formal occasions.

Tikopia headrests are a form of minimal art. They are made for use rather than aesthetic enjoyment. Experiment in their form or ornamentation is extremely restricted. The shapes they employ are hardly capable of generating any very subtle affect in the observer. Yet the variations in these shapes are an expression of personal creative activity, and they seem to be generated by diverse individual reactions to the significance of bodily features and positions in domestic situations. As such they seem to display a code for communication of generalized diffuse social values.

The influence of society on art can vary greatly in its degree of organization. Tikopia headrests are an example of the relatively unorganized influence of society in a field of creative achievement in which there are almost no formal training patterns and very few rewards for the craftsman. Society provides the craftsman with traditional patterns and some guidelines of popular choice, but leaves him to develop his experimental interest in design. The result is art on a very low level. But elementary as the variations in Tikopia headrest design may be, they do suggest that Tikopia craftsmen have aesthetic interests, and that these are primarily in the field of geometric design. Moreover these variations convey, albeit in non-explicit fashion, statements about the structure of Tikopia society. Signs of a critical attitude by Tikopia artists to their own society or to the novel forces by which it is confronted in modern times appear as yet only in their songs and not in their graphic art.

What can be the role of an anthropologist in studying such minimal art? His systematic exploration and classification can uncover information about the objects from their makers and their consumers in the society, which while not necessarily altering his aesthetic experience as an observer, does amplify the communication received from the art material. From his general experience of the social behaviour of members of the society, too, the anthropologist can suggest clues to interpretation which are not explicit at the verbal level.

NOTES

1. In this I was helped by my colleagues James Spillius in 1952 and Torben Monberg in 1966. The specimens from 1928–9 were added to the Australian National Research Council collections in the University of Sydney; those from 1952 went to the Australian National University collection in Canberra, now housed in the Institute of Anatomy, to which the earlier material has now been joined. Monberg's collections have gone to the Royal Danish Ethnographical Museum, in Copenhagen. I am grateful to Professor Monberg for Plate 1. The drawings have been done from photographs by Tass Hesom.

2. I saw one huge example of this type, attributed to Pu Kafika Lasi, a chief of the early nineteenth century. I was told by several informants that formerly such large headrests were provided with a bar across the high wings, to ward off a blow from the sleeper's head in the troublous time when prominent men sought to seize power by killing one another (Firth, 1961). But this may be apocryphal.
3. For these and other rates, see Firth, 1959, p. 144.
4. Sometimes, however, the identification goes wrong. In 1952 a man of rank identified from a photograph a headrest which I had collected twenty-three years before as the work of the craftsman Pa Panapa who was with us. Pa Panapa did not deny this at the time, but later explained that the other man had been mistaken. He himself did pick out from the photographs other examples which he said quite categorically that he had actually made earlier.
5. I discuss this in some detail in an article on posture and gesture (Firth, 1970).

REFERENCES

Burrows, Edwin G., 'Ethnology of Uvea (Wallis Island)', *Bernice P. Bishop Museum Bulletin 145,* Honolulu, 1937.

Firth, Raymond, 'Tattooing in Tikopia', *Man,* no. 236, London, 1936.

——, 'Bark-Cloth in Tikopia, Solomon Islands', *Man,* no. 74, London, 1947.

——, *Social Change in Tikopia,* London, 1959.

——, 'Tikopia Woodworking Ornament', *Man,* no. 27, London, 1960.

——, *History and Traditions of Tikopia,* Wellington, N.Z., 1961.

——, *Work of the Gods in Tikopia,* 2nd ed., London School of Economics Monographs on Social Anthropology nos. 1 and 2, London, 1967.

——, 'Postures and Gestures of Respect' in J. Pouillon and P. Maranda (eds.), *'Échanges et communications; mélanges offerts à Claude Lévi-Strauss à l'occasion de son 60ème anniversaire,* vol. I, The Hague, 1970.

Firth, Raymond, and Honor C. Maude, *Tikopia String Figures,* Royal Anthropological Institute Occasional Paper no. 29, London, 1968.

Forge, Anthony, 'Art and Environment in the Sepik', *Proceedings of the Royal Anthropological Institute for 1965,* London, 1966, pp. 23–31.

Hauser, Arnold, *The Social History of Art,* 2 vols., New York, 1952.

Hinks, Roger, *Carolingian Art,* London, 1935.

Lethaby, W. R., *Medieval Art: From the Peace of the Church to the Eve of the Renaissance 312–1350* (rev. ed. by D. Talbot Rice), London, 1949.

MacGregor, Gordon H., 'Ethnology of Tokelau Islands', *Bernice P. Bishop Museum Bulletin 146,* Honolulu, 1937.

Read, Herbert, 'Art in an Aboriginal Society: A Comment', *The Artist in Tribal Society.* Proceedings of a Symposium held at the Royal Anthropological Institute (ed. Marian W. Smith), London, 1961.

CHAPTER 4 Kilenge Big Man Art

Philip Dark

I

The anthropologists' understanding of art as a phenomenon of
culture has advanced little in comparison with his increasing
comprehension of many of culture's other facets: our compara-
tive knowledge of social, political, and economic institutions
has advanced greatly over recent years as the amount of data
has accumulated. But while interest in art is extensive, parti-
cularly in view of the growth of public acquaintance with a wide
variety of forms from many exotic cultures, actual knowledge
of art as a system in culture, of the cultural background of art,
of art as an institution, or of the domain of culture occupied by
art – however one may prefer, at a general level, to phrase it –
remains far behind the data and understanding brought to bear
by anthropologists on other social institutions.[1] In fact, art
provides us with an exciting world of phenomena for speculation.
It often produces for man a crystallization of some emotion in a
concrete form; of a fear felt which is realized by some artist and
given form, causing tension to be released and relieved, or
reinforcement and greater agony, the stuff of ecstasy; the boost
to esteem or pride, as a personal symbol receives public attention;
a means of fulfilment of a creative self which all have to a greater
or lesser degree, some would hold. The facets of art are many;
its forms, almost of an infinity of inventiveness. Its processes
and the feelings of artist and observer often function largely at a
non-verbal level. It is a phenomenon produced not only by men
but by women too; and it is there in the world of children where
the aesthetic system of the culture is tried out. If in one form or
another it occurs in all cultures, what are its principles?[2] Are
they universal? Is it, in fact, possible to obtain data from different
cultures which will allow us to posit principles applicable to all
cultures? Our conceptual world of art may have no counterpart
in another culture. If we seek in it the world of art as we circum-
scribe it we may discover it in our terms and within our precepts.
But to a member of another society the phenomena we have
already selected to study may not be classifiable in terms of our
selection. How, however, then, does he classify phenomena in
general and, more specifically, the kind of phenomena we are
interested in? Are there factors which approximate to those that
delimit our interest? Are there areas of agreement and about the
same kind of things? How are the spheres of visual and linguistic
symbolism integrated? What is the domain of art in culture?

Questions such as those just posed, questions directed towards
establishing the limits to formal expressions of art and their
manner of interpretation in the social fabric, in particular social
fabrics, have but rarely been investigated directly by anthropo-
logists in societies with traditions very different from our own;
notably, those which contrast with civilized ones, and which are
often conveniently called 'primitive', as used in this symposium.[3]
The urgency for conducting some kinds of anthropological
inquiries has been stressed in various quarters.[4] It seems a pity
to let an era of man's artistic creativeness slip by undocumented
and not understood, just as we are becoming aware of it and
enjoying the results which survive for our pleasure.

For the conference needs of the Wenner–Gren symposium on
'Primitive Art and Society', with its broad scope of interests
and hope to stimulate further research, it seemed appropriate,
as I was at work in the field at the time of receiving the invitation
to Burg Wartenstein, to attempt to review what the general
context of art was in the culture which was being investigated
for the express purpose of trying to find answers to some of the
questions touched on in the above paragraphs. A preliminary
statement on art in Kilenge culture was prepared in the field. The
statement follows in Part II of this paper and has been left almost
the same as when made at the time. The anthropological investi-
gations conducted in Western New Britain were made by
Professor Adrian Gerbrands, my wife, and myself over a fifteen
month period.[5] These investigations were specifically directed
towards seeking data to help learn something of the context of
art in one 'unknown' culture, namely, that of the Kilenge.

II

The Kilenge people live in the extreme western end of the
island of New Britain, Territory of Papua and New Guinea,
occupying villages on the coast and in limited areas of the bush
of the mountainous hinterland. Those living in the bush are
referred to locally as *nalolo*, meaning people of the mountain.
Those living on the coast are referred to as *natai*, people of the
coast. Both *nalolo* and *natai* speak Kilenge. The term Kilenge is
used locally to refer to the five villages on the north western tip
of the island, six miles from Cape Gloucester air strip, namely,
Portne, Kurvok, Ongaia, Ulumaiinge, and Waremo. Within the
five villages the term is also used to refer to the two villages of
Ulumaiinge and Waremo, including the two wards of Saumoy
and Poroso associated with the latter. In Kilenge is concentrated
about a quarter of the total population of the Kilenge–Lollo census
division which numbers 3,458, living in 35 villages.[6]

There have been doubts as to the position of Kilenge in linguistic groupings due to lack of data on the peoples and cultures of West New Britain, but recent investigations would seem to place it as definitely a Melanesian language.[7] It would seem to me, if one includes speculative thoughts on petroglyphs and on other sites awaiting excavation which we found in the area, that one is dealing now, in the case of the Kilenge, with a people who are a mixture of two older strata: people of the hinterland bush and Melanesian coastal migrants. Only recently in the neighbouring Bariai and Kaliai have interior peoples settled on the coast. Kilenge, as spoken in Lollo, may have been different from coastal Kilenge at one time – there are differences in vocabulary – but differences now are only ones of dialect. The attraction of peoples in West New Britain to the coast was probably due, first, to the pacification of the Territory of New Guinea by the Germans. Small groups of people were no longer confined by hostile neighbours to migrating within inhospitable areas. Settlement on the coast was also due to a probable increase in diffusion of cultural traits and complexes to and from New Guinea and West New Britain within what can be termed the Huon–West New Britain culture area. It seems probable that such a culture area was fairly well formed before the advent of the Germans in 1885 but pacification would have led to the demarcation of its boundaries rather more clearly than before. The area seems to embrace Bali–Vitu, Kombei, Kaliai, Bariai, Kilenge–Lollo, the Siassis, 'greater' and 'lesser', Tami, and some coastal cultures of the Huon peninsula. Trade in this very extensive area, or a vast exchange ring, had stimulated art to its most dynamic expression round about the 1890s. A major exemplification that survives to us is the art of the Tami islands, but it is mainly a carver's art in wood which remains, hence it is only a section of what was probably a much broader range of art forms at which one can only guess by putting together the bits and pieces surviving to us in the culture area I have designated. In this paper I will be referring primarily to the Kilenge and their art as I see it today or hear about it today as it was.

The island of New Britain is volcanic and the Kilenge area has one active cone, Mt. Langila. Two mountains, Talawe and Tangis, reaching to just under 6000 feet, are of an old volcanic formation. The area is heavily forested, providing a wide variety of timbers used for houses and canoes, as well as a considerable number of useful wild plants. Quite a wide range of plants are grown in gardens, including taro, yams, sweet potato, manioc, bananas, sugar cane, and coconuts. Those Kilenge who live on the coast benefit from a potentially rich harvest of a wide variety of fish and from shell fish gathered on reefs by the women. The land

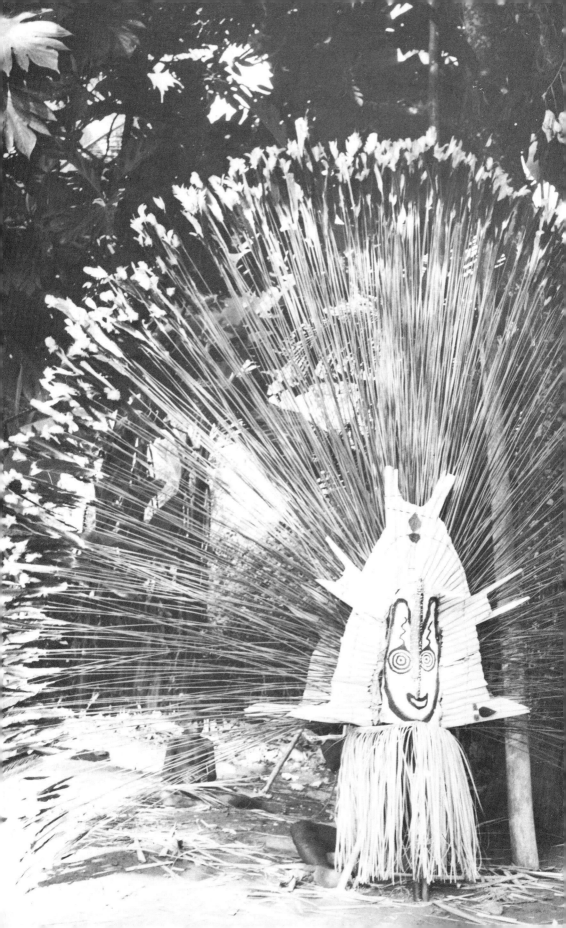

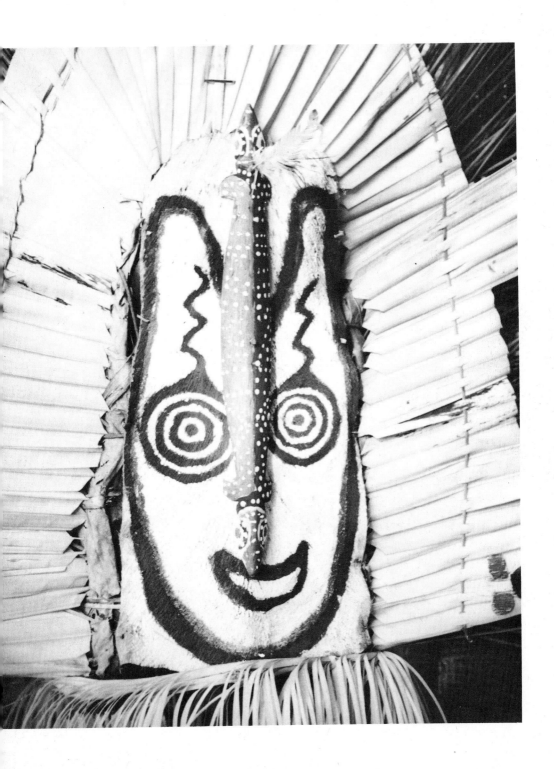

4 The *nataptavo* masquerader,
sukovilim, completing the
adjustment of his costume
outside the men's house in
Portne

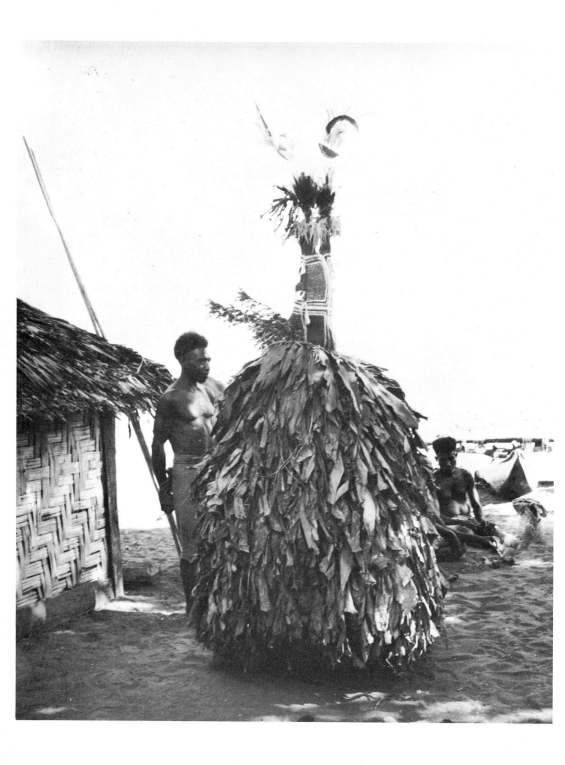

fauna is limited, except in the field of birds. There is a wide variety of birds, particularly of parrots and eagles, which are eaten, if taken, as is the cassowary. The wild pig is hunted. Limited supplies of trade goods are available and the Territory's currency is used for cash; the only cash crop is copra, production of which has shown signs of increasing considerably in the last two years. Both Catholic and Anglican missions have been active in the area since before the 1939–45 World War, overlapping in a few villages. But the Kilenge are only just on the edge of our modern world, for shell money is used extensively in payments and the bride price, while embracing new items such as cash, requires traditional payments, including such as carved wooden bowls and pots, both of which are not made by the Kilenge but are traded from the Siassi islands by sailing canoe.[8]

Major manifestations of art in Kilenge culture occur at festivities, or sing-sings, given mainly to mark *rites de passage* and/or enhance the prestige of the donor as a 'big man'. At such sing-sings costuming of performers and decoration of participants are important expressions of art, though one must not lose sight of singing with accompaniment on hour-glass drums, and the dances performed, as forming a part of the total sphere of artistic expression.

Three types of masks are made by the Kilenge. The most striking is a mask, some twelve feet in diameter, called *bukumo*, which would seem to have originated in the Lollo area of the division, probably close to neighbouring bush Arawe people (Pls. 1, 2, 3).[9] The mask is constructed on a wooden frame which fits on the head of the wearer and is held steady by handles extending down, parallel to his arms. Into this frame are stuck a large number of canes which have hornbill and eagle feathers at the ends so that a huge half circle of long-stemmed feathers is formed. A painted mask on coconut bast covers either side of the centre of the half circle. The total appearance is of a giant, cocked hat with feathered spokes sticking out which concertina as the masquerader walks along, jogging up and down to vibrate his fan of feathers. *Bukumo* requires considerable feeding and a very big feast of food has to be collected together by the sponsor, who decides to 'call up' *bukumo* to grace a sing-sing on the occasion of the circumcision of his child and the piercing of his ears. *Bukumo* appears at dusk and the sing-sing continues all night until dawn, when he is told to go away.

Another major, constructed mask form is the *nataptavo* mask, of which there are two major types.[10] One is conical in form; the other is cylindrical with two peaks to it (Pl. 4). Both are made of a frame of cane, covered with coconut bast and painted. A cloak of banana leaves hangs from the shoulders almost to the ground,

completely covering the dancer. An extension of feathers to the conical form of mask sways around as the masquerader performs. The two peaks of the other form of mask are decorated with feathers, including those of the cassowary. *Nataptavo* masks are made in connection with a cycle of events concerned with the planting and cropping of yams. The *nataptavo* may dance at circumcisions. A cycle may last about two to three years at the end of which the masks are burned. The second type of mask, with the two peaks, can also function as a symbol of social control, being sent round a village to mark the imposition of a *tambu* or its removal. The origins of the Kilenge *nataptavo* masks are in doubt though the construction type of mask is widespread in New Britain.

The third type is a carved and painted wooden mask, called *nausuŋ*, which the Kilenge copied from the Tami islanders (Pl. 5). *Nausuŋ* appears at a sing-sing given to honour a man's first son at which he is circumcised. The form of mask is a prototype for a face form which appears on a number of carved objects and is particularly noticeable on Tami carving.[11]

While masqueraders appear at three types of sing-sings, for *bukumo, nataptavo,* and *nausuŋ,* they do not appear at four other main types of sing-sings, which provide occasions for the circumcision of boys or marking the puberty of a girl as well as for enhancing the donor's prestige.[12] One of these sing-sings, *navoyo,* is no longer performed by the Kilenge though it is continued in Vitu (and probably Bali), the easternmost extension of Kilenge cultural influences. The sing-sing takes place in a *naulum* (men's house), which is shaken, and carved crocodiles forming the end part of poles sticking through the front wall are manipulated.

A second type of sing-sing is given on the occasion of the erection of a pole, which has been specially carved as a centre pole to a men's house or in honour of a young girl.[13] If the former, then the pole would be decorated with low relief forms of *nausuŋ* faces and human figures, man and woman, but if the latter, the *nausuŋ* faces would be omitted, for women used not to see *nausuŋ* just as they were banned from sight of the *nataptavo.*

A third type of sing-sing, *aiyu* or *agosaŋ*, provides a major occasion for women to dance in grass skirts, over whose preparation they take considerable time and pains (Pls. 6, 7). Dressed in their finery, with ornaments and painted faces, they dance towards a half circle of men, who form the chorus of singers and drummers protected by men with shields and spears who, in turn, from time to time dance aggressively towards the lines of women performers and retreat back to the safety of their closed circle. *Agosaŋ* provided an outlet for aggression and its social control, for, in the past, fighting would break out at the

close of the sing-sing at dawn, occasioned by the need to 'pay back' or get even.

A fourth type of sing-sing, and certainly the most theatrical, is called *sia* and has been acquired by the Kilenge from the Siassi islands. It originated, it would seem, on the mainland. Twenty or more men costumed with feathered, cocked hats dance, each with a carved, hour-glass drum (Pl. 8), in chorus, solo, and duet forms (Pls. 9, 10). Women in the finery of their coloured, grass skirts dance slowly in a circle round the men who occupy the centre of the 'stage'. The completion of a *sia* cycle may take two years. A closely related dance, called the 'mother of *sia*' used to be performed by the Kilenge. It exists today only on the mainland.[14]

Architecture among the Kilenge is concerned mainly with two types of houses: a dwelling house and a men's house. Both used to be built on the ground. The dwelling house has for some time now been built on piles (Pl. 11). Two years ago the people were made to build the men's house on piles too. One finds here and there in Kilenge a carved house post, but no longer are there to be seen carved heads at the houses' peaks, carved king posts, or plank walls, although two examples of the last remain in Lollo. Decorative aspects of Kilenge houses today are to be seen only in the screens of plaited bamboo which form the walls and in the roofing of neatly folded and stitched sago fronds (Pl. 11). A number of household utensils and personal belongings are the object of the carver's art. Carved wooden bowls, used for holding food, are obtained from the Siassi islands; similarly, clay pots find their way from Sio island via the Siassis. The Kilenge artist carves mortars and pestles for pounding and mixing tapioc and coconut milk, or other foods, and taro spoons. A person's comb of bamboo has the handle carved and a man's mortar for mixing betel and lime is generally carved with a human face.

A major sphere for artistic expression among the *natai* is the single outrigger, sailing canoe and associated implements. Canoes are primarily of two sizes; first, a large form for deep sea-going purposes, and, second, a smaller one for fishing within and close to the reef (Pls. 12, 13). Bow and stern of canoe must be painted for the canoe to be considered seaworthy, and quite a number of designs are used (Pl. 14). Paddles and bailers are, however, decoratively carved. The floats of fishing nets are of three kinds; two are painted and the third is decorated by carving only.

Some indication of the range of materials used by the Kilenge for artistic expression can be gleaned from the above paragraphs. Various woods are carved and used in house and canoe construction. Bamboo is used for making house walls and carved

5 *nausuŋ senkana*, belonging
to the *palivo* pidgeon of
Portne, pausing in a dance in
Portne village

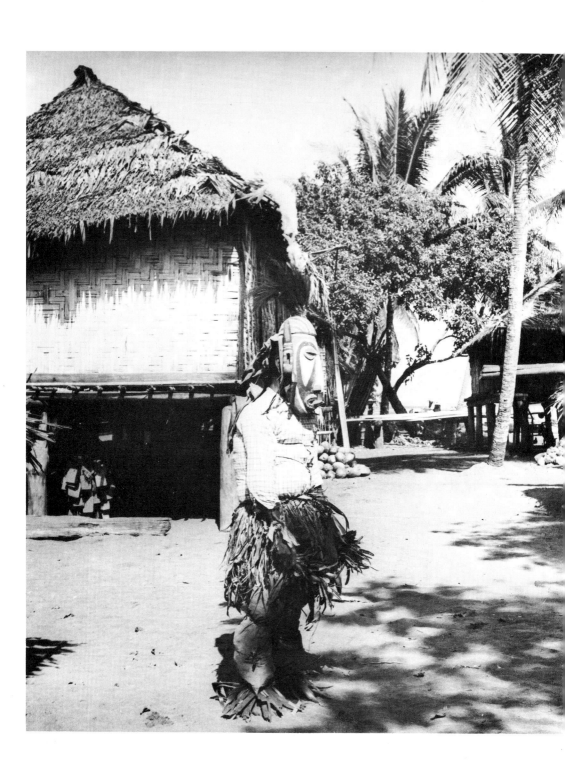

wife of Talania of
ge, in her finery
ance, *aiyu*

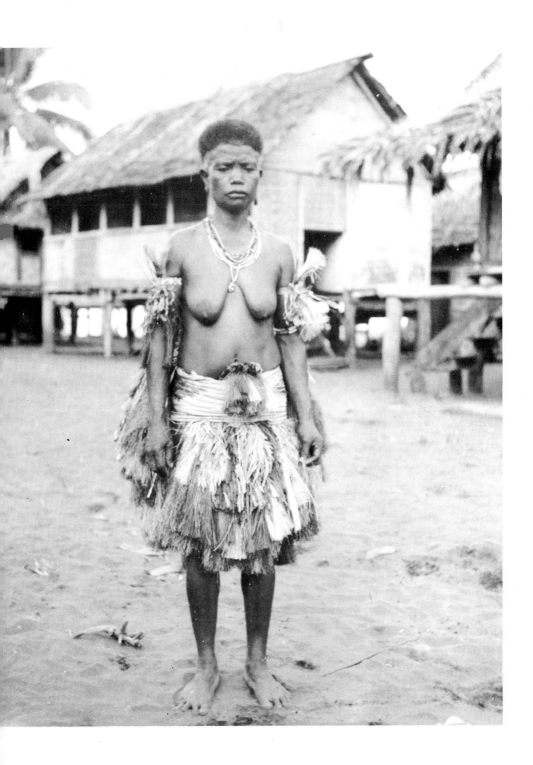

7 Abiwa, wife of Sagia of
Ongaia, in her costume for
aiyu. Women often dance
with a young baby
supported on one hip

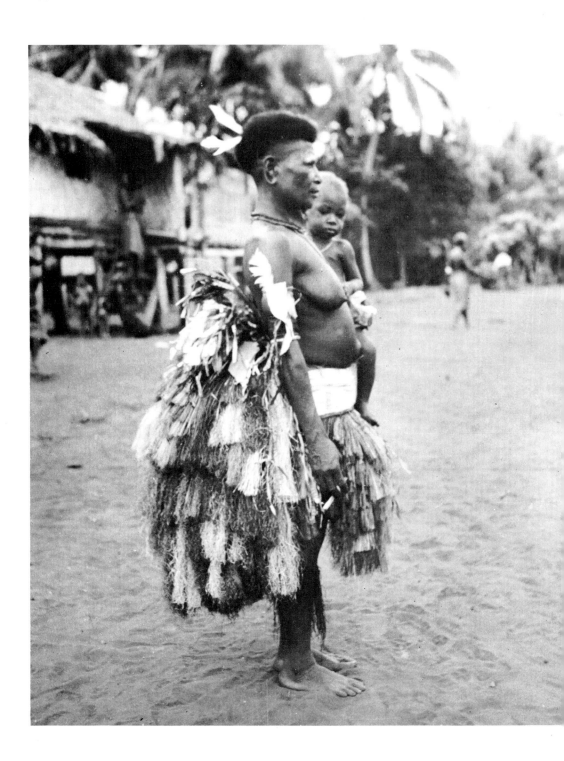

8 Three *napariwa*, hour-glass drums, owned, from left to right, by the author, Nɔŋi of Kurvok, and Nake of Portne

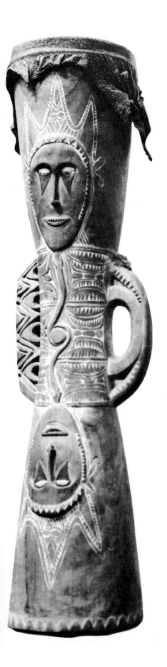
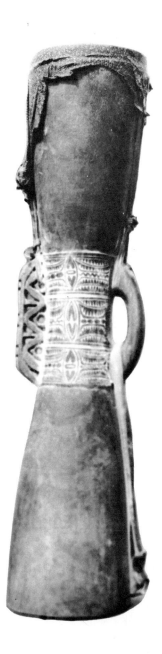
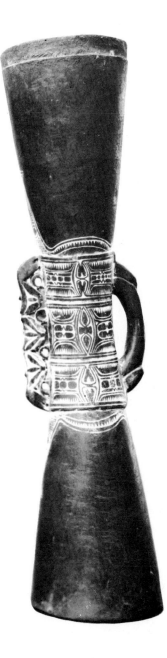

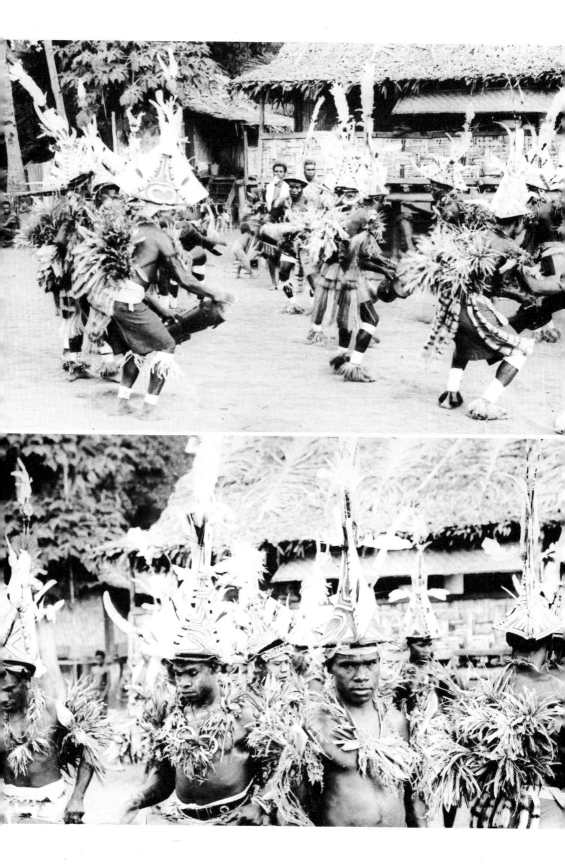

combs. Coconut bast is the major material for covering constructed masks. Several different fibres are dyed with locally obtained dyes to make grass skirts. Local dyes, plants, and feathers are used widely as decorative devices. Shell and turtle shell are made into personal ornaments.

The main tools of the Kilenge are iron bladed adzes and axes. Stone ones were used before the Germans introduced iron, and shell blades were also used. Bone awls were used in making a simple form of coiled basketry. Bone knives, used for extracting foods and as daggers, are usually made from the thigh bones of the pig and cassowary. Such knives are sometimes embellished with decorative carving.

The designs employed by the Kilenge in decorative carving would seem largely to stem from the Siassi islands and hence, basically, derive from Tami. But the Kilenge will generally provide a local explanation or term for a carved form. In the sphere of painting the designs employed would seem to be largely native to the Kilenge, though the painting of facial and eye marks on masks, whether *nausuŋ* or *nataptavo,* would have been copied from Tami, if one can be certain that *nausuŋ* and *nataptavo* masks derive from New Guinea. While having a vocabulary for some geometric forms, such as square, circle, dot, and triangle, the artist recognizes that a number of natural

forms are the basis of his designing elements or vocabulary. Design elements derive from birds, fish, and other animals such as pigs, crabs, snakes, bats, and crocodiles, from the human form, whether all or part, and from certain features of nature such as the sun, moon, Venus, or a mountain.

Kilenge society is basically one of a dual division of the society into exogamous patri-sibs. The members of each village belong to one or other of the two patri-sibs present. The same patri-sib is to be found in more than one village today. Locally the term *namɔn aiiŋe* or 'pidgeon' is the equivalent of a sib. A particular pidgeon in a village is considered 'big' and the other 'small'. In Kilenge, where the social organization is relatively complicated, due to a recent increase in the population, certain pidgeons in the five villages are considered 'big' and the first or original ones. Others have accrued over time.

Each pidgeon has a big man or 'lord', *natavolo,* as its head. The position is hereditary: the first born of a *natavolo* succeeds his father; if the first born is a daughter, then she is entitled *nagarara* and her oldest brother will be named *natavolo.* The lands of the pidgeon are held in trust by the *natavolo.* He is head of the principal men's house of his pidgeon, though a pidgeon may have several men's houses.[15] Activities requiring a large labour force generally lead to a muster of personnel of the same pidgeon

though this force is augmented by calling in the affines of its members. In fact, while a man's membership in a pidgeon may determine his marriage, what land he gardens, and provides a basis for co-operation, he will extend his ties of expected reciprocation by all means available, for the main purpose of life seems to be to enhance one's prestige and bask in the warmth of respect paid one by one's fellows. If he is a little man, he can at least achieve some recognition. If he is a big man then he must continually remind his fellows that he is one by some exploit such as a successful trading expedition or pig hunt, or by sponsoring a sing-sing. The sponsor would take no part in it himself but by giving away large quantities of food, by killing many pigs, he will have made his point, and have men respect and praise him.

Art among the Kilenge functions largely as a means of enhancement of the prestige of big men and its internal structuring can be considered to follow lines demarcated by pidgeon affiliation. I do not mean to imply that there is not a basic set of forms, colours, and designs upon which the artist draws but that, given the grammar and vocabulary of his calling, he organizes what he selects on the basis of its function in the context of the way people are organized socially, namely on the basis of belonging

11 Houses and canoes in Ongaia

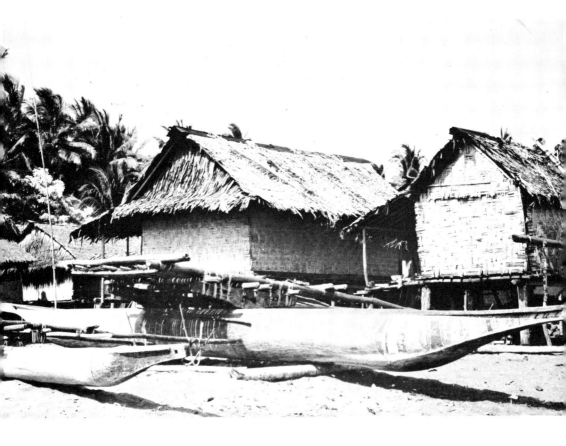

to a particular pidgeon; a pidgeon has its own 'crest' which
cannot be used by other pidgeons, nor can it use another pid-
geon's designs. *Nausuŋ* masks are owned by the big man, or men,
of a pidgeon; *nataptavo* masks likewise. The design of a man's hat
for *sia* is from his pidgeon's repertoire. *Bukumo* ownership is by
pidgeon. Each pidgeon has a set of names which belong to it.
One of these will be given to a new canoe. Another will be given
to a new *napariwa,* hour-glass drum. Yet another is the name of
the pidgeon's *nakure,* slit gong. The manner in which a woman's
face is painted for a sing-sing depends, on certain occasions, on
the pidgeon to which she belongs, or that of her husband. The
artist serves his pidgeon. He serves a big man. He is fed while
working and given tobacco. If working for a man not of his
pidgeon or not one of his wife's immediate relatives, then he will
receive a present in payment for his services. But it is not the
artist who is making a new drum, a canoe, a sing-sing hat, a mask.
He is only carving it, painting it, or fashioning it. It is the big man
who is working the new drum, the new canoe. I, myself,
commissioned an hour-glass drum for the purposes of recording
and photographing every step of its production (see Pl. 8, left).
I was praised for my new drum. One big man in the village

A large, sea-going
|igger canoe on the
:h of Ongaia

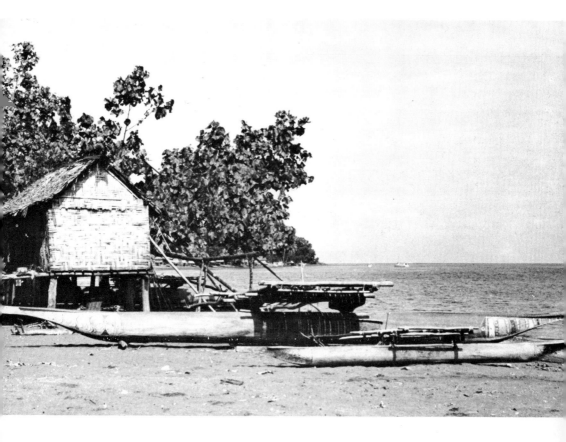

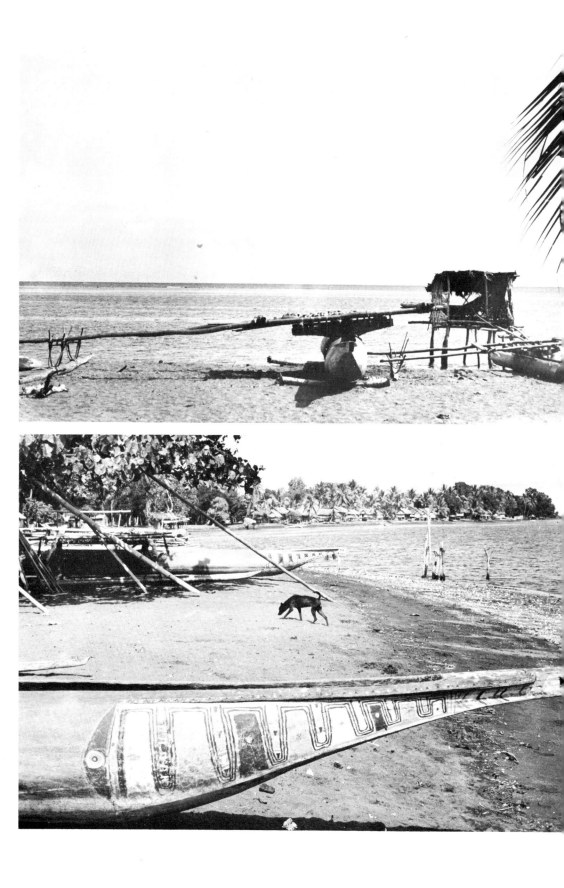

borrowed my marking inks and paper to do some drawings, apparently as the result of a conversation we had about ghosts which had stimulated him to want to draw. He returned the next morning with some nice designs and a drawing of a witch. He had worked them. I found out later that this was so but it was an artist in the village who had executed them.

III

If my first view of the Kilenge and their art, as I saw them, having lived with them for a short time, is a relatively accurate one, even though described at a rather general level in the preceding section, then one can but be led to a characterization of that art as big man art.[16] Such a characterization is open to the many pitfalls which any process of generalization can run into, but, like the term 'set' of a culture, which Benedict used, it provides one with a *modus operandi* for organizing the phenomena encountered; or a hypothesis as to its systemic nature, as a system in culture. It helps give a focus to the domain of art in the culture. The characterization indicates the cause of artistic activity, or its motivation; the kinds of contexts in the culture in which art will be manifest; and an indication of the manner in which it is integrated in the social fabric. The motivation for

Two large canoes on the
ch of Ongaia. In the
kground are the villages of
vok and Portne

artistic activity in Kilenge lies with the desire of big men to outstrip their fellows in the social regard of their peers, to enhance their prestige by outdoing their rivals. The activation of artistic activity has its economic and social aspects, for the big man has to see to the mustering of certain resources, such as food, as well as to promote production by the artist. The kind of work the artist will produce is determined, in the large, by the big man, but in detail by the limits of the traditional repertoire of forms comprehended by the artist. Actual execution of the work of art will be limited by traditional manners of execution but given monotony or vitality depending on the flair of the individual as artist and craftsman. There is, however, both a passive and active role for the resultant work of art. Even if an object can be admired as an object out of context – a drum that sounds true, a mask that is finished and ready to be worn, a canoe hull on the beach just painted but not rigged for sea – its use rests at the command of the big man. It is only he who can activate it and the role it plays in the total sphere of artistic expression in the culture. Among the Kilenge major manifestations of their varied art forms occur at ceremonies; the art of the carver, the painter, the musician, the dancer, even the little personal expressions of those who are not artists but who prefer one kind of leaf to another with which to decorate or perfume themselves, are

brought together at sing-sings; here the artist feels gratified at his work, receives approbation for his or her skill and pleasure from performing, while the spectator feasts his eye and ear and, with the additional stimulation of betel chewing, feels a general sense of euphoria. The next day, tired and weary, he returns home, to sleep, to fish, to go to his garden. 'X' was certainly a 'Big man'.

But have we been considering a system which the anthropologist has devised? After due consideration of observable phenomena has he unwittingly classified them within his own notions of art? Do our rather elaborate ideas about what is art and what isn't, and about art itself, have anything comparable in cultures quite different to our own, such as that of the Kilenge? The Kilenge can be quite positive as to what is art and what isn't, if the translation of the term *namos* as embracing phenomena which we would include as artistic, is accepted. But many cultures are undoubtedly less positive and may not classify at all what we consider as art. What do we have to compare? The anthropologist is left with determining the types of classification of phenomena made by any culture and their systemic nature. Only then can he work comparatively, selecting a comparable level. Or perhaps not, for what if there is nothing comparable? In the case of the Kilenge the hypothesis of big man art rests on subsequent analysis.

NOTES

1. See Dark, 1963, p. 707, and 1967, p. 131.
2. See Dark, 1954, pp. v–vi and 1963, p. 708.
3. Dark, 1965; 1967.
4. Notably, Heine-Geldern, 1958–65, and Sturtevant, 1967. With respect to art, see Dark, 1963, p. 707; 1965; and 1967, pp. 131–4.
5. Field work was made possible by a grant from the National Science Foundation and by Southern Illinois University under whose auspices the work was undertaken. The support of both institutions is gratefully acknowledged. The help of both the Kilenge people and officials of the Territory was much appreciated: specially, Mr. and Mrs. Ross Kelly and Mr. Clifton McKinnon.
6. This section of the paper was written in February 1967. It was entitled 'Art in Kilenge culture: a preliminary statement' and has been left almost as before. At the time of writing, field investigations had been conducted at Kilenge, among the coastal villages on the shores of Borgen Bay and among villages of central Lollo.
7. Capell (1962, p. 375) felt that the languages of the south-west coast of New Britain 'are only non-Austronesian languages overlaid with a veneer of Austronesian' but that Kilenge was more Austronesian than the others. Linguistic data shown to Ann Chowning in 1966 elicited her feelings that Kilenge was a Melanesian language. In a survey which I made with my colleague, Joel Maring, in 1964, he inclined to this view; the morphology, he concluded, was purely Melanesian in type; the phonology showed Papuan influence (Dark and Maring, 1964).

8. Notably from Mandok and Aromot islands. In earlier times, Tami held the monopoly on producers: in 1964 there were some twenty-six carvers on Mandok island. It would seem that decentralization has occurred still further with the advent in 1967 of the carving of bowls by two artists in Kilenge. If such carving takes root then it may be a further significant factor in the gradual disintegration of the culture area posited.

9. Photographs for Plates 1–5 and 11–14 were taken in Kilenge in 1964; those for Plates 6–10 in 1966.

10. The Kilenge term *nataptavo* is used for this form of mask but the Kilenge generally use the pidgin term *tumbuan*.

11. See Bodrogi, 1961.

12. Sing-sings marking occasions other than *rites de passage* do, of course, occur, e.g. in honour of a new canoe, of a great voyage, a very successful pig hunt, but are not considered here.

13. Ann Chowning told me that a similar trait occurs among the Kombei islands which she visited in 1966.

14. I have not been able to check whether it has died out in the Siassi islands as among the Kilenge.

15. Today, in most villages, one men's house only is found – in some cases none – and it will be shared by the pidgeons of the village.

16. When the elaborate process of analysing one's field data has been completed, and comparative study made, a change of view might occur.

REFERENCES

Bodrogi, Tibor, *Art in Northeast New Guinea*, Budapest, 1961.

Capell, Arthur, 'Oceanic Linguistics Today', *Current Anthropology*, vol. 3, no. 4, 1962, pp. 371–96.

Dark, Philip J. C., *Bush Negro Art, an African Art in the Americas*, London, 1954.

——, Review of *Primitive Art: Its Traditions and Styles*, by Paul S. Wingert, New York, 1962, in *American Anthropologist*, vol. 65, no. 3, June 1963, pp. 706–8.

——, 'Discussion of a Problem posed by Adriaan G. H. Claerhout: The Concept of Primitive Applied to Art', *Current Anthropology*, vol. 6, no. 4, October 1965, p. 433.

——, 'The Study of Ethno-aesthetics: The Visual Arts' in *Essays on the Verbal and Visual Arts*, Proceedings of the 1966 Annual Spring Meeting (ed. June Helm), American Ethnological Society, 1967, pp. 131–48.

Dark, Philip J. C., and J. M. Maring, *A Survey for Ethno-aesthetic Research in the Territory of Papua and New Guinea*, Illinois, 1964, pp. 1–38, Pls. 1–7, map.

Heine-Geldern, R. (ed.), *International Committee on Urgent Anthropological and Ethnological Research, 1958–65*, Bulletins 1–7.

Sturtevant, William C., 'Smithsonian Wenner-Gren Conference on Urgent Anthropology', *Current Anthropology*, vol. 8, no. 4, 1967, pp. 355–61.

CHAPTER 5 Art and History in Ghana*

Roy Sieber

I

The study of the so-called primitive arts has been essentially
non-historical. There exists the implication, most probably
unintended, undoubtedly incorrect, but nevertheless mis-
leading, that these arts have no history, that there was no change
over the course of time. The only major exception with respect to
Africa concerns arts in imperishable materials such as the early
arts of Nigeria: Nok, Ife, and Benin. As a result, the usual survey
of the arts of sub-Saharan Africa describes a sequence of styles
that is not historical but geographical, with rare and usually
brief digressions into the history of stone, fired clay, or brass
objects of a figurative nature.

Undoubtedly a major factor in this absence of historical data
for the arts lies in the paucity of historical studies. Data useful to
the scholar concerned with the arts is to be found primarily in
the writings of anthropologists and ethnographers and only very
occasionally in the works of historians. To all intents and pur-
poses the writings of early travellers have been ignored.[1]
Inadvertently art 'historians' became trapped in the time depth
of the great majority of anthropological writings: the fictional but
useful concept of the 'ethnographic present'. As a result, two
sorts of methodologies emerged: stylistic studies and context
studies. Stylistic studies – following on the pioneering work of
Kjersmeier – tend to be surveys, geographical in extent and
'tribal' in focus.[2] Context studies – a major example is the work
of Griaule – tend to become in-depth studies of a single unit (or
'tribal' style) exploring the cultural bases and uses of the arts.

I do not in any way wish to denigrate or demean such studies.
They have been and will continue to be major aspects of research
into the arts of Africa. Indeed, I feel strongly that the results of
researches into the context of African art, and the tools developed
to conduct such research should be applied to the arts of other

* My interest in the subject of this paper was encouraged during my first
period of teaching and research at the Institute of African Studies of the
University of Ghana in 1964. My visit was sponsored by the African–American
Universities Program and Indiana University. A special note of gratitude is due
to Ivor Wilks and Paul Ozanne, historian and archaeologist at the Institute at
that time. Their encouragement – and patience – gave rise to a paper, 'Some
Comments on Art and History in Ghana', published in *Ghana Notes and Queries,*
Historical Society of Ghana, vol. 8, January 1966. Further research and the first
draft of this paper were undertaken during a second period of research and
teaching in Ghana in 1967.

parts of the world. The bases for study of, for example, Renaissance art could be broadened and our knowledge increased with a little intradisciplinary cross-fertilization. In brief, I am arguing neither that such studies are obsolete nor that they are inconsequential.

Rather my argument, or, better, my plea is that unless we explore all possible areas and sources of data we cannot hope to achieve even a reasonably full understanding of any art form. Certainly there are major problems in the study of African art *history*. There are relatively few specimens of any age: the climate, insects, and use patterns have seen to that. To this point archaeology has unearthed major traditions in few areas; it would seem naïve to expect further extensive finds, for the dominant tradition of producing works in perishable materials is apparently a very old one. Yet some arts do survive above or below ground, and the oral histories of many groups are still recoverable. It is the purpose of this paper to present tentatively and with some trepidation areas of study I feel could profitably lead to an increase in our knowledge of the history of the arts in sub-Saharan Africa.

Elsewhere (1972) I have written of the terracotta funerary traditions among the Kwahu of Ghana. In summary, that paper purported to show that in certain cases it seems possible to place existing art forms in an historical as well as a stylistic and functional setting.[3] The funerary terracottas of the Kwahu and other Akan groups are limited to 'royals' (i.e. descendants of the founders of villages or states) and are portraits of the dead to be used at formal funerals.

The distribution of these terracottas is reasonably broad; from near Accra westward into the Ivory Coast and from the coast northward probably as far as Techiman.[4] In much of this area they are still used or were used within living memory. Although I have travelled fairly extensively in this area it is obvious that I have only scratched the surface of the problem.[5]

Before turning to some of the problems associated with the recovery of the history of this tradition I should like to turn to some notes about the context of the 'portrait' aspects of the terracottas. First, the terracottas appear to be substitutes for the actual body of the deceased. The formal funeral follows some time after the actual death and interment and the clay head or figurine may be viewed as a surrogate for the real corpse. It is not buried, however, but may be placed in or near the cemetery, in a shrine, or in a room of the deceased's house (the body apparently having been buried beneath the floor of that room).[6]

Because the terracotta is a substitute for the body it is not unnatural that it should be considered a 'portrait'. Among the

examples I have seen there is little evidence that the heads
represent the deceased in a physiognomic sense. A 'likeness'
is intended in only the broadest sense; for example, I was told
that if a man had a beard it would be shown, a woman would have
pierced ears, and the likeness of a priest would be modelled with
plaited hair. At the same time my informants (primarily chiefs
and elders, some well educated) insisted that these objects were
portraits, at times describing them as 'photographs' of the dead.
Obviously a naturalistic likeness was neither intended nor
sought, for the context of use – public display in a funeral hut
erected in the middle of the village – and the context of visual
association – one or two attributes of the deceased – were suffi-
cient to establish an adequate set of identifying marks.

Indeed, it would seem that a wider study of the degree of
likeness sufficient to the use of a 'portrait' might be in order.
In our view of African art (and primitive art in general) we have
tended to ignore the degree to which resemblance is sought;
instead we tend to apply ethnocentric criteria of 'likeness',
naturalism, and so forth. We have not sought the range of
requirements, probably varying from style to style, for a
resemblance suitably 'accurate' for the use intended for the
piece.[7]

Turning now to the historical setting for the funerary
'portraits' I should like to indicate the general setting of Akan
leadership objects. Among the various Akan groups (e.g.
Ashanti, Kwahu, Agni, Baule, etc.) there exists a highly consistent
set of objects associated with leadership. Stools, royal swords,
linguist staffs, umbrellas, gold jewellery, war trumpets (deco-
rated with the jawbones of enemies), particular cloths and
'crowns', and clay funerary portraits are some of the parapher-
nalia of kingship. In good part because of the relatively exclusive
contact with the Ashanti and because such objects seemed to be
in use by groups under the influence of and/or adjacent to the
Ashanti such objects are almost without exception attributed to
that nation. Yet some of the traditions obviously precede the
formation of the Ashanti nation (*c.* 1700). Ashanti traditions
clearly indicate that the concept of the 'royal' stool (and its ritual
'blackening' as an ancestral shrine object after the death of the
leader) preceded the foundation of the nation and the invention
of the golden stool. Ibn Battuta in the mid-fourteenth century
describes umbrellas associated with kingship at Mali. Swords of
the type usually termed 'royal' and attributed to the Ashanti are
not only known from other groups (e.g. the Agni) but examples
in the National Museum at Copenhagen and the City Museum in
Ulm were brought to Europe at least a half-century before the
foundation of the Ashanti nation.

It is thus apparent that the simple assignment to the Ashanti of all objects similar to those used by them is to ignore the historical backgrounds of both the cultures and the objects.

Similarly, it would appear that the royal portraits are pre-Ashanti in date and that their distribution is not to be described as dependent on the spread of Ashanti influence. At best it might be stated that the turmoil coincident with the emergence of the Ashanti nation may have contributed to their distribution, for the migrations of the Baule and Agni, as well as that of the Kwahu took place at about the same time as the formation of the Ashanti nation. The causal relationships are not yet clear.

There is a fairly clear cut and discernible historical context for the terracottas of the Kwahu, a group immediately to the east of the core Ashanti and a part of the larger Ashanti nation, or confederacy. The Kwahu apparently brought the terracotta tradition with them when they moved into their present area in the eighteenth century.[8] Their original homeland was somewhere quite near Ahinsan (south of Kumasi). At Ahinsan Oliver Davies excavated a number of terracottas which he dates to the latter half of the seventeenth century (Davies, 1956; 1965).[9] A more recent study by David Calvocoressi at Ahinsan would seem to reinforce this dating.[10] Various resemblances in type, style, and technique would seem to link Ahinsan with Kwahu thus reinforcing the oral tradition.

Further research combined with a rather more systematic survey of collections in Ghana has somewhat broadened my view of the funerary terracotta tradition in Ghana. I should like to summarize the results and try to correlate them with the works of historians.

In the past few years research at the Institute of African Studies and the Department of History of the University of Ghana has shown highly promising results. Particularly noteworthy is a series of articles published in *Ghana Notes and Queries* (9, 1966) which deal with the history of the Akan. Although much more needs to be done, it is evident that many of the conclusions of earlier researchers need clarification and revision.

The terracotta tradition summarized here has two limitations with reference to a broad view of the history of African art. First, the tradition of 'portraits' in fired clay is again one of relatively imperishable material. By far the greater portion of African art is in perishable material with particular reference to wood sculpture. Secondly, these notes refer to a single type of object fixed in time and space, with no evidence for general or specific cross-cultural interactions. In short they are based on the traditional 'tribal' base for African art studies adding only the attempt to achieve some time depth for the tradition.

II

The following notes and charts dealing with Ghanaian terra-
cottas are not meant to be definitive. Far from that goal, they
quickly reveal the problems and confusions that exist, but that
would seem, for the most part, capable of clarification. They are
an indication – a sort of status report – of the tools available to
the art historian at this point; basically these are the researches
of anthropologists, historians, archaeologists, and linguists. Not
only can the art historian use these disciplines, he can, I firmly
believe, contribute to them through his special disciplinary tools.
 The notes which follow are:
A. Archaeological Evidence. That is, surface and/or excavation
 finds which are not susceptible to direct oral data.
B. Recent Field Studies. Examples and/or data collected, in a
 recent (twentieth-century) use context.
C. Map. The sites from A and B are given.
D. Several pieces that add usefully to the corpus of known
 examples.
E. Problems of Origins, 1. A summary of the migration and/or
 origins of the groups listed in B.
F. Problems of Origins, 2. A summary of the early states and
 their dispersions.

EVIDENCE FOR FUNERARY TERRACOTTAS IN GHANA

See map for sites. Arranged roughly east to west, and north to
south.

A. *ARCHAEOLOGICAL EVIDENCE**

AREA	SITE	PUBLICATION OR SOURCE	DATE
Akwapem	Dawu	Shaw, 1961, pieces at G.N.M.	17th c.?
Shai Hills	Adwuku	Sieber find, 1964, piece at I.A.S.	17th c.?
Accra	Wodoku (airport site)	Shaw, 1961, at G.N.M.	late 17th c.?
Adansi	Ahinsan	Davies, 1956	18th c.
		Davies, 1965, pieces in D.O.A., I.A.S., G.N.M.	2nd half 17th c.

* D.O.A. Department of Archaeology, University of Ghana; I.A.S. Institute
of African Studies, University of Ghana; G.N.M. Ghana National Museum.

Twifo	Hemang	James O. Bellis, three excavated sites plus surface finds of hitherto unreported terracottas (see section D)	1650–1700
Fanti	Asebu (about 10 m. from Cape Coast)	G.N.M. specimens	
Brong-Ahafo	Hani (Surkoko stream)	Collected by David Calvocoressi, specimen at D.O.A.	end 1st millennium B.C.?

B. *RECENT FIELD STUDIES*

AREA	SITE OR VILLAGE	PUBLICATION/SOURCE*
Kwahu	Mpraeso and nearby villages: Oba, Oba-meng, Twenedurase, Asakraka, Pepiase, Kwahu Tafo, etc.	S. V., Sieber (1972). Pieces in D.O.A., G.N.M., I.A.S.
	Nkami	Old graveyard pieces in I.A.S. Site now inundated
	Akroso	Pieces in D.O.A. (In 1905 the Germans ordered the destruction of all local pottery. People claim to have come from Kwahu. Style of terracottas supports this)
Akim	Akim Kotoku	Field, 1948, Pls. 3, 4, and p. 44
	Akokoaso	Davies, 1956
	Ayirese	I.A.S.
Swedru	Swedru	Davies, 1956; photograph in G.N.M.; S.R. (near Winneba)
Asin	Asin Akropong	Davies, 1956
	Asin Nyankumasi	I.A.S. (particularly fine head, c. 1866) (see section D)

* S. Sieber data; V. seen; R. reported.

Fanti	Otsweo Tukwa (village near Winneba)	S.V.
	Dunkwa (north of Cape Coast)	S.R. from chief and elders. Tradition lapsed about 50 years ago
	Mouri Village (near Cape Coast)	No terracottas
Ashanti	Kumasi	Rattray, 1927, ref. to family pots. S.R. portraits made of Asantehene for funerals
Adansi	Fomena	Wild, 1934
	Kusa	I.A.S. (close technical resemblance to Ahinsan type) (see below section D)
Sefwi	Wiaso	S.R. from chief and elders
Aowin	Enchi	S.R. from chief and elders. S.V. fragments on grave of founder of city
	Achimfu	S.R. from chief and elders. Tradition moribund
	Dadiaso	S.R. from chief and elders. Tradition gone
Wasa-Amanfi	Asakrangwa (city contains Aowin and other groups as well as Wasa-Amanfi)	S.R. from chief and elders
Wiasa-Fiase	Bogoso	S.R. from chief and elders
	Mansu (17 m. NW of Sekondi)	Kerr, 1924
Nzima	Axim	S.R. from chief of upper town. Still in cemeteries, but tradition moribund

D. *SEVERAL PIECES THAT ADD USEFULLY TO THE CORPUS OF KNOWN EXAMPLES*

1. Four pieces in the Institute of African Studies

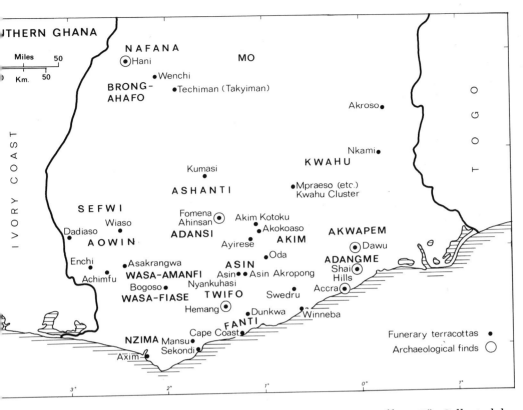

e sites from A and B

I64.93 A head from Nkwatia, Kwahu.[11] 11·7". Collected by K. Ameyaw. A relatively large, flat, solid head with more appliqué decoration than most. In this respect it resembles the Ahinsan flat examples.

I64.233 A head from Atibie in Kwahu. 6" high. This head, which resembles the flat Ahinsan heads (dated second half of the seventeenth century by Davies), was collected by K. Ameyaw from the ruins of Abomprawa near Atibie. It was used for the funeral of Nana Tie Fua who died in the eighteenth century (He had come from Kanyasi in Ashanti.) (Pl. 1, left).

I67.18 A head from Kusa in Adansi. About 6". Collected by K. Ameyaw. This head, simply described as 'old', had been used in a shrine. It resembles the small hollow-ware heads from Ahinsan, both in style and technique particularly with reference to an air vent at the back of the head (Pl. 1, right).

I66.38 A head from Asin Nyankumasi in the Asin area. 11" high. Collected by K. Ameyaw. It was made after the death of Nana Kusi Boadum who was enstooled about 1811, therefore this specimen probably was made in the third quarter of the nineteenth century (Pls. 2 and 3).

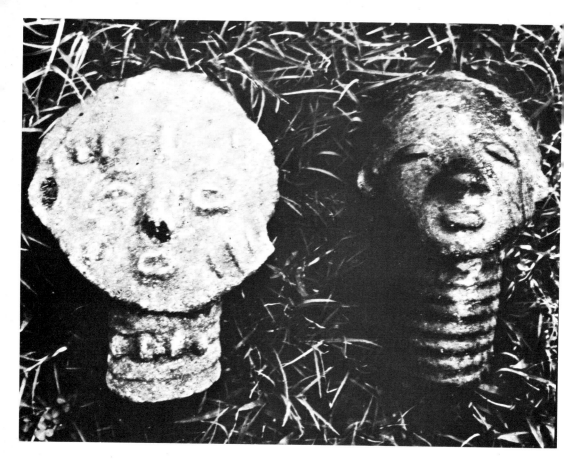

1 *left*
Terracotta head from Atibie in Kwahu. H. 6″. Coll. K. Ameyaw. Said to be 18th c. Institute of African Studies, Legon. I 64.233
right
Terracotta head from Kusa in Adansi. H. *c.* 6″. Coll. K. Ameyaw. Institute of African Studies, Legon. I 67.18

2, 3 (*see over*) Two views of a terracotta head from Asin Nyankumasi in the Asin area. H. 11″. Coll. K. Ameyaw. Probably third quarter 19th c. (1866?). Institute of African Studies, Legon. I 66.38

This head closely resembles examples published by Wild (1934) and reported to have come from Fomena in Adansi. The specimens now in the British Museum were reported to have been made at least seventy-five years earlier, or roughly the same time as the I.A.S. example. Wild's data came from Nana Kobina Fori, then Omanhene of Adansi.

It is important to note that these rather large hollow-ware heads are clearly distinct from the 'typical' Ahinsan small flat and hollow heads found by Davies and others. However, several tantalizing fragments of larger heads from Ahinsan (now at the D.O.A.) are rather close to these in style.

2. Recent excavations by James O. Bellis.[12]

Excavations of three sites near Hemang in the Twifo traditional area of the Central Region resulted in the discovery of terracottas on two of the sites and ceremonial pottery from all three. A fourth and unexcavated site revealed terracottas as surface finds.

To my knowledge these are the first terracottas to be reported from the Twifo area (called Quiforo on the

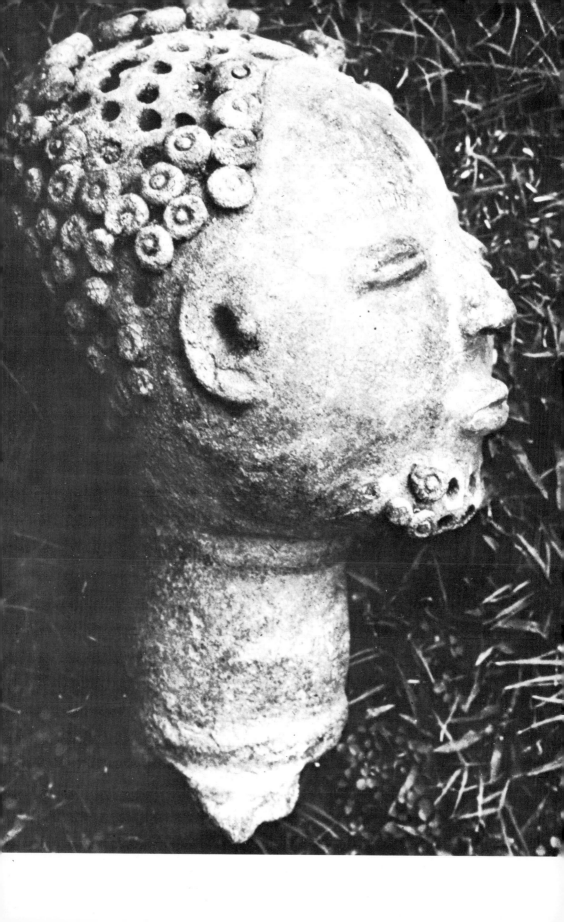

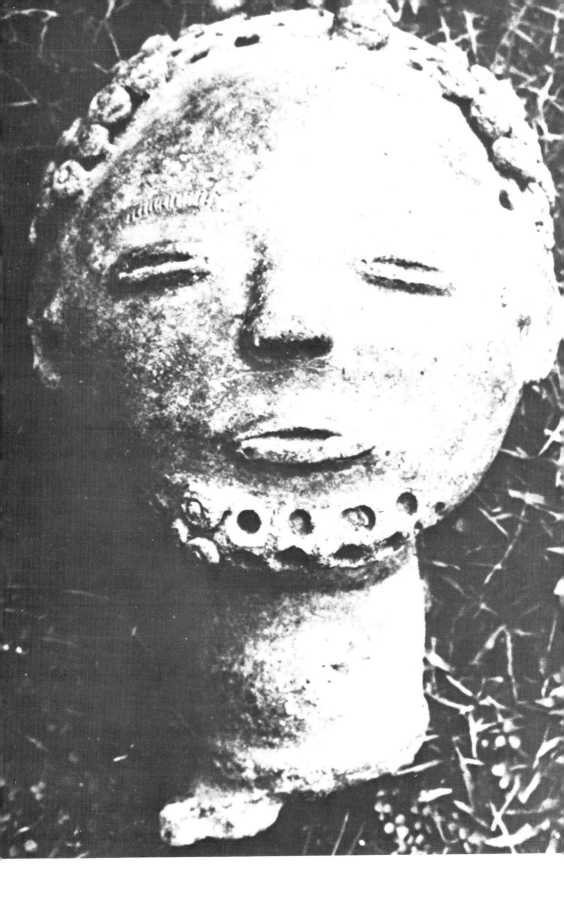

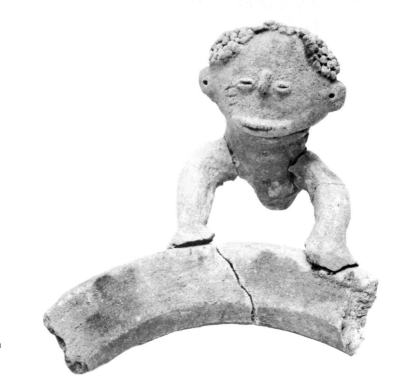

ce excavated by Bellis
his Site 1, Hemang,
. Figure attached to rim
erary vessel. *Photo*
is

up of terracotta
ents from Bellis's Site 2,
ng, Twifo. Clearly two
erhaps all three of the
hollow-ware heads were
aits'. *Photo J. Bellis*

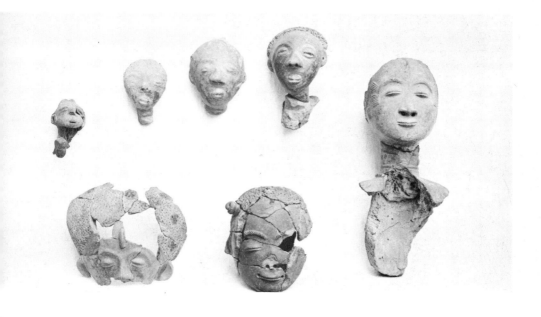

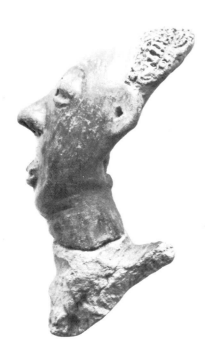

6 Three smaller heads from
Bellis's Site 2 which were
attached to funerary vessels.
Photo J. Bellis

1629 Dutch map noted below in E, under Adansi).
They would seem, on Bellis' evidence, to date 1650–
1700.

Site 1 revealed a number of fragments of clay
figurines. All of the heads appear to be appliqué or
portions of secondary figures (Pl. 4).

Site 2 revealed a number of fragments of which at
least two were clearly 'portraits'. The larger of these is
an exceptionally finely modelled example (Pls. 5, 8,
9). Interestingly, a nearly identical piece without data
was acquired by the Museum of Primitive Art in New
York (Pl. 10).

Sites 1 and 2 appear to be similar to Wild's 'Place of
the Pots' (1934), that is a specially designated area for
the funerary terracottas, but not the cemetery itself.
Bellis found no burials associated with the terracottas at
these two sites.

Site 3 revealed no terracottas, but ceremonial pottery
identical to that of Sites 1 and 2 was uncovered.

Site 4 was not excavated, but revealed surface finds
of terracotta fragments (Pl. 7).

The Hemang excavation is of particular importance
because it has revealed for the first time undisturbed
funerary pottery and hearths which establish close
parallels to current practices.

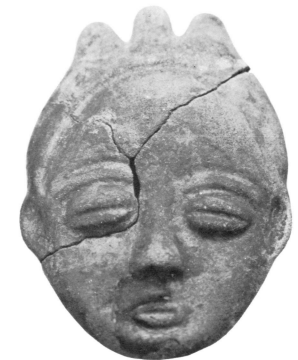

...acotta from Bellis's
...t Hemang, Twifo.
...ad was the only one
...of the sites at
...g to have a red
...It was attached to a
...ry vessel by a small clay
... mouth level. *Photo*
...s

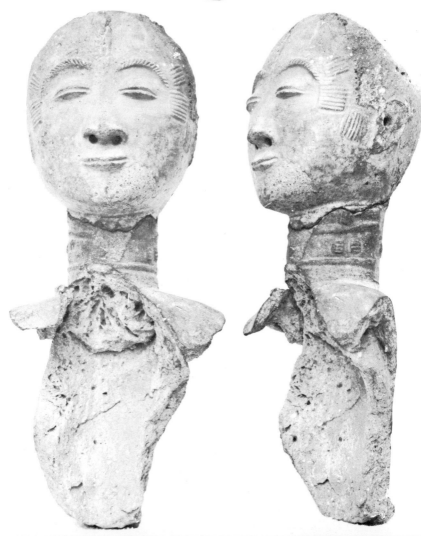

...wo views of a
...ait' terracotta from
Photo J. Bellis

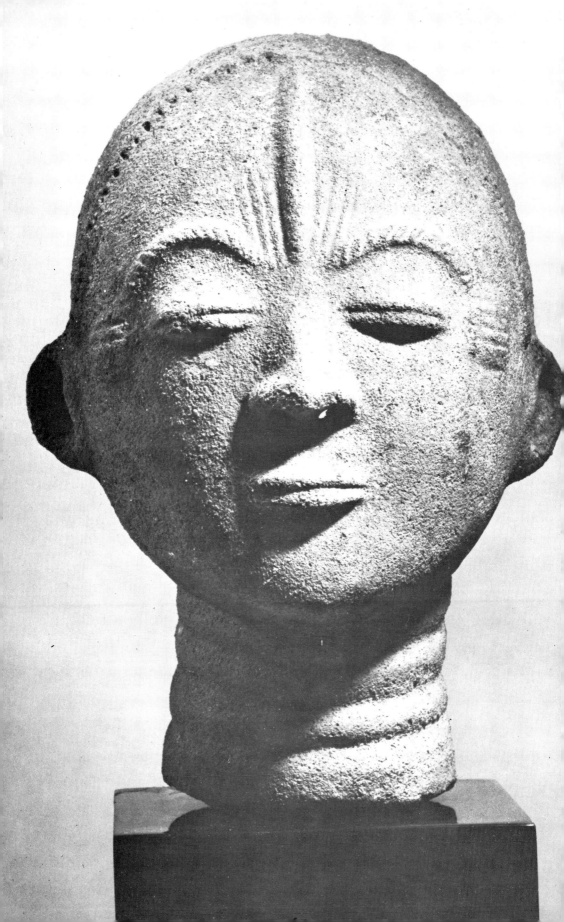

E. *PROBLEMS OF ORIGINS, 1*

Following the field examples in B, this section attempts to give traditions of origin for the groups and/or sites noted. With few exceptions I have limited myself to the works of Meyerowitz and more recent studies emanating from the University of Ghana.

Kwahu The history of the Kwahu has been recorded by Kwabena Ameyaw of the Institute of African Studies, University of Ghana. It is published in mimeographed form.[13]

Original home: Ahinsan area of Adansi.

Dates: earliest major wave of migrants early in the eighteenth century. The only other reference I have found is in Meyerowitz (1952, p. 133), where she states that the 'Tena clan people from Ahensan in Adanse found the Kwahu state' in 1690. The Tena people from an unidentified place in the north had come to Ahinsan to 'join their brothers, the Beretu people,' about 1660 (ibid.).

Akim Meyerowitz (1952, p. 133) states that both the Akyem-Kotoku state and the Akyem-Bosome state were founded about 1701 by refugees from Denkyira, which had been destroyed by the Ashantis under Osei Tutu in that year. Field (1948, p. 200) states that only Oda was founded from Denkyira and then only in the nineteenth century after the refugees had stopped at various intermediate spots. She states that Akokoaso was founded by peoples from Adansi Fomena; and Ayirese by peoples from Ashanti Ofuase. She offers no dates for these settlements.

The dates of Meyerowitz and Field refer to the recent states in the area. The earlier Akyem states are dealt with below (section F).

Swedru No data.

Asin Reported to have been under the control of Denkyira before 1701 (Kumah, 1966, p. 33).

Fanti From Dunkwa, north of Cape Coast, inferential data was obtained from the keeper of the chief shrine of the town. The shrine was founded, and a tree planted, at the time the peoples migrated from Techiman (Quarcoo and Sieber, field survey, April 1967).

Among several Fanti migrant groups, Meyerowitz (1952, p. 134) mentions Fanti refugees from the Bono kingdom (including Techiman or Takyiman) after its defeat by the Ashanti in 1740.

Ashanti One of the best recent surveys of the development of the Ashanti State is by J. K. Flynn, 'The Rise of Ashanti':

The beginnings of the Ashanti Kingdom are rather obscure. It is clear, however, that the majority of the peoples who later constituted the nucleus of the Ashanti Union, originally lived in the Adanse and Amanse districts of modern Ashanti (1966, p. 24).

He goes on to point out that the 'ancestors of the Ashanti were . . . subjects of the Akanny state which may confidently be identified with the old Adanse Kingdom. . .' (ibid.) and that the 'migrations of Adanse and Amanse peoples northwards, during the second half of the seventeenth century, was a direct consequence upon the emergence of Akyem, Akwamu and Denkyira . . .' (p. 25).[14] The latter were the three major states along this stretch of the coast; not as coastal states but as hinterland states – just inland, really – which controlled trade with the coast and, thereby, with Europe (see below, section F).

Adansi Meyerowitz (1952, pp. 92, 93, 132, and 133) states that Adansi was settled by people apparently from Beeo-Nsoko (destroyed *c.* 1630)[15] and was not fully operational as a kingdom until 1660.

This seems incompatible with other data: if Beeo-Nsoko was destroyed in 1630, Akanny, identified with the old Adansi kingdom by Flynn (see *Ashanti* above)[16] could hardly appear on a Dutch map of 1629 (Map, 1966).

If Davies' estimate (1965) of the date of his finds at Ahinsan is correct the terracottas from that site would date about the time of the move northwards or possibly just before. In either case they could be termed 'Old Adansi Kingdom'.

Sefwi There are three states in this area. Sefwi Wiaso, the only one I have visited, is reported by Meyerowitz (1952, p. 117) to be ruled by the descendants of a founder installed at the orders of the Asantehene Opoku Ware after 1743. A tradition collected from Nana Kwado Aduhene II, Omanhene of Sefwi Wiaso Traditional Area[17] contained no reference to this. Instead he cited a move (undated) from Techiman.

Aowin As noted under Nzima a complex of problems arises when attempting to sort out the origins – and dates – of the Aowin state.

Meyerowitz (1952, p. 117) argues a migration from the north after 1743. Yet the Aowin may well have been in their present area in the previous century.

Nana Attah Kweku II stated that the Aowin had migrated from Techiman but offered no date or datable event for the move.[17] The Aowins extend into the Ivory Coast; they are part of the Baule-Agni language group.

Wasa-Amanfi See Wiasa-Fiase. Meyerowitz (1952, pp. 99, 115) states that the state was founded (and ruled?) by remnants of the Akwamu state after 1734 (Wasa – name of conquered states; Amanfi 'encircled by states').

Wiasa-Fiase Meyerowitz (1952, p. 115) states that the Wiasa-Fiase state was founded by defeated Wasas after the Wasa-

Amanfi state was established. The Wasa are to be found on a
Dutch map of 1629.[18]

Nzima Meyerowitz (1952, p. 84) argues an origin from the
northern Ivory Coast and states that they are said to be Agnis.
There seems to be some confusion with the Evalue of this area.

An oral tradition recorded[19] at Enchi and given by the
Omanhene of the Aowin Traditional Area, Nana Attah Kweku
II, includes a reference to the Nzima. The Nzima parted from
..the Aowin at Anyaayau (in Aowin territory) after they had
moved southward from Techiman.

If a common origin for the Aowin and Nzima and/or Agni
does exist,[20] Meyerowitz's date for the departure of the Aowin
from the north, 1743, should hold for all three groups. How-
ever, J. K. Kumah (1966) posits the presence of the Aowin in
their modern area before the end of the seventeenth century.
He cites Bosman as authority for a major trade route through
Wasa and Aowin, and notes the capture of Aowin by Denkyira
in about the 1670s.

Furthermore, the Dutch map of 1629 gives the name Incassa
to an area near that of the modern Aowin. Goody (1966)
suggests that 'Incassa might refer to one of the Akan-speaking
kingdoms of the present Ivory Coast (i.e. "Jaman", Bayle, or
Agni).' Could it be Aowin?

F. *PROBLEMS OF ORIGINS, 2*

No discussion of historical factors can omit three major king-
doms south of modern Kumasi but inland from the coast itself:
from east to west these were Akwamu, Akyem (Akim),[21] and
Denkyira (Denchera). Further north were Bono (Brong) and old
Adanse (Adansi). These states, at various times, emerged as
major forces known to Europeans on the coast but often appear-
ing semi-legendary or – at least in the reports – vague indeed.

Akwamu A large state in south-eastern Ghana, identified with
Aquemboe on the Dutch map of 1629.

Flynn suggests that the migrations of the Adanse and Amansi
northward (to effect in time the Ashanti Union) was consequent
on the emergence of Akwamu, Akyem, and Denkyira.

Akwamu outlived the formation of the Ashanti, in part
because it lay some distance away, and possibly because
Akwamu supported the Ashanti and saw the growth of the
Ashanti kingdom as a force balancing the power of the Akyem
whose state separated Akwamu from Ashanti. Indeed Opoku
Ware (the second Asantehene) is said to have made war against

the Akyems in 1742 in part because they had attacked the Akwamus (Flynn, 1966, p. 26).

Meyerowitz (1952, pp. 98, 137) suggests that the Akwamu state was founded from Denkyira in 1575, destroyed (to all intents) by the Akyem states in 1734, and later reformed as the present state in the Volta region. The Akwapem state, formerly a part of Akwamu, emerged after 1734. An Akwamu prince founded Wasa-Amanfi after defeating the Wasa and the new Wiasa-Fiase state was formed by the defeated Wasas.

Akyem (Akim) A large state in the east central area of southern Ghana identified with Akim or Great Acanij on the Dutch map of 1629.

Meyerowitz (1952, p. 99) states that the three Akyem states became independent after their defeat of Akwamu (1734). Two of these states (Akyem-Kotoku and Akyem-Bosome) had been founded by refugees or emigrants from Denkyira (c. 1701). The third state (Akyem-Abuakwa) had been founded earlier (c. 1650). In 1742 they were defeated by the Ashanti under Opoku Ware. Apparently the present states were reformed under Ashanti overlordship.

Apparently an early Akyem state existed, one which predated the traditions Meyerowitz records.

Denkyira A state in the central and western areas of southern Ghana. According to Kumah (1966, p. 33) its capital was a few miles south of present Kumasi and its power extended over Ashanti, Sefwi, Wassaw (Wasa), Twifo, Assin (Asin), and Aowin. Denkyira – at least under that or another identifiable name – is not to be found on the Dutch map of 1629. Kumah refers to Bosman (Eng. trans., 1705) and other sources to indicate that it was known to Europeans in the later seventeenth and in the eighteenth century.

Oral tradition (here Kumah relies on Meyerowitz, 1952) gives the Mande area (between the Niger and Volta river) as the original homeland. The future Denkyiras moved southwards to the Bono kingdom c. 1620. They defeated the Akyerekyere, gold traders well known to Europeans. (If this date is correct, it is not surprising that they should not be shown on the 1629 map.)

Denkyira was defeated by the Ashanti under Osei Tutu in 1701, in the course of the foundation of the Ashanti Confederation.

Because Meyerowitz is primarily concerned with the Bono state, her data for other early states is often sketchy in the extreme. She certainly does not do justice to the Denkyira. For example, she lists three kings (1952, p. 136); Kumah (1966) lists eight (and perhaps implies a ninth)[22] and suggests a date

of origin about thirty-five years earlier than Meyerowitz (i.e. 1585 *v.* 1620). In that case one wonders about their absence from the 1629 map.

Denkyira had a state stool of 'convoluted beads' (ibid., p. 34). Might this be a prototype for the Ashanti golden stool?[23] Further a state sword existed. Unfortunately there is no mention of funerary terracottas.

Bono Due primarily to the publications of Meyerowitz[24] the old kingdom of Bono and its capital Bono-Manso have become well known. She firmly believed that it was the oldest centre of Akan culture south of the Black Volta and, indeed, parent to the later Akan cultures, particularly the Ashanti. To some extent this may be true; to some extent it is an exaggeration for the states of Akwamu and Denkyira contributed in no small part to the customs, politics, and paraphernalia of the Ashanti.

Meyerowitz (1952, pp. 130, 134) gives the foundation date of the Bono state as 1295; its destruction by Ashanti as 1740. (The Gonja Chronicle gives a date of 1722–3.)

Adanse Under *Adansi* (section E, above) I have indicated some of the difficulties that confront the historian when he tries to correlate old European reports and maps with oral traditions. Daaku (1966, p. 11) notes that Barbot and Bosman are 'silent about Adansi, which preceded Denkyira and was the leading power in the interior . . .' . He argues (see n. 16) that the state called Akanny (with variant spellings) was the source of confusion. 'The Europeans were unable to ascertain what this state really was. A glance at the 1629 map confirms [this].' He goes on to state that the area called – on the 1629 map – Acanij was the cradle of the Adansi and (later) Denkyira kingdoms. He suggests that Akani was a linguistic term used to refer to traders who came from this area. From this he concludes that European silence with regard to states known to exist from oral traditions can be deceptive. I would add that the old maps are useful for positive evidence: that is, when they do give a traceable name we have a positive dated correlation; when they do not give data (as with Adansi) we must be most cautious not to accept such 'negative evidence' as factual. Europeans were interested primarily in trade; their assessment of interior states and geography was based on information from the coast. The evidence they offer to historians must be screened carefully. It is to be hoped that studies will emerge which combine European sources with oral traditions and archaeological investigations. Such studies will give a clearer picture of Ghana history than now obtains.[25]

Adanse preceded and coincided with Denkyira, Akyem, and Akwamu. Indeed, pressures from these states were

responsible in part at least, for the migrations northward to lead to the formation of Ashanti and the (further?) settling of Kwahu.

This complex of confusing and often incomplete histories needs further research. When an attempt is made to correlate historical and archaeological data with the terracottas no 'source' can be identified. Living traditions do not fit neatly in a pattern, nor do they coincide or support (nor are they supported by) traditions of origin in a way that leads to more than the most hypothetical of conclusions.

Archaeological data would seem to jump from the Hani head (in modern Brong-Ahafo area) which, if its date is estimated correctly, predates the foundation of Bono, the first major Akan state in the area, by at least 1000 years. (Provocatively its date does put it in the time of the Nok culture of Northern Nigeria though it bears little or no resemblance to the Nok terracottas.)

Other archaeological finds from the Akwapem, Shai Hills, and Accra plains are tentatively dated to the seventeenth century. Again presuming the dates to be reasonably accurate estimates, they could have been made by the Akwamu whose state covered much of this area. However there is no evidence that the influence of Akwamu was widespread enough, or its people dispersed enough to suggest that the Akwamu were originators of the terracotta tradition in southern Ghana.

Similarly the finds at Ahinsan in Adansi (accepting Davies late seventeenth-century date) conceivably could have derived from Akwamu although the intervening Akyem area has yet to reveal pieces this early in date. To my knowledge no pieces earlier than the nineteenth century have been reported from Akim. Further, if the Adanse were a major factor in the formation of Ashanti culture one might suspect a stronger tradition among the later Ashanti than in fact seems to have existed.

Nor, thus far, can we suggest that the terracotta tradition sprang from the Bono kingdom. No firm data exist for the present Brong, and no archaeological support exists. At the same time several of the groups which produce, or in the recent past produced, funerary terracottas do have migration histories which include Techiman as a point of rest and departure. Techiman (or Takyiman) is the modern centre of the Brong and much of Meyerowitz's data for the Bono was obtained from the chief and his elders.

To my knowledge no archaeological finds of terracottas exist for the old states of Denkyira, Akyem, Aowin, Sefwi, Nzima, or Fanti. Some oral traditions of migrations or old ties might be useful, however. In summary these are the following. (In each

case I shall use the name of the old kingdom, that is the pre-Ashanti state, and not the modern state or areas that bear the name. Dates are the *end* dates of the state.)

Akwamu (1734) Refugees to the new Akwamu state in Volta and to Wasa-Amanfi. Terracottas from the Akwamu area and south (Akwapem, Shai Hills, Accra plains) are tentatively dated to the seventeenth century. No data on terracottas from the new state. Examples from Wasa-Amanfi.

Akwapem A part of the Akwamu state, became independent.

Akyem (1742) Became vassal states of Ashanti. Modern terracotta tradition in area. No archaeological finds.

Adanse (1650–1700) Migrants moving northward to help found Ashanti Confederacy. The date of this movement coincides exactly with Davies' estimate of the date of the Ahinsan finds. At the same time or later the Kwahu moved to their present home. No pre-1700 terracotta finds in Kwahu area.

Denkyira (1701) Partially incorporated by the Ashanti as a vassal state. Some refugees to Wasa-Amanfi where they settled at modern Dunkwa. No archaeological finds.

Bono (1740) Hostages to Ashanti. Possibly as refugees (from Takyiman?) at this time or as earlier migrants were the peoples of Sefwi, Aowin, Nzima, and, possibly, the Agni of the Ivory Coast. Except for the possibly very early head from near Hani no terracottas reported from modern Brong area. However all the groups mentioned above have had funerary terracottas in the recent past.

From this summary it is evident that no clear pattern can emerge, no single source appear. The three most promising areas for further research would seem to be the areas of the old Akwamu, Adanse, and Bono kingdoms. At the same time Denkyira cannot be ignored. Nor, indeed is it impossible that the tradition has its origins outside the present area of the Akan. Oral traditions, especially regarding the terracottas, need collecting and where possible archaeological evidence is needed.

In brief the results are provocative, even promising, but by no means definitive. I trust future research will lead to clarification.

III

I should like to raise one last point concerning art and history and that is the area most often neglected in African art studies of the interactions between groups and styles. In a very real sense most of the studies of African art traditions deal with each 'tribal style' as if it were an hermetically sealed unit.

This phenomenon, like the failure to seek after history, is

possibly the heritage of a 'frozen culture' concept. This heritage of early evolutionary theories[26] has long been abandoned as a serious avenue for research, yet I fear it still infects our thinking about African art. There have been and, I am certain, will continue to be useful studies of style: from tribal styles to those of individual artists. At the same time we tend to accept and to use rather loose categories for supra-tribal styles (e.g. Congo, western Sudan). As often as not, however, we use such terms interchangeably with terms such as 'Nigerian art' which has neither ethnic nor stylistic validity but becomes a convenience of national boundaries.

In short I suggest two approaches: one the study of supra-tribal styles as defined by Bascom (Biebuyck (ed.), 1969), and the correlation of such studies with history. Often the material collected by historians has not been correlated with art studies. The southern half of the Congo is an outstanding example. Many others exist, and I should like briefly to outline an area and set of problems which are concerned with the interactions over time of various ethnic groups in a reasonably circumscribed area.

In the roughly triangular area from Wenchi in west central Ghana north to the Black Volta river and from those points to Bondoukou in the Ivory Coast there live a number of groups with a history of contacts and interactions. These include the Numu, Hwela, Ligby, Dyula, Mo, Kulango (Bedu), Nafana (Fantera), and Bron (or Brong).[27]

The area is of considerable historical interest and may prove extremely important archaeologically.[28] It includes the site of Begho (Beeo-Nsoko in Meyerowitz),[29] an important early trade city linking the gold areas to the south with the western Sudan. It was, in part at least, included in the Bono kingdom. Indeed, Bono-Mansu, the capital of the Bono kingdom was a trading centre rivalling Begho. Some refugees from destroyed Begho settled in Bondoukou which inherited its prosperity.

Later the area became known to Europe as Jaman or Gyaman; today Gyaman is split between the Ivory Coast and Ghana. The state is said, by the Brong, to have been founded by emigrants from Akwamu. Thus the founders of Gyaman were Akans. In their long migration from Akwamu they were known as the Dormaas, and a group of Dormaas under a leader named Adu Ben founded Gyaman sometime after 1620 (Agyeman, 1966, pp. 36–9). The empire, the people and their language are called Brong in the literature and are part of the modern Brong-Ahafo area. Despite a long tradition of Muslim settlers and traders, 'Gyaman remained predominantly a pagan kingdom under Brong (Dormaa) rulers' (Agyeman, 1966, p. 38).

In this all too brief sketch it is apparent that the area has been

entwined with an old and extensive trade between the forest goldfields and the western Sudan, an avenue not only of trade but of Islamic religious and martial incursions. Further, it is intimately tied to the history of the Akan through the Bono and the Brong.[30] Add to this other ethnic groups such as the Senufo (Nafana or Fantera) and the Mo (Gur), and the study of the arts becomes not only a challenge but a type of problem all but ignored in African art studies.

The following notes, which are meant to do no more than indicate the character of the problem, are from research conducted by René A. Bravmann.[31]

The *Numu* (Mande speakers) are a specialist group widely distributed in the western Sudan. In the area under consideration nearly every village has one or more Numu families: the men are blacksmiths, the women potters. They claim to have migrated in the company of traders (Ligby, Hwela, or Dyula). The traders moved to control the gold trade, the Numu artisans moved with them and provided iron tools and pottery to the traders and possibly through them to the areas traded with. This symbiosis needs further study.

In addition, Bravmann has found two Numu villages founded from Begho. These are specialist artisan villages serving a large market area. The two villages have masks. The mask and the cult, composed of all adult males are called *gba*. The masks are cleansing agents, clearing the village of alien forces (witches, for example). The masks are horizontal 'bush cow' types resembling Senufo *korubla* masks.

The *Hwela* (Mande speakers) state that they came from the Niger region. They are now heavily Islamized, although this may be a fairly recent phenomenon. The Hwela have a masking tradition; the cult and mask are called *gbain*. All adult males may belong to this anti-witchcraft cult. They too are horizontal masks. Of particular interest, the masks are used by and 'owned' by Muslims; they appear at night after Mosque services.

Ligby. Masks called *do* have been found. Again they are used by Muslims.[32]

Dyula. Masking and figure carvings are reported, but not yet investigated.

The *Mo* (Gur speakers) have a long history of contact with the Akan. As a result Mo leadership uses a great deal of Akan regalia: stools, umbrellas, swords, palenquins, etc. Local traditions date this to the time of Opoku Ware (1720–50). The regalia was not made locally but came (as gifts?) from the Asantehene or was ordered from Kumasi.

Mo women are excellent potters, acknowledged as such over a large area. There are figure carvings in wood. *Bedu* masks (see Nafana) are reported.

The *Kulango* or *Bedu* (Gur speakers) have migrated from the north (Lobi country). They use Akan regalia which, unlike the Mo, they make themselves. *Bedu* masks (see Nafana) are reported.

The *Nafana* (Fantera) are Gur speakers (closely identified with the Senufo in this instance). They have a masking tradition called *bedu*.[33] They are large (4' to 8' in height) with large superstructures; they appear in pairs. The male is usually larger than the female and is topped with horns. Unlike the masks of the Numu, Hwela, and Ligby, the masks are public and may be seen by women and children. The masks cleanse the villages. In the area of Bondoukou the Mo and Kulango have *bedu* masks.

The cult of *Sakrobundi* may still exist in some villages, but seems to be lost in the major centres.

The Nafana leadership uses Akan regalia. It was first received from the Ashanti according to tradition. The regalia was obtained in Kumasi, and not made locally. There are figure carvings.[34]

The *Bron* (Brong) are the major Akan group in this area. Their regalia and pottery traditions closely resemble those of the Ashanti. Now, however, much of the pottery is Mo in origin and the Mo potters are acknowledged to be the best in the area.

It is not clear whether Bron regalia derives from the Ashanti or was the prototype for Ashanti leadership arts as Meyerowitz suggests. Bravmann reports that the Bron insist that they possessed the types at the time of their origin (i.e. before the Ashanti Union).[35]

It may be possible for Bravmann to discern the sources or origins of the masks used by different groups. In some instances the borrowing of art forms such as regalia and pottery is clearly remembered, in others origins may prove more difficult to ascertain.

In any case, the situation studied by Bravmann is one that probably exists to a greater or lesser degree for many African art traditions. Obviously the 'test tube' approach to African art needs reconsideration and, more importantly, research in the field is needed to determine the interactions of traditions and peoples. Although the original objects may have perished, the traditions of their origins are often recoverable and can lead to a history of the art forms.

NOTES

1. A major and early exception was H. Ling Roth, who, in *Great Benin*, London, 1903, presented one of the earliest surveys of the writings of early travellers who had described the leadership arts of Benin City.
2. Dr. Goldwater's paper explicitly indicates the nature and shortcomings of stylistic studies conducted thus far.
3. The results were summarized in Sieber, 1966.
4. An area in excess of 50,000 square miles.

5. George Preston of Columbia University has also worked on this problem.
6. Sub-floor burials may have preceded cemeteries; for example, at Teshie Beach (probably pre-fifteenth century) near Accra there are clear indications of burials beneath the living floor.
7. For example Maori 'portraits' were careful renderings of individual facial scarification placed on a very generalized form of a face.
8. The oral traditions of the Kwahu have been collected and reported by K. Ameyaw, 1966 (1 and 2).
9. More recently terracottas from the seventeenth century have been reported from south of Ahinsan and from three sites near Accra.
10. James Bellis, personal communication.
11. Illustrated, Pl. I, Ameyaw, 1966 (1). Pls. II and III depict a queen-mother figure from Asakraka, Kwahu. I discuss this figure in 'Kwahu Terracottas' 1972, and there note that although it is most probably a replacement for an earlier figure (dating into the early eighteenth century) its existence reinforces the tradition that terracottas were brought from Ahinsan in Adansi.
12. I am most grateful to James Bellis for his correspondence and discussions concerning the Hemang excavations. I am privileged to announce some of the results and publish some of his photographs prior to their publication in full by Bellis.
13. A brief version is published in Ameyaw, 1966 (2).
14. Wilks, 1961, offers other reasons for the formation of the Ashanti kingdom. Causative arguments need not concern us here.
15. Beeo-Nsoko, more usually called Begho, was a major city on the trade route from Mande country to the coast. Near modern Wenchi, the ruins of this city are scheduled for archaeological investigation.
16. K. Y. Daaku, 1966, p. 11, agrees that Akani, Accany, Arcany, Hacany on the early maps refer to Adansi.
17. Recorded by A. Quarcoo and R. Sieber, April 1967.
18. Meyerowitz, 1952, p. 115, n. 1, reports that the Takyimanhene told her the Wasa, migrants from an unidentified area, were in Techiman into the seventeenth century. This is not compatible with the Dutch map of 1629.
19. By A. Quarcoo and R. Sieber, April 1967.
20. Meyerowitz offers evidence to equate Nzima with Agni – or Anyi (1952, p. 84, n. 2) and terms the Aowin State the Anyin State and the people Anyi whose origin she places in the Ahafo region, NW of Kumasi, i.e. near Techiman (ibid., p. 117).
21. In each case the spelling of the modern area is given in parenthesis.
22. Some of Meyerowitz's list for Agona (pre-Denkyira) kings include names similar (identical?) to Kumah's for the first three kings.
23. However a golden stool is reported from the early empire of Ghana. See quotation from 'Nubian's Geography', 1619, translation in *West African Sketches,* compiled from reports of Sir G. R. Collier, Sir Charles MacCarthy, and Other Official Sources, London, 1824 (mimeographed reprint at the Institute of African Studies, University of Ghana, Legon, 1963).
24. See for example, 1952 and 1958.
25. I should like to add that the works of Ivor Wilks and the authors of *Ghana Notes and Queries,* 9, 1966, indicates that this is not a vain hope.
26. I discuss the 'tool kit syndrome' in Biebuyck (ed.), 1969, pp. 192–203, esp. p. 194.
27. The use of linguistic evidence for history is discussed with reference to the Akan and other groups in the papers by Painter and Stewart noted in the list of references.
28. Although too early to be of concern here, the area includes part of the Kintampo Culture (tentatively dated to the second millennium B.C.). C. Flight and R. York, personal communication.
29. Destroyed in the first half of the seventeenth century.
30. Ashanti influence and control existed over much of the area following their

capture of the Bono Kingdom in the early 1700s.

31. 'Third Field Research Report', 1967. Unpublished MS. Bravmann's research, supported by a Foreign Area Training Fellowship, has led to a Ph.D. dissertation. I am grateful to Bravmann for permitting me to use this material.
32. I saw some of these masks, similar to Senufo *kpelie,* near Banda in 1964.
33. These masks are tall, flat structures usually inaccurately identified as Gyaman or northern Ashanti.
34. At any rate I saw one in Banda in 1964. Bravmann did not see any.
35. A third alternative exists: the regalia may have come with the Gyaman (Brong) from Akwamu. In which case Akwamu may have been the centre of dispersion to both Ashanti and Brong.

REFERENCES

Agyeman, E. A., 'A Note on the Foundation of the Kingdom of Gyaman', *Ghana Notes and Queries,* vol. 9, 1966, pp. 36–9.
Ameyaw, Kwabena, 'Funerary Effigies from Kwahu', *Ghana Notes and Queries,* vol. 8, 1966 (1), pp. 12–17.
——, 'Kwahu – An Early Forest State', *Ghana Notes and Queries,* vol. 9, 1966 (2), pp. 39–45.
Bellis, James O., 'Archaeology and the Culture History of the Akan of Ghana', Ph.D. thesis, Indiana University, 1972 (unpub.).
Biebuyck, Daniel (ed.), *Tradition and Creativity in Tribal Art,* Berkeley, 1969.
Boahen, Adu, 'The Origins of the Akan', *Ghana Notes and Queries,* vol. 9, 1966, pp. 3–10. This article, although not cited, is an excellent introduction to the broad history of the Akan.
Bravmann, René A., 'Third Field Research Report', 1967 (unpub.).
——, 'Islam and Tribal Art in West Africa: A Re-evaluation', Ph.D. thesis, Indiana University, 1971 (unpub.).
Daaku, K. Y., 'Pre-Ashanti States', *Ghana Notes and Queries,* vol. 9, 1966, pp. 10–13.
Davies, Oliver, 'Human Representations in Terra Cotta from the Gold Coast', *South African Journal of Science,* January 1956, pp. 147–51.
——, *Report No. 1 Ashanti Historical Scheme,* Institute of African Studies, Legon, 1965.
——, *West Africa before the Europeans,* London, 1967.
Field, M. J., *Akim-Kotoku,* Crown Agents for the Colonies, London, 1948.
Flynn, J. K., 'The Rise of Ashanti', *Ghana Notes and Queries,* vol. 9, 1966, pp. 24–30.
Goody, Jack, 'The Akan and the North', *Ghana Notes and Queries,* vol. 9, 1966, pp. 18–24.
Kerr, R., 'Clay Heads from Sekondi, Gold Coast', *Man,* 1924, Art. 27.
Kumah, J. K., 'The Rise and Fall of the Kingdom of Denkyira', *Ghana Notes and Queries,* vol. 9, 1966, pp. 33–5.
Map, Dutch map of 1629, recopied in *Ghana Notes and Queries,* vol. 9, 1966.
Meyerowitz, Eva L. R., *Akan Traditions of Origin,* London, 1952.
——, *The Akan of Ghana,* London, 1958.
Painter, C., 'The Guang and West African Historical Reconstruction', *Ghana Notes and Queries,* vol. 9, 1966, pp. 58–66.
Rattray, R. S., *Religion and Art in Ashanti,* London, 1927.
Sieber, R., 'Some Comments on Art and History in Ghana', *Ghana Notes and Queries,* vol. 8, 1966.
——, 'Kwahu Terracottas, Oral Traditions, and Ghanaian History' in D. Fraser and H. M. Cole (eds.). *African Art and Leadership,* Wisconsin, 1972.
Shaw, T. *Excavations at Dawu,* Edinburgh, 1961.
Stewart, J. M., 'Akan History: Some Linguistic Evidence', *Ghana Notes and Queries,* vol. 9, 1966, pp. 54–8.
Wild, R. P., 'Ashanti Baked Clay Heads from Graves', *Man,* 1934, art. 1.
Wilks, I., 'The Northern Factor in Ashanti History: Begho and the Mande', *Journal of African History,* vol. II, no. 1, 1961.

Tapa Techniques and
Tapa Patterns in Polynesia:
A Regional Differentiation

Simon Kooijman

The cloth now generally named *tapa* is called by different names in the various island groups of Polynesia. In the Samoan Archipelago and the surrounding islands it is indicated by *siapo* or *hiapo*, the Tongans call it *ngatu*, *masi* is the Fijian word, and *ahu* is the term which was used in ancient Tahiti. Only in Hawaii it was called *kapa*, the Hawaiian variant of the general Polynesian form *tapa*. In the Hawaiian language the word also had the meaning of edge, border, and boundary.[1] In the latter sense the word occurs in many other Polynesian languages.[2] In Samoa the word denotes the uncoloured border of the coloured and decorated bark-cloth sheet or *siapo* (Te Rangi Hiroa, 1930, p. 282) and it was here also occasionally used to indicate the *siapo* as a whole. It is the white stranger who has been responsible for the spreading of the term over the whole of Polynesia and, eventually, for its general acceptance as the designation for this kind of fibrous material. The first large influx of westerners into the Pacific area started with the coming of the whalers at the end of the eighteenth century. The whaling crews were attracted by the coloured, decorated pieces of bark-cloth which they bought and brought home as curios. Much of the large and valuable collection of early nineteenth-century *tapa* in the Peabody Museum in Salem, Massachusetts, for instance, originated from the whalers whose home ports were located along the coast of New England. In Hawaii, one of their most important bases, the technique of manufacturing and decorating bark-cloth had reached a high degree of development and refinement, and there was an ample supply. These decorated cloths were admired and collected by the westerners as *kapa* or *tapa*; in Samoa, which later became an important ship-chandling station, this much sought article was referred to as *tapa*, and as early as the first decades of the nineteenth century this term had come into general use throughout Polynesia (Moerenhout, 1837, II, p. 113). Together with the cloth, the word found its way to Europe and America, where it was universally adopted as a technical term. Its application did not remain restricted to the Oceanic bark-cloth, however; cloth made of bark in other tropical regions – Indonesia, Africa, and South America – was also called *tapa*.

Bark-cloth or *tapa* is made in Oceania from the inner bark of a number of trees, most of which belong to the genera *Broussonetia*, *Artocarpus*, and *Ficus* of the family of the *Moracae*. Of these the

Broussonetia papyrifera or paper mulberry was, and in some islands and archipelagos still is, the most important source. This tree, whose trunk reaches a thickness of three to five centimetres and a height of about 3 metres, is not indigenous to the Pacific; it was brought from eastern Asia where it grows almost everywhere in China, Formosa, Japan, and Korea, and also occurs in Further India. It was brought by emigrants to Indonesia and when the Malayo-Polynesian groups radiated farther out to the east, travelling from island to island until they reached the region they now inhabit, the ancestors of the present Polynesians carried *Broussonetia* cuttings with them. In Polynesia the plant was unable to maintain itself on the low atolls with their calcareous, unfertile soils, and limited rainfall, and its distribution was restricted to the high islands where the volcanic soils are fertile and the rainfall is abundant and regular. On the Indonesian islands where the manufacture of *tapa* had reached a high degree of development – particularly in Java and among the Toradja of the central part of Celebes – as well as on the high, volcanic islands of Polynesia the *Broussonetia* was planted especially for this purpose. It was used for the best quality of *tapa*, and *tapa* manufacture had become concentrated on this plant. The *Artocarpus* which in all probability was also carried to Polynesia by the earliest colonists, is primarily a source of food and only in the second place served for the production of *tapa* of lower quality. Such bark-cloth was also obtained from the *Ficus* which was probably native to the Pacific area.

In discussing the preparation and decoration of bark-cloth within the framework of the various Polynesian cultures, we may begin with a description of the more elaborate *tapa* techniques of the central and marginal part of Polynesia and place them in their social context. The *tapa* complex in Tahiti of about 1800 and Hawaii in the middle of the nineteenth century provide excellent examples. In both regions the physical environment is formed by high islands with what by Oceanic standards is a large land surface, a superabundance of rainfall, and a rich vegetation supplying the relatively dense population with an ample quantity of bark material. This provided both regions with a basis for a technical development in the preparation and decoration of *tapa* that indeed far surpassed what was achieved in other parts of Polynesia and was not equalled in all of the Indo-Oceanic area except by the Toradja of central Celebes (Kooijman, pp. 16–29, 56–8).

It is possible to reconstruct the processes of making and decorating *tapa* for both Tahiti and Hawaii from literary sources. For Tahiti we are fortunate in having very precise and highly detailed descriptions written by trained and critical European

observers[3] and the picture of the Tahitian process therefore is remarkably clear. For Hawaii the contours have remained vaguer because only one European eye-witness account is available (Ellis, 1826, 1853, iv) the majority of information coming from native sources.[4] The process was not identical in the two regions, but the differences may be considered as variations of the general central and marginal Polynesian pattern due to local development and specialization.

In the manufacturing process used in both Tahiti and Hawaii, strips of the soft, sticky inner bark were separated from the outer bark and then subjected to fermentation or retting. For this process the strips were wrapped in leaves and kept damp for a number of days to loosen the fibres and facilitate beating. The beating was done on a wooden anvil with wooden beaters. Throughout Polynesia these beaters are four-sided mallets with rounded or cylindrical handles. The four beating surfaces are provided with parallel grooves running longitudinally with a constant spacing. The grooves of the Tahitian and Hawaiian beaters are fine and closely spaced, much more so than those of western Polynesia. The number of grooves often varies from one surface to another. On the Tahitian type, this variation is present on the same beater, the average number of grooves on the four surfaces being 10–17–23–40 (Pl. 1). For the Hawaiian beaters, whose surfaces often show the same number of grooves, this variation occurs between beaters, the basic numbers being about 10, 15, 35, and 50. A special category of Hawaiian beaters are those provided with a patterned surface (Pl. 2). The latter was used after the completion of the sheet by beating. It was then pressed on the *tapa* and the pattern hammered into it as a kind of watermark.

The fermented strips of bark were beaten first with the coarsely grooved surfaces. Under the beating the strips became much wider but they also became indented with the pattern of the beater. As the work continued, the less coarse beating surfaces were used successively. In Hawaii the final beating was done with a smooth-surfaced beater, which resulted in a very even thin sheet, often of a fine, papery quality.

Tapa beater from Tahiti showing the surfaces with the smallest and largest number of grooves (12 and 41). Rijksmuseum voor Volkenkunde, Leiden, no. 74–25

Hawaiian *tapa* beater with one surface provided with a 'watermark' pattern and the other three with longitudinal grooves. *Rijksmuseum voor Volkenkunde, Leiden, no. 4131–2*

The size of the final product could be determined before beating began by allowing a given number of strips to merge during the retting process. The final dimensions that could be reached in this way were not unlimited and when larger *tapas* were needed the beaten pieces were placed next to each other with the edge of one lying over the edge of the other, after which the overlapping pieces were felted together with blows of the beater.

The cloth was given a solid colour by immersion in a dye bath, but decorations were applied by hand-painting or, more often, by a method of printing. The latter technique consisted in Tahiti of applying leaf motifs by pressing leaves dipped in dye on the *tapa* (Pls. 3 and 10) or creating a pattern of circular and crescent shaped figures by pressing the cut end of a piece of bamboo or the top end of a longitudinally sectioned bamboo tube against the cloth after dipping in the dye. The Hawaiian method of printing consisted of the use of stamps, usually made of bamboo, to construct predominantly geometrical patterns of many different kinds. The figuration obtained by this method is shown by the stamped pattern on a *kapa pa'u hula* or woman's dancing skirt (Pl. 4). Another technique of decorating the finished *tapa* sheet, which in Polynesia was only known in Hawaii, was the hammering of a kind of watermark into the *tapa*. This was done with a patterned beater surface of the type mentioned above and the type of watermark pattern produced in this way is shown in Plate 5. Peter Buck pointed out that many of these geometrical designs produced in block printing are identical with the designs on the patterned beaters and that those which are identical have the same names. In reconstructing the watermarking technique he suggested that the rather vague designs formed by it may have stimulated the *tapa* workers to experiments which eventually led them to the use of the block printing technique producing clearly visible designs on the *tapa* (Te Rangi Hiroa, pp. 191–2).

This decoration by hand-painting and printing was carried out in a broad range of colours and shades: brown, red, black, and yellow (with a brownish red and yellowish orange as well); in Hawaii blue, green, pink, and grey were also used. A large number of dye-giving plants and trees were known. A comparison with western Polynesia – Samoa and Tonga – on this point gives the following picture:

	Number of plants used as a source of dye			
	Brown	Red	Black	Yellow
Tahiti and Hawaii	6	12	6	9
Samoa and Tonga	7	5	1	2

...emoemoe, the widow of ...omare II of Tahiti, ...g a *tapa* garment with a ...af pattern. From L. I. ...rey, *Voyage autour du* ...Paris, 1826, Atlas 13

...man's dancing skirt *(kapa* ...ula) from Hawaii; ecru ...printed designs in red ...lack. *Bernice P. Bishop* ...um, Honolulu, no. 2332

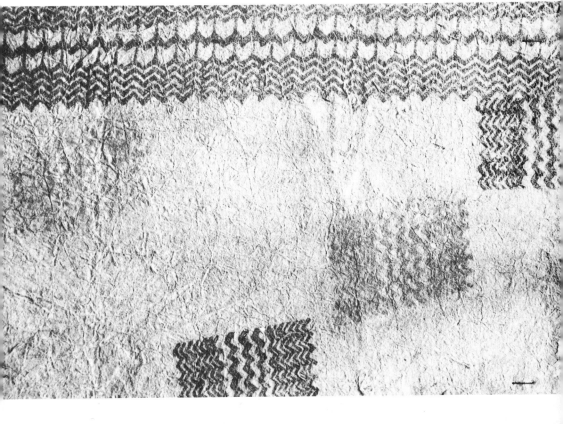

It is evident from these figures that in Tahiti and Hawaii many sources of black and yellow dyes were available for the elaborate methods of ornamentation. In Samoa and Tonga, however, the plants used for black and yellow were few since here ornamentation was almost exclusively brown and red.

These refined techniques of ornamentation and, in particular, the meticulous way in which the designs and patterns were applied to the *tapa,* were closely linked with the latter's function. In central and marginal Polynesia *tapa* was used mainly for clothing and magical-religious purposes. In both Tahiti and Hawaii *tapa* clothing was widely used both for daily wear and for ceremonial occasions. The decorated *tapa* in particular often served to indicate the wearer's high social status or was worn as festive clothing. Public attention was focused on the wearers of these *tapas* whether worn as a status symbol or for participation in a feast, and this meant that every member of the village-community could look and evaluate them. Great care therefore was expended on the preparation, finish, and decoration of these *tapas*. This also held of course for the *tapas* used to clothe the figures of the gods. The yellow, perfumed *tapa* garments in which the god-figures were wrapped during religious ceremonies in Hawaii, were highly refined specimens of bark-cloth. In Hawaii,

5 Sheet of a Hawaiian sleeping *tapa (kapa moe)* with a hammered 'watermark' pattern. *Bernice P. Bishop Museum, Honolulu, no. 2338*

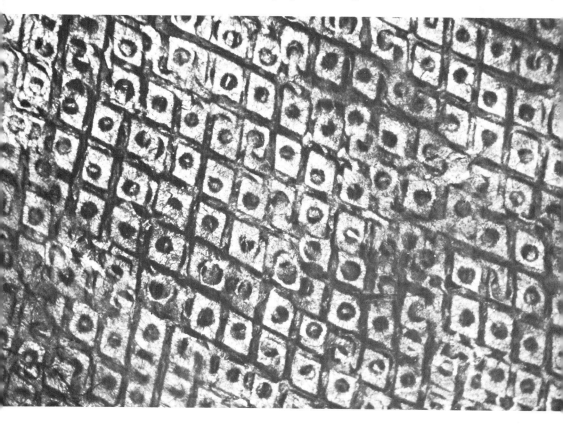

tapa of a very fine, gossamer-like quality had come to be used as a covering during the night. The *kapa moe* or sleeping *tapas* consist of a number of large, rectangular sheets sewn together on the longest sides. When necessary they could be folded together like the pages of a book and this was essential for the sleeper's comfort during the tropical night with its gradual fall in temperature in the hours after midnight. In comparison, the clothing of western Polynesia, especially Samoa and Tonga, and particularly the latter area was characterized by a striking sobriety. The Samoan dress, however, was enriched by the introduction of the Tahitian poncho during the early missionary period.

The comparison of the *tapa* complexes, especially the elements of manufacturing, decorating, and function, of Tahiti and Hawaii with those of Samoa and Tonga in western Polynesia reveals a number of striking differences. In the manufacture of bark-cloth in the west, where *tapa* is still made, the strips of inner bark are not subjected to a fermenting process but instead are separated from the outer bark, dried, and then rolled up, sometimes in bundles, to be saved until a sufficient amount has been accumulated for beating to begin. The object of this accumulation is the manufacture of carpet-like sheets of considerable length that play an important role in ceremonial practices. The beaters used to work this large quantity of bark have the same basic shape as those of central and marginal Polynesia but otherwise differ greatly from them. Those of western Polynesia are appreciably heavier and wider, and the beating surfaces have only five to eight grooves (Pl. 7). The action of these heavy, coarsely-grooved beaters quickly reduces the material to the required thickness, after which it is smoothed and made even with the smooth side of the beater (Pl. 6). This is all the beating the material receives, neither the felting together of pieces by joining overlapping edges by hammering, nor watermarking by means of patterned surfaces being practised. This beating, which is far quicker and more superficial than that of Tahiti and Hawaii, together with the omission of the fermentation process, results in a *tapa* which is rather thick and not very flexible and cannot stand comparison with the thin paper-like sheets made in the central and marginal Polynesian areas.

These flattened strips of bark are then subjected to a semi-mechanical processing by a team of women. The work consists of joining together the beaten strips into large carpet-shaped sheets and simultaneously applying an ornamental pattern. The basic tool used in this process is the design tablet which usually consists of a rectangular plate made of *Pandanus* leaf strips and provided with a relief decoration formed of fibre cords sewn on the leaf background in certain patterns (Pl. 9). This leaf tablet

6 The beating of the bark
strips on the island of
Taveuni, Fiji. This eastern
part of the Fijian archipelago
is culturally related to Tonga
and the beating is done in a
similar way in both areas.
*Photo Rob Wright, Public
Relations Office, Suva, Fiji*

7 Samoan *tapa* beater with
two coarsely grooved and two
smooth surfaces. *Otago
Museum, Dunedin, N.Z.,
no. D 44.2*

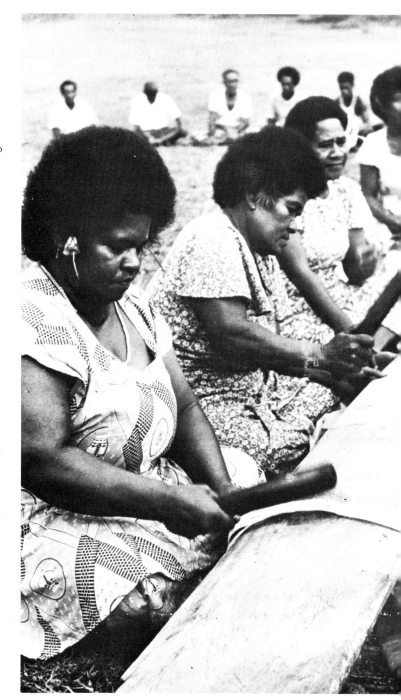

is firmly tied to a board shaped wooden base which is curved over its width. In Samoa, and occasionally in Fiji too, wooden tablets are used, the relief ornamentation standing out from the slightly convex upper surface (Pl. 8). A number of bark strips are first combined by laying the side edges one over the other and pasting them together with a sticky material made from either the arrowroot which is native to the Pacific or the manioc which has been introduced in the western contact period. The resulting sheet of *tapa* is then placed over the design tablet and stretched tight. The *tapa* makers then dip a wad of bark-cloth in the dye and rub it over the *tapa*. The relief pattern on the tablet is thus rubbed into the cloth in the same way as children reproduce the relief design of a coin with a pencil (Pl. 12). The dye is brown or reddish brown and usually consists of a substance called *koka* (Tonga) or *'o'a* (Samoa) which is easily extracted in large quantities from the bark of a tree called by the same name which grows wild in great numbers (*Bischofia javanica*). A portion of bark is separated from the living tree – which forms new bark within six months – and the scrapings are arranged lengthwise over an oblong mat which is then wrapped round this material and tied up. This sausage-like object is hung from the branch of a tree, the lower end being provided with a noose into which a solid stick has been put. The 'sausage' is stretched and twisted by two women sitting on both ends of this stick and turning it round, thus pressing out a liquid dye.

For a more detailed description of the rubbing process we will restrict ourselves to Tonga, the Tongan technique having been amply recorded[5] and being typical of the western Polynesian pattern. No mention therefore will be made here of the slightly different methods practised in Samoa and the Lau Islands, Fiji. In Tonga the *tapa* which is to be decorated in this way is laid on the tablet in two layers. The under layer, which is prefabricated and consists of two strips with the longitudinal sides pasted together, is laid lengthways over the tablet. The latter's pattern is then rubbed into it. The under layer is then smeared with the sticky material and five bark strips, which are to form the top layer, are glued to it with the longitudinal sides partly overlapping. Into this layer the design pattern is also rubbed. The *tapa* is then moved along, usually over the width of the tablet. By repeated overlapping and pasting together of the bark strips, both layers are extended till the design tablet is covered again and its pattern rubbed into the cloth.

By repeating the combined treatment of rubbing and pasting many times, a long runner of *tapa* is formed with a ladder-like distribution of the decorative pattern, each section showing the same design because the same tablet is used throughout. By

8 Samoan design tablet
(*'upeti*) made of wood.
*Rijksmuseum voor
Volkenkunde, Leiden,
no. 1256–137*

10 Tahitian *tapa* with fern
leaf designs. *Rijksmuseum voor
Volkenkunde, Leiden,
no. 360–7007*

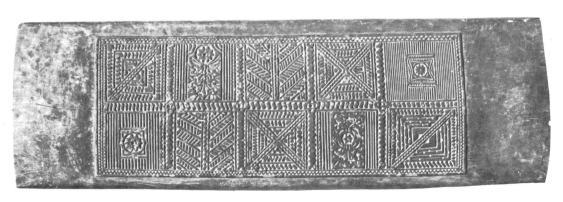

9 Tongan design tablet
(*kupesi*) made of *Pandanus* leaf
strips and provided with a
relief pattern of fibre cord.
*Peabody Museum, Cambridge,
Mass., no. 53872*

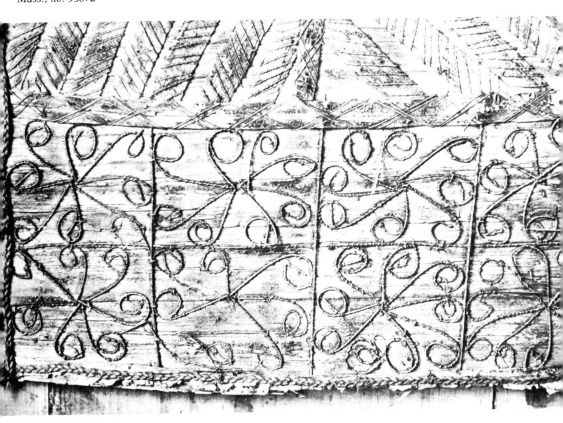

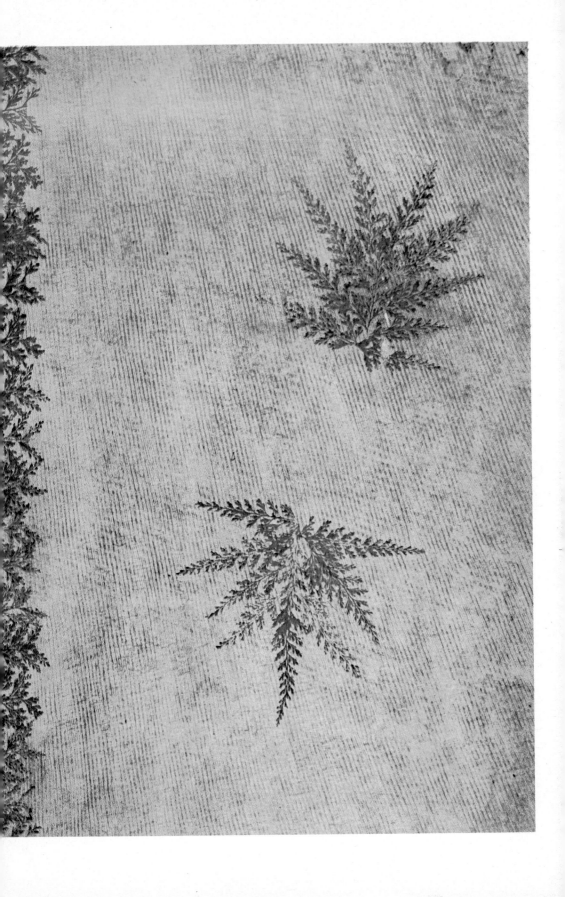

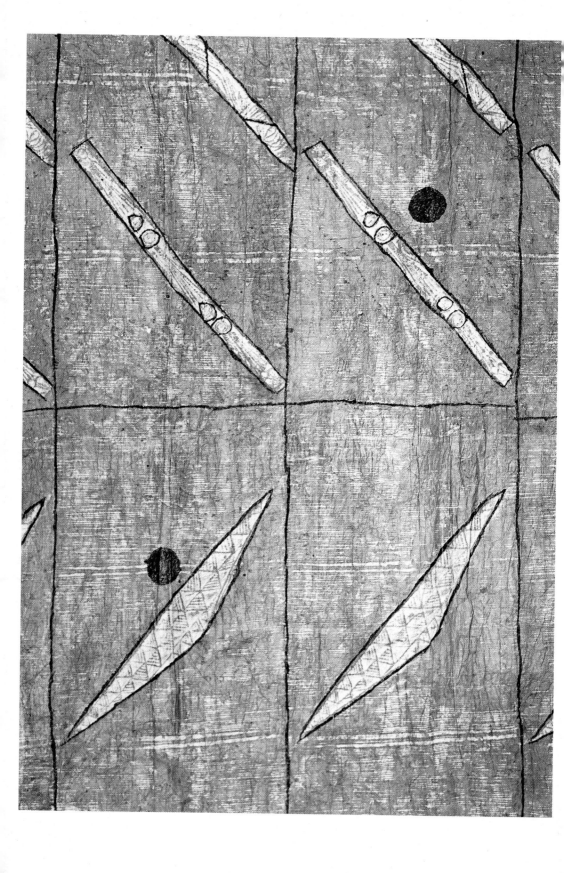

Tapa decorated by
-ing on a design tablet, the
lines having been drawn
and round dots added.
Islands, Fiji. *Rijksmuseum
Volkenkunde, Leiden,
89–87*

making the *tapa* runner wider than the length of the tablet,
undecorated borders are formed on both sides of the ladder-
shaped pattern. On these edges numbers are often placed to
indicate the width or half the width of the design pattern, from
which the length of the *tapa* as a whole can be calculated.

The figures produced on the cloth by rubbing do not of course
have sharp outlines. Actually, the entire *tapa* has taken on a
reddish brown tint with darker lines and stripes reproducing
the designs on the tablets against a lighter toned ground only
superficially coloured. To bring out the pattern as a whole, the
main lines are drawn over freehand with a dark brown dye, and
large dark brown dots are applied in the same way (Pls. 11 and 13).
The colour of the dye employed for this last step is a darker shade
of that used for the rubbing. In Tonga this colour is obtained by
slowly boiling down the dye to a more concentrated liquid with
a darker tone. As mentioned above brown and red are used
predominantly by the *tapa* makers of western Polynesia, the
main source of dye being *Bischofia javanica*.

As has been mentioned already, the manufacture of these long
tapa runners is accomplished by groups of women working
together as a team. The operations are performed efficiently, the
tempo is rather high, and the time required to complete these
tapas is relatively short. It has been recorded for Tonga that
twelve women took only five hours to make – from previously
beaten bark strips – and decorate a runner shaped sheet with a
length of thirty metres. It may be imagined how long it would
have taken to complete a cloth of this size, decorated over almost
its entire surface, without these technical tools and procedures.

The function of these western Polynesian *tapas* differs greatly
from that of the refined and meticulously decorated bark-cloth
of Tahiti and Hawaii. While the latter serves individual purposes
such as being worn by a prominent man or woman or placed on
the image of a deity, the long *tapas* of the west, made without
much care and with a simple decoration applied semi-
mechanically, are intended to serve as gifts. Plate 14 shows how
such a *tapa* is carried unfolded by two long lines of men, in this
instance, as a ceremonial presentation at the occasion of a feast
marking the end of a period of mourning for the death of a chief
of Tumbou, island of Lakemba, Lau islands of Fiji. In this context
it is not the quality of the cloth and the careful execution of the
designs which really matter. The most important aspect of this
tapa is its spectacular size and the impression made by the piece
as a whole, as a product of communal labour and as a communal
gift whose presentation by one group to another takes place in
the festive atmosphere of a village square thronged with people.
In this context it is not important that the cloth is only of

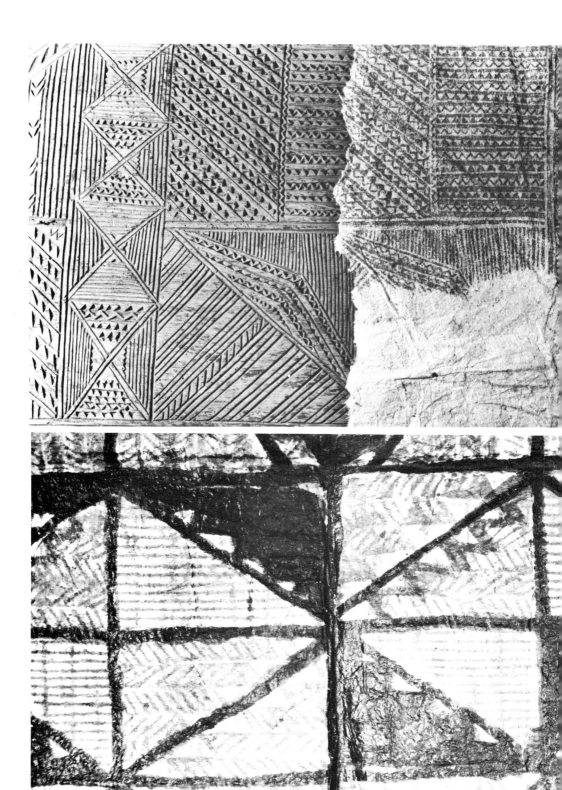

piece of *tapa* into which
of the pattern of a
len Samoan design tablet
een rubbed. Experiment
e Rijksmuseum voor
enkunde, Leiden

amoan *tapa* with rubbed
hand-painted pattern;
, brown, and black.
erbury Museum,
stchurch, N.Z.,
138.370

The ceremonial
entation of *tapa* on the
d of Lakemba, Lau
ds, Fiji. *Photo Rob*
ht, Public Relations
e, Suva, Fiji

mediocre quality because the bark strips were not fermented and were only superficially beaten. Similarly the aesthetic quality of the ornamentation and the quality of the workmanship are subordinate to the primary object of the decoration, which is to emphasize the great length of the cloth, by the continuous repetition of the same pattern.

It seems clear therefore that these very special techniques for the manufacture and decoration of *tapa* have been developed in western Polynesia to cope with the demand for ornamented *tapa* sheets of a spectacular size for use in ceremonial contexts. Since the institution of ceremonial presentations continued to function throughout the western contact period it is not surprising to find that these techniques and these *tapas* have persisted even to the present day, especially in Tonga and the Lau Islands of Fiji which are strongly influenced by Tonga.

This interrelation between the techniques of manufacture and decoration, the size of the *tapas,* and their design patterns on the one hand, and their function in society on the other, has also been demonstrated for Tahiti and Hawaii. This social integration of the *tapa* complex, which in all probability is the main reason for its having remained a vital part of the culture in these western Polynesian island groups, was, on the other hand, an important

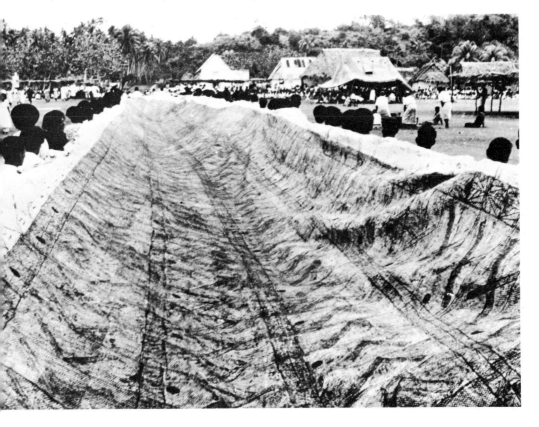

factor in the process of its extinction in central and marginal Polynesia. In the latter areas, particularly in Tahiti and Hawaii, the making and decorating of bark-cloth has become one of the lost arts, and this failure of the *tapa* complex to withstand the impact of white civilization is very closely related to the function of the *tapa* in the community. We have seen that *tapa* was used here as clothing and for magical-religious purposes, and it was at just these two points that the influence of the west was very great. Textile clothing, which was as a rule one of the first products to be introduced, was accepted with enthusiasm and soon replaced the *tapa* garments. The traditional gods and their images were the objects of fierce and continuous attack by the missionaries; with the latter's success and the resulting conversions to Christianity, these symbols of the old religion disappeared and with them one of the main reasons for making *tapa*. The undermining of these two most important pillars that had supported the structure of *tapa* production resulted in a total collapse. In Tahiti no *tapa* has been produced since about 1830, and in Hawaii even the oldest inhabitants no longer know how to make it (Melville, 1958 ed., p. 180; Brigham, 1911, p. 3). In these communities *tapa* also had other functions which were of minor importance, that is, in ceremonies and as a status symbol. These, however, proved to be insufficiently vital to prevent the disintegration. For Hawaii this is not surprising since, in view of the nature of these ceremonies and the character and the quantity of the *tapa* required for them, the size of the production for these ends must have been small. It was much greater in ancient Tahiti where persons of rank were presented with long sheets of *tapa* wound round young men or women and where chiefs possessed large rolls of *tapa* as status symbols. None the less, *tapa* disappeared here too. A technical factor in all probability can be held mainly responsible for this disappearance. It will be evident from the description given above, as well as from a study of the Tahitian bark-cloth material, that extreme care, great skill, and a thorough training were required in the processing, especially the beating and the felting of the bark, to a fine, paper-thin cloth. As the demand for *tapa* for clothing and religious purposes dwindled, the number of women capable of making the high quality *tapa* needed for ceremonial purposes probably became so small that in the end even the smaller quantity could not be supplied.

Missionary influences were felt first in this part of Polynesia as early as 1797, with the arrival of the '*Duff* missionaries'. It was especially the members of the leading classes of society who came into close contact with this aspect of white civilization, and the traditional use of highly refined *tapas* as status symbols, which

was their prerogative, may have been given up under this influence.

NOTES

1. Mary K. Pukui and S. H. Elbert, 1961, entry *kapa*.
2. See, for instance, E. Tregear, 1891, entry *tapa*.
3. J. Banks, 1896; W. Ellis, 1853, I; J. R. Forster, 1783; H. Melville, 1958 ed.; J. A. Moerenhout, 1837, II; D. Tyerman and G. Bennet, 1831, I; J. Wilson, 1966.
4. A. Fornander, 1918–19; S. M. Kamakau, 1964; D. Malo, 1951; J.F.G. Stokes (MS.).
5. G. Koch, 1954–5; W. C. MacKern, 1923; W. Mariner, 1827; Maxine, J. Tamahori, MS., 1963.

REFERENCES

Banks, J., *Journal of the Right Hon. . . . during Captain Cook's first voyage in H.M.S. Endeavour in 1768–1771 . . .* (ed.) Sir Joseph D. Hooker, London, 1896.
Brigham, W. T., 'Ka Hana Kapa. The Story of the Manufacture of Kapa (Tapa), or Bark-Cloth, in Polynesia and elsewhere, but especially on the Hawaiian Islands', *Memoirs of the Bernice P. Bishop Museum,* vol. 3, Honolulu, 1911.
von Bülow, W., 'Beiträge zur Ethnographie der Samoa–Inseln', *Internationales Archiv für Ethnographie,* vol. 12, 1899, pp. 66–77.
Burrows, E. G., 'Western Polynesia, a Study in Cultural Differentiation', *Etnologiska Studier,* vol. 7, 1938, pp. 1–192.
Ellis, W., *Narrative of a tour through Hawaii, or Owyhee; with remarks on the history, traditions, manners, customs, and language of the inhabitants of the Sandwich Islands,* London, 1826.
——, *Polynesian Researches during a residence of nearly eight years in the Society and Sandwich Islands,* 4 vols., London, 1853.
Fornander, A., 'Fornander Collection of Hawaiian Antiquities and Folk-lore', *Memoirs of the Bernice P. Bishop Museum,* vol. 5, Honolulu, 1918–19.
Forster, J. R., *Bemerkungen über Gegenstände der physischen Erdbeschreibung, Naturgeschichte und sittlichen Philosophie auf seiner Reise um die Welt gesammelt* (übersetzt und mit Anmerkungen vermehrt von . . . Georg Forster), Berlin, 1783.
Hambruch, P., *Oceanische Rindenstoffe,* Oldenburg i.O. 1926.
Ihle, A., 'Ponchoartige Gewänder in der südostasiatischen und ozeanischen Inselwelt', *Abhandlungen der Gesellschaft der Wissenschaften zu Göttingen, philologisch-historische Klasse,* neue Folge, vol. 24, no. 3, Berlin, 1837.
Kamakau, S. M., 'Na Hana a ka Po'e Kahilo – The Works of the People of Old' (translated from the newspaper *Ke Au 'Oko 'a* by Mary Kawena Pukui, arranged and edited by Dorothy B. Barrere), *Bernice P. Bishop Museum Special Publication, 51,* Honolulu, 1964.
Kennedy, R., 'Bark-cloth in Indonesia', *Journal of the Polynesian Society,* vol. 43, 1934, pp. 229–43.
Koch, G., 'Die Tapa-Herstellung im Tonga-Archipel', *Tribus,* neue Folge, vols. 4–5, 1954–5, pp. 122–30.
Kooijman, S., 'Ornamented Bark-Cloth in Indonesia', *Mededelingen van het Rijksmuseum voor Volkenkunde,* vol. 16, Leiden, 1963.
Krämer, A., *Die Samoa Inseln,* 2 vols., Stuttgart, 1903.
MacKern, W. C., Excerpt from manuscript 'Tongan Material Culture', at Bernice P. Bishop Museum, Honolulu, 1923.
Malo, D., 'Hawaiian Antiquities (Molelo Hawaii)' (translated from the Hawaiian by N. B. Emerson), *Bernice P. Bishop Museum Special Publication, no. 2,* 2nd ed., Honolulu, 1951.
Mariner, W., *An account of the natives of the Tonga Islands, in the South Pacific Ocean* (compiled by John Martin), 2 vols., 3rd ed., Edinburgh and London, 1827.
Melville, H., *Typee,* New York, 1958 ed.

Moerenhout, J. A., *Voyages aux îles du Grand Océan,* 2 vols., Paris, 1837.

Pukui, Mary K. and S. H. Elbert, *Hawaiian–English Dictionary,* Honolulu, 1961

Stokes, J. F. G., Notes on tapa making collected by . . . containing a critical treatment of the data on the making and ornamenting of tapa provided by nine native informants, viz. Fornander, Kaahaaina, Wahineaea, Kalokuo kamaile, Mrs. Lepeka Kaiwi, Nalimu, Mrs. Kapana, an anonymous norma school student, and an unknown informant. Manuscript in the Bernice P. Bishop Museum, Honolulu.

Tamahori, Maxine J., 'Cultural Change in Tongan Bark-Cloth Manufacture' M.A. thesis, University of Auckland, N.Z., 1963 (unpub.).

Te Rangi Hiroa (P. H. Buck), 'Samoan Material Culture', *Bernice P. Bishop Museum, Bulletin 75,* Honolulu, 1930.

——, 'Arts and Crafts of Hawaii', *Bernice P. Bishop Museum, Special Publication no. 45,* Honolulu, 1957.

Tregear, E., *The Maori–Polynesian Comparative Dictionary,* Wellington, 1891

Tyerman, D. and G. Bennet, *Journal of Voyages and Travels by . . . deputed from the London Missionary Society to visit stations in the South Sea Islands, China, India, etc., between the years 1821 and 1829 compiled from original documents by James Montgomery,* 2 vols., London, 1831.

Wilson, J., 'A Missionary Voyage to the Southern Pacific Ocean 1796–1798', *Frühe Reisen und Seefahrten in Originalberichten,* Band 5, Graz, Austria, 1966.

CHAPTER 7 The Role of the
Individual Indian Artist

Frederick J. Dockstader

This commentary is something of a personal statement based upon experiences gained while working and living with Indian artists of the Southwestern United States, most particularly in northern Arizona. The remarks are wholly limited to my own reactions – another field worker might well have encountered completely different experiences while investigating the various aesthetic or economic factors involved in arts and crafts work.

I have always been more interested in the place of the individual artist in his own culture than of the product which he creates. Yet in the museum world, one can usually relate only to the specimen itself, and must willy-nilly project from that article to the maker, with hypothetical conclusions of dubious accuracy.

My earliest memories of the role of the individual are closely related to the silversmith's craft. I started as an apprentice, bringing in the wood at a tender age, working the bellows, and observing the smith at work. For a long time, I was never permitted to go beyond this stage, but was expected to learn while watching. Slowly, such tasks as preparing silver scraps for casting, hammering bulk metal into crude form, and doing in general the preparatory work which did not require other than simple skills were allotted me. In time, I learned the technical processes of soldering, casting, forming, stone setting, and so on.

But I did not regard myself as a master silversmith for many years – not only because my work had yet to reach that level, but also due to certain interesting reactions on the part of the Indian people around me. Initially, they were amused – tolerant of my efforts, but never respectful. They were always willing to point out flaws, courteously provide helpful suggestions, and even assist physically – but there was always a joking, if friendly, air of amiable indulgence expressed in their attitude.

Indeed, it was not until I found that my silverwork was being resented that I felt I had achieved any degree of success. Then, there was no more of the friendly *camaraderie* which earlier obtained; one could now sense an awareness of competition.

In time, with school, travel, and other obligations, I entered a quite different world, and eventually attended college, while supporting myself by silversmithing. At one time I worked in curio stores selling silver jewellery, taught the craft for several years, and entertained the thought of a professional silvercraft

career. I have always been closely related to the art, and those connected with its manufacture and sale.

Presently, I am a 'patron' of sorts in view of my role at the Museum of the American Indian, where I have the responsibility of purchasing, collecting, evaluating, and exhibiting Indian arts. A twelve year period during which I was a member of the U.S. Indian Arts and Crafts Board gave me valuable insight into the political and promotional aspects of the art.

Based on these several activities, I have enjoyed a breadth of experience in the work of the Indian artist which may be of interest. How deeply this allows me to evaluate and analyse, is another question. Perhaps I overestimate this exposure to the thinking of others, but I do feel there are some facets of Indian art and the aboriginal artist which are not usually realized as freely as one might think.

For example, I was very intrigued by Nancy Munn's comment on the ability of one artist to determine what another artist had created – to read into it something symbolic, perhaps. This is not equally true in my own experience; very often – in fact, usually – a silversmith, potter, or weaver, will create a design purely for the decorative aspect, wholly ignoring what are termed the 'symbolic' factors. I wonder whether some of the other designs which in my view were wholly ornamental were likewise simple ornamentation in the mind of the artist?

I have been equally interested in the matter of art for fun, rather than art for art's sake. In the area I know best, there is a very real attitude of the total enjoyment of art, and I am confident that this must exist in all the arts. How often is a design executed simply to see where it will lead. . . . I wonder if Nancy Munn's circular design might not have something of this quality? Or in the matter of differing colours: might this not simply represent an extension of colours purely because the artist happened to have in hand three colours of crayola instead of two; and were he to have four, he would have used them as well. I think we often attach undue significance to such individual idiosyncrasies or circumstances.

I wonder also, about the degree to which an art critic might limit the imagination of an artist. The preferred expression of a given artist may not find favour with a critic; such adverse criticism could readily inhibit the artist – and thus in time have a marked cultural effect.

It would seem to follow that a young apprentice starts out to learn not only the techniques and customs of his craft, but is also instructed just as firmly about what he may *not* do. I can well remember my early experiences with silver casting: a design was cut in sandstone, the silver prepared, heated, melted, and

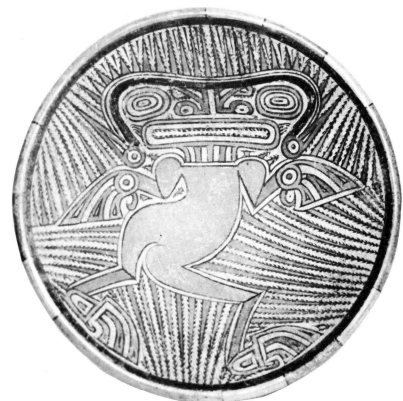

olychrome frutera dish,
design of the Crocodile
on the interior, from
iago, Veraguas, Panama.
3″. *c.* 1250–1500

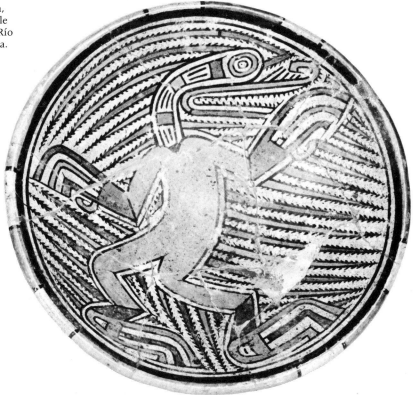

olychrome frutera dish,
a design of the Crocodile
on the interior, from Río
esús, Veraguas, Panama.
$9\frac{1}{4}$″. *c.* 1250–1500

then poured into the mould. The result was a strong, effective design; the technical prohibitions were delicacies, refinements, or extrusions which became possible only with centrifugal casting. The traditional sandstone mould is simply not conducive to extremely delicate work; there were no cultural prohibitions – the controls were solely technical. You were told over and over, 'don't let your lines get too thin; they will be weak parts of the jewellery. You can put those in later, by tooling.'

I have often wondered if this did not introduce a set of expectations and limitations internalized by the artist: when your work became too delicate, you were going beyond what was regarded as good silverwork; it was not functional. You were invading the painter's arena, creating a delicate tracery which is practical on paper, but not feasible in metal. Aesthetic appreciation must also have been affected by this set of expectations.

Similar limits are often set in other crafts, such as textiles. A weaver learns just how far she may go in design and workmanship; if she exceeds these limits, she is told that one does not do this with the loom. Although legendary or quasi-religious reasons may be offered, in actuality most reasons simply mirror practicality – experience has shown that the result will not be favourable. In order to reinforce sound function, recourse is made to mythology.

A painter, on the other hand, has less restriction; to my knowledge, the only serious limitation on Indian painters is in the field of ritual: a painter may not depict certain ceremonial subjects or practices. These are not technological limitations.

Certain economic relationships became established in the past – weavers and silversmiths tended to work with specific traders, and this relationship tended to remain fairly steady. Although the traders accepted work from anyone, providing they felt it was saleable, there was a natural tendency for them to deal with those people working in the general region in which their store was located. This was based primarily upon simple geography. In turn, this relationship established a mutually proprietary attitude, leading to monopolies in practice, if not in theory. Such associations tend not only to affect the economics, but the practice of the art: much of what has become accepted as 'traditional Indian art' is more often those forms of work which curio stores, Indian traders, and similar taste-makers prescribed – or introduced. Reinforced by the demands of traders, design forms and styles became established, and in time are regarded as 'right', i.e. so familiar as to even affect the Indians' own point of view. The very fact of their widespread acceptance gives a certain *cachet* to the style.

And this has a tremendous influence whenever any person

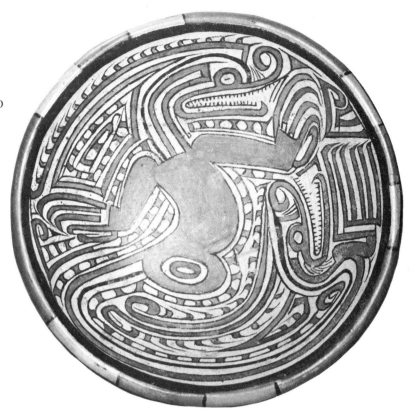

Polychrome frutera dish,
with design of the Crocodile
God on the interior, from
San de Jesús, Veraguas,
Panama. D. 9¾″. c. 1250–1500

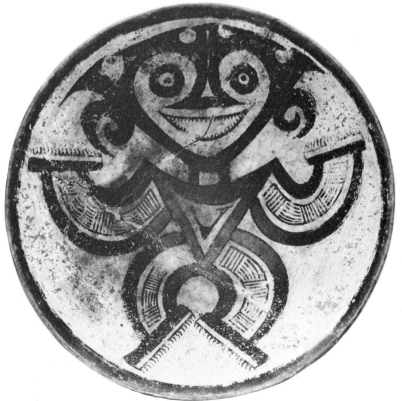

Classic polychrome frutera,
suggesting prehistoric
armour, from Coclé, Panama.
D. 11″. c. 1000–1250

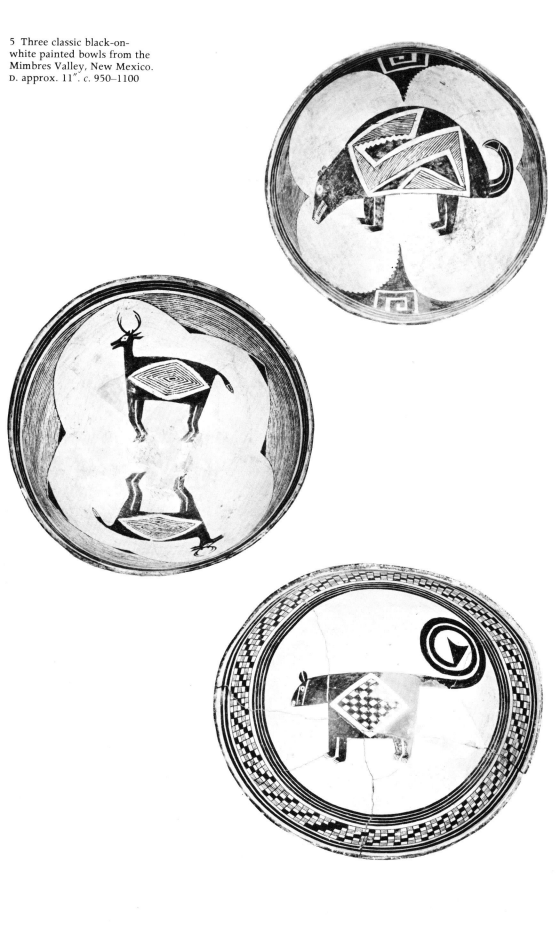

5 Three classic black-on-
white painted bowls from the
Mimbres Valley, New Mexico.
D. approx. 11″. c. 950–1100

tries to introduce a new idea. There is inevitably strong resistance on the part of those who have been working in an older technique or style. One example is what is known as 'channel work'. This is the employment of turquoise or other gem stones set in a silver form, usually in geometric designs, buffed flush on the surface. This is actually a prehistoric technique, employed largely in shell work. It did not come into the silversmith's craft in any considerable degree until the mid-1930s, and even then took a long time to catch on; the technique was difficult to learn, was a time-consuming practice, and was 'new'. Most channel work was done by Zuñi silversmiths at first, and it was not until the technique became relatively mechanical that it enjoyed wide acceptance. Today it is familiar to most smiths, although remains a specialized branch of the craft. More recently, a newer form of turquoise use has been introduced, in which rough, uncut stones are polished by means of rotational tumbling and then set into the jewellery. This again is a re-introduction of a prehistoric technique, refined by use of a mechanical tumbler.

The point of all of this is simply that these latter are all non-Indian introductions, from white entrepreneurs searching for variety, and having at their command a stable of silversmiths who produce the work in assembly-line fashion. Yet each has come to be regarded as 'traditional Navaho jewellery'.

Another aspect of Indian art influence is the effort of the Federal Government to increase sales of craftwork to tourist markets, to increase quality, or to introduce marginal income for otherwise unemployed people. Perhaps the most remarkable example of the introduction of non-traditional art forms which have become accepted as standard are the Eskimo carvings in soapstone and prints from the Hudson Bay area. They are certainly economically profitable, and are well-accepted in the fine arts market; the question of ethnic verity remains a problem only in the minds of persons who are more concerned with tradition than innovation.

A major problem in ethnic arts is that of identification. When I first began working, the silversmith who hallmarked his work was almost non-existent; I think the practice became established with Ambrose Roanhorse, at Fort Wingate. It was fostered by the Indian Arts and Crafts Board, and is now a much more commonly-followed practice, although not as widely observed as it should be. A few potters sign their work, as do some wood-carvers; but surprisingly enough, even in the field of painting one still finds artists reluctant to attach their names to their work. Indeed, anonymity is often one of the criteria of folk art, and it is rare that the name of a given artist can be reliably attached to any ethnic product. Only a few people, such as María Martínez, Lucy

Lewis, Kenneth Begay, or Fred Kabotie have become well-known to connoisseurs. With the establishment of identity, of course, the work of known individuals becomes sought after – with the resultant increase in price, and it is unfortunately not surprising that curio and art dealers often refuse unsigned work, regardless of the excellence.

Going farther afield, these factors are very relevant to the problems of the anthropologist or art historian who seeks to interpret the work of an individual artist – or to evaluate a culture as seen through its archaeological leavings. In my own opinion, far too many judgements of cultural subdivision are based upon these very factors of individual difference, rather than group expression. Allow me to illustrate a few examples. I have become interested lately in the pottery of Panama, in which I believe one can demonstrate the work of a given individual by style, form, and technique.

6 Matte-finish blackware pottery developed by Julián and María Martínez, from San Ildefonso, New Mexico. H. 8″. c. 1935

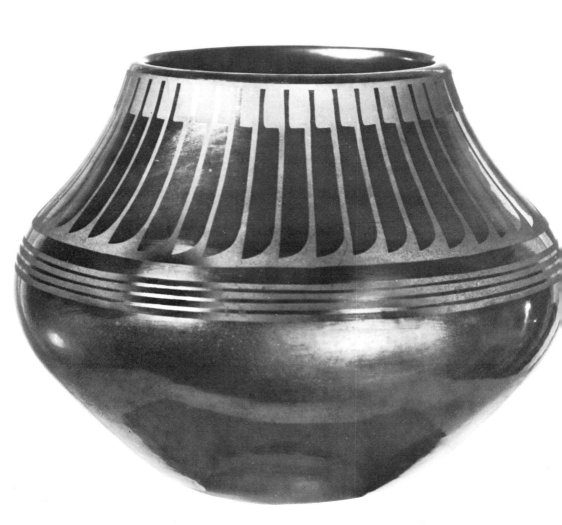

Plate 1, one of the so-called 'crocodile god' vessels from Veraguas, is a superb example of the polychrome ceramics for which this region is justly famous. Plate 2 is a similar example, from the same region, but from another tomb. Notice the tiny little lines – the way in which the feet are rendered – the eye form, mouth, nostrils, and general body proportions. I submit that the technical and conceptual similarity is so great as to assure us that both plates came from the same hand. There are many such examples known in museum collections, and one can readily establish a stylistic range which strongly supports such identification. When the firm, tiny lines, and the refined technique are absent, a slightly different hand is seen, for example, Plate 3. I suggest this is not by the same person. It represents an artist working in the same tradition – may be even in the same studio – following a master pattern, but in a variant style. If one takes a dozen or so of these vessels and places them in a row, their forms are so similar that they almost suggest the use of a mould; the materials are identical, as are the sizes, yet the design execution shows the difference, if such exists.

This may reflect a school of artists, in the formal sense we know today, or it may be a scattered handful of individuals following accepted, popular designs of the day. But whatever the case, I doubt whether a large number of people were responsible for these vessels. More likely, these came from a relatively limited group who traded their wares widely throughout the area, as far south as Venado Beach, in the Canal Zone, and north into Coclé.

The jaunty individual from Coclé (Pl. 4), is in another style found throughout central Panama. It has exact duplicates, as well as parallel forms, which together are commonly known as the Coclé style, and again suggests a master design with many copiers.

Another area noted for similarity of pattern is in south-western New Mexico, where the Mimbres people produced a readily definable form of pottery featuring black designs on a white clay background. It is not unlike the pottery from Ácoma and Zuñi pueblos today. Mimbres pottery is highly prized for the wonderful freedom of design in the animal, human, and bird forms, and genre scenes, as well as for the delightful humour often expressed in crisp, clean designs. The work offers intriguing clues into the cultural life of the people. At first glance, the pots (Pl. 5) appear identical; yet closer examination reveals qualities by which individual artists can be identified; the stylistic devices used, the body forms, design proportions, technical application of lines – all suggest that here is the work of one or a few individual artists. In Plate 5, note the fineness of detail in the upper two

Adaptation of the bowl below by Lucy Lewis, 1960. From Acoma, New Mexico. H. 7"

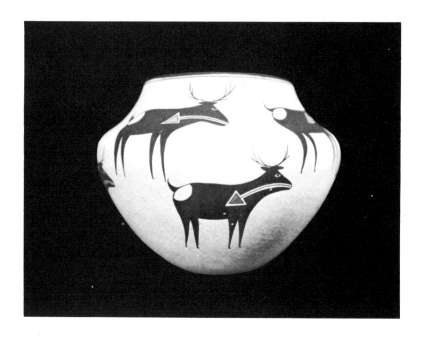

Original deer design olla, collected in 1880 by Douglas D. Graham, Indian Agent. From Zuñi, New Mexico. H. 10"

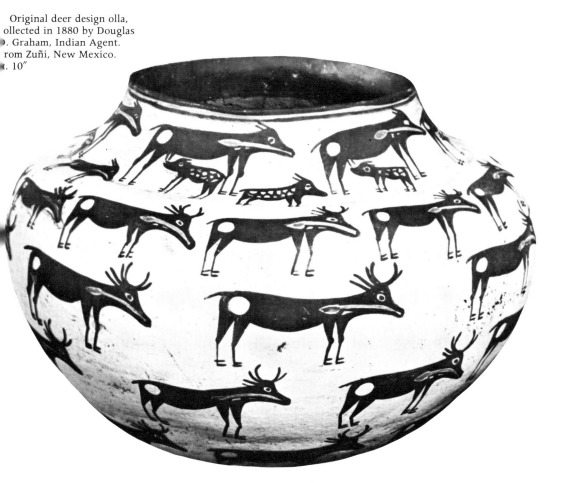

bowls as against the coarser delineation in the lower one. The top two were, I am convinced, created by the same hand; the third cannot have been produced by that individual, even though all three show superficial similarities.

That such an inspiration can develop surprising cross-cultural results is best illustrated by two well-known examples. The first, the work of María Martínez, represents the efforts of a remarkably talented potter whose base products provided a foundation upon which her husband, Julián, painted strong, bold designs before the pottery was fired (Pl. 6). This couple produced some of the loveliest pottery made in the Southwest. After the death of Julián in 1943, María continued making the same high quality ware, having the decoration applied by other hands, most recently by her son Popovi Da. Aside from a certain confusion in the minds of purchasers of the pottery, there is nothing wrong in this; it is a common Pueblo tradition, and the work of the Martínez family re-introduced a new vitality into Pueblo pottery art.

A second example is the work of Lucy Lewis, a potter from Ácoma pueblo. Not long ago, the Museum acquired a remarkable collection of ethnological material which had been obtained at Zuñi in 1881. Among the specimens was a most attractive bowl (Pl. 8), quite different from the usual Zuñi work; it was eventually published in a volume on American Indian art. A curio dealer in New Mexico found the bowl particularly appealing. She showed the illustration to Lucy Lewis, who also liked it, and proceeded to make a copy (Pl. 7). Today one finds many examples of this deer vessel in contemporary pottery, all by Lucy Lewis. But the intriguing fact is that this Ácoma potter has so capably adapted this Zuñi design to her own work. . . . What will the archaeologist conclude, a century from now, upon discovering one of these Zuñi-designed-Ácoma-made vessels?

There is also the matter of traditional monopoly, which I suspect plays its part in this problem of 'tribal' identification. About fifty years ago, a new village chief was installed at Oraibi; coincidentally, the white man 'discovered' the Hopi, and began to visit the pueblos in regular tourist fashion, buying crafts as souvenirs – basketry, pottery, and particularly, the small carved and painted wood *kachina* dolls. The chief quickly realized the money that could be made in such objects, and shortly established a monopoly: no one in the village but the chief could make and sell such dolls to outsiders.

By tradition, the Hopi do not restrict the manufacture of *kachina* dolls; any properly initiated person may make them. However, the chief went way out in left field, and created a style all his own . . . traditional only in that it was carved from wood

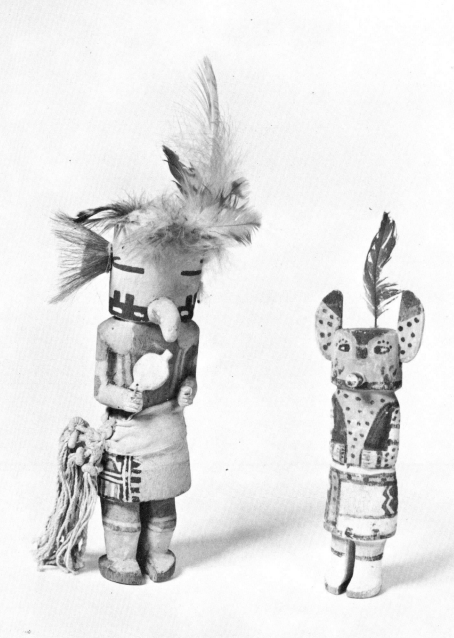

and decorated with feathers; the designs were entirely his (Pl. 9). Until his death – or, more accurately, until he went blind – only he supplied Oraibi *kachina* dolls. Any villager who wanted to sell *kachina* dolls had to make and dispose of them elsewhere. The size of the chief's output was surprisingly large; he was an extremely prolific carver, and examples of his work are to be found in all the larger museums. Any attempt to identify these with traditional *kachina* representations is, however, not possible; the forms are all aberrant ... his dolls are Hopi only because a Hopi Indian made them. Do these objects represent 'tribal' art, to be so identified and catalogued, or are they simply individual, aberrant art forms, of minor cultural significance in anthropological terms?

Another, and last example: the restriction to be found within the tradition. I have in mind a young Hopi man, a particularly gifted artist, who attended Alfred University, studied pottery, and returned to his home. Among the Hopi, pottery is a woman's craft, just as weaving is customarily done by men. He is a fine potter, as is his wife; both of the young people set up a studio in the village – but in time were forced to leave. Men simply do not make pottery. They went to Scottsdale, where they opened a pottery and jewellery crafts shop, then later joined the staff of the Institute of American Indian Art in Santa Fe, where he taught jewellery, and she taught pottery. In time, he returned to the village, where he now resides; to my knowledge, he no longer works in clay, restricting his creativity to metal. As an interesting sidelight, he is now one of the major supporters of the 'old way' – he participates in all religious activities, and is a staunch, traditional Hopi.

To conclude. We have examined a variety of individual, traceable, applications of the artistic impulse among native artists. All students of traditional art can tell similar stories, and many are aware of the reasons behind some of these activities, aberrant or normal. My basic point is simply that we make certain judgements daily, basing our stylistic analyses, evaluations, and cultural identifications upon just such wide-ranging examples. And when we judge a given culture, apply specific criteria of identification to it, and make certain diagnoses for permanent reference, do we not run the risk of building whole cultural concepts upon the work of a single artist in that culture?

I think we do, and I would urge that greater attention be given to this matter of the individual quality of man's artistic activity in our efforts to achieve a better understanding of the cultural interaction between peoples.

CHAPTER 8 Mask Makers and Myth
in Western Liberia[1]

Warren L. d'Azevedo

This paper is concerned with the role and status of certain wood-
carvers among the Gola and some adjacent peoples of western
Liberia. These craftsmen, perform a unique service which high-
lights the function of a particular kind of personality and creative
ability in the tribal societies of the region. They are the makers of
the supreme objects of aesthetic appreciation and ritual defer-
ence, yet woodcarvers are persons of ambivalent social character
who are seldom eligible for a titled position among the custodians
of tradition and sacred institutions. In the following pages I will
describe a situation in which the virtuoso craftsman emerges as
the creative artist at odds with his society, while at the same time
being accommodated by a symbolic and traditionally validated
role which orients his talent to a prime social task.

The material upon which this discussion is based was collected
among the Gola, Vai, and De chiefdoms of the coastal section of
western Liberia. These peoples constitute a segment of what has
been termed the 'Poro cluster' of tribes whose distribution and
relatively common cultural features have been described else-
where (d'Azevedo, 1962 (1) and (2)). Briefly, however, it may be
pointed out that the Poro-type pantribal and intertribal male
association has its most intensive distribution among the Mande-
speaking and Mel-speaking[2] peoples of north-western Liberia
and southern Sierra Leone. Closely connected with Poro is the
Sande (or Bundu) female associations which are localized as
lodges among the women of specific chiefdoms. They are also
spread throughout the region and have a wider distribution than
Poro. The tribes of this cluster are divided into numerous petty
chiefdoms traditionally controlled by the landowning patri-
lineages of the founders of each unit. The economy is based upon
intensive slash-and-burn agriculture with supplementary hunt-
ing and fishing. Warfare, trade, population mobility, and
periodic confederacies have characterized relations among
groups for centuries.

THE MYTH The greatest public dramas of life are played out in the cycle
of ceremonies connected with the recruitment and maintenance
of membership in the all-powerful and universal male and female
secret associations.[3] The major theme of these dramas is the
unresolved rivalry between the sexes and the unrelenting

struggle of the ancestors – together with their ancient tutelaries among the nature spirits – to ensure the integrity and continuity of the community. The actors are the uninitiated youth, all the adult men of Poro, all the adult women of Sande, the sacred elders representing the ancestors, and the masked impersonators of the nature spirits who are allied with the founders of the country.

The plot which ties the cycle together is simple and is derived from myth which explains the origin of crucial institutions. In the beginning, it is said, there was Sande. Women were the custodians of all ritual and the spiritual powers necessary for defending sacred tradition in the interests of the ancestors. The initiation and training of females for their roles as wives and mothers was a central task in which the entire community participated. The generations spring from the wombs of women, and it is the secret knowledge of women which ensures the fertility of families, of the land, and of all nature. For this reason, women have always been more diligent than men in the tending of ancestral graves and in the guarding of the shrines of spirits who protect the land.

The primacy of Sande in general myth among the Gola is attributed to the conditions attending their origin as a people. It is believed that all 'real' Gola of the extended territory which they occupy today may trace their descent patrilineally (or ambipatrilineally) to the ancient lineages of chiefdoms in an interior homeland region known as Kongba. Thus, the founding ancestors of these legendary units constitute the original ancestors of all the Gola, though local genealogies seldom include them except to name the migrant ancestor who is claimed to be the link to Kongba. The original lineages and chiefdoms emerged under a charter between the founders of Kongba and the autochthonous nature spirits whose land they occupied. The particular class of spirits to whom the founders were obligated for patronage were those who resided under the waters – the 'water people'. These spirits helped the ancient Gola to drive away monsters from the territory, and guaranteed the fertility of the land. In return they required an exchange of women in marriages that would validate a co-operative alliance between the human and spirit communities.

Thus the spiritual male and female spouses of the founders became the ancestral tutelaries whose descendants formed similar alliances with complementary human descent groups in each succeeding generation.[4] Moreover, in each generation there were to be certain human beings assigned to the special role of regulating commerce between human beings and the water spirits. These persons were designated by titles which passed down through specific core lineages of those founders who originally held such positions. The first *Mazo* was, therefore,

the woman chosen among the founding families to carry out this task. The title became a property of her patrilineage, while one of her elder male lineage mates was given the title of *Mama fuwɔ* to serve as her sponsor in sacred office. The *Mazo* and her 'brother' were responsible for the organization and control of all women of the legendary Gola chiefdoms in order to inculcate in them the crucial tradition of alliance with the nature spirits, their sacred role as potential wives and procreators in two worlds, and their special responsibilities with regard to the propitiation of two classes of ancestors. This is how, it is said, Sande came into being.

In Sande ritual, the *Zogbe* is the masked impersonation of the male water spirit of a lineage – parallel to that of the *Mazo*'s core lineage – in the spirit community.[5] During sessions of Sande, or at any time when his services are required, he asserts the ancient rights of his 'people' by venturing into the human community in visible form to officiate and to ensure the continuity of the charter. The women of Sande are referred to as his 'wives', and human males are not to interfere with any of the demands that might be made upon their own wives or their female relatives while Sande is in session. In a populous chiefdom there may be many *Zogbea* visiting from the other world, each presiding over a band of women assigned by the local *Mazo*. During the session, women are said to 'control the country'. Their normal activities are curtailed by rigorous involvement in the complex rites and numerous tasks of 'cleansing the land', training initiates, and tending ancestral shrines. Men complain that their own interests are being neglected, but the powers of Sande are great and its work must be carried out for the good of all.

In brief outline, these are the essential features of Sande as they are expressed in general myth. The myths of the founding of new chiefdoms in the expanded territory of the Gola are local restatements of the grand design, and ritual is an enactment of modified commitments to the ancient charter. The founding ancestor is directed by a diviner to make a pact with the local nature spirits. This pact invariably involves a 'friendship' with a woman of the spirit world, and the assignment of one of the founder's female relatives to a similar alliance with a male relative of his spirit spouse. Just as the founder is frequently given a vague genealogical connection with the lineages of Kongba, the local nature spirits with whom the pact is made are thought to have kinsmen among those of their kind who were allied with the original Gola. Local Sande lodges are led by a succession of women who inherit the title from a core lineage of the founder, often the same lineage from which kings and other officials are selected. Therefore emphasis is placed upon sacred obligations to

1 *(see frontispiece)* The mask of a *Zogbe* of Gola Sande

local ancestors and nature spirits, but always with reference to the stipulations of the grand charter, the sacred lore of Gola origin.

In the ancient days of peace and perfect social order – long before the Gola began to migrate from Kongba – it is said that Sande was the single and all-powerful sacred institution. Though men ruled, women controlled all communal intercourse with the ancestors and their spirit guardians, and men submitted to female domination in ritual matters. It is even suggested, in some versions of this lore, that Gola men had not learned about circumcision in those distant days. But there came a time of terrible wars in which enemies attacked and tried to destroy the country. When the men of the Gola chiefdoms attempted to organize themselves for defence, the women resisted because it interfered with the activities of Sande. In their view, Sande, alone, with its powerful spiritual guardians would be sufficient to protect the land and its people. But the attacks continued and the situation became desperate. Furthermore, men learned that women cannot be trusted with the secrets of war; for though they jealously kept the secrets of Sande from men, they would speak out the plans of men to their enemies. This is how the ancient Gola men learned what every man knows today. A man cannot trust his wife unless she is from his own family, for a woman is loyal only to her own kin and to Sande. A woman can betray her husband's family and chiefdom.

Thus women and war brought about Poro.[6] With war came disaster, and women could not understand it or cope with it. As a consequence, it was necessary for men to find a special instrument of power of their own. They searched the forests of the interior until they discovered an awful being, much like the monsters which had once roamed the land and had been driven out by the ancestors and their spirit allies. The being was captured, and certain brave men were assigned the task of subduing and tending it. They, and certain qualified descendants of their lineages came to be known as the *Dazoa* of Poro, the highest and most sacred officials of the men's secret organization. The strange being they had captured became the Great Spirit of Poro whose aspect was so frightful that women could not look upon it, and even the *Zogbea* were reluctant to test its power. Armed with their new spirit, the men were able to subdue the women. Boys began to be taken from the care of their mothers at an early age in order to prepare them for the rigours of manhood. They were removed from all female company to teach them obedience to their elders, secret signs by which they would recognize their fellows, endurance of all kinds of hardship, self-reliance, the arts of war, as well as co-operation and absolute loyalty to the Poro. Women and

strangers were told that the boys had been 'eaten' by the Poro Spirit which would eventually give birth to them in a new adult form. Circumcision was explained as part of the process of being reborn. The Poro Spirit removed all that was 'childish and useless' in order to produce men. During the Poro session the Great Spirit was never seen by outsiders. It remained in the seclusion of the secret forest grove of Poro guarded by a *Dazo* and the leading men. But its terrible voice could be heard admonishing the boys and raging to be set free among the uninitiated of the community.

When the Poro became strong, the women beseeched the men to remove their Great Spirit and allow things to be as they were. But the men refused. They did, however, agree to an arrangement. The *Mazoa* of Sande and the new *Dazoa* of Poro decided that each association would take its turn of control over the country. The Poro would have four years to carry out its tasks, and the Sande three years. At the end of its session the presiding association would remove its spiritual powers from its grove to allow for the entrance of the other. Since that time, the number four has been the sign of men, and the number three the sign for women.

THE ENACTMENT In all the extended chiefdoms of the Gola, the endless rotation of Sande and Poro sessions are co-ordinated by the *Dazoa* who are responsible for various sections of territory inhabited by Gola. The Poro sessions do not begin until all the chiefdoms have completed the sessions of Sande and there has been a year or more of interval 'so that the country can rest'. Then the *Dazoa* secretly confer and send word among the groves of the chiefdoms that Poro is about to claim the country. Just as in the ancient days of origin, the Poro Spirit is led stealthily into the chiefdom and confined in the local Poro grove. Word spreads that it has been brought from the deep interior forests and that it is wild and hungry after its long absence. Young boys and uninitiated men begin to disappear causing consternation to mothers and quiet satisfaction to fathers.

When all is in readiness, a *Dazo* appears in each of the chiefdoms and announces that the time has come for men to assume leadership again. At the sacred towns of the groves he heads a procession of all the men of Poro to the Sande enclosure where the *Mazo* and the leading women of Sande are waiting. The *Dazo* requests that she turn over her power and send the *Zogbe* protectors back to the forests and rivers whence they came. He informs her that the Great Spirit of the men is already in the Poro grove and that it has begun to gather boys for training. The *Mazo* confers with her attendants and reluctantly agrees. At that

moment the Poro Spirit is heard singing in the grove. It sings of its great hunger, and begs that uninitiated boys be brought to it for food.

During the following weeks all the boys of appropriate age disappear from the villages of the chiefdom, and uninitiated men are ambushed on the roads and will not be seen again until the end of the session. It is explained to the women that though they have been eaten by the Poro Spirit, they will be born again from its stomach in a new, clean, and manly form. It is a time when women weep for their lost sons and men smile wisely because of the return of masculine principles to the world. There is much rejoicing among men, and emblems of male supremacy and strength appear at all feasts and public ceremony. Foremost among these are the masked figures, the 'dancing images', which represent spirits controlled by the various subgroups of local Poro. One of these figures is known as *Gbetu* whose magnificent helmet mask and awesome acrobatic feats create an atmosphere of intense excitement at feasts and other ceremonies.[7]

However, these masked figures do not have the same ritual importance as the visible *Zogbe* of Sande or the invisible Great Spirit of Poro. They are the 'entertainers' or 'mummers' of Poro and represent minor spirits who have been brought to enhance the ceremonies of men. They are handled by their attendants as scarcely tamed animals who must be whipped, cajoled, and contained. This is a symbolic projection of the role of the great Poro Spirit which must be rigorously controlled by the men of Poro to restrain it from doing harm to the community.

At the end of the four-year Poro session, it is announced that the Great Spirit is about to give birth to newly adult males.[8] A mass mourning ceremony takes place as a wake for the boys who had 'died' four years before. The ceremony concludes with the entrance of the initiates into town, their bodies rubbed with clay, and their faces and movements those of dazed strangers. They do not recognize their mothers or other female relatives. They must be encouraged by gifts and endearments to speak or to look at human beings. This condition lasts for days until they are ritually 'washed' by the elders of Poro. They are dressed in all the finery their families can afford and are placed on display in the centre of the town. Their first act is to demand food, but they show their new independence and male vigour by wringing the necks of chickens brought to them as gifts. They address their female relatives authoritatively and maintain an attitude of aloof contempt for all commonplace human emotions. The final ceremony is marked by their public performance of the skills they have learned during the Poro session. There are exhibits of dancing, musicianship, and crafts after which they return to their

homes accompanied by proud parents.

Within a short time the women of Sande will have laid the plans for reinstatement of their own session. At last they approach the chief and elders of the chiefdom with the request that the *Dazo* return and remove the Great Poro Spirit from the country. When the time is finally agreed upon, the *Dazo* is called to conduct the ceremony of transition. His demeanour is one of great reluctance and annoyance. Why has he been disturbed? In what way have the women shown that they have earned the right to take over the country? Each day he dances in the central clearing of the town surrounded by his musicians and the men of Poro. He continues to deny the solicitations of the *Mazo*. At last he relents, and a time is specified for the removal of the Poro Spirit. The women are ordered into their houses along with all the un-initiated, and the shutters and doors are closed. The Great Spirit can be heard singing sadly as it is led by the men from their grove and through the town. At moments it rebels and howls in anguish. It must be dragged forcibly, and its teeth leave long grooves in the dirt of the paths. At last it is gone, and the sound of guns being fired indicate that the men have succeeded in driving it away in the company of its keeper, the *Dazo*.

The *Mazo* is summoned from her house to meet with the elders of Poro in the centre of the town. They hand her the emblem of power of the secret societies. The moment this transaction takes place, she and her attendants shriek with joy and call the women to take over the country. The men flee into the houses as the *Zogbea* and their singing women attendants stream from the sacred Sande grove and from the various houses of the town. The *Zogbea* rush here and there, waving their spears at tardy men, and the women cry warning that the country will now return to proper leadership. The entire day is spent exacting fines from chiefs and other important men for the 'crimes' that have been committed during the rule of men. They admonish children and remind them of their duties. Towards evening the men dare to move about more freely. They are invited by the women to take part in a joyous festival during the night, but are warned to remain respectful and humble before the *Zogbea*, 'our new husbands who have come to rule the land'.

This cycle of male and female secret society activity is part of the rhythmic chronology of tribal life and may be said to mark the decades of passing time while the agricultural cycle marks the years. Individuals frequently determine their ages by the number of farms since their birth as well as by the name of the secret society session in which they were initiated. The institutionalization of male and female principles in two compulsory organizations, each with its own structure of administration and

its own secret body of knowledge, has a profoundly pervasive influence throughout every aspect of culture. It qualifies all interpersonal relationships by its rigorous codification of male and female roles and by its pressure to conformity with traditional concepts of ideal social order involving absolute obedience to authority as represented by the hierarchies of age, lineage status, and official position. The notion of 'secrecy' is a paramount value in this system – secrecy between men and women, secrecy between the aged and the young, and secrecy between the initiated and uninitiated.

The most common expression of this mutual exclusiveness of spheres of knowledge is the continual reference to 'women's business', 'men's business', or 'society business'. Men will disclaim any knowledge of the content of Sande ritual or training, and women adamantly deny any curiosity concerning the mysteries of Poro. Children must never inquire into these matters, and non-initiates are warned that banishment or worse will befall anyone whose eyes, ears, and minds are not closed to all mysteries which lie behind the public performances of the secret associations.

In this context, the mutual exclusiveness of activities and information creates the necessity for intermediaries between Poro and Sande. These roles are performed by certain of the elder women and men who carry sacred titles in the local organizations. All such persons are assigned the general title of *zo*. Thus, the *Mazo* and the *Dazo* are the titled heads of the Sande and Poro respectively. The *Mazo* is aided by three or four elder women attendants who are also *zonya* (plural), and there are a number of colleagues and assistants of the *Dazo* in each Poro lodge. All such persons are *zonya,* and their specific titles are conferred by Poro and Sande in accordance with criteria of age, service, personality attributes, and required lineage status. The formal title of *zo* may also be conferred on certain other respected elders who are masters of crucial knowledge and skills that have benefited the entire community. Such persons may be respected herbalists, diviners, bone healers, snakebite curers, or special craftsmen. Elder blacksmiths who have been permanent residents of the community and who are members of high ranking lineages are invariably *zonya*. The term *zo* is also used informally as a reference to any admired and proficient individual in the same sense as we speak of someone as a 'master' or 'expert', but this is quite distinct from the use of the title for the traditional offices.

The leading official *zonya* are said to be beyond the age which restricts their involvement to one or other of the secret associations. Their age and experience are considered to have removed them from the petty rivalries of local lineage segments, from the

temptations and irresponsibilities of younger persons, or from the passions and immediate concerns of sexuality and procreation. They are the 'grandparents' of the people and are about to join the ancestors. The *Mazo* and her attendants are women who know all matters pertaining to Sande and who have also learned the major secrets of Poro from their counterparts in the male organization. The *Dazo* and his aides are also informed of the mysteries of Sande. It is through the agency of these elders that the continuity and mutual co-operation of the sacred institutions is maintained through each generation. The average person views this commerce between the closely guarded provinces of male and female authority with awe, and a high degree of charisma is associated with the roles of those who move freely in this regard.

This charisma is shared to some degree by the *zo* specialists who perform necessary services for both Poro and Sande which require knowledge of sacred procedures. The blacksmith is a prime example of such a role in that he is not only master of the resources and techniques of metallurgy which provide the implements of agriculture and warfare, but he is the secret maker of certain emblems of sacred office as well as of the tools of circumcision and scarification for both associations. In this position he commands information about the most secret rituals. To some extent other *zo* specialists perform duties which might take them, under certain carefully arranged conditions, into the groves of the society of the opposite sex. It is this peculiar aspect of their roles which is a basic feature of official *zo*-ship.

MASK MAKERS AND THE PERSONAL MYTH

Among the specialists who perform crucial services for both Poro and Sande, the position of the master woodcarver is unique. Despite the fact that the woodcarver is the creator of the masks which represent the most powerful supernatural guardians of the secret societies, I know of no instance where the formal title of *zo* has been assigned to a woodcarver during the period of his most productive activity as a craftsman. The product of the woodcarver's art is central to the public drama of Sande. He participates intimately in the affairs of the woman's organization to a degree allowed to no other man excepting the eldest sacred officials. His involvement in the secret stagecraft and technology of ritual is every bit as important as that of the blacksmith. Yet the carver, regardless of the excellence of his work, appears to be excluded from the company of the *zonya*.

As these matters are subject to the most extreme secrecy and sanction, it is rarely possible for the investigator to inquire directly about them. I spent more than a year among the Gola and other neighbouring peoples before I encountered wood-

carvers who would reveal that they were producers of masks, and it was much longer before I was able to discuss these materials with them or with any other person. Fear of exposure is intense, for heavy fines and disgrace can follow the discovery that an individual has converted sacred objects to the external market or has revealed the conditions of their production.

I found, however, that woodcarvers were quite willing to discuss any aspect of their craft and to produce examples of it for non-traditional purposes as long as they could be assured of being undetected by those members of their own culture who would bring them to account. This was not true of any of the official *zonya* whose circumspection and limited tolerance with regard to questions concerning Sande and Poro is a standard response. It seemed to me, therefore, that woodcarvers represented something quite unusual among those persons who were involved by skill and knowledge in the preparation of the impressive effects and illusions of public ritual. It appeared that they were less moved by the social value of their role than by subjective concerns such as recognition for the masterpieces for which they cannot receive direct public acclaim. These early impressions proved to be well-founded, and subsequent observation has confirmed my view that the woodcarver in this area represents, in personal orientation as well as social status, many of the characteristics which are associated with our own concept of the artist.

Vocational specialization is not highly developed among the coastal groups of western Liberia. There are few full-time specialists of any kind, and these invariably supplement their incomes by farming or periodic shifts to alternative pursuits. The professional *zonya* are relieved of direct subsistence tasks due to their age and hereditary status within the large and relatively wealthy lineages of the founders of a chiefdom. Political offices are also hereditary and provide, at least for major chiefs, the emoluments and services which make a full-time political vocation possible. Among craftsmen, it is only the local official blacksmith who can be said to be a full-time professional supported by the local community. His position is also an hereditary one, and the nature of his craft is such that there is a continuous demand for his products locally, and a traditional assignment of community labour to assist him in farming and other subsistence activities.

Professionalism, aside from the above vocations, is achieved only by those who appeal to a wider area of demand than that of the local community, or by those who are supported as clients of wealthy patrons. Thus, itinerancy and patronage are requirements of any full-time specialization which does not carry the

traditional credentials of local sponsorship. Highly skilled singers, dancers, musicians, and craftsmen may make their services available throughout a region and are frequently solicited from distant chiefdoms of other tribes. In the past they were part of the heterogeneous retinues of great chiefs, and were often the instruments of competition for prestige among powerful rulers. In more recent times there has been some replacement of these traditional supports of specialization by new external spheres of demand created by foreigners and by national government interest in tribal culture.

With the exception of the locally sponsored *zonya,* an aura of mixed distrust and admiration surrounds the full-time specialist of any kind. As persons of exceptional ability, they are no longer fully dependent upon sponsorship or approval from their own families, or from the community of their origin. They are likely to shift their loyalties in accordance with the fortunes of patronage. Every local group of any prominence has its own roster of talented amateur craftsmen and performers who contribute to the on-going economic, recreational, and ceremonial needs of the community. The community can also rely to some extent on its own healers and diviners who are permanent residents engaged in part-time practice. But few people can avail themselves of the services of the famous specialist whose name has spread far and wide, who has become associated with legends of remarkable successes, and who is sought after by the wealthy and the great. Their talent seems to be derived from special powers that others lack, and their individualism and apparent freedom of choice is attributed to the kind of 'luck' that comes from commerce with private supernatural agencies.

Almost without exception, renowned specialists are believed to be sponsored by one of a variety of possible tutelaries among the classes of *jina* who are thought to engage in 'friendships' with certain human beings. Such tutelaries are called *neme* among the Gola, a term which means literally 'the thing belonging to one', but they are also spoken of as 'friends'. All great and successful persons are suspected of having a spiritual liaison of this sort. The *neme* relationship is both feared and envied. Since it is often kept secret, there is no way for the average person to be certain that it exists except by careful observation of the behaviour and fortunes of those suspected. Among the venerable *zonya* there are those who are known to be sponsored by a powerful *jina.* Yet they have the gratitude and trust of the community because their private spiritual guardian has been inherited by them from among the totemic spirits who have been associated with their ancestors since time immemorial. Though the *zo* may not always speak freely of this spiritual connection,

the fact of its existence and, usually, the conditions of its consummation are matters of public tradition.[9]

There are, on the other hand, many free-roving *jina* who seek mutually rewarding friendships with human beings. Such friendships may be established before a person is born, or they may come later in life as a result of a dream or a waking encounter. There are good and bad *jina* just as there are good and bad human beings. An evil or ambitious person may become the ready instrument of an evil spirit. Most persons claim that they have, at one time or another, rejected the advances of *jina* who approach them with seductive promises of love and luck. The rejection must be emphatic, for once a pact is made the *jina* has complete power over one and will wreck vengeance if it is broken. A good human being may make a private pact with a free-roving *jina*, but such pacts are usually made early in life, or even by the human soul before a person's birth. Sudden and unexpected success at the expense of others is always attributed to either sorcery or to a newly established pact with an evil *jina*, whereas consistent excellence in a line of work is usually attributed to a benign and lifelong spiritual friendship. From the point of view of the average person, however, any such phenomena are considered precariously unpredictable and fraught with danger for the community.

In this context, a clear distinction must be made between the notions of communal and private spiritual guardianship. As pointed out above, the spiritual sponsorship of the honoured *zonya* is derived from the totemic tutelaries of the ancestors of the high-status descent groups of the community. These are closely connected with the supernatural beings who are represented in Sande ritual. The ancestors acting through their living agents, the sacred elders, demonstrate the essence of the myth which unites the community with its ancient protectors among the autochthonous nature spirits of the locality. It is under these conditions that the *neme* concept is expressed on the level of communal tradition and organization. At the same time, there are numerous opportunities for the private pursuit of fortune through the auspices of human or supernatural patrons. The use of personal sources of power or luck is considered to be the most direct means to advantage. It does not require the arduous courting of public favour, the obsequious obedience to one's elders, or the ascribed virtues of wealthy family or high lineage rank. But the risks to self and family are great, for the powerful controls exerted by the sacred institutions are neither effective nor enforceable under these conditions.

The personality characteristics often associated with renowned independent specialists are conceit and lack of humility before

2 A *Zogbe* dancing with its Sande attendants

3 A *Gbetu* of Gola Poro being presented at a festival

superiors. These are traits which are said to accompany the aggressive assurance which comes from having a strong private tutelary. It is much the same behaviour which one might expect from a person who is backed by a powerful human patron who protects him from the indignation of others and encourages his wilfulness as a reflection of the patron's own prestige. Great chiefs of the past were surrounded by 'followers' or clients, many of whom were from foreign chiefdoms and not connected by ties of kinship to the local community. These were warriors, diviners, entertainers, and craftsmen of all sorts who had become attached to the ruler's household. The favouritism afforded them was frequently the source of friction within the chiefdom, for they were partially insulated from the sanction of local kinship groups or secret associations. Such persons were sometimes referred to as the 'spoiled children of the king' whose fate depended entirely upon the fortunes of the chiefdom and the whims of the royal household.

In the case of individuals thought to have private supernatural sponsorship, the traits of pride and arrogance might be even more pronounced and less susceptible of regulation. This was particularly true of highly skilled persons whose products or services were so superior to those of others that they were in constant demand despite their strange behaviour. Not all specialists were in this category, for many disclaimed any supernatural guidance. But others, among whom were usually the most famous, tended to proclaim and dramatize their spiritual resources. Some who presented themselves in this light commanded the respect due only to the official *zonya*. It might be said of such a person that 'he is a true *zo* for his work', which is a high form of praise, but also indicates that he is a *zo* without portfolio, so to speak. One might also hear the expressions 'he is a *zo* before his time', or, 'he has crowned himself *zo*', suggesting awareness of the ambition and striving for recognition that is frequently a component of the personality of the talented and popular person.

Though these characteristics were in the past, and are today associated with all specialists whose excellence appears to be derived from private connection with supernatural agents, they are said to be especially evident among those whose skills are demonstrated in public display, and who exhibit themselves or their works at festivals and ceremonies. Famous singers, dancers, musicians, story tellers, and masters of legerdemain are commissioned to participate in these events, and many others come unsolicited to collect gifts. Much of the quality of any great gathering, whether it be a funeral feast, a celebration for a dignitary, or the festivity surrounding ritual, is provided by the excitement of competition for public recognition among these

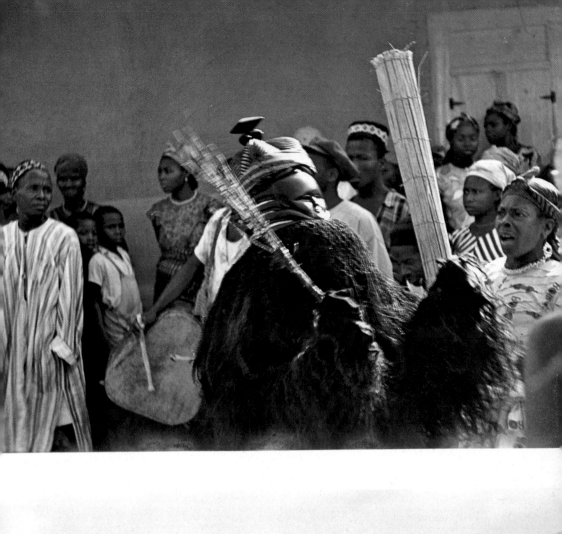

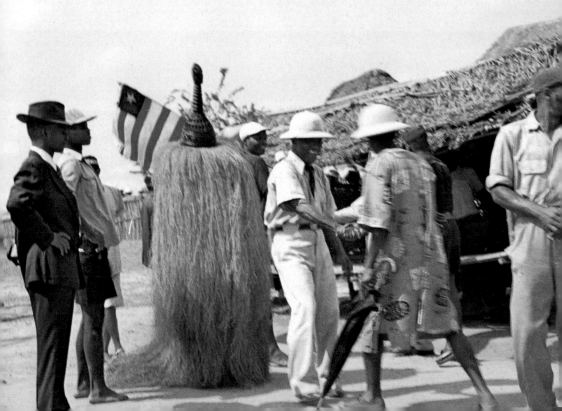

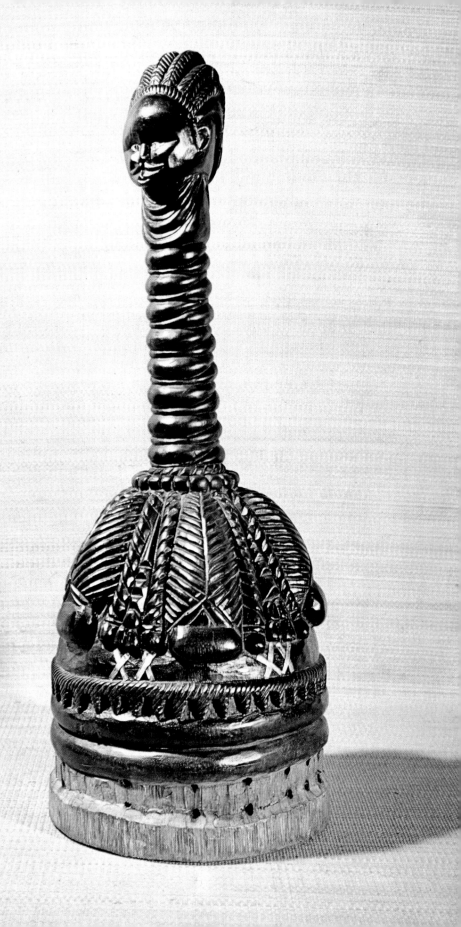

he mask of a *Gbetu* of Gola

performers. Great female singers, in particular, are centres of attention. Many of them are already legend because of their important lovers, their endurance and creativity as leaders of songs, their beauty, and the personal myth of supernatural inspiration which they help to perpetuate. Such women often claim to have a *jina* lover who trains their voice and brings them songs. The *jina* is not jealous of human husbands or lovers, but is a ruthless taskmaster of their talent and success. Singers are often childless and they will state that barrenness is a condition imposed by their *neme*.

A similar aura of private sacrifice and supernatural liaison surrounds other exceptional performers and artisans whose fame has spread far and who seem to have found alternatives to the limited avenues of advancement in the local community. They are most often young or in the prime of life. They flaunt their unusual deportment and supernatural connections in ways that would be unacceptable from the average person. Yet they may be persons of low birth, disreputable and untrustworthy in all else, and quite unlikely candidates for *zo*-ship even in old age.

The master woodcarver has a special place in this category of persons. As maker of the prime ritual objects of Poro and especially Sande, his craft and his activities are under continual scrutiny. Without his expert services, the required perfection and impressiveness of the masks which represent the spiritual power of the secret societies would not be achieved. Among the Gola, Vai, and De, of the coastal Liberian section of Poro tribes, these masks constitute not only the epitomy of the woodcarver's art, but are a major focus of aesthetic and ritual values. Unlike some of the more populous tribes of the interior, where guild specialization and numerous secret associations in addition to Poro and Sande create conditions for a greater variety and productiveness in woodcarving forms, the coastal tribes concentrate on a few basic types of masks and figurines.[10]

Not all men known as woodcarvers produce masks for the secret societies. Woodcarving, like other skills, is generalized in so far as many young men carve combs, dolls, toys, swagger sticks, and utensils as part of their training in Poro as well as for gifts and petty trade. But the term *yun hema ku* (one who carves wood) is usually applied to a man for whom this activity is a recognized vocation and who is at least suspected of having carved objects of ritual importance. He is also a man whose skill is considered to be extraordinary and who is believed to be inspired by a tutelary. Among woodcarvers themselves there is considerable difference of opinion as to whether supernatural guidance is a necessary factor in superior workmanship and success. Those who claim to receive their 'ideas' directly through

a 'dream' which comes as a gift of a *jina* friend are emphatic in claiming ascendancy to such work, and state that they are able to recognize the work of 'dreamers' as against those who do not dream. When confronted by the fact that a certain carver whom they have praised denies supernatural aid, these men will take the position that the denial is a subterfuge. On the other hand, some carvers who seem honestly to deny any consciousness of supernatural guidance will admit the possibility that they are given such aid without their knowledge. They are also prone to admire the dramatic stance of those excellent carvers who claim to be 'dreamers', and who attribute each new work to the productive exchange of the *neme* relationship.

Once the woodcarver has participated in the production of Sande or Poro masks that actually appear in public, he has become a peculiar individual of a type for which there is no counterpart in the culture. The objects he produces are not to be thought of as having been made by human hands but are, rather, the visible form of a supernatural being. The more remarkable his execution of the mask, the greater is the reinforcement of the desired public illusion, and the greater is his surreptitiously acknowledged fame. No one is ever to allude to a mask as having been made, or to refer to this aspect of the woodcarver's craft. Children are severely punished for even inquiring about such things, and adults may be fined heavily for an inadvertent slip in public. I found that most very young people claimed never to have considered the possibility of local human workmanship being involved in the production of these masks, and adults who claimed to have wondered about it in their youth say that they had concluded that all such things had been made long ago and were passed down by the ancestors.

Those few who will discuss these matters freely describe their youthful discovery that such objects were made by living men as having evoked in them the most intense anxiety. It seemed unbelievable that ordinary men could have made such marvellous things, and they claim never to quite get over this feeling. For this reason it is still a very shocking experience for rural villagers or their children to come across one of these masks in the shop of an urban trader. Fear and indignation are followed by attempts to track down the source of the illicit object and to punish the betrayer of the secrets. I have noticed in such situations that people do not always recognize the work they see as authentic, but think of it as a possible copy made by an unscrupulous Mandingo or other foreign craftsman. This response is, I think, genuine, for few people in the more traditional sections of the interior see these masks apart from their public presentation in ritual, and tend to perceive them quite differently when

these conditions are not operative. A striking exception to this is the response of woodcarvers themselves. They make immediate judgements about masks as masks, as products of degrees of skill, and as representative of the styles of particular carvers. Very few other members of the culture make objective judgements of this kind. Discussions concerning the quality of a piece of workmanship rarely occur except on those occasions when certain leading persons in either Poro or Sande prepare to commission a carver to copy an old mask or to create a new one.

A degree of choice is exercised in the selection of a carver, but the choice is limited by the scarcity of carvers and by the vast difference in cost between the work of an ordinary craftsman and that of the rare master carver. The importance of a particular mask does not, however, depend entirely upon the quality of workmanship. Each of the spirit impersonations has its own name and a distinct 'personality' expressed in its dancing, its public mannerisms, and through the legends of its peculiar powers. Thus certain masks which are seen in ritual may be, from the master carver's point of view, very poor workmanship; yet the respect and admiration afforded it by the public and by its ritual followers may be great. On the other hand, the appearance of a magnificently executed mask will invariably elicit expressions of awe and delight from a crowd. The aesthetic values awakened by technical proficiency and creative innovation are an enhancement of the fundamental traditional values associated with these ritual objects, but are not crucial to their effectiveness. The artistic component is, therefore, optional and the role of the exceptional carver is considerably influenced by the fact that he controls a skill whose rare products are highly desirable but not essential. The work of a less skilled craftsman might be solicited for practical reasons.

In order to understand the special value which is attached to products of exceptional talent, it is necessary to know the conditions under which the woodcarver learns his craft and at what point certain carvers become producers of secret society masks. Formal associations of specialists do not exist among the Gola, Vai, or De. Excepting for the blacksmith and the official *zonya*, few vocations are hereditary. Becoming a specialist, therefore, is individualistic in orientation and involves factors of personal inclination, self-appointment, and opportunity. Most professional woodcarvers with whom I have worked attribute their choice of a vocation to the force of their own incentives in the face of obstacles created by their families. They claim that any special talent is looked upon with jealousy by others and as a potential threat to the family in its efforts to develop loyal and dependable members. Intensive devotion to

one activity – particularly where it seems to be accompanied by unusual personality traits – is discouraged by adults. The development of varied skills during the sessions of Sande or Poro training is encouraged, however, for this occurs in the context of a programme directed by adults.

The attitude which woodcarvers attribute to the community with regard to themselves is confirmed by my own observations. Woodcarvers, like professional singers, dancers, and musicians are generally looked upon as irresponsible and untrustworthy people. If they achieve a degree of success, it is said that their independence and self-concern removes them from the control of family or local group, and provides them with alternatives through new attachments and patronage. They are said to yearn for admiration and are always to be found where there are crowds. They squander their resources foolishly and are impoverished in their old age. But most important of all is the danger which everyone knows to surround such work if it becomes the major preoccupation of an individual.

One woodcarver recounted how his mother begged him to give up his work because of its threat to the fertility of the women of the family. Another told how his father had angrily destroyed the tools he had made for himself as a child in imitation of those he had seen in the kit of an adult carver. Others spoke of having run away to a more tolerant relative, or placing themselves under secret apprenticeship to a local or itinerant carver. Such men, whether great or lesser craftsmen, distinguish themselves in retrospect from the other children they knew in youth who may have learned to carve for enjoyment, but who never persevered. They speak of having been driven by an urge to carve that they could not control. This is true even of those who do not admit to an active *neme* relationship. Another common feature of this early experience is a sense of having been different from others in curiosity and ambition. Each claims to have been inordinately ambitious and determined to prove himself superior. This was accompanied by a prying curiosity about things inappropriate to his age, and resulted in rejection or punishment.

THE CREATION OF A DEITY

Among the things which every woodcarver mentions as one of the great wonders of youth were the *Zogbea* spirits of Sande and the masked images of Poro. One Gola carver said that he had surmised as a child of seven or eight that the head-dresses of these figures had been carved by living men and that, in one case at least, he had guessed that a particular local carver had been the creator because of a similarity between the designs he had placed on a drum and those on a *Zogbe*. When he mentioned this to other children, his parents heard of it and he was severely

whipped. He describes his interest in the masked figures of the secret associations as an obsession, and says that he often dreamed of them or saw himself carving them from blocks of wood. He once swore a number of boys his own age to secrecy and took them to his hidden workplace in the forest. There he showed them the crude Sande *Zogbe* and Poro *Gbetu* that he had carved. He remembers the thrill of experiencing their shocked admiration at his audacity and skill. When this escapade was discovered, his punishment was so severe that he does not speak of it, but merely says that his family wanted to destroy him. They finally sent him away to an older brother in a distant village, a silver-smith.

In that village he met an adult carver who made ornate utensils and ornamental objects for trade, but who would not reveal himself as a maker of masks. He took to tracking the man into the bush and soon found where he did his secret work. He spied on him for days as he completed a *Zogbe* mask, an experience he recalls as the greatest and most moving of his life. When it was almost finished, he walked boldly into the clearing. The man sprang up with his cutlass and threatened the boy with death for spying and intruding. But the latter felt such great joy that he had no fear. 'I only said to that man, I am here, I can do what you are doing, I want you to show me what you know.' The carver eventually took him into training, his first formal instruction.

Shortly after this event he began to have overwhelmingly vivid dreams. Once a woman's voice spoke to him. She offered love and 'great ideas'. She began to come to him frequently and brought 'patterns' which she would draw on the sand before him to guide his work. His first *Zogbe,* sponsored by his teacher and inspired by his *neme,* was so successful that the older carver presented it as his own work to the first group of Sande women who commissioned him for a mask. It was not until much later, however, that his name became known to a few people in the secret associations so that he was approached independently. More than ten years after these experiences (when I had first known him) he was sought after among Gola, De, Vai, and Kpele chiefdoms. He was never able to catch up with the demand for his work. He complained of the exhaustion it brought him and he frequently disappeared for months to do farming or wage labour in order to recover his interest. During these periods he says that his *jina* avoids him, as though she too is resting.

Though differing in detail and intensity, the experience of other master carvers is similar. Some do not claim *neme,* and some are not so driven to direct confrontation with the norms of their society, but the theme of misunderstanding and the lonely pursuit of a beloved craft is consistently expressed. Another

theme which appears in the discourse of adult carvers and their admirers is that of the man who lives daringly, who has surmounted obstacles, and who has intruded into realms which even the elders fear. It is essentially the theme of the precocious child who is ridiculed, defies his elders, masters their knowledge, and then produces something of his own which all must acclaim. The woodcarver may see himself, and is often seen by others, as the omnipotent free agent whose vision is indispensable to the very society which holds him in distrust and contempt. All these factors contribute to the charisma of the master woodcarver, and to the romanticism associated with his role.

The primary source of the woodcarver's unique status among craftsmen and performers is the special connection which they have, as men, with the female secret association. It is in this capacity that they enter into an intimacy with sacred female mysteries that is given to no other men excepting the highest ranking elders of Poro. The elders are considered to be free of the temptations of youth and wise enough to bear the great burden of public trust. The woodcarver, however, is neither an elder nor a *zo*. He is seldom a substantial citizen and in many other respects might be looked down upon by the community. Yet it is this same craftsman who may participate in a highly ritualized and sexualized commerce with the leading women of Sande.

The organization of any local Sande lodge is maintained under the authority of the *Mazo* and her elder *zo* assistants. The initiated women of the community are ranked into three 'degrees' in accordance with their age, lineage status, and dutiful service to Sande. The women of the 'third degree' are usually of middle age and constitute a body of the leading matrons of the community. It is from this group that the impersonators of the *Zogbe* are chosen. For this role a woman must be a great dancer, show exceptional endurance and forceful personality, and be beyond reproach in performance of Sande tasks. It is also required that she be a member of one of the lineages from which *Mazoa* are recruited, for the rigours of the *Zogbe* impersonation are considered to be an essential and final part of the training for a *Mazo*.

In each Sande grove the number of *Zogbe* groups depends upon the size of the local membership. A *Zogbe* presides over a group of from ten to fifteen followers of second degree status, and is attended by a few assistants of the third degree. The leader of the group, who is also the impersonator of the *Zogbe*, is responsible for the care of the mask and costume of the image. Many of the *Zogbea* of a given local lodge are ancient and have appeared for generations in each Sande session. Upon the death or the upgrading of the leader of a group, a new leader and impersonator must be chosen. This must be someone not only with the necessary status

qualifications, but one who has learned the style of behaviour or the 'personality' of the *Zogbe* she is to impersonate. Masks and costumes must be renewed frequently, for the life of a mask in active service is seldom as long as twenty years. And should the female membership of the community increase, it may be necessary to 'bring out' new *Zogbea*.

Towards the end of the four-year Poro session, the leading women of Sande secretly begin making preparations for the Sande session to follow. The preliminary preparations involve the repairing and renewal of ritual paraphernalia. The women of each group meet and discuss the problem of commissioning a carver and acquiring the necessary funds. Secret inquiries are made through elder male relatives, and negotiations are cautiously begun. In some instances carvers who have been solicited previously are approached to repair their own work, or to copy a piece. But in the 'bringing out' of a new *Zogbe* it is often thought most desirable to find a carver whose work has attracted attention in other chiefdoms and whose fame has spread through the groves of Sande. This is very expensive, for the group is competing with many others for the services of a carver. Only very determined and well-to-do groups of Sande women can afford to make such arrangements. But it is under these circumstances that the greatest excitement is generated and the prestige of a *Zogbe* group is enhanced. It also provides the conditions for the classic relationship between the women and the creator of the sacred image.

Great carvers are commissioned by Sande in one of two ways. If a carver is known by a member of the group, through kinship or other connections, he might be approached directly. Where possible this is the procedure used because it means that the Sande group can deal with the carver independently and it ensures an element of surprise and mystery in the first appearance of the mask. On the other hand, it places the major burden of expense, as well as the control of the arduous encounter with the carver on the women themselves. Therefore, another procedure is more frequently employed whereby the women commission a carver through the good offices of an elder of Poro or the ruler of the chiefdom. Such a man can summon the carver and provide him with the hospitality that may encourage him to accept the commission.

The contact between the women and the carver follows a pattern that obtains to some degree in all relations between skilled specialists and their patrons. But the classic arrangement between woodcarvers and their female patrons is uniquely elaborate and intense. When a carver is approached secretly by the emissary of a Sande group, he is brought 'encouragements' in the form of

token gifts of money and cooked food. It is said that in the past some carvers were given large sums of money or the equivalent at this point, and presented with a slave. There are also legends of Sande groups studying the amorous habits of a carver and contriving his capitulation to their terms by assigning one of their members to the task of captivating him prior to negotiations. Carvers claim that women make strong medicines in order to control the proceedings. The situation is spoken of as one of 'war' in which a man must defend himself against the wiles of women.

In his first dealings with the women the carver impresses them with the importance of his own role. He appears distracted by overwork and reluctant to take a new assignment. He claims to have an enormous thirst for strong drink, to be very hungry, to be in need of cohabitation with a virgin. He keeps them waiting for appointments and may even disappear for a day or two. He attempts to embarrass and subdue them by alluding to the secrets of Sande he has learned in his work. He wittily inquires why it is that they must come to a man such as himself for so important a task, or he berates them for trying to seduce and cheat him. The women, in turn, continue to bring him small gifts and promise to 'satisfy' him if he will do the work. They offer to cohabit with him or to find him the love he wants. All of this is carried out in an atmosphere of intense enjoyment. At the same time the women will appear to be angered by the unruly and disreputable person they have been forced to deal with and, at certain points in the negotiations, may make veiled threats of supernatural sanction.

If the negotiations are concluded favourably, certain terms will have been agreed upon which will guide the relations until the completion of the project. The woodcarver often requires total support during the period of his commission. As the work may take from one to two weeks, during which time he must remain almost continually in the seclusion of the forest work-place, he demands to be fed, entertained, and dealt with in accordance with the personal code which supports his inspiration. Some carvers, particularly those with strong tutelaries, require that the women who visit them in the forest humble themselves by complete nudity. Others may demand that 'wives' be brought to them whenever they declare a need for sexual gratification. Still others prefer to work in total privacy, claiming that this is the condition prescribed by their tutelaries. Food and other necessities are brought to a separate place in the forest and left for the carver to take them when he pleases.

The women, for their part, will attempt to direct the work of the carver by insisting upon particular stylistic elements, and lecturing him on the character and powers of the *Zogbe* whose

image he is creating. The attempted influence upon the carver may include direction as to the use of certain standard motifs such as deer horns, fish or snake scales, neck wrinkles, hair plaiting, or even the desired facial expression of the deity. A highly individualistic carver will invariably resist such advice, or will accommodate only those suggestions which fit into his subjective plan. Woodcarvers have been known to destroy their unfinished work in a rage because of continued criticism as the work progresses. This is always the cause of scandal, and every effort is made to avoid a break with the carver. Some woodcarvers are more tractable and will accept advice or close supervision with the idea of producing a mask which is exactly what the women have themselves envisaged. But master woodcarvers who are 'dreamers' speak of such men as 'slaves of the knife' who get their ideas from others and who lower the standards which in former times surrounded the woodcarver with glory.

The struggle between the carver and the Sande group may continue throughout the process of production and even for a long while after. When the mask is completed the carver gives it a name, the name of a woman he has known, or a name given by his tutelary. But the Sande women have already selected a male name for their spiritual 'husband', and the carver will insist upon a special fee from them for the right to use another name. He will also instruct the women concerning the care of the mask and inform them of the rules which govern its 'life'. These rules involve strong prescriptions with regard to the storage of the mask, the maintenance of its surface texture, and certain restrictions that may limit its public appearance or necessitate sacrifices to the carver's tutelary. In this sense, the carver affirms his symbolic ownership of the mask. He tells the women that he has the power to destroy his work at any time if it is treated with disrespect (that is, if the rules are not followed).

This threat of the carver is an effective one, for there are many tales of *Zogbe* masks cracking or bursting into pieces with a loud report before the horrified eyes of the spectators. An occurrence of this kind is considered to be a disaster of such terrible proportions that the sponsoring group of the *Zogbe* may be banished while angry spirits are propitiated. The destruction or 'shaming' of a *Zogbe* can be caused by a rival *zo*, or by sorcery. But such an event is frequently attributed to a displeased carver. The source of his displeasure is usually the failure of the commissioning group to complete final payment for his work, or their failure to show him the respect he feels is due him. For this reason, every effort is made to satisfy a carver and to conclude all arrangements with him amicably.

But the peculiar relationship between the carver and the new

owners of the mask is never fully terminated. He enjoys special privileges with the group. They refer to one another jokingly as 'lovers' and he, theoretically at least, can expect sexual favours from them. The relationship is carried on with the air of a clandestine affair, with the woodcarver in the unique position of a male sharing secret knowledge and illicit intimacies with important women of Sande. Whenever he is present during the public appearance of his mask, the *Zogbe* and its followers must acknowledge him in the crowd by secret signs of deference. The women bring him food, arrange liaisons for him, and praise him by innuendo in their songs.

A productive woodcarver will have helped to create *Zogbea* for Sande lodges in many chiefdoms. During the years of the Sande session he may visit various villages to see his work and to receive the homage due to him from the women. He is among the few men who can move about freely and confidently during this period, for he is protected from many of the sanctions of Sande by his compromising knowledge of its ritual. Woodcarvers speak nostalgically of the pleasure they receive from watching their masks perform as fully appointed *Zogbe*. They mingle with the crowds, listen for comments, and watch for every spontaneous effect of their work. They are critical of the leading woman who impersonates the spirit, particularly if her performance is not equal to the intended characterization, and word will be sent to her through her followers. No other man could think of such direct intrusion into Sande matters excepting the most honoured *zo* of local Poro.

One carver explained to me that the sensation of watching his masks 'come to life' was one of intense and mysterious fulfilment.

I see the thing I have made coming out of the women's bush. It is now a proud man *jina* with plenty of women running after him. It is not possible to see anything more wonderful in this world. His face is shining, he looks this way and that, and all the people wonder about this beautiful and terrible thing. To me, it is like what I see when I am dreaming. I say to myself, this is what my *neme* has brought into my mind. I say, I have made this. How can a man make such a thing? It is a fearful thing I can do. No other man can do it unless he has the right knowledge. No woman can do it. I feel that I have borne children.

This identification of the created object as an offspring is not uncommon among woodcarvers who have a tutelary. They speak of the exhaustion which follows the completion of each mask and how continued production is impossible without periods of rest and distracting activity. The 'dream' which provides the inspiration for a specific work is often referred to as the 'gift' of a loving *neme,* and the completed work as the child of the union.

In the setting of his society, the master woodcarver is an individual whose role is imbued with the kind of romance and grudging admiration reserved for the brilliant and useful deviant in many other societies. The most significant aspect of his role is the freedom it affords him with regard to the traditionally hostile and mutually exclusive camps of male and female sacred institutions. He is the creator of sacred objects and the interpreter of symbolic effects. His product embodies the ambivalent principles of male and female orientations to life, and it is his vision which integrates and expresses them as powerful representations of the sacred. He is, to a considerable extent, the conscious recreator of his own status; for he manipulates the symbolic content of his role through the continual re-enactment of the private drama of spiritual guidance. This private drama represents his individual and subjective mastery of the powers which his society as a whole seeks to control in the cycle of Poro and Sande activities, and in the communal myth of ancestral commerce with sentient nature.

NOTES

1. The field research which made these observations possible was supported by grants from the Ford Foundation in 1956–7, and from the Social Science Research Council in 1966.

 The author wishes to acknowledge a debt of gratitude to Professor Raymond Firth for early encouragement and the example of his own work, as well as for the opportunity to present and discuss these materials during the intensive conference on Primitive Art and Society which he chaired at the Wenner-Gren Foundation Symposium in 1967. Thanks are also due to Anthony Forge, Robert Goldwater, and Douglas Newton who shared in the tasks of organizing the conference.

2. Recent discussions by linguists have indicated the necessity for extensive revision of earlier classifications of these languages. Among these are Welmers, 1958, and Dalby, 1965.

3. In the literature on this region, these associations are often referred to as 'secret societies'. Initiation and life-long membership in one or other of the mutually exclusive organizations is compulsory for all citizens. They are 'secret' in the sense that non-members are rigorously denied knowledge of rites and lore, and that 'secrecy' is a core value inculcated in the members. Each of the tribes of the Poro cluster of peoples in this region have their own names for these associations. 'Sande' and 'Bundu' have a wide distribution as terms for the female association. However, though Poro is a general term for the male association where it occurs, there are special local terms as well. The Gola refer to it as *Bõ*, or *Bõ Poro*.

4. Theoretically, the lineages of water spirits derived from the original charter alliance constitute relatives of the local human descent group 'on the *jɪna* side'. This community of water spirits stands in the same relationship to the local human community as do the individual tutelaries (*neme*) who engage in private alliances with human beings.

5. The impersonation is carried out by a high ranking woman of Sande.

6. This statement is the most common response of elders who are asked about the origin of Gola Poro.

7. The *Gbetu* represents a mountain spirit and was used as a 'messenger' of Poro and local rulers in the past. It is one of five or six subsidiary spirits of Poro each 'owned' by small co-operative groups of local members.

8. Though the Gola have held to the traditional length of 'bush school' sessions

more tenaciously than most neighbouring peoples, initiates are released earlier in some of the chiefdoms near the coast where Liberian government influence has been greater.

9. The term *jina* has had wide currency throughout West Africa and is similar to the Arabic and Latin terms for tutelaries or the residing spirits of a place. Among the Gola, the term refers to all classes of nature spirits, exclusive of ancestral spirits. These are spirits of the waters, mountains, forests, animals, etc. The most common and powerful in forming *neme* relationships are the spirits of the water (*yun kuwi*) who are believed to have some vague totemic connection with the most ancient ancestors and the heroic founders of chiefdoms. A person's *neme* is usually of the opposite sex and the relationship is ordinarily depicted as an amorous one. For a more detailed discussion of these phenomena in the context of social organization, see d'Azevedo, 1973.

10. The highly developed tradition of mask production in relation to Poro and other associations of peoples in eastern Liberia are described in Harley, 1941, and Harley and Schwab, 1947 and Harley, 1950.

REFERENCES

d'Azevedo, W. L., 'Some Historical Problems in the Delineation of a Central West Atlantic Region', *Annals of the New York Academy of Sciences,* vol. 96, 1962 (1), pp. 512–38.

———, 'Common Principles of Variant Kinship Structures among the Gola of Western Liberia', *American Anthropologist,* vol. 64, 1962 (2), pp. 504–20.

———, 'The Sources of Gola Artistry', in W. L. d'Azevedo (ed.), *The Traditional Artist in African Societies,* Indiana, 1973.

Dalby, D., 'The Mel Languages: A Reclassification of the Southern "West Atlantic"', *African Languages Studies,* vol. VI, 1965, pp. 1–17.

Harley, G. W., 'Notes on Poro in Liberia', *Papers of the Peabody Museum,* vol. 19, no. 2, 1941.

———, 'Masks as Agents of Social Control in Northeast Liberia', *Papers of the Peabody Museum,* vol. 32, no. 2, 1950.

———, and G. Schwab, 'Tribes of the Liberian Hinterland', *Papers of the Peabody Museum,* vol. 31, 1947.

Welmers, W. E., 'The Mande Languages', *Georgetown University Monograph Series,* no. 11, 1958.

In Search of Meaning
in African Art

William Fagg

Searching for a subject for this paper, it occurred to me that, as
one whose job requires him to pretend to a complete knowledge
of African art and material culture, it might be worthwhile for
me to examine some of the factors, other than my own short-
comings, which cause me to fall short of this desirable omni-
science. For a museum man, though he may be able to do some
field work of his own, will be very largely dependent for his
knowledge upon the accumulated wisdom, the experience, and
the writings of others; and though the literature of African art is
by now very extensive, its coverage of this large field is sadly
partial and defective. The gradual increase of knowledge which
the serious student achieves over the years is accompanied, if he
is honest with himself, by an ever expanding realization of the
remaining areas of ignorance.

Of basic descriptive studies of art in African tribes a fairly sub-
stantial corpus now exists, varying greatly in quality, reliability,
and thoroughness; yet of some hundreds of tribes which have
produced art, hardly more than a handful have been satis-
factorily studied even to the point where undocumented works
can be readily identified by tribe, locality, cult, etc. The rich art
forms of the Bakuba have been well known for more than half a
century; but if we turn to the Grasslands of Cameroon, which of
all areas seem to have produced the most vigorous sculptures,
we simply do not yet have the means of sorting out the many
tribal styles and their mutual influences, or of attributing most
undocumented sculptures to an area more specific than the
Grasslands as a whole – and are now somewhat unlikely ever to
do so, since a plague of African dealers and thieves has descended
upon the country.[1]

Even, therefore, at this descriptive level, there is need – and
urgent need – for vastly more recording of data than has yet been
done. The compilation of such data is well within the competence
of ethnologists (in the sense of specialists in material culture),
even if they will need a lot of help from others if they are to do the
job in time. But I do not wish to concern myself here with this
necessary accumulation of concrete facts so much as with the
ends towards which it is a means – the study, understanding, and
full appreciation of works of art and of their real place *as works of
art* in the life of men, as distinct from their more superficial
function (to which their status as art is irrelevant) as counters in a
system of social structure.[2]

The study of tribal art beyond taxonomy may not be quite a virgin field, but the attempts (including my own) which have been made to enter upon it from various directions have so far been amateurish. This need not surprise us, since there are no professionals to do it. Not only are we anthropologists (and archaeologists) not trained to be competent in this field; we are specifically trained to be incompetent in it. I mean of course that we are taught to exclude all value judgements from our method-ology; the prohibition being enforced by precept when necessary, but much more by a strongly adverse climate of opinion. And this climate must clearly exert a strong pre-selective effect upon entrants to anthropology. I do not suggest that this situation is due to any particular school or branch of anthropo-logy; it would appear to be almost universal in the anthropo-logical and archaeological worlds, and in general among most scientific or semi-scientific disciplines.

'Value judgements' is a term used, generally with somewhat pejorative intent, to refer to the operation of man's subjective judgement, or intuition, as distinct from his intellectual judge-ment. These, the two great complementary faculties of the human mind, are found in creative balance in the greatest periods of art – and perhaps also of science, since it is by intuitive leaps that scientific advances tend to be made. Thus science draws on the intuition as well as the intellect, and art on the intellect as well as on the intuition.

The indispensability of the subjective judgement – duly guided, complemented, and above all recognized by the intellect – in the study of tribal arts is perhaps most easily demonstrated in terms of the actual objects with which the student must work. In working on the art of a given tribe he is typically confronted with a large though scattered corpus of works attributable to the tribe, and of this, one large segment is (if he is lucky) to be found still *in situ* in the tribal dwellings and shrines, while the remainder are scattered among the museums, private collections, and dealers' stocks of the rest of the world, having been collected at various times mainly during the present century. In the country of origin, wherein lies his best hope of documenting works to the standard required for his purpose, he may find surviving examples of the work of about three generations of artists, and in so far as he can identify and document these, they will serve as a control in all his other studies of the art. However, these undoubtedly genuine and traditional works will vary con-siderably in quality, as they have always done, though the predominant trend in this century will usually have been one of progressive degeneration; our student, as we shall see, will need to be able to distinguish fine works from mediocre and poor

ones. But in addition he is likely nowadays to find two other classes of work in the country, often in great profusion: one is the tourist art, developed increasingly in the course of this century for the unsophisticated foreign traveller, most of it not made by traditionally trained artists and only occasionally showing much resemblance to the tribal art; the other, of more recent origin (though appearing older), consists of forged antiquities made largely to external order for the international art market, and commonly by traditional artists working for local entrepreneurs after their tribal commissions have more or less come to an end. Since such forgeries often exhibit uncanonical exaggerations and elaborations introduced for greater saleability, our student may have to look out for signs of stylistic feedback occurring in recent work found in traditional use, as has happened among the Siena.[3] As for collections in the rest of the world, they include an additional large category of misleading objects, namely fakes made in Europe on a large scale before the Second World War, though that industry may be said to have entered a decline when it became possible to procure them, with a greater show of authenticity, from the countries of origin. And in general it may be said that the great majority of genuine examples have passed through the hands of dealers and are therefore devoid of documentation.

The mere enumeration of these categories of works which our student must examine or exclude is enough to make it clear that connoisseurship in the chosen field is a prerequisite of successful research in tribal art – a connoisseurship not dilettantist like some in the European past but having regard both to universal values in art and to the specific tribal values. It is obvious that research based in part on unrecognized fakes is vitiated at source, and will be at least partially discredited by discovery of this fact. But such expertise is not, it seems, within reach of all: just as some people are said to be 'tone-deaf', so some appear to be 'art-blind' because they lack (whether the lack be biological or cultural) the faculty of intuitive appreciation. For it is not sufficient (though it is useful) to learn a series of specific formal criteria to distinguish fakes from genuine pieces; what is required is instantaneous intuitive recognition (to be followed up as necessary by analytical methods) of the qualities, including the authenticity, of the work. (He who appraises only by the letter and not by the spirit will be not only painfully slow in rejecting the irrelevant but also wide open to deception, since it is precisely the letter which the studious forger can successfully reproduce, whereas the spirit requires a creative artist.) Nor can the student sidestep the requirement of connoisseurship by confining his attention to works which he can find actually in traditional use by his

tribe, unless the tribe is one of the very few remaining in which an adequate range of its most characteristic work still exists *in situ*.

But the elimination of fakes and other dubious pieces is of course only the preliminary qualifying test of connoisseurship, though even this calls for a fair amount of experience in the field and the museum. We can all agree that fakes should be eliminated from our universe of discourse, and I have introduced them only to show that even at this lowly level the student's subjective judgement is needed and should be used. The next, and doubtless more controversial, step in the argument is the proposition that intuitive discrimination in point of quality among the available genuine works in the tribal tradition is equally indispensable if they are to yield their full value as anthropological data; and specifically that the finest works are of much the greatest value in any attempt to interpret the art of the tribe. The range of quality will normally be very wide, from a few works of top quality through a mass of competent work to those which, while technically complying with ritual prescription, can only be described as bad art. This variation of quality will be especially great among the peoples most prolific in sculpture, such as the Yoruba, since the number of carvers who could make a living at it greatly exceeded the number who had a special aptitude for it; a carver's son, himself innocent of natural genius or talent, would almost inevitably be taught the craft in order to help meet the demand, whereas unrelated apprentices of the master, prompted by a real vocation, would be more likely to produce creative work. There may well be a million or more Yoruba sculptures extant, and of these a fairly small proportion are works of real genius, fit to stand with the greatest works of African art, whereas a far larger number, perhaps the majority, are by comparison naïve and uncommunicative, conveying nothing beyond their overt subject-matter. I do not claim that the student's exercise of his subjective judgement is necessarily to be accepted as a mystery, beyond reach of analysis and study. But if we discern in it more than one process, we must not suppose that they are really discrete in practice; our analysis is purely expository, and does not detract from the instantaneity of the flash of insight. I think, then, that when a student has become proficient in the *métier*, his judgement may be seen as falling into two main parts (though which, if either, should be placed first I do not know). Let us suppose him confronted by a masterpiece for the first time. He will at once see that the artist has *succeeded*, that he has solved his problems and done what he has set out to do. (Even when a great artist is engaged on some transcendental religious work, the communication between brain and hands must surely

be concerned above all with concrete and material problems of form.) And he will see also that those problems are problems of *sculpture*. The first criterion is incomplete without the second because it is possible to be completely successful in a misguided enterprise, as when a skilled carver for the tourist trade produces a photographic (one might almost say pantographic) likeness of his subject. Even in naturalistic art the true sculptor is likely to be thinking in terms of stylization, of introducing regularities by heightening emphasis on one feature, reducing it on a second, perhaps suppressing a third altogether.

Visual art, like music, is a form of communication and is concerned especially with communicating the ineffable, that is truths, values, feelings, etc., for which the normal channels of communication such as speech are unavailable or inadequate. Art in Africa, as in medieval Europe, was primarily inspired by religion, and its prime purpose may similarly be assumed to have been to evoke, and associate with worship, the deeper levels of spiritual feeling. We may reasonably regard the different methods of communication open to man – through which alone he can be known, studied, and understood – as a continuum or spectrum, encompassing the spoken and the written word, the drama, music and the dance, and the visual arts. There should not be a pale beyond which some part of this continuum is considered inaccessible to 'the study of man' – especially if it is the part through which man can express himself most freely, most directly, and most profoundly. These means of communication – poetry, music, dance, art – must be penetrated chiefly by the divination of the subjective judgement, which cannot for example give equal weight to Robert Burns and the Great McGonagall. And this faculty of qualitative discrimination between banality and genius in the interpretation of the nature of things becomes preeminently indispensable in the arts which are beyond words, such as sculpture, and which must be 'read' directly, without the intervention of words. For the mediocre artist simply does not have the creative ability to conceptualize through form the most important truths of art which are also (I divine) the most important truths about his society. The student cannot 'read' what is not there, and in the case of poor work the sculptural forms will be so vague and 'blind' as to be unreadable. I am not here despising the study of mediocre or even bad art, from which a great deal can be learnt, but I do suggest that one of the main uses of such art is to provide a frame of reference within which can be identified and evaluated the work of the master artists who alone have the power to embody the quintessential values of the community.

Everyone who is familiar with tribal art will be able to think of countless examples to support the foregoing paragraphs, works

which manifestly do or do not communicate, which do or do not realize the artistic and religious possibilities of the type. What I think a particularly telling illustration is afforded by a pair of small wooden standing figures collected by P. A. Talbot before the First World War in western Iboland (Pl. 1). Although he failed to document them, it is perfectly clear that they come from the same place (probably a village in the Owerri district) and had the same ritual purpose; they differ only in that one is by a poor carver, who has managed little more than the minimum called for by ritual prescription or convention, while the other is by an artist of genius who has achieved a small masterpiece of Ibo art. If we imagine them enlarged, the former would seem more and more painfully banal, the latter would increase in power and effect, its forms so bold and sure that even a twelvefold enlargement to a height of six feet would show no weakness. And above all, the sculptural forms of the second are clearly significant.

Philistines (of whom there are a number in anthropology and the other social sciences) often naïvely argue, bowing to the prohibition on value judgements, that it is useless to try to apply artistic criteria to the arts of the tribal peoples because these peoples simply do not have the concept of art. In fact, of course what they do not have is the *literary* concept of art which has dominated western art in the last two centuries and is associated with the rise of aesthetics (which etymologically *ought* to be about feeling) – a concept which is at war with the very nature of visual art. The philistine case is, paradoxically, destroyed precisely by the fact that the tribal peoples express their concept of art not in language but in art itself (a super-language). Even the Greeks, for all their preoccupation with verbal analysis, seem to have apprehended this, having no separate word for art in our sense but making do with the word for skill of all kinds (τέχνη).[4]

We should here say a word on the much belaboured question of whether there are universal values in art. All those who are able and willing to use an informed subjective judgement on the problem *know* that universal values exist. Those who restrict themselves to the objective judgement, on the other hand, are almost necessarily in doubt on such matters. Even they, however, may be influenced by such statistical experiments as that on Bakwele masks reported by Child and Siroto (1965)[5]: a comprehensive collection of photographs of these masks was first placed in order of merit by a group of art pundits at Yale and then submitted to various Bakwele groups – who achieved a remarkable degree of concordance with the Yalemen. Where discrepancies appeared, reasonable ethnographical or technical explanations seemed to be available. For while these universal values may be said to have absolute validity, they are veiled for

d art and bad.
nall Ibo carvings
" and 7") collected by
Talbot before 1916 –
tly from the same
 in the Owerri region of
a and from the same
 is suggested that,
gh both figures contain
ne ritually prescribed
ts, that on the left is a
piece of expression
bly of ideas connected
ynamism and the life
 while the other is by
rison a naïve failure to
unicate, in artistic and
y anthropological terms.
rtesy of the Trustees of
itish Museum

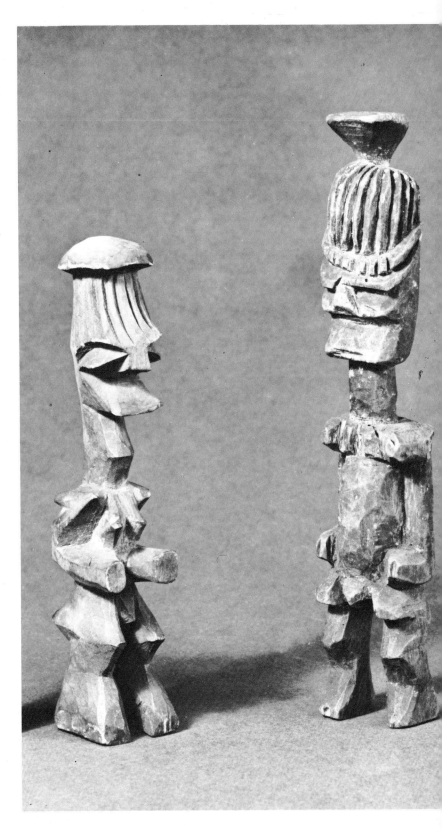

2 Buffalo head-dress mask, Mama tribe, Nigeria. This and the succeeding four photographs (all taken in the exhibition of African Sculpture at the National Gallery of Art, Washington, D.C., 1970) have been chosen to illustrate a large group of artistic forms, all associated with the exponential curve, which are commonly found in the art of tribal societies but rarely in that of civilizations. In this piece (from the Nigerian Museum, Lagos) the imitation of the natural curve of growth is well maintained in spite of the fanciful treatment of the horns, while the rest of the head is reduced to a slender projection for the mouth

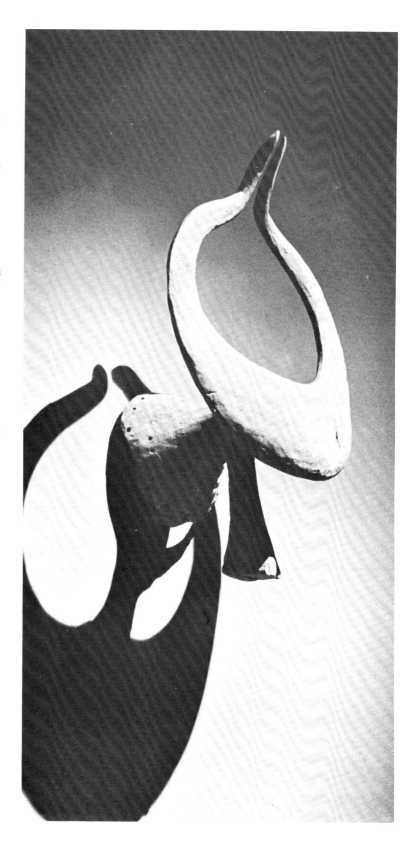

sk, Bakwele tribe,
– Brazzaville.
one of the finest of
ele masks (in the
tion of M. Charles
, Paris), would by some
arded merely as an
ple of 'the heart-shaped
But the stylized horns
aps of a buffalo or a bush
meeting below the chin,
it clear that the human
conceived under their
nce in terms of paired
ential curves

4 Head-dress mask by Ochai
of Otobi, Idoma tribe, Nigeria.
Collected for the Jos Museum,
Nigeria, by Professor Sieber,
this is probably the
masterpiece of Ochai's
surviving work. It was
conceived by him not in any
previously known mould but
as an entirely new work
designed to give full
expression to his originality.
Its co-ordinates flare upwards
and outwards like those of an
explosion or a flower. Only
brief reference is made to
horns, but the exponential
principle was evidently used
instinctively by Ochai
throughout the main forms

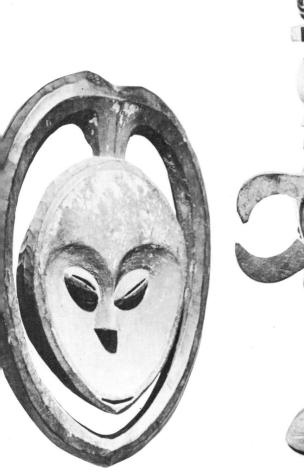
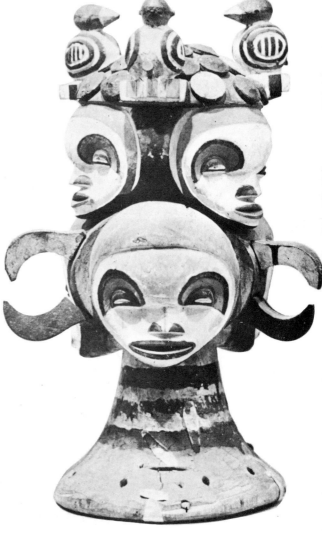

most people by their cultural preconceptions. The western art world may now, as a result of the influence of Malraux and others, be said to be completely eclectic and 'open' in the sense that none of the world's arts are barred from our universe of art; at the other extreme are the tribal peoples of Africa and elsewhere, whose art forms are so closely tied to the religious beliefs peculiar to them as to be of little interest or meaning for their neighbours, except where the relationship between any two or more tribes is itself undergoing a change. Thus cultural ethnocentrism operates as a barrier between African tribes to the appreciation of universals, while the traffic in them between the tribes and the western world is one-way: that is, the enlightened and omni-competent art-loving westerner can in theory appreciate the universals in the art of each tribe, which presents so to speak a window in his direction but, more or less, a blank wall to other tribes.

In this paper we are concerned especially with the problem of meaning in African art. It will clarify thought if we observe the distinction between (1) subject-matter, or overt content, (2) subject, or real content or meaning, and (3) style. The first and the last of these are often confounded (as when, for example, the Yoruba convention of the mouth as two parallel bars is regarded as an element of style rather than of subject-matter – though it is of course a useful concomitant of style and is quite properly used to identify Yoruba works). But it is the second that is our quarry, and this is, at least for the ordinary man who is not an artist, something far more fugitive and volatile. It tends to be expressed through a subtle synthesis (as is the nature of art), which if subjected to objective-analytical study, simply disappears. The ethnographer who does not wish this to happen must equip himself with other, more subjective tools – which he should not hesitate to regard as a necessary part of ethnography.

We should not allow our attitudes towards tribal art to be too much coloured by one of the major wrong turnings taken by revolutionary modern art and its expositors from quite early in the century – the 'liberation' of artistic form from content or subject. (We may note in passing that this left form and style very much at the mercy of fashion, which is no doubt how they became commercially manipulable.) The point is that if the ethnographer is going to seek help, as he must, from artists, there will be little profit in approaching those artists who are still floundering down this cul-de-sac. For our great need is to study form not only in itself but as an expression of subject. (All the anthropological-sociological studies so far undertaken of 'art in society' seem to have been really concerned more with 'society around art', since they stop short of entering the field of art

itself – although some few of them, such as those of Edmund Leach, are written with considerable understanding of art and sometimes even succeed in the limited objective of capturing certain small areas for sociological explanation which had previously been assumed to be within the province of art.)

The study of meaning in African (and, more generally, in tribal) art is at a rudimentary, not to say primitive, stage. Collectors have generally been content at most to record the overt content (such as 'figure of a woman with two children'), or if they do more ('the earth goddess') are often merely reproducing European conjectures. These, however, are still within the realm of subject-matter, whereas meaning or real subject is to be looked for within the realm of ideas, which are the province of philosophy. It is in this crucial field of tribal philosophy that our pilgrim in search of meaning in art finds himself face to face with a virtual desert, a dearth of knowledge which is in many cases so absolute that he can apprehend intuitively more philosophical propositions from his study of the art alone than can be verified from the published literature of the tribe concerned. Here, as with tribal history among other subjects sometimes thought autonomous, we should note that a philosopher equipped only with European philosophical systems will be of little use in filling the lacuna; an anthropologist trained in philosophy, or at the very least a philosopher who has seen that he must master the anthropology of a tribe before he can apply philosophical methods to it, is needed, for philosophers are peculiarly prone to the harbouring of the preconceptions of 'civilized' society. It is a pity that full and detailed accounts of the philosophies of tribes are almost universally absent from the many excellent anthropological monographs which have appeared in English since the war. But anthropologists traditionally distrust the philosophical approach as at least in part speculative, and it is perhaps another way of making the same point to say that the pragmatic preoccupation of British social anthropology with 'problem-orientation' does not encourage holistic studies of tribal philosophies. (There may therefore be more profit for us in formulating problems which are of interest both in art or material culture and in social anthropology than in crying for the moon.)

It is a little disappointing that there seems as yet to have been little help forthcoming from African students of traditional African philosophy among peoples known for the practice of visual art. There have of course been the admirable studies by Kagame of Rwanda philosophy;[6] the Rwanda are without sculpture – and the philosophical 'nerve ends' which might otherwise connect with sculptural forms and ideas may have been distorted, or never have developed in other directions – but

5 Altar of the Hand from the Onitsha Ibo, Nigeria. This is an *ikenga* (lit. the right hand and lower arm), the cult of which is widespread in the Lower Niger area; it is in the collection of Mr. Harry Franklin, Los Angeles. The essential feature of any *ikenga* is a pair of horns, in this case attached to the head of the central figure. The knife and ivory trumpet held in the hands are given more than natural curvature, as is the seat, and growth curves also issue gratuitously from the ankles

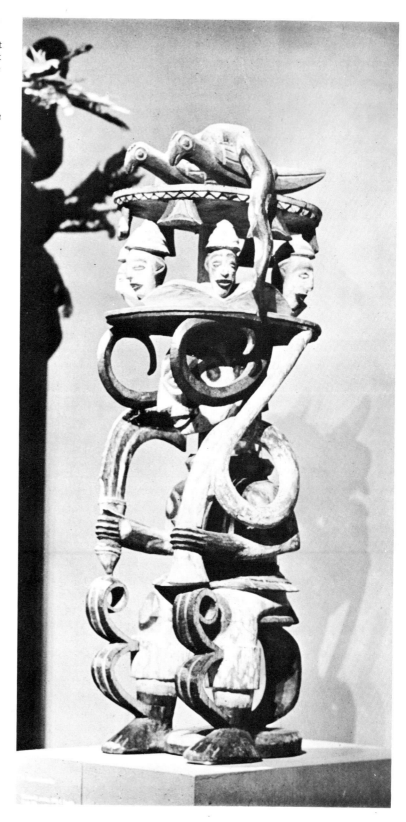

it is important as tending to confirm for us the broad lines at least of the Belgian Father Tempels's account of philosophy among the Baluba,[7] among whom sculpture is, or was, very important indeed. Unfortunately, Tempels's rather short summary does not go into much detail on matters of specific sculptural interest, though the general thesis is most important for anyone seeking a working hypothesis to use with tribal art. It is of course entirely understandable that African scholars, as part of their alienation from their tribal societies, are prone to adopt rationalizations ('compatible' with western ideas) of their tribal beliefs, the original meanings of which are thus obscured or negated. Ontological beliefs, which are of course particularly relevant to our needs, are especially fugitive, and because they are usually latent, probably at subconscious level, presumably call for psychological techniques not usually in the equipment of anthropologists. But do such techniques exist for use in tribal or immediately post-tribal societies such as those of Africa?[8] My own working hypothesis, first formulated in 1953–4, has been best expressed in my *Nigerian Images* (1963, pp. 122–4), but since this book has been out of print since 1965, I must beg leave to quote liberally from it. The language in which it is written is scarcely that of a symposium paper, but this will I hope be taken as a sign of grace, making as clear as possible its hypothetical character.
If we search for some common ground between the tribal arts of Nigeria, we find ourselves forced eventually into the realm of broad philosophical conceptions – a realm in which we cannot avoid a certain amount of informed speculation, since it has yet to be probed widely and deeply enough by the methods of inductive science . . . and I must ask the indulgence of those who feel that we must wait for the replacement of informed conjecture by scientific knowledge before we form theories on this subject – even if this means the prior disappearance of those systems and the art which they have inspired. Let us not suppose, however, that if we seem to discern some common basis of belief for the Nigerian arts, we are thereby approaching the isolation of a specifically Nigerian quality, or even a specifically African quality . . .; for this quality, whose many forms may be subsumed under the term 'dynamism', appears to be present in the philosophical systems of all the peoples of the world except those of the 'higher' or industrial civilizations, who seem always to have abandoned or devitalized it as a precondition of embarking on the path of materialistic progress and the mastery of nature. Indeed, since systems of this kind seem to have been in use among all the tribal peoples at the time of their discovery by civilization, we may be justified – strictly by way of hypothesis – in extrapolating into prehistory and suggesting that before the first development of civilization in the Near East they formed part of the universal condition of man. It is a characteristic of such systems that man treats himself as an integral part of nature,

always seeking to adapt himself to it and to work with it, so to speak, whereas man in civilization sets himself apart from nature and sets out to tame it and bend it to his will. (Hence, paradoxically enough, the European 'love of nature', surely in some measure a conscience-stricken response, but one which by its very overtness defines the detachment of man from nature; and hence the curious European impression that tribal Africans do not 'love nature' which arises simply from the impracticability of discerning relationships within a unity.)

Of all the thousands of pre-industrial tribal philosophies in the world, it is unlikely that any two will ever be found identical; yet in this one fundamental respect they would seem to be all alike, that their ontology is based on some form of dynamism, the belief in immanent energy, in the primacy of energy in all things. That is to say that whereas civilizations see the material world as consisting of static matter which can move or be moved in response to appropriate stimuli, tribal cultures tend to conceive things as four-dimensional objects in which the fourth or time dimension is dominant and in which matter is only the vehicle, or the outward and visible expression, of energy or life force. Thus it is energy and not matter, dynamic and not static being, which is the true nature of things. This conception is more readily intelligible to those versed in modern physics than to other Europeans, and indeed it would appear, at least when stated in this summary form, to be closer to the objective scientific truth than is the static conception of matter by which we live. By itself it might be of academic rather than practical importance in the study of tribal culture and art, but its corollary – that this force or energy is open to influence by man through ritual means – is the very basis of all tribal belief and observance. Given these premises – which themselves are not to be lightly dismissed – all these tribal systems are found to have been worked out in a remarkably logical and internally coherent manner, so as to provide complete explanations for all phenomena. When properly understood, these systems are intellectually satisfying, but they are the products of intuitive sympathy (or better, empathy) with nature; and it is this intuitive element which is sacrificed at the birth of civilizations in favour of an intellectual simplification of nature in order to bring it under man's practical (as distinct from spiritual) control. At that point, as in early Egypt, dynamistic beliefs wither away, or are rationalized in terms of the new geometry, and the art forms which they inspired tend to become static in sympathy.

In most tribal systems it would seem that the source of all the life force of the world is the Creator, a generally remote being who is not always the object of worship, and whose function may perhaps be loosely compared with that of the queen ant in a nest of termites. The channels through which the force passes to man and the material world vary from tribe to tribe: in many cases there are high gods such as Shango, the Yoruba thunder god, or Ala, the earth goddess of the Ibo; in others there are lesser nature spirits; in others again the tribal ancestors – whether the mythical original ancestors as among the Afo and the Tiv, or immediately recent and genealogically traceable

mask, Zavara Gurunsi
Upper Volta.
ask (in the Musée
al de Haute-Volta,
dougou) transcends the
y somewhat pedestrian
of Gurunsi and
Ule or Bwa masks. Once
the whole mask is
ved in terms of a system
onential curves, tightly
nd flaring upwards in all
ions. The mask is said to
ent an aquatic bird, but
ld be surprising if there
not some reference to the
ill

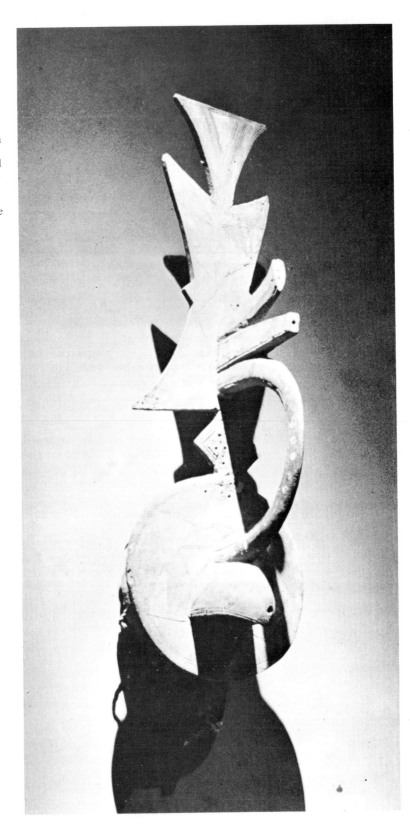

ancestors as among the Bini – are a main source; or it may be drawn upon more directly by means of 'fetishes'; or several of these and other channels may be in use in a single tribe. The purpose is in all cases the same – the procurement of increase of force, necessary for the propagation of the race, the means of subsistence and the ability to cope with life.

The arts in Africa are no mere decorative embroidery on the fabric of religion; they are a vital part of the process of the generation of force. This becomes especially clear if we consider dancing, a universal African art closely related in several different ways to sculpture (the distribution of which is largely confined to the great basins of the Niger and the Congo). For there is strong reason to believe that in tribal society all dancing, whether sacred or profane, is held to increase the life force of the participants, that a person in stylized movement is *ipso facto* generating force, which can, moreover, be physically passed on to others by a laying-on of hands (as I saw done most strikingly in a women's cult dance at Ilesha in Yorubaland). There is no doubt that much tribal dancing is 'recreational', but this word itself is a clue to its function in the recreation of force. The power of the dance is greatly enhanced within a context of ceremonial control, as at the annual festival of a spirit (when the generated force can be ritually harnessed for the community, and not allowed to 'run wild' in a way that can cause dangerous pollution, as though from a faulty atomic reactor); it is especially great when a trance state, or 'spirit possession', is achieved – and the sight of this condition must seem a powerful confirmation for dynamistic belief. Above all, the addition of sculpture in the form of masks raises the intensity and efficacy of the dance to the highest degree, and masks, though seen in museums in unnaturally static form, must always be thought of in their dynamic context. They are in fact designed as mobiles: in the Epa festivals of north-east Yorubaland the grotesque face of the mask proper suddenly becomes dominant in a most unexpected way over the more naturalistic figures above it.

Aspects of the concept of increase provide the subject not only of the masks but of figures and of virtually all African sculpture, as is notably demonstrated in Nigerian art; of all the sculptural forms given to the concept the most striking is the exponential curve described in the growth of the horns of rams and antelopes, the tusks of elephants, the claws and beaks of birds and the shells of snails. Such curves are by their nature a record of growth in time, and sculptures based on them, though having only three dimensions, convey the fourth as well; it is by this means above all that they are given their remarkable intensity and sense of movement and their deep affinity with the dance. It is certain that tribal peoples, with their profound understanding of nature, see in these animal excrescences potent symbols of growth. Sometimes the artists incorporate actual horns in sculptures; more often they carve them more or less realistically but almost always emphasizing the exponential character of their curves. But they go far beyond this in composing whole sculptures under their influence; and it is no wonder that modern artists, deeply moved by their intensity and

directness, have failed to rival them because of the inaccessibility of their informing belief.

The last paragraph (which has been more or less elaborated in various other places)[9] is of course intended not as a complete explanation of the phenomena, but as a contribution to the understanding of one group of African (and, generally, tribal) art forms which was most obviously present in tribal and absent from 'civilized' art. This was borne in upon me with great clarity by my first reading of that masterpiece *On Growth and Form*, by Sir D'Arcy Wentworth Thompson[10] – a fit man to bridge the sciences and the humanities – at the suggestion of the late Professor H. J. Fleure, F.R.S. His two long chapters on the exponential curve or equiangular spiral and its implications are an apocalyptic experience for that great majority of Europeans who are not advanced mathematicians, physicists, or certain types of biologists. I fell to wondering how the whole literate culture of Europe, with its art, had been able to dispense with so significant and beautiful a segment of nature, and indeed to develop a blind eye for the curves of growth. And at the same time I was amazed, once I knew what to look for, at the enormous profusion and endless variations of such curves to be found among all peoples of the tribal world who have practised art.

I have been only too well aware, in searching since then for evidence bearing on my hypothesis, that it (like the tribal religions themselves) is a closed, self-supporting system, and that it would be easy, by concentrating on the more favourable facts, to erect an ever more satisfying theory, which eventually would become far more than a theory – the path of the Lost Continent of Atlantis, the Great Cryptogram (or Bacon is Shakespeare), and Galloping Diffusionism. By way of prophylaxis, I have always tried to collect against the grain, seeking facts and specimens above all which appear to conflict with my hypothesis, and begging others to do likewise. But alas, none of the objections which I have thought that I had found have survived closer scrutiny, and as to others, they have either tended to give more or less mild approval, or have confined their criticisms to a generalized amusement. To these last, especially, I would like to say sincerely that I am anxious to test my hypothesis, or have it tested by others, to destruction, in the confidence that something better will follow.

The purpose of this paper has by no means been to advocate unrestricted or uncontrolled use of the subjective judgement in the anthropological study of art, but it must be given its place ungrudgingly whenever it is demanded by the nature of the phenomena under study. The least of our fears should be that we shall need to separate off subjective from objective writing, and

keep them in watertight compartments; for the English language, if only it be properly used, provides perfectly adequate means of discriminating them, even when they occur within a single sentence.

A final advantage of admitting art to closer communion with anthropology is the fact that anthropologists will have no need to try to define art (as they may some day succeed in defining 'culture'). To define art or its boundaries would be an impiety if it were possible (and would be ludicrous if attempted by the intellect alone). The artist is a seer, and makes his own rules (the grammarian, the scholiast, and the art critic perform only the menial task of codifying them). Perhaps we may finish with a pseudo-definition: 'art is what artists do'.

NOTES

1. Though information about one small tribe, the Bangwa, who produced some of the finest of all African sculpture, has been rescued in the nick of time by Robert Brain and Adam Pollock (*Bangwa Funerary Sculpture*, London, 1971).

2. In using the word 'superficial', I am far from wishing to underrate the value of those exceptional studies, by Leach and one or two others, wherein artistic phenomena are given sociological explanations of great ingenuity and penetration; these have sometimes displaced 'artistic' explanations, but I do not think them capable of bearing upon more than the subject-matter of art.

3. I now prefer the term 'Siena' (following M. Delafosse) for the congeries of tribes more usually known by the Baule name 'Senufo'.

4. Conversely, it may be relevant to note that modern artists in the western world have in the last decade achieved a form of 'art' which is, for the most part, completely describable in words and/or mathematical formulae; it is a moot point whether 'op art' retains any content of art – as opposed, perhaps, to aesthetics – at least in any sense other than that of decorative art.

5. I. L. Child and L. Siroto, 'Bakwele and American Aesthetic Evaluations Compared', *Ethnology*, vol. 4, no. 4, 1965.

6. Alexis Kagame, *La Philosophie bantu – rwandaise de l'être*, Brussels, 1956.

7. Placide Tempels, *Bantoe-Filosofie*, Antwerp, 1946; English trans. *Bantu Philosophy*, Paris, 1953.

8. Too often, psychological studies of Africa seem still to be a vehicle for ethnocentric preconceptions, such as one particularly prevalent among Freudians to the effect that phallic cults are a part of tribal society, whence they probably spread to the civilizations, whereas almost the opposite is the case: tribal increase cults (which are not normally phallic cults even when the human penis is represented or used) are manifestations of more generalized concepts of force and its increase, that is of the tribal philosophy, in which they generally do not play any exaggerated part. Civilized phallic cults, on the other hand, have become ends in themselves for intellectual and dilettantist 'underground' movements – although some of them may be descended from tribal practices taken out of context, just as Hinduism was presumably based in part on an intellectual exaggeration of the ancestral cults which preceded it.

9. See for example E. Elisofon and W. B. Fagg, *The Sculptures of Africa*, London, 1958, pp. 24–5, and W. B. Fagg and M. Plass, *African Sculpture: An Anthology*, London, 1964 (new ed. 1970), pp. 148–58.

10. D'Arcy Wentworth Thompson, *On Growth and Form*, 2nd ed., Cambridge, 1942.

CHAPTER 10 Style and Meaning in Sepik Art

Anthony Forge

The Sepik river area has long been recognized as one of the finest art producing areas of the primitive world; the art of the various cultural groups which live there have many stylistic features in common. There is in fact a whole series of stylistic features in common to all the groups, but some of these features are developed and exploited in one area while remaining latent in others. For example the *Yi'pon* figures of the Arambak peoples of the Upper Karawari and neighbouring groups on the southern tributaries of the Sepik stretching as far as the Hunstein mountains, have a style dominated by series of opposed hooks. These are beautifully carved and balanced and the rest of the carving is totally subordinated to them. The *Yi'pon* carvings (Pl. 1) have virtually no frontal aspect, being made to be seen from the sides; the only anatomical features clearly represented are the face and the leg, again dominated by the sideways view (only one leg is necessary), the face in profile is recognizably 'Sepik'.[1] The opposed hook motif can also be found in undeveloped form in other parts of the area, for instance in the Middle Ramu, the Yuat, and the Eastern Abelam, very considerable distances from the Karawari. I have no suggestions as to why the Arambak should have selected this opposed hook element from the repertoire of Sepik motifs for special development, but it seems obvious that they did, and that they must have attached some special significance to it. In other parts of the area where opposed hooks occur the hook is identified as birds' heads and beaks (particularly hornbill), bone daggers, noses, and so on. There are two preliminary points I want to make. First, that within such a style area the various cultures, whatever may have been the 'origins' of their stylistic repertoire, develop their own styles for their own purposes. Second, that between cultures there is no necessary connection between motif and interpretation; whatever the opposed hook element means in Arambak it would seem certain that it is not now birds' heads or noses. A stylistic element or motif is developed because it means something to the culture that produces it and we can only find out why by a study of the culture concerned. But we should not dismiss the association of a style with a culture as something that just happens until we have exhaustively investigated other possibilities. I want in this paper to make a few tentative suggestions as to what these possibilities might be.

1 *Yi'pon* figure, Upper Karawari river. *Museum of Primitive Art, New York*

In most of the Sepik cultures there is one fairly coherent style, at least in carving, that is used throughout the art and makes a piece identifiable as a product of that culture. Style may vary geographically within a single culture, but within a village there is basically one style. Among the Iatmul of the Middle Sepik river, however, there are at least three major styles used in representing the face of humans or spirits with human-like faces. All three are to be found in all Iatmul villages and although the style of each of them varies geographically, the stylistic distinction between the three basic types is maintained in all villages. These three major styles are all represented in ritual objects, made and manipulated by initiated men, but these objects are also public in that all three forms are displayed to women and children at some stage during ceremonial. They are therefore in the middle-sacred range of art. They are not mundane for daily use, but they are not so sacred that they can only be seen by a restricted group within the total society.

The three types of face are:

1. 'Naturalistic' modelled skull type, actually modelled on skulls of dead ancestors and enemies; also reproduced in light wood and worn in the 'tail' of certain ritual performers.
2. A flat broad face used in most wood carvings and on the *awan* masks.
3. *Mwai* type masks, very long and narrow elliptical face with upswept eyes and long nose extensions ending in a totemic animal. (See Chapter 12 Pl. 4.)

There are several other styles of face to be found in Iatmul art, especially when painted on the flat, but these three are numerically the most frequent and the most important in public ritual contexts.

Although the distinction between the styles is maintained throughout the area there is also a universal expression of the essential unity of the three types, in that each style of carved face is painted in the same style of face painting, with its sweeping spirals and black circles. This face painting, which contrasts markedly with the 'herring bone' pattern of face painting used by the Lower Sepik groups, is applied to all three styles of face and to the faces of ceremonial performers. The facial features, eyes, nose, mouth, etc., have different forms and different spaces between them in each of the three styles, but the face painting pattern is applied to each so that its main lines fall in the same relationship to the facial features in all cases. Various authorities (Wirz, Speiser, Schmitz) have postulated different origins external to the Sepik for these styles. Be that as it may, postulated origins are not sufficient to explain why the Iatmul

maintain these individual, clearly distinct styles at the moment. It seems not unlikely that one could demonstrate some naïve functionalist hypothesis of the order of: these three styles would not persist and be sharply differentiated unless they served some function in the society. All three appear and are used in different ritual and social contexts. The *awan* masks as such are very clearly associated with the clan as a provider of other people's mothers and the function of male clan members as mother's brothers to non-clan members. The more aggressive and masculine aspects of the clans would seem to be expressed in the *mwai* masks which, with their long nose extensions and totemic animals, are the public representatives (junior analogues is Bateson's term) of the secret and sacred flutes and *wagan* heads, with obvious phallic associations. The modelled skulls are clearly linked to individuals, man as victor or victim. These three views of man are echoed in names, each Iatmul receives an *awan* name from his mother's brother, accumulates and then loses a series of patrilineal clan names as his powers as a man wax and then wane, and is also reputed to have a secret individual name.[2]

It is interesting that the separateness of styles is perfectly maintained only at the level of sacred objects that are nevertheless shown to the public; at a more sacred and secret level objects sometimes draw on more than one style. For instance a pair of fine carved wood *wagan* heads at Korogo village have faces of basically the flat face style, with a band starting at the forehead and ending at the chin, linked to the nose, and ending in totemic animals, which echo the *mwai* style. Similarly a mask of *awan* type, now at Basel, has a typical *awan* face at the bottom, but the top face is a modelled skull in which the jaw has been displaced downwards so that the face is long and narrow with a huge nose;[3] this object, in fact, has elements of all three styles. The skull is reputed to be that of Mwaim the elder brother of the fraternal pair of founders of Kararau village from which the mask comes. Although the mask was classified as *awan* its use was very restricted compared to that of the normal *awan*. This sort of material suggests that the three face forms may be correlated with Iatmul concepts of aspects of man in society, so providing a system that is codified and maintained by traditional sanctions at the level of public ritual, but which can be manipulated to express essential unities and esoteric fundamentals at a higher level of sacredness.

A recent study by Schefold (1966) of suspension hooks from the Middle Sepik in the Basel Museum, apart from its introduction of mensuration and statistics as a means of quantifying and objectifying the study of stylistic variation, shows that some sort of, what we might call, the dynamics of stylistic variation also

applies at the mundane level of utilitarian objects. Schefold also finds three main styles of face (since his sample is not restricted to the Iatmul, direct comparison is impossible) and he somewhat reluctantly comes to the conclusion that the styles must have had different origins. However, his pioneer study makes it quite clear that in the secular context of hook production artists draw with great freedom on the contrasting styles, combining and re-combining elements to produce variety without losing the reference to traditional and ritually sanctioned forms. It would seem that such freedom to vary and experiment is essential if any art, whether it be required to maintain ancestral forms for ritual purposes or not, is to remain vital and satisfying to the artist and his public. But among the Iatmul the secular carvings not only provide a source for the slow change in ritual style, but also may serve to represent other facets of Iatmul theology. For instance it would have been possible in any Iatmul village to produce a collection of suspension hooks which could in sequence show the gradual transformation of a human head with nose extension of the *mwai* type, through a bird's head with human nose, and ending with a bird's head devoid of human reference. It would seem likely that such carvings are statements about the relation-ship between man and the supernatural, particularly ancestors and totems. Similar subjects are the preoccupations of myth, invocation, and ritual generally, but there is no reason to suppose that they are all saying the same thing, or indeed that Iatmul culture gives the same primacy to verbal forms that we do, influenced as we are by our long tradition of writing as a means of communication. It is indeed the carvings, masks, and other ceremonial paraphernalia that persist and are the objects passed from generation to generation as the concrete embodiment of Iatmul culture in much the same way as books are in our own.

I have used the Iatmul material in outline above, though I do not have enough information to complete such an analysis, mainly because the art is well known and provides a clear example of what I have called the dynamics of stylistic variation. The main part of this paper is concerned with the less strikingly differentiated material from the Abelam, with whom most of my time in the field has been spent.[4] The Abelam are one of the largest groups speaking mutually intelligible dialects of a common language in Lowland New Guinea. They number over 30,000, live in large villages (300 to 800) and have a very high population density for their slash-and-burn horticulture (100 to 400 p.s.m.). The Abelam live on the foothills of the Prince Alexander Mountains about thirty to forty miles north of the Sepik river and the closely related Iatmul. They have a vigorous and still maintained art, dominated by polychrome painting; all carvings

are painted and in cult situations acres of painting on flat sheets of sago spathe are also produced. They have two distinct cults, that of long yams and that of tambarans. The ceremonies of the tambaran cult are held after the long yams have been harvested and displayed, and before the sacred gardens are prepared for their replanting. Both cults attach a great deal of importance to paint. It is the essential powerful magical substance of the yam cult, indeed all magical substances are classed as paint; and although the paint used in the tambaran cult is not intrinsically sacred or powerful, the final phase of tambaran ceremony preparation which is devoted to painting involves the observance of a whole series of taboos for the initiators. Painting in short is a sacred activity and the paint, although mundane before its use, under ritual conditions becomes the main means by which the benefits of the ceremony are transferred to the initiates, to the village as a whole, and to the villages of those who have assisted and attend the ceremony. It is not only the paint applied to objects that takes on this character, the face and body paint applied by the initiators to themselves becomes similarly charged by the ceremony and may only be removed after a due period with elaborate ritual precautions.[5]

Within the Abelam area there is a great deal of stylistic variation particularly in painting on the flat; there is also evidence, plentiful in the east, that there have been considerable stylistic changes over time. The neighbours of the Abelam have been heavily influenced by Abelam art and form a sort of fringe extension to the various Abelam styles. In passing it is interesting to note that those neighbours actually in contact with Abelam villages tend to copy in a rather slavish manner, but that further away elements deriving from Abelam styles are to some extent reordered and integrated into new styles. Thus eastern Abelam ceremonial house façade styles are 'abstract' in that they have no recognizable faces or indeed any element that by its form refers to any shape outside the closed system of painting. The Nugum groups immediately to the east copy these façades in every detail, but if one penetrates ten miles or so into Nugum territory the façades, although obviously related, show subtle changes, most noticeably the broadening of some of the 'abstract' forms so that small faces can be included, thus reintroducing an anthropomorphic element where the 'abstract' forms no longer have even the meaning, 'this is the way the Abelam do it'. The evidence for the Abelam being the exporters rather than the importers of style can be summarized thus: the process is still going on; the names attached to art objects are Abelam ones even though such names have no meaning in the language of the neighbours; the styles tend to be unskilfully used and their component elements

misunderstood within about five miles of the Abelam border while they often peter out altogether within ten to fifteen miles. The process is mainly but not exclusively one way; the huge southern Arapesh confederation of villages, Ilahita, which seems to have formed a bulwark against Abelam expansion to the north and west (most southern Arapesh villages average 150 population, while Ilahita is well in excess of 1,000), has elaborated an individual style of figure painting on the flat which is called *ŋgwal* (that is an Abelam word without Arapesh etymology) which is now being re-imported into some parts of the Abelam territory.

The geographical distribution of stylistic variation within the Abelam area has been somewhat modified by the imposition of peace following the founding of a government post at Maprik in 1937 (although there was Japanese occupation from 1942–5 and no real re-establishment of government control until 1948), free travel throughout the area is now totally accepted and big men or men ambitious to become big men have ties of friendship with villages that were unknown even by name to their ancestors. In this broadening of horizons, the northern Abelam round the government station have had a considerable advantage, they have benefited most from agricultural extension activities and have the most cash, while mission hostility to the traditional cults was in this area limited to argument and exhortation rather than the more extreme forms it took elsewhere in the region. In fact the area close to the station seems to have been the only part of Abelam where the orderly performance of cult ceremonies has proceeded without faltering since the war. But these non-traditional reasons for northern superiority are overshadowed to the Abelam by the fact that the long yams of the northern Abelam are longer than those of the east, south, or south-west. There are various factors which explain this difference, terrain, quality of soil, length of fallow, planting season, etc. To the Abelam, however, although differences of cultivation technique are not discounted, such consistent success implies superior supernatural techniques, and, since the success is general as well as individual, the superiority of the general ritual as well as the individual magic is believed to be responsible. This has led to a general move towards the style typical of the Maprik area more particularly in the east. In general then the northern and eastern Abelam are moving at the moment towards a single style both in façades and all painting on the flat, and in carving, the old eastern carving style, which only had heads of 'human' form, has given way to carving of full anthropomorphic figures.

Before recent stylistic changes the 'abstract' style of the east,

Fig. 1 *left*
Basic elements of the centre of a single ŋgwalndu face from a façade at Maprik village, north Abelam.
right
Basic elements of two 'man's hair' motifs from a façade at Wingei village, east Abelam. Both are repeated to form bands across the whole façade. Apart from the pointed oval (see below) present in the eastern example both designs are made from the same elements. The left hand one is representational, the right hand one is not. Although the latter has graphic elements closer to our conventionalization of eyes than the representational one, all informants denied they were eyes.

although to Abelam and our eyes totally different from that of the north, had in fact some formal similarities. The ŋgwalndu heads, which form the dominating bottom row of northern façades, (Pl. 2) are made up of pairs of elements which, taken separately, are very similar in formal structure to the units which strung together make the bands of painting on the eastern façades, and are identified as either man's hair or cassowary (Pl. 4). In the east it is quite clear that no form of figurative intention is present; any suggestion that the central feature might be eyes was vigorously repudiated by easterners, they were *mbia* (belly, or alternatively the whole trunk); how man's hair could have a belly they were unable or unwilling to explain.

Such formal similarities can be demonstrated between other motifs of eastern painting and the northern 'figurative' style. But the dichotomy between north and east that I have been making is basically misleading. I call the northern style 'figurative' solely because among the elements included in virtually every painting are certain ones which the Abelam consistently identify as the eyes, nose, and mouth, of whatever is being represented; ears are less frequently included, but perhaps the most important and constant of all is the *wakan,* a huge red feather head-dress with a white U-shaped mark near its peak, which is an inevitable feature

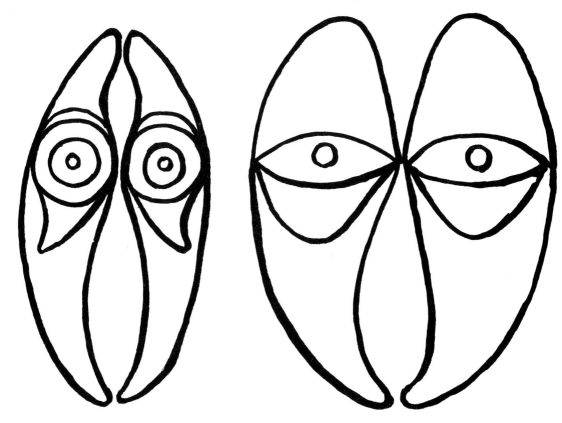

of any northern painting of anything in anthropomorphic form. Both styles are arrangements of elements in satisfying patterns, there are in each style constellations of elements that are named *ŋgwalndu*, man's hair, flying fox, etc.; other constellations with some of the same elements have different names. Each constellation may be used in series to form a band on the façade of a ceremonial house, or separately as panels of the initiation chamber inside the house. These identifications are little more than a handy reference system used by the Abelam themselves, there is no attempt to explain why things are represented in a particular way, nor is there any attempt to express stylistically any relationship between the two-dimensional paintings of *ŋgwalndu* on the façade with the three-dimensional carvings of *ŋgwalndu* inside the house. As I have argued elsewhere (Forge, 1970), two-dimensional painting for the Abelam is a closed system having no immediate reference outside itself and certainly not to the three-dimensional painted carvings; except in the essential theological point, also made by the Iatmul in the same manner, that whether painted on the flat or on three-dimensional carvings, and regardless of the relative disposition and size of nose, mouth, and eyes, the face painting style used is basically the same; and identical to that used by initiators during ceremony, and that used on the carved wooden masks attached to the heads of the displayed long yams. This single face painting style provides an expression of the fundamental unity of the trinity, man, yam, and *ŋgwalndu*. Apart from this theological point it is also obvious that any closed communication system must have in addition to diversity and opportunities for manipulation, certain unities to mark it off as a system.

In painting on the flat, except for the well known and ritually essential motifs of the ceremonial house façade, artists frequently refuse to identify what they are painting until it is finished. At first I thought this was just bloody mindedness, but for various reasons became convinced that they frequently just start with a few of the forms of their two-dimensional 'language' and see what it suggests. I have also recorded cases of artists who, having decided half way through that they were painting X changed their minds and made it Y at the end. In other cases artists who have co-operated on a painting argue about what they have painted even after it is finished. The point here is simply that the names are not of importance to the artist. What it seems to me is important is that a whole series of elements, collectively and individually charged with sentiments associated with ritual, secrecy, and power are manipulated to make effective communication, the impact very definitely being enhanced by the aesthetic effect.

2 Bottom of ceremonial house façade, *ŋgwalndu* faces. Bugiaura ceremonial ground, Yanuko village

The presence or absence of figurative elements in contemporary Abelam styles is possibly misleading for another reason. In many areas now using figurative designs there is evidence that not very long before, the style may have been less figurative. Such evidence is to be found mainly in engraved objects, bone daggers, and coconut shell bowls. Engraving throughout the area is in the flat painting style and not the three-dimensional carving style. Engraved objects last on the whole much longer than paintings, this is particularly true of the treasured bone daggers. In most villages, if one can see twenty or thirty bone daggers, one can find quite wide variation between figurative and abstract styles. Daggers from the same village show engravings of *ŋgwalndu* in exactly the style to be seen on the façade, as well as daggers totally covered by three sets of concentric circles, said to be eyes and mouth, and also unhesitatingly identified as *ŋgwalndu*. In fact, even though the concentric circle degree of abstraction is not found anywhere nowadays, much abstraction is to be found even in those areas where the ceremonial house façades appear to us totally figurative. Among the northern Abelam, where the red *wakan* head-dress forms a part of almost every design, it is used to 'anthropomorphize' and relate to the world of spirits, objects of ritual concern that are not themselves spirits. Plate 3 shows such a painting. In it the volute element has been repeated and manipulated to form the eyes, nose, and mouth of a *ŋgwalndu*-like face, topped with a row of hibiscus blossom, a dog tooth ornament, and the *wakan* head-dress. The body of this being is almost circular, the arms and hands, legs and feet are clearly marked, the rest of the panel is filled with a pattern of volutes. This element was identified by the various holders of the ceremony at which I saw it as an immature fern frond, legs of pork, or swirls in a river, the artist when appealed to said any one or all of these were correct as far as he was concerned.

3 Painting displayed at Maŋgəndu ceremonies, Wambundu ceremonial ground, Kwambikum village

The use of a head-dress and accompanying ornaments to indicate membership of a class, is a simple iconographic device, similar to identity of face painting style in both Abelam and Iatmul art, but is restricted to the northern part of the Abelam area. In the east heads as we have seen are almost unknown in the flat painting style and there is a corresponding rarity of head-dresses. In the south-west, an area of very high population density containing about half of the Abelam and always called the Wosera, heads occur but not with any great frequency. Head-dresses are however more common, often appearing on their own (Pls. 8 and 9) without any sort of head or facial features shown, or as in Pl. 5 with the head totally absorbed into the head-dress and only partial facial features indicated.

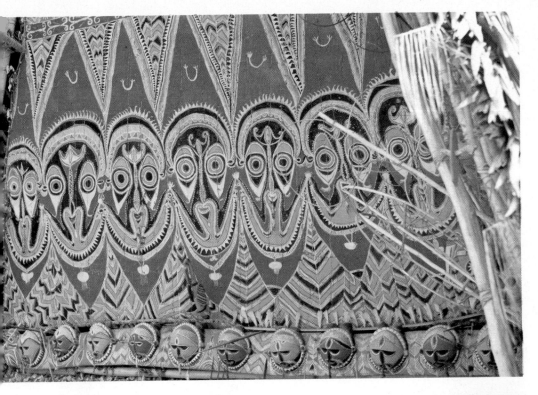

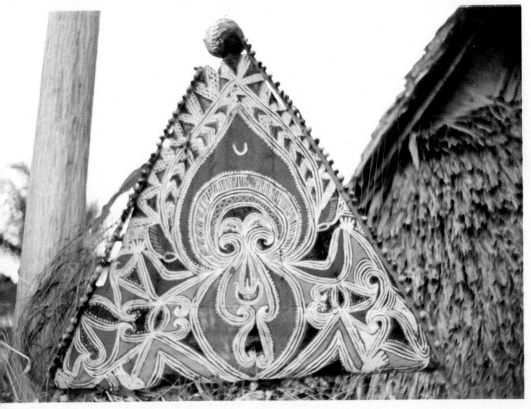

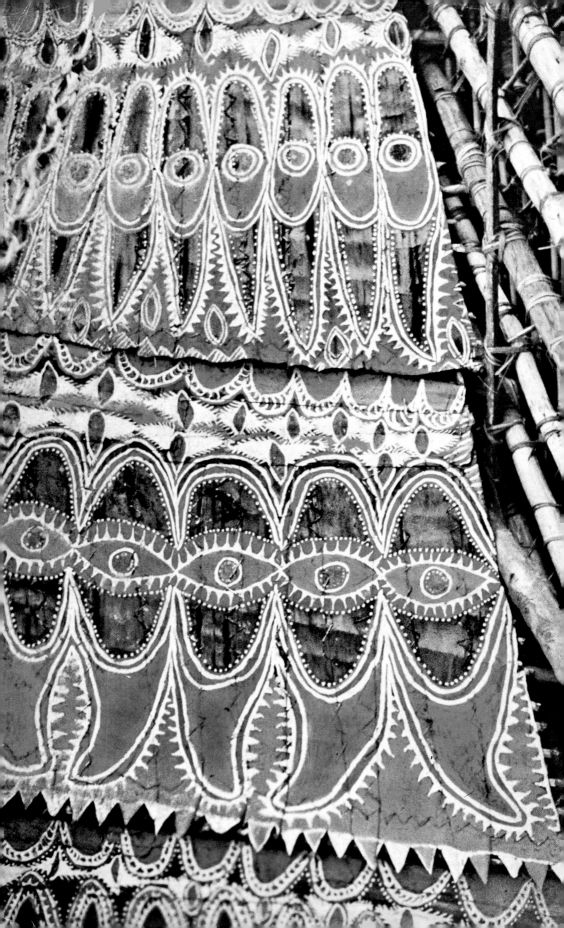

Fig. 2

In these areas the omnipresent feature is the pointed oval identified in the east as *mbia* – belly, in the Wosera either as *mbia* or more directly as *asa* – mother. The *mbia* is also universally present in the northern style, but tends to be overshadowed by the representational character of the paintings. In Plate 3 two *mbia* forms can be seen joining the elbow and knee on each side of the figure. It is quite clear from many discussions with informants that *mbia* has connotations of the fecund maternal belly even in areas where the alternative name 'mother' is not applied.

I have already made it clear that our dichotomy, abstract versus figurative or representational, is misleading at the very least in Abelam terms and I now wish to analyse a set of paintings from one village which includes both types in one corpus. My aim is to show how Abelam artists handle the elements of their flat painting style and manipulate the different bits and their relationships to create association and relationships between disparate valued aspects of their culture.

The paintings to be considered are on paper provided by me, using tempera water mixed paint in the four colours that corres- pond to the basic earth paints. The recording of traditional designs was a problem that I tried to tackle on a large scale during my second field trip; the details cannot be given here, but the method was basically to provide artists with materials as close as possible to their traditional materials – black paper for sago spathe coated with black mud, and powder tempera colour instead of powdered earth paints – and leave them to mix the colour to their preferred consistency (very thick), and provide their own brushes. The shapes of the pieces of paper were also traditional – oblong and triangular. Although they were smaller in size than traditional surfaces used for ritual purposes, few artists had any problems with scaling down the designs. All the paintings illustrated here come from the village of Kwanim- bandu in the north Wosera and are part of a group of more than one hundred and fifty paintings from that village which I collected in 1962–3. As far as I can tell this collection exhausted the traditional repertoire of all the artists in the village. As there was no ceremonial house in the village they were all painted on the veranda of my house with barricades placed at each end to exclude women and children. These precautions were taken seriously and I had to promise to show the paintings to none but fully initiated men while in the Abelam area. When a young man dropped one of the brushes used to paint fine lines, which are themselves secret, through the slats in my floor, there was an outcry and a demand that he should provide a pig as a fine for having created a situation in which a woman or child might have

ern Abelam façade
Rows of 'man's hair' and
ary. Mbalwara
nial ground, Wingei

seen part of the male secrets. Although there were no sanctions available to enforce the demand, the young man concerned stayed away from the painting thereafter. The painters did not observe the taboos associated with the painting stage of a tambaran ceremony, but there was virtually no meat eaten during the period and although none of them bled their penes to purify themselves from sexual contact, several mentioned that they painted better after avoiding intercourse for a few days. These painting activities were spread out over a few months, some days whole groups coming to paint, other days only one or two men, rarely were more than two or three days a week devoted to painting. While men were painting in my house I provided generous supplies of tobacco and a certain amount of betel nut, as would the hosts during preparation for a ceremony, but I did not provide any food, instead I made a small cash payment at the completion of each painting.

The ten paintings to be discussed below are all, except the last, designs suitable to be used in ceremonial contexts, they are also competent examples of Kwanimbandu painting, all of them were passed on both counts by the twenty-two major artists involved at various times in the painting sessions. Such designs would either be used in bands across the façade of a ceremonial house, or else singly or in small groups on triangular or oblong panels of sago spathe sewn to a cane framework and coated with black mud. The panels, called *wut* are used to line the initiation chamber inside the ceremonial house. *Wut* refers also to the only female artistic activity, decorated string bags, and also to *nyan wut* – womb – (Forge, 1967). In some areas men painting *wut* use the female colour names, those for the string dyes, instead of the male colour names, for the paints (Forge, 1970). The fact that the Abelam artistic form most capable of manipulation, and therefore of communication, is so predominantly feminine accords well with their traditions of women as creators of the vegetation and discoverers of both yams and tambarans. See below pp. 188–9.

I shall give a description of the main formal elements of each painting first with the identifications of elements provided by the artist and discuss them later. I have no space in this paper to discuss the significance of the different types of cross-hatching employed or the bands of polychrome triangles. They are all classified as various forms of *wut*-string bag, and their almost ubiquitous presence in the various designs strengthens the feminine association of these panels. I shall also be ignoring the difference between thin and thick line techniques since most of these examples show the use of both.

Plate 5. *Ndu* 'man' by Nyagərə; a straightforward design, the body with a bailer shell ornament on a black trunk outlined in

polychrome cross-hatching, the same technique used for the arms and legs, which with black joint marks at elbow and knee are in the so-called 'hocker' position, the head without nose or mouth is absorbed into the head-dress. There is a band of polychrome cross-hatching across the bottom, at the sides, in yellow, *aŋgwə-mbabmu* – the crescent moon.

Plate 6. *Ndu* 'man' by Tagwo ŋgwu; basically the same, but the head has disappeared and a band of white hatching separates off the top of the triangle which is filled with a black triangle representing the female sexual organs (*kitnya*). The W formed by the arms has a pair of white circles in it, as do those formed by the legs. These may be identified as either eyes or stars.

Plate 7. *Wama yui* 'sulphur crested cockatoo's feather' by Tagwo ŋgwu; the feather of the title takes the place of the head. This feather is the prerogative of men who have been initiated into all the tambaran ceremonies except the last. The penultimate ceremony, at which they acquire the right to wear this feather, is associated with war and killing. Only one pair of circles in the upper position, identified by the artist as eyes. There is no polychrome cross-hatching in this design and the bailer shell breast ornament is missing.

Plate 8. *Kwarumban* by Aŋgə; a class of head-dress which I have never seen in use, associated with the hornbill, whose stylized head and neck always form the top inverted W shape, the lower W is in this case also a pair of hornbill heads, but is sometimes shown as arms, whose form they clearly replace in this example. The rays on the white circles beneath the legs make the identification stars. The top feature springing from the junction of the W forms is, in carved examples, always a head on a long neck.

Plate 9. *Ləpaŋga* by Aŋgə; a leaf with a silver back used in tambaran ceremonies of every level. The tree species *Ləpa* (*ŋga* – leaf, also house) is said to be the preferred species for making the light throwing spears used in warfare. The trunk with its bailer shell ornament is much reduced and the legs, although still present, are single white lines, the W of the arms has, however, been extended in elaborate polychrome cross-hatching to form a dominant *mirtŋga* (literally *mirt* – Ficus species, *ŋga* – leaf), the classic form of ceremonial head-dress in the north Wosera. The *ləpaŋga* takes the place of the head and is totally absorbed into the head-dress. Two *kitnya* (female pubic triangles) occupy the bottom corners.

Plate 10. *Kulambə* 'large owl' by Djaŋgərə; all the elements are familiar except that the W form of arms and legs has been replaced by paired loops. The artists and others refused to identify these loops and suggestions about eyes, wings, etc.

were all rejected. The elaborately decorated black circles at the bottom were specifically identified as *Wasaman*, a group of stars in the constellation of Orion. (The word literally means 'dog's leg').

The next three paintings are all by the same artist Tsirətsitban and were all identified by him under pressure from me as *Ndu* 'man'; Plate 11 is familiar and basically the same as Plate 6; in Plate 12 the layout is similar but the *mbia* element has been rotated through 90°, while the two circle segments usually in yellow at the sides have maintained their orientation with respect to the central *mbia* by being transferred to the bottom edge, but being black they were identified as 'half-bellies'. At the top the oval in a diamond is clearly related to the centre part of the large design, but again rotated through 90° with respect to it, this form was identified as 'flying fox' whose conventionalization it closely resembles. Plate 13 was painted on the same day immediately after finishing the previous painting, Tsirətsitban converts the opposed Ws into zigzag lines with the *mbia* alternating in orientation, and three pairs of 'eyes' in the V-shaped forms left. The design was abandoned because of poor light before all the white dots had been added. He also explained that he was dissatisfied with it since he had not left enough room to include a large *mbia* at the bottom and therefore was unable to take the enclosing Vs to the edges of the paper, leaving himself with large blank areas in the bottom corners and a top heavy composition.

Plate 14 was produced by Toto in response to a request for innovation, the borders on the three sides are well executed and totally traditional and he did them first; having limited the space available he then did a thoroughly traditional figure with rather more attention paid to the head, in size and detail, than is usual. Having used almost all his space he then started to innovate: at the top are four letters – when asked what they were, Toto replied *'olsem baibel long skul'* (pidgin English) 'as in the Bible at school' (mission school was all that was available in that area). On the head is a motif which had me flummoxed for some time much to his joy, but he eventually identified it as the hilt of the sword used as a trademark by 'Dettol' (an antiseptic much in use in the medical services) which he had copied off a gallon can standing on my verandah. Finally the figure holds in his right hand a white circle, overpainted on the red ground (overpainting is unknown in the traditional art), this he identified as a shell ring, which is indeed a white ring but which is never represented in the art of this area and rarely elsewhere. This last innovation is particularly instructive since shell rings are the most highly valued objects known to the Abelam. While Abelam painting

from all areas abounds in white ring shapes, yet with the excep-
tion of this one case of conscious innovation and its use as female
ornament on some northern façades, no ring of any colour was
identified as a shell ring, nor was any other sign or element so
identified.

This set of paintings from one village illustrates some of the
processes that are used in all Abelam flat painting systems, but
they also make some general points as well. The most obvious is
that there is no line to be drawn between representational and
abstract (or non-representational) at least in Abelam terms. Plate
5 is clearly anthropomorphic albeit highly stylized. Plate 13 is
a pattern and little else to non-Abelam eyes. Yet both rely on
the same set of simple graphic elements – Vs, Ws, circles, pointed
ovals – to build up the main design. Both designs were called *Ndu*
by their composers, but this was in response to my questioning
and especially in the case of Plate 13 with some reluctance, really
to humour me since Tsirətsitban had learnt by then that I always
asked for a name for the final design. All the information I ob-
tained suggests that no difference in ritual effectiveness or
acceptability is involved. All, except the conscious innovation
(Pl. 14), would be used for *wut* designs, although, judging from
the few ceremonial houses from this area that I have seen, there
may have been a preference for the more 'representational'
designs for use on the façades.

The constant element in all these paintings is the pointed oval,
the universal of Abelam painting; usually it has the bailer shell
chest ornament, this ornament is a sign of masculinity and the
identification of the pointed oval as *mbia* (belly) rather than *asa*
(mother) can be expected; nevertheless the topmost pointed
ovals in Plates 12 and 13 as well as the central one in Plate 10
were all identified as *asa*. The chest ornament and its supporting
strings often take on a form very similar to that used for the
nose and mouth of a face when they are shown. This is best seen
in Plate 6. Indeed most of the chest ornaments have the up-
turned crescent or straight line form in painting, thus echoing
the mouth, although the actual bailer shells look like the version
shown in Plate 5. As this particular set of paintings has been
chosen to demonstrate other features this particular homology –
nose and mouth: chest ornament and strings – does not come out
very clearly, but is striking in the full corpus of north Wosera
paintings. The tendency in north Wosera paintings to suppress
the head, absorb it into a head-dress, or omit some of the facial
features if it is shown, is one of the most obvious characteristics
of the sub-style. The eyes as we have seen often appear as pairs
of detached circular forms, the nose and mouth as chest ornament,
but there is another facial feature that also makes a transmuted

appearance in many of the designs. The traditional hair style of adult Abelam men was a fan of hair across the top of the head from ear to ear with ringlets down the back, in front the hair was shaved, or plucked, to leave a triangular piece of hair on the forehead. This, called *kitnyambei,* was explicitly identified with the female pubic triangle (*kitnya*).[6] This motif occurs in four of the reproduced paintings, where it is explicitly identified as such. Of course the W lines of the arms and legs in the 'hocker' position automatically tend to produce triangular forms, which if they are filled in in black are visually equivalent to *kitnya* whether so identified or not. Plate 6, therefore, although it lacks a head in our representational terms, has eye forms, nose and mouth forms, and forehead hair forms as integral parts of the design.

The next most obvious features of this set of paintings are the arms and legs forming two opposed Ws. They are present in all the paintings except Plate 10; in Plates 8 and 9 they are transformed, in the case of the top W, into part of some other sacred object, while in Plate 13 and the top of Plate 12 they are extended into a zigzag in the first case and their essential enclosure (the diamond) in the other. The replacement of the head by a feather, which is worn in the hair (Pl. 7), and by two different forms of head-dress (Pls. 8 and 9), one containing sacred leaves, is obviously a similar process of visually stating relationship between various classes of sacred object by transformation, creating homology of form as the northern Abelam example using face and head-dress in Plate 3. The three paintings by Tsirətsitban (Pls. 11, 12, and 13) show the artist really playing with the basic forms of pointed oval and opposed Ws with a freedom totally unhindered by any canons of representation and adding eyes/stars wherever his composition has created the V shape to contain them. In Plate 12 his choice of yellow to fill in the bottom Vs means that the crescent moon shapes at the bottom edge must be a contrasting colour if they are not to be lost, Tsirətsitban's choice of black and identification as half bellies makes explicit an important identity of form very common in the north Wosera style. *Aŋgwə-mbabmu* (the crescent moon) is the identification of any yellow curved area less than a semi-circle. Such forms are very often used at the edges of both triangular and rectangular compositions, almost always the straight line is parallel with the long axis of the pointed oval regardless of what the rest of the design may be; Pls. 5, 6, 7, 8, 10, 11, and 12 all show this very clearly. The crescent moon shape is basically half of the pointed oval and indeed is bound to occur when any band of *ndu* figures comes to the end of the sago spathe panel which forms the painting surface and always has straight edges.

The customary identification with the crescent moon re-

Fig. 3

inforces the belly shape as essentially feminine. The moon is quintessentially female, the Abelam consider that it menstruates, retiring for three nights every month into its menstrual hut. More importantly, all male ritual activity and the magical cultivation of long yams is not only regulated by the moon, as is the holding of all ceremonial, but involves direct invocation of her and the use of objects, white stones, etc., considered to be manifestations of the moon. The moon in fact represents the ultimate in female creativity and the tapping of some of its supernatural power a main objective of male ritual.[7]

The colour of the crescent moon is always yellow; when, however, the full moon is shown, it is in the form of a disc of solid white, a solid yellow disc being, apparently, the sun, but both these are rare motifs. I only have two examples of the sun in the three hundred plus Abelam paintings I collected and have never seen anything like it on sago spathe. The full moon is almost as rare in flat paintings. It seems possible that yellow is used for aesthetic reasons, since areas of white, particularly at the edges, tend to be dominating, certainly no artist or bystander has ever identified a yellow crescent as the sun or any part of it.

The conscious attempt at innovation (Pl. 14) has some points of interest; first it is obvious that there is in no sense any stylistic innovation, it is very obviously a north Wosera painting and this was true of all the other innovations I managed to obtain, even those on white paper. Second, although there are two new motifs, one of the innovations is the attribution of a new meaning to a white ring, one of the commonest motifs in the corpus, and the placing of the motif in a non-traditional position. The motifs chosen for inclusion are significant, the writing is specifically said to be from the Bible, an obvious link with European supernatural power, while the Dettol sword hilt, significantly enough

converted into a head-dress, was copied from a tin that the artist knew I used in treating sores and cuts and so was associated with another aspect of European supernatural power – medicine, some aspects of which are much appreciated by the Abelam. The shell ring held in the right hand of the figure is the wealth item of traditional Abelam society, essential for brideprices and buying pigs to fulfil ceremonial obligations; it is highly valued and control of many shell rings is still essential for moderate prestige and any chance of becoming a big man. The motives of Toto in including this in a painting so obviously concerned with tapping new reserves of supernatural power, present little problem. He was an ambitious man and seems to have taken my request for innovation as an opportunity to paint something that would be powerful in benefiting him in the present world rather than a traditional design designed to benefit the community by recreating the power of the ancestors and spirits. One problem that this painting raises is why does so important an item as a shell ring not appear to any large extent in the traditional reper-toire? Especially as white ring forms abound why are so few of them ever identified as shell rings?[8] No Abelam could give an answer to such a question, but it seems likely that part at least of the reason is that the rings are always physically present in the context for which the paintings are made. All Abelam painting on the flat is made either for the façade of a ceremonial house, or for the *wut* panels that line an initiation chamber or form the background for some tambaran ceremony. At the opening of a new house the owners and all the visitors bring their finest shell rings which are hung in lines just below the façade; similarly at every tambaran ceremony the ritual group concerned and all the visitors bring shell rings which are laid before the centre of the display and stay there for the three days the display lasts. In both cases the shell rings become the carriers of some of the supernatural benefit generated by the ceremony. When they are withdrawn they are washed in bespelled coconut milk on the ceremonial ground of their owners and the milk sprinkled on the ceremonial house and stones associated with the ancestors.

But there is another reason, or so it seems to me, for not in-cluding such an obvious identification between a white ring shaped object and a painted white ring and this is relevant to my whole hypothesis about the function of the flat painting system among the Abelam. White rings are almost always stars or eyes as we have seen, in the northern Abelam they are also used for the navel and sometimes for the breasts, although most northern painters use the pointed oval for female breasts.[9] Eyes, stars, and navels are all associated with the ancestors and with sacredness in the human body. In this set of meanings shell rings have no

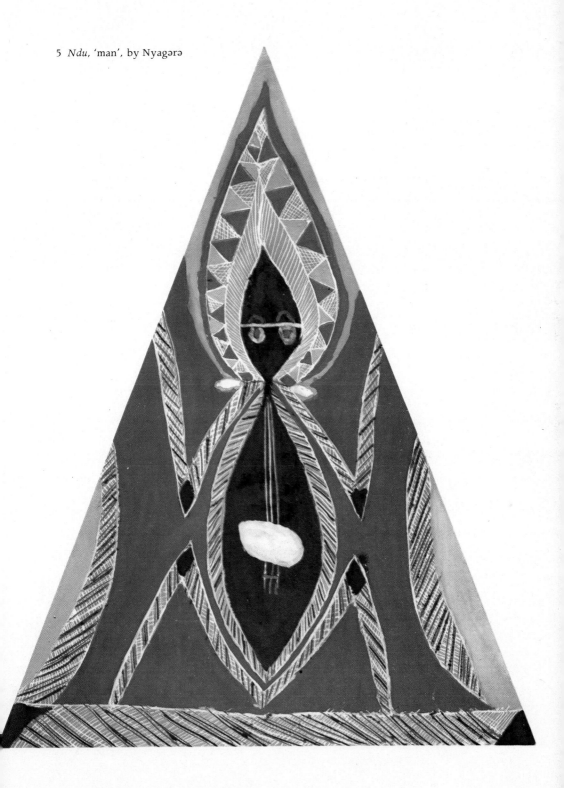

5 *Ndu*, 'man', by Nyagərə

Ndu, 'man', by Tagwoŋgwu

7 *Wama yui*, 'sulphur crested cockatoo's feather', by Tagwoŋgwu

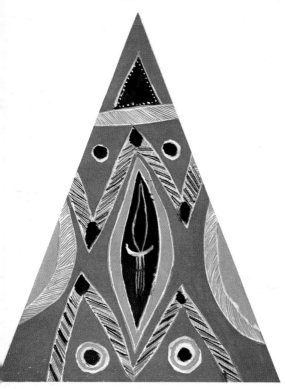

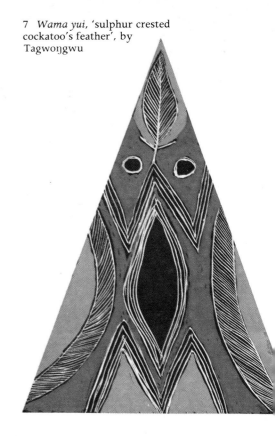

8 *Kwarumban* by Aŋgə

9 *Ləpaŋga* by Aŋgə

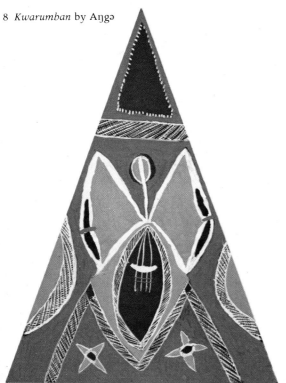

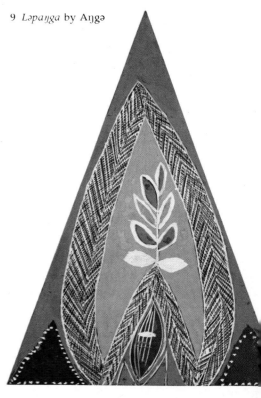

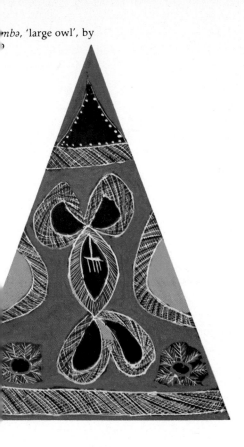

...mbə, 'large owl', by
...

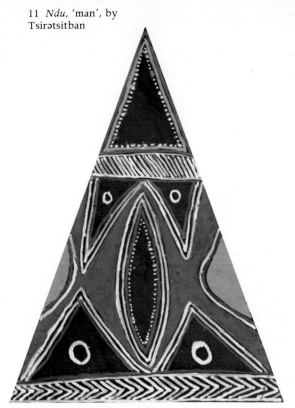

11 *Ndu*, 'man', by
Tsirətsitban

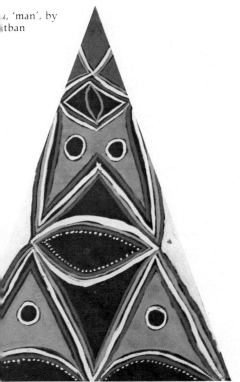

...u, 'man', by
...tban

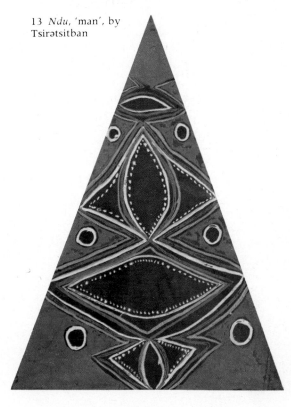

13 *Ndu*, 'man', by
Tsirətsitban

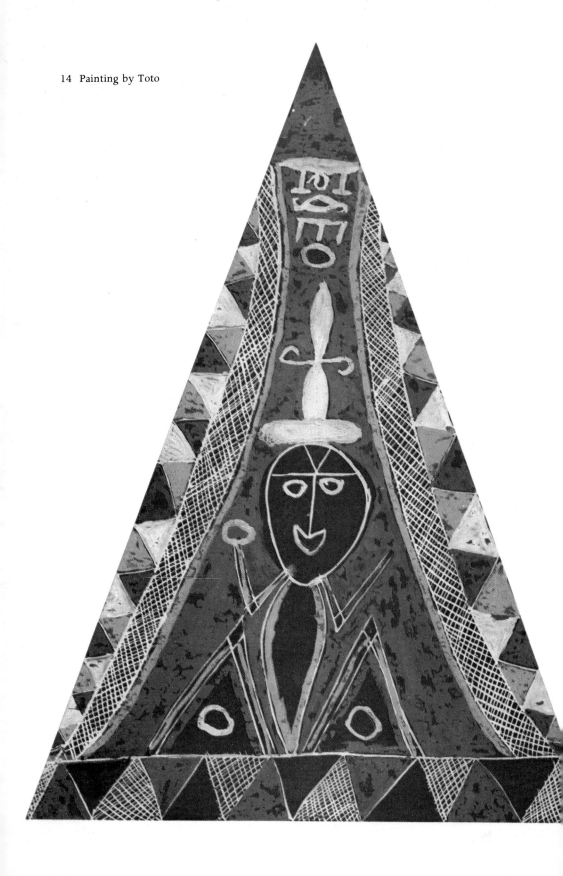

14 Painting by Toto

place since they are very clearly associated with male aggressiveness and competition. There is no space to pursue and exemplify this point here, but what is important is that the identifications of their motifs by the Abelam have a definite arbitrary element.

It seems to me that Abelam flat painting is a system in which a limited number of motifs, some themselves simple graphic elements, most with several alternative meanings, are combined and arranged in harmonious designs, ancestrally sanctioned, and believed to be intrinsically powerful. The total design may or may not have a name or 'represent something' in our terms, what is important is the expression of relationship between the parts and the meanings of those parts. Similarly, although in a design such as Plate 7 one competent Abelam may identify the pair of rings as eyes and another equally competent as stars, this is not important, stars/eyes are a sort of visual pun, both are implicit in each other, it is not a question of choosing a meaning in a certain situation – both meanings are always present, Abelam themselves do not ask for these meanings to be made explicit, it is only the ethnographer who commits such a solecism. The ethnographer of course comes from a culture in which from the earliest years pictures are meant to mean something in words, and ethnocentrically assumes that secure iconographies, absolute translatability between verbal and visual systems, is a feature of human culture. There is, of course, no *a priori* reason why this should be so, indeed no one suggests that all or any music should be translatable into words, why should such an assumption be made about visual communication? I am, of course, aware that there is a great deal of non-representational work in modern art, but this is a conscious turning against art as illustration and representation which still is the basis of advertising, children's book illustration, newspapers, etc. and as such forms the basis of attitudes to visual/verbal translation. Anyway, the point I have been trying to make in the context of Abelam flat painting is that the representational/abstract dichotomy is meaningless, to identify a 'representation' is not to find out what the painting means, it is merely one element in a complex web of meaning which is to be found in the relationships of the parts that compose them.

To take a simple example, a very common element on the façades of northern Abelam ceremonial houses is a band of female figures, which come immediately above the bottom band of huge *ŋgwalndu* faces. When I started to collect information about the art and its meanings these presented a problem, no one identified them with any sort of spirit or totem, they were frequently referred to as *Mandji-tagwa* (foreign women), although I often found that some were jocularly identified with prominent women

Fig. 4

of the village. There are no female spirits involved in the tambaran cult and although female ancestors may be important in certain contexts, everyone agreed that they were not ancestors, indeed no ancestors male or female are portrayed at all. For the time being I had to be content with just the name of a prominent set of façade paintings that had no apparent reference to any part of the Abelam cosmos or any of the other parts of the façade. It was only when I came to analyse the way the paintings were composed that I realized that the function of this band of females was most likely to be the emphatic statement of the essential femaleness of the pointed oval. In Fig. 4, taken from a façade in Yanuko village but representative of all such bands, the head-dress and the arms and legs are standard and could as well be for a male figure. The head and body of the figure are made up of the following elements: the outline of the head itself, the eyes, and the navel are all circles making four in all; there is one mouth and one pubic triangle, the rest is totally composed of pointed ovals, eleven in all. The ovals are as follows: the trunk, and in the north it is only the female trunk that appears on façades, all the spirit representations are of face only or of face and attributes;[10] the vulva, within the pubic triangle; two breasts; the nose; the two lower pointed ovals on the face, said to be the area under the jaw, but only shown on female faces; the two upper pointed ovals on the face said to be hair; and the two pointed ovals on each side of the trunk, said to be the small of the back. It is of course arguable that I am trying to read too much into this band of females, that their function is aesthetic or simply for fun, but in the context of all northern Abelam ceremonial house façades they are so regularly present and so different from all the other façade designs in their lack of obvious symbolic reference, that there would certainly seem to be something to be explained. Immediately below the band of females are the huge *ŋgwalndu* heads, the visually dominant and lowest design on the façade; these are the major spirits and the focuses of all the tambaran cult ceremonies, they also influence the long yams, the pigs, and the general fertility and success of the clans to which they belong. They are the high point of all male values and the women are not even supposed to know that these faces, which of course they can see, are those of the dreaded *ŋgwalndu*. As was noted above when considering some of their basic elements, they do not display pointed ovals as a major element in their design. Yet on examination their design presents some peculiarities, e.g. in Plate 2 at the top is the huge red head-dress with its white U-shaped ornament, which is mandatory in the northern style of painting, but at the bottom there is an echoing pointed shape also in red that has in it the bailer shell suspended from elaborate shell encrusted strings.

But why that shape? No informant was able to volunteer any information other than that was the correct way to do it. There is plenty of width at the bottom of the triangular façade and indeed so much space is left by the design that large areas of 'string bag' design filling have had to be used. The pointed shape makes the design symmetrical about a horizontal axis, but then all the other bands on the façade have pointed red head-dresses but none of the others have tried for such symmetry. It seems to me inescapable that the *ŋgwalndu* is encapsulated within a pointed oval; the essentially female maternal character of this symbol being emphasized in the band of figures immediately above. At the bottom of two of the enveloping pointed ovals in Plate 2 are small black pubic triangles, a feature which is painted on the carvings of both sexes, but in painting on the flat is restricted to females. Abelam informants never agreed that this was a correct interpretation, the younger men particularly were fervent in their denials, some of the older men looked knowing but said nothing.[11] If my hypothesis is right, what the *ŋgwalndu* faces are expressing is the primacy of female creativity, which in Abelam terms is natural, over male creativity which is cultural in that male access to supernatural power is through ritual. Ritual from which the rival female power, mainly sexuality and maternity, must be excluded. It also accords well with the tradition that it was the women who originally discovered the *ŋgwalndu* who were then alive and became their lovers, it was only when the suspicious men discovered them that the *ŋgwalndu* turned to wood, to become the focus of male ceremonial. This encapsulation of the most potent male spirit within a female form fits too with the nurturing aspect of the carved *ŋgwalndu* inside the ceremonial house (Forge, 1966).

What I am suggesting is that in an art system such as Abelam flat painting, elements, in this case graphic elements modified by colour, carry the meaning. The meaning is not that a painting or carving is a picture or representation *of* anything in the natural or spirit world, rather it is *about* the relationship between things. The meanings may well be at several levels, thus the bands of paintings on a northern Abelam façade are paintings of things, but they also have a more important meaning not immediately accessible or contained merely in the name of a class of spirits; such meanings as the nature of man and the nature of woman, relevant to the access to supernatural power, these lower level meanings are, in short, cosmological and theological. Woman as prime creator and man as nourisher come clearly out of much of the Abelam art I have so far analysed. Such themes are common throughout New Guinea and Australia, but sometimes they are expressed in myth, sometimes in ritual, not necessarily in art.

Such themes are not talked about openly by the Abelam, they
may even be denied if suggested to them in certain contexts and
indeed some of the messages that the art is putting across do not
seem to operate at a conscious level at all. Abelam art acts directly
on its beholders, properly socialized and initiated Abelam. They
learn the various meanings of the elements while acting as helpers
in the preparation of ceremonies, but I suggest that the arrays of
paintings with their constellations of elements, never named or
expounded in any way during the ceremony, communicate
directly to the Abelam not as an illustration of some spoken text.
If this is so there should obviously be a grammar of painting,
certain combinations of elements should be meaningless or
objectionable in meaning and therefore should not occur in any
corpus. There is no more need for this to be a conscious process,
than there is for a native speaker of a language to know con-
sciously the whole grammar in order to detect an ungrammatical
sentence. If there is such a grammar it should be detectable by
the analysis of a large corpus of paintings. All the evidence I have
collected and analysis I have done to date suggest that there are
definite regularities in the way elements are combined and the
colours used for certain elements, and that these are meaningful
in terms of Abelam cosmology and values.[12]

The ambiguity involved is, in such a system, part of the
communication; it is the ambiguity of poetry, not the lack of
clarity of poorly written prose. That stars are also eyes is a basic
assumption at one level of Abelam cosmology. Abelam deny that
they portray their ancestors and this is literally true, yet the
great white circles of the *ŋgwalndu* eyes staring down on the
ceremonial ground from the façade, catch the moonlight and any
firelight available, and seem to dominate the night ceremonies.
The *ŋgwalndu* are not the ancestors yet the association of the
white circles with stars (*kwun*) is the beginning of a sort of
punning chain – *kwun* are also fireflies, which in turn are
specifically identified as ancestors come back to observe their
descendants, so that in a sense the *ŋgwalndu* eyes are also those
of the ancestors.

The styles of Abelam flat painting are, I believe, systems of
meaning, the various styles are related and have in fact elements
in common, particularly the most important *mbia* shape; they are
in fact dialects of a single language, and vary within the Abelam
area in the same way as do the spoken language itself, the social
structure, emphases in ritual, and so on. This language of style
is as much a part of the culture as the spoken language and neigh-
bours who borrow may well misunderstand the system, as do
some of the southern Arapesh who in carving, add to a typically
Abelam figure with its normal arms and legs, the two Ws used for

arms and legs in the Abelam flat painting style, thus in Abelam eyes the figure has eight limbs, but to the Arapesh the Ws are meaningless, except in so far as they embellish the figure and therefore make it more potent.

Style in cultures such as those of the Sepik is essentially a communication system. A system that, unlike those to which we are used, exists and operates because it is not verbalized and probably not verbalizable, it communicates only to those socialized to receive it. The constantly invoked ancestral sanction or magical correctness which is all the explanation the Abelam give, are true precisely in so far as the paintings do transmit across the generations concepts and values and their inter-relationships that are fundamental to Abelam society and do fit with the society as it is when they are received. Change in style, in the elements and the combinations, must be meaningful to be accepted, even though the changes are not consciously evaluated. In this paper I have not mentioned aesthetic aspects of art, not because I do not believe them to be important, I have indeed argued elsewhere that I believe them to be equated with super-natural power (Forge, 1967), but because I wished to concentrate on the aspect of style as a system, a visual system, but also a system of meaning.

NOTES

1. See Forge, 1960, Haberland, 1964, and Newton, 1964 and 1971. I accept Haberland's correction that *Kamanggabi* is the name of an individual figure and not the generic term.
2. The Iatmul material is drawn mainly from Bateson, 1932 and 1936.
3. It is likely that the *mwai* effect of this modelled skull was intensified by the use of a nose extension made of cowrie shells on a string base. There are such extensions in the Bateson collection at Cambridge and they were used by men as well as skulls.
4. For a general description of the Abelam see Kaberry, 1940–1 and 1966. My own field work among the Abelam was in two trips, financed by generous grants from the Emslie Horniman Anthropological Scholarship Fund of the Royal Anthropological Institute and the Bollingen Foundation, respectively. I am most grateful to both of them, and to the Wenner-Gren Foundation for assistance with technical expenses between the trips.
5. For the magical character of paint and the organization of artistic produc-tion, see Forge, 1962 and 1967.
6. The alternative form of forehead ornament, and the one most frequently used in carving and painting, consists of an embellished pointed oval (See *ŋgwalndu* in Pl. 2) thus maintaining a clear feminine reference.
7. Further material on the Abelam attitude to the moon is in Forge, 1969.
8. There also exists a class of shell rings not used in transactions at all but preserved as heirlooms by those clans that possess one. These are called *Waləmini* (*Walə* – an earth linked spirit responsible for conception and much of creation, *mini* – eye). They are believed to have been made by the *Walə*, certainly not by man. Their ancestral reference and eye aspect may link them with the white ring as eye in the painting style.

9. On carvings in the northern style the navel is frequently shown as a circular boss, often this is enclosed within an engraved design having as centre the pointed oval, again with embellishments, sometimes the same as the forehead ornament. Cf. n. 6.

10. For further discussion of the ceremonial house façades and their designs, see Forge, 1966.

11. Yet the *ŋgwalndu* figures themselves, the most sacred and secret material manifestation of the supernatural, and the focus of both male cults, are kept in the female ceremonial house and when they are displayed to initiates are put into a chamber, lined with *wut*, which has clear womb associations. See Forge, 1966 and 1967.

12. This hypothesis is about to be tested by a formal analysis of the entire body of paintings on paper collected by me and of all properly attributed photographs of Abelam flat painting to which I have access. The project will take two years and the analysis of form is being carried out by Miss Sheila Korn, who represents a 'naïve eye' in that she has no Abelam-like preconceptions; her analysis of the elements and their combinations will therefore be objective. The rules and regularities she uncovers will then be translated into meanings on the basis of my collected material on the identifications given to elements. If the grammar of graphic form and colour makes sense when translated into cosmological terms I shall consider the hypothesis supported. At the completion of the formal analysis it should be possible to paint ungrammatical paintings, that is with traditional elements but in nonsensical or objectionable combinations. It would be extremely interesting to get the reactions of Abelam artists and ritual experts to such paintings. I am most grateful to the Nuffield Foundation Small Grants Project for providing funds to fix the paintings on paper and for photographic expenses; and to the Social Science Research Council for financing the two year analysis.

REFERENCES

Bateson, G., 'Social Structure of the Iatmul People of the Sepik River', *Oceania*, vol. 2, nos. 3 and 4, 1932.

——, *Naven*, Cambridge, 1936.

Forge, A., 'Three Kamanggabi Figures from the Arambak People of the Sepik District', in A. Forge and R. Clausen, *Three Regions of Melanesian Art*, New York, 1960.

——, 'Paint – A Magical Substance', *Palette*, no. 9, 1962.

——, 'Art and Environment in the Sepik', *Proceedings of the Royal Anthropological Institute for 1965*, London, 1966.

——, 'The Abelam Artist' in M. Freedman (ed.), *Social Organization: Essays Presented to Raymond Firth*, London and Chicago, 1967.

——, 'Moonmagic', *New Society*, 17 July 1969.

——, 'Learning to See in New Guinea', in P. Mayer (ed.), *Socialisation: The Approach from Social Anthropology*, A.S.A. 8., London, 1970.

Haberland, E., 'Zum Problem der "Hakenfiguren" der Südlichen Sepik-Region in Neuguinea', *Paideuma*, vol. 10, no. 1, 1964.

Kaberry, P., 'The Abelam Tribe, Sepik District, New Guinea. A Preliminary Report', *Oceania*, vol. 11, 1940–1, pp. 233–58, 345–67.

——, 'Political Organization among the Northern Abelam, *Anthropological Forum*, vol. I, nos. 3 and 4, 1966.

Newton, D., 'A Note on the Kamanggabi of the Arambak, New Guinea', *Man*, vol. 64, 1964, art. 5.

——, *Crocodile and Cassowary*, New York, 1971.

Schefold, R., 'Versuch einer Stilanalyse der Aufhängehaken vom Mittleren Sepik in Neu-Guinea', *Basler Beitrage zur Ethnologie*, Band 5, 1966.

CHAPTER 11 The Spatial Presentation of
Cosmic Order in Walbiri Iconography

Nancy D. Munn

INTRODUCTION The communication of ethnic concepts of the socio-cultural
order in non-verbal models has recently attracted considerable
interest in anthropology (see, for example, Cunningham, 1964;
Fernandez, 1966; Forge, 1966; Stanner, 1964; Turner, 1964).
One type of non-verbal system which may function in the storing
and communication of such concepts is an iconography, i.e. a
systematically elaborated representational tradition, materialized
in two or three-dimensional artefacts.[1] In this paper I wish to
explore the relation between a particular visual structure of
Walbiri iconography and certain fundamental notions of space,
time, and natural process in the philosophy of this central
Australian people.

While my concern here is with the part played by a particular
representational tradition in providing spatial arrays that model
cosmic order, such arrays may also, of course, be provided by
various non-representational forms such as house structures,
arrangements of objects in ritual, or residential patterns and
village plans. Indeed, it would appear that in some cultures one
can abstract underlying, simple visual shapes and arrangements
such as circles, crosses, or concentric structures, etc., which are
reiterated throughout a range of media and behavioural contexts,
and to which are bound cultural notions about order in the world
as a whole. Cunningham (1964, p. 64) suggests, for example, that
'patterns of concentricity and intersection in the "order" of
the Atoni house continually concern what . . . groupings are to
be included or excluded. The circle (or quadrangle) and the cross
are ubiquitous symbols in Atoni material culture, I believe, as
expressions of these basic concerns. . . .'

The way in which a people organize visual forms in space is a
subject central to aesthetics; thus one task of anthropologists
concerned with aesthetic phenomena is the examination of
different spatial arrays in a given culture so as to determine basic
visual ordering patterns. Certainly, such studies may throw light
on the relationship between aesthetic form and the 'command
patterns' of a culture, those pervasive ordering principles which
Robert Miller (1964, p. 94) has suggested keep a culture 'viable as
a system moving through time'.

The Walbiri are a people of western central Australia[2] whose
social structure includes exogamous patri- and matri-moieties,
eight subsections, and an Aranda type kinship terminology.

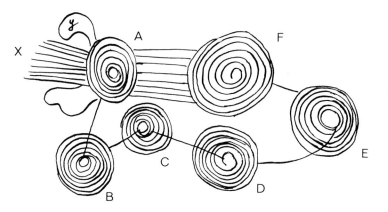

Fig. 1 Site-path figure: typical elements of a
guruwari design (after Walbiri paper drawing)

○ = camp sites
| = paths. Some paths are shown joined directly to
the centre of the circle (see n.17). The lines
at X represent the Dreaming standing up from
the waterhole.
ϒ = ? meaning not given

1 The Circle and 'Birth'
A Walbiri drawing of a lizard
and grasshopper site showing
an ancestral family. The
parents are lizards and the son
a grasshopper. (A black and
white version of this drawing
is reproduced in Munn, 1964).
The sections which are
relevant to the reference in the
text are shown in Fig. 2.
Additional meanings are as
follows. Meander lines at the
bottom of the cave represent
the *yawalyu* designs of the
mother which she wore when
she danced at her son's
initiation ceremony; criss-
crossing lines in the head of
the cave represent the father's
guruwari, while those at the
bottom are the mother's.
Short, curved lines extending
from the cave are the mother's
digging sticks (equated with
the penis); the hole at the base
is the digging stick hole and
mother's genitals (cf. n.15).
Arcs at the top edge of the
cave are old men sitting at the
boy's initiation ceremony
with their shields behind
them. Inside the cave are arcs
representing men of the
opposite patri-moiety from
the boy and his father. The
small arc below the family is
the boy's father; the circle at
his left represents the
mother's genitals

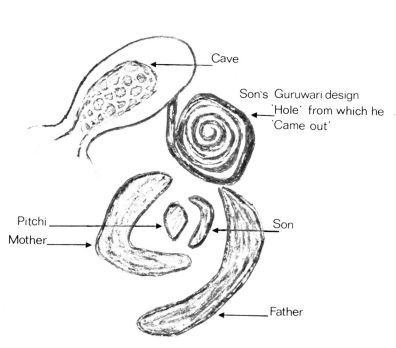

Fig. 2 The mother and father
lizard sitting with their son.
The 'Pitchi' is the wooden
scoop in which the son is
carried

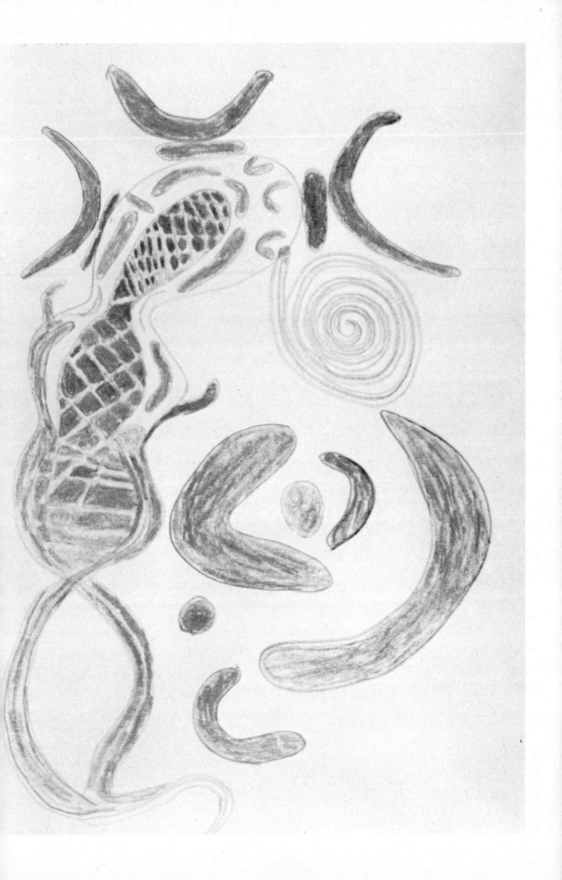

2 Kangaroo design with rock hole at centre of camp circle (Walbiri paper
drawing. Also discussed in Munn, 1962)

∪ | ∪ = tail (path) and footprints of kangaroos travelling
 towards camp

(o) = rock hole (inner circle), camp

C = kangaroo sitting at camp

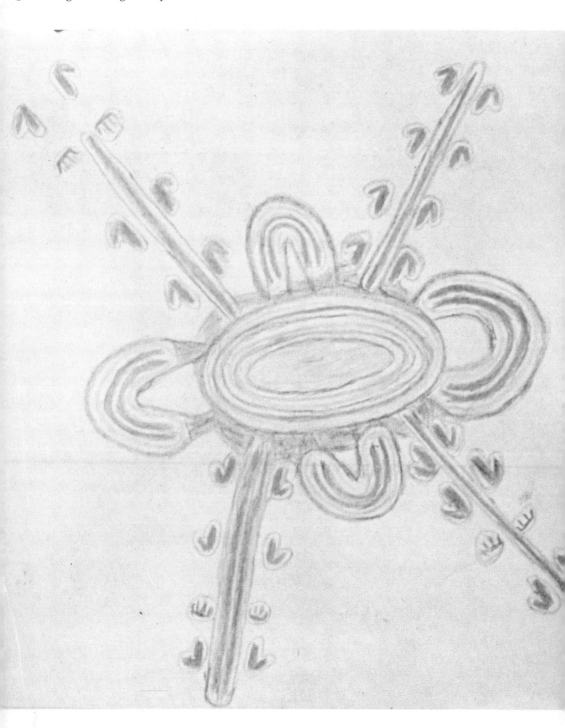

They have a typical central Australian totemic ideology involving belief in innumerable ancestral beings whose travels created the topography of the country. Many of these are personified aspects of the environment such as rain or honey ant; but others are wholly human or non-human.

The ancestors and the times in which they travelled are called *djugurba,* a term that also means 'dream'. Walbiri men say that the ancestors, sleeping in their camps at different sites, dreamed their songs, graphic designs, and ceremonial paraphernalia. These phenomena record their travels, and the gist of Walbiri views on this matter seems to be that they also dreamed the world they create in their travels; as one man suggested, they dreamed their track (*yiriyi*). To translate the Walbiri term *djugurba,* I use the label common in the literature on Aborigines, 'Dreaming'; the ancestors I call 'Dreamings',[3] and the ancestral period as an historical locus, the 'Dreamtime'.

Ritual rights over Dreamings are vested in patrilineal lodges of men, who are responsible for the maintenance of a number of Dreamings within a given segment of the country (defined in terms of particular sites), and the care of the symbolic paraphernalia and ritual associated with them. Other members of the patri-moiety to which a given lodge belongs have classificatory interests in these Dreamings, but are 'masters' (*gira*) only in a more generalized sense. At the fertility or 'increase' ceremonies (*banba*), dancers are *gira* (ordinarily patrilodge members) while 'workers' (*guruɳulu*), who prepare the paraphernalia, belong to the opposite moiety.

In a number of communication contexts – both ceremonial and non-ceremonial – Walbiri make use of a system of graphic representation that I have described more fully in earlier papers

Fig. 3 Rainbow snake sending out the rain (after Walbiri sand drawing)

○ ○
○ ○ = pearl shells (children) sent out in the rain

\\\ = rain

◎ = rock hole, camp of snake; medial circle is the
snake coiled in the rock hole

(Munn, 1962, 1966 (1), 1966 (2)). Here I shall briefly outline some features relevant to the present study.

Walbiri representations consist of elements such as circles, arcs, and lines that can be combined into larger configurations of varying complexity. Both men and women may draw these graphs in the sand during story telling or more general discourse to illustrate narrative meanings. Women have formalized this narrative use of graphs in a distinctive genre of story telling where sand drawings are used as a running notation; men, however, use sand illustration in a more desultory fashion.

Certain classes of graphs are associated with the different Dreamings; these are presented on various media during ceremonial, but may also at times be drawn on the sand during narratives about the associated Dreamings. I call these graphs 'designs' because, unlike the usual transient assemblages of story telling, Walbiri regard them as more or less fixed configurations of elements remembered over time and linked with specific Dreamings whose characteristics and/or activities they depict.

Walbiri refer to all such designs as *wiri*, 'strong', 'important', although there are differences in the degree of importance attached to different design categories. Thus while the ordinary notation is merely a referential instrument, the Dreaming design is intrinsically valuable: value and importance are, in effect, turned back upon the graph itself.[4]

Both men and women control such designs. Women paint their designs (called *yawalyu*) on their bodies during men's ceremonies in which they take part, or in ceremonies they perform alone. These designs are of only passing importance in this paper. Men's major designs are called *guruwari*; it is within the iconography of these designs that the visual structure I am concerned with here is most fully elaborated. Men's designs are incised on sacred boards and stones (*churinga*) and are variously materialized in ceremonial as, for example, in body decorations with bird or vegetable fluff, or with ochres; in ground paintings of red and white fluff; in painted designs on shields, etc.

There is a single graphic art or 'language' of which men's and women's Dreaming designs constitute different genres. This language has a characteristic internal structure involving a stock of visual elements and implicit rules governing their combination.[5] In any given usage each element has a specific referential meaning and provides a simple pictorial likeness in linear, two-dimensional terms of the object to which it refers.

The relative positions of elements in larger assemblages are also usually pictorial:[6] i.e. they depict spatial arrangements of objects in three-dimensional space. For example, two people lying down next to each other in camp can be represented by two

parallel lines with an arc (the windbreak) placed at one end of the lines (⊓). This represents the windbreak behind the heads of the sleepers, as in the actual spatial organization of the camp. Thus the rules for combining the elements embody iconic principles.

The range of meanings that can be specified by an element in any of its occurrences constitutes a single visual category. These categories vary in degree of generality, but the major elements in the system convey what I have called elsewhere 'discontinuous elementary categories' (Munn, 1966): they comprehend a number of separate class meanings. The meaning range of the circle – a form with which much of this paper is concerned – is a good example of the discontinuous category type. The circle comprehends a range of items, such as camp sites, waterholes, fires, circular paths, etc., that are closed in contour and non-elongate or 'roundish' in shape.[7] In any single usage only one of these classes is relevant except where metaphorical associations between classes are actualized.

The elements and combinations of Walbiri art can be used to generate an indefinite number of messages; the art is characterized by what linguists call 'productivity'. Another important feature is that the one system embraces a range of functions sometimes separated out into distinct systems in other cultures: it provides pictures of various phenomena and also diagrams of a map-like kind; in addition, some of the elements and element combinations function as visual symbols of the cosmic order.

'COMING OUT' AND 'GOING IN': A WALBIRI WORLD THEORY

If we examine Walbiri statements and narratives about the Dreaming, we find that a particular kind of process in which phenomena 'come out' (*wilbibari*) and 'go in' (*yuga*) recurs in a variety of contexts and is figured in different concrete images.[8] The prime occurrence of this notion is in Walbiri beliefs about the origin and death of the Dreamings, but various other events in men's myths are also patterned in these terms.

As we shall see, 'coming out–going in', with its correlative positions, 'outside–inside', is extended as a general principle over the whole of existence to explain the structure and maintenance of the spatio-temporal order. We might call it, using Stephen Pepper's title, a 'world theory' (Pepper, 1961, pp. 84ff.).[9] My contention is that this 'theory' is stored and communicated in direct, immediately perceivable form by a visual model elaborated within the iconography of Walbiri men.[10] I shall attempt to show how the structure of the model images the basic categories of the theory: the spatial focuses 'outside' and 'inside' and the process of 'coming out' and 'going in' that connects them.

Walbiri men state that the Dreamings began their travels by emerging from the ground; at the end of their journeys, 'growing tired', they went back inside. Between these two events – the beginning and end of their above-ground existence during the Dreamtime – they created their paths (*yiriyi*) and camps (*ŋura*) and in doing so made the features of the countryside. Between emergence and re-entry they can, as Walbiri men say, be 'followed'.

Fig. 1 is an informant's depiction of the typical elements of a *guruwari* design showing how a Dreaming might travel through the country.[11] The Dreaming came out (*wilbibaridja*) from circle A, stood up, and travelled to nearby B, then on around to C, D, E, F, and back again to the first circle where he finally went into the ground forever. Each circle represents a camp or camp site, a single country (*walaldja*), where he 'sat down'. The informant said that this is the way Walbiri 'follow' the Dreaming; that is, by means of *guruwari* designs, one way, in the Walbiri view, of giving visible form to the Dreaming track.

As the drawing indicates, the circle is the locus out of which the Dreaming emerges and into which he finally returns. The line conjoined to the circle expresses the process of moving away from the camp site or towards it; thus it can mean going away from the emergence point or going towards the point of re-entry. The latter need not be the same place in the country as the emergence site, but when an ancestor moves within a single region or returns home rather than (as often occurs) going away forever, the place of final re-entry will coincide with the emergence site.

As I have discussed elsewhere (Munn, 1964),[12] this final 'going in' is not an irreversible death. The Dreamings still exist under ground at the present day. They are inside (*ganindjara*) the country in the sense of underneath, covered over, or at the bottom. The visible surface of the country and the sky are by contrast above, or on top (*gaŋgalani*). From this perspective, *djugurba* exists inside the country, covered over as it were by the physical forms of the present. The Walbiri term for the present, *yidjaru*, also means 'true' or 'actual'; it can be used to contrast waking reality with that of dreams. Although Walbiri contrast *djugurba* and *yidjaru* they also assert that *djugurba* is *yidjaru*, for it is true, and moreover, the Dreamings still exist underground.

When rituals are performed in which dancers decorated with *guruwari* designs impersonate Dreamings, the latter are re-embodied or given physical form (*balga*, body, physical presence) for the period of the performance. Thus they come out again. Referring to *banba* ('increase') rituals, one man remarked that men 'pull out' the Dreaming.[13] By this he meant not only that the

ceremony re-embodies the ancestors, but also that it assures replenishment of the relevant species (Munn, 1964, p. 94).

At each place to which they travelled the Dreamings left their generative powers. Men sometimes express this notion by saying that many people or children resulted from their activities and went into the waterholes, but the powers themselves are really viewed as a kind of essential potency – sometimes likened to the fluff used to decorate dancers[14] – which invests the country. Walbiri call this potency *guruwari,* the same term as that for the designs. It is, in effect, the non-visible marking (in contrast to the visible markings of designs and topography) that the Dreaming leaves in the soil and waterholes. When children or members of the relevant species are born they have these *guruwari* inside their bodies. When they die, the *guruwari* return to the soil. In this sense, the Dreaming is continually coming out of the ground and being re-embodied as a living entity, as well as continually returning to the ground in death.

Thus the cycle marking the beginning and end of an ancestor's life also figures in what happens at each site: his generative powers or children go into the country, but are drawn out again in the continuous replenishment of life. Similarly, he himself can come out again in the context of ritual. 'Coming out–going in' is a 'metaphor of repetition' (Leach, 1961, p. 126) which provides a way of thinking about the socio-natural order as an on-going continuum. It codes the experience of birth and death into a polarized conceptual pattern.

The sexual implications of this cycle are apparent in many images of men's myths. For example, the digging sticks of certain Dreaming women are *poked into* the ground as they dance along; the holes they make are waterholes in the countryside. Men equate the sticks with decorated poles (*wanadandji*) that they erect in the ground at certain ceremonials. One informant, drawing a pole to illustrate his account of the women's travels said that it was standing in the waterhole. At this site, he pointed out, 'People danced, then went into the hole'.

The association of the pole with the male genital and of the hole or waterhole with female genitals is a regular feature of Walbiri men's thinking on these matters.[15] In general, they equate circular or ovoid ceremonial objects with women (*ganda*) or mothers (*ŋamadi*) and elongate, pole-like objects with men (*ŋarga*). The circular objects are also *camps*, while the elongate ones are *paths*.

A few other brief examples of the sexual connotations of 'coming out and going in' will suffice here. The kangaroo of one account is said to obtain his long tail (*ŋindi,* tail, penis) by taking it out (*wilbimani*) from a rock hole at one site; in another version

he takes it out from inside a hill. Certain Dreaming men who made the tall leafy poles with which men dance at boys' circumcision ceremonies pulled the poles out of their bodies. These poles are their penes, and also their spears. Similarly, lightning, the masculine aspect of the rain, emerging from his rock hole home, 'stands up' and goes into the sky. In the iconography a circle depicts his rock hole and a meander line extending from it, is the lightning. As he travels along in the storm, the lightning 'spears' (*bandini*) the earth, thus destroying trees; but new trees emerge as a result.

These images clearly suggest that 'coming out' can imply the erection of the penis as well as birth (in fact, erection is treated as a kind of birth or creation of the penis in the examples given); and that 'going in' can imply sexual intercourse as well as death.

Fig. 4 Enclosures

GRAPH	Enclosure	Item enclosed	Other	SOURCE
		MEANINGS		
a.	[Hole]		Paths of actors going into hole	Typical sand story finale
b.	Tree	Dead man sitting inside	Paths of actors going in	Sand story about 'tree people' of the Dreamtime
c.	Breast of murdered woman; boy walking around	Nipple		Sand story
d.	Hill	Woman sitting on hill		Sand story
e.	1. Wooden scoop 2. Sand hollow	Baby lying on scoop; or elongate object like digging stick Sleeper lying in hollow		Common sand story figure

THE CONCENTRICITY OF THE CIRCLE

I turn now to a closer examination of the visual structures used to convey this cycle. Plate 1 and Fig. 2 illustrate the association between the circle and birth. The spiral joined to the cave is the 'hole' (*ŋulya*) from which the son of the Dreaming man and woman (sitting at the lower right) 'came out'; it is also the *guruwari* design of the son. There is an obvious analogy between the country or camp site and the mother, since it is from the *guruwari* circle that the son emerges. The implied spatial relationships are important: both the mother's womb or belly (*miyalu*) and the country provide covering, enclosing physical forms inside of which the child-regenerative powers are contained. We can ask then, whether the notion of one thing covering or containing another is directly conveyed in the visual structure with which we are dealing. To answer this question, we must look more closely at the camp site circle itself.

PH	MEANINGS			SOURCE
	Enclosure	Item enclosed	Other	
	Nest	Eggs		Common sand story figure
	Mother	Berry daughters inside mother		*yawalyu* design for a berry Dreaming
	Water running around a hill	Hill		Sand story
	Men standing around fire	Fire with boy burning on it		Man's description of punishment of a boy who has broken ritual taboos; sand drawing
	Indicates the sites are all 'one country' with one patri-spirit (*bilirba*)	Sites		Man's explanation; sand drawing
	Rain falling around tree; rain *guruwalba* dancing around tree	Tree		Woman's discussion of the rain. Dreaming and related *yawalyu* designs; sand drawing

Fig. 5
Modes of representing a tree
a.

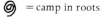 = leafy tops of trees

= camp in roots

= man sitting

= shield

b.
Diagram showing modes of representing the top and bottom of a tree

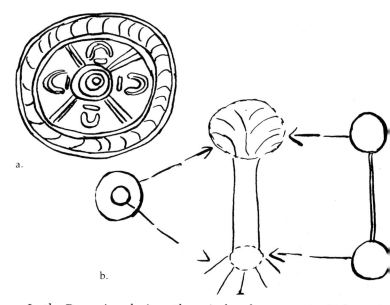

a.

b.

In the Dreaming designs the spiral and concentric circle are in 'free variation': men treat them as equivalent forms and may use either to represent the camp site. The innermost point of the spiral (which may sometimes be a loop so that the spiral may hardly differ in appearance from the concentric circle), or the inner circle of the concentric form is regarded as the actual point of emergence or re-entry. Men may explicitly identify this centre as a hole or waterhole, and some explained that the enclosing circles represent the Dreaming walking around his camp, or walking around making camp; or the outer lines were simply identified as the camp, the centre as the hole. The camp thus rings the hole.[16]

There are, as we shall see, some variations on this meaning in different contexts, but the general principle in these instances is still that the site circle represents something enclosed by something else. This circular construction also functions, however, as a single unit contrasting with the extended line, and in the usual, brief interpretation the circle is simply the 'camp', 'water' ('waterhole'), or 'hole'; Walbiri may also identify it by giving the proper name of the site. The circle conveys the unity of a single country, but its concentricity is expressive of an internal segmentation or structure.

The inner circle of the kangaroo design (Pl. 2) is a rock hole (*waniri*) resulting from the emergence of the kangaroos who are sitting at the camp. The surface of the rock hole is coloured blue to depict the water. The peripheral circles mark where the kangaroos walked around after emergence. After going out hunting they returned, ate, and slept here. Finally they went back into the same rock hole.

...des of representing a tree
drawing is also discussed
...nn, 1966)

____ =tree trunks and
branches

=top; all the circles
are camps
=roots

=leaves

=rain drops

...in Dreaming design: rain
...ing out' (Walbiri paper
...ing)
=rain emerges at centre
and walks around
making camp
=path of the rain
travelling away from
his home.
Blue=rain; green=
rainbow; red=
lightning. The colours
in the circle have the
same meaning

EMERGENCE OF
RAIN DREAMING

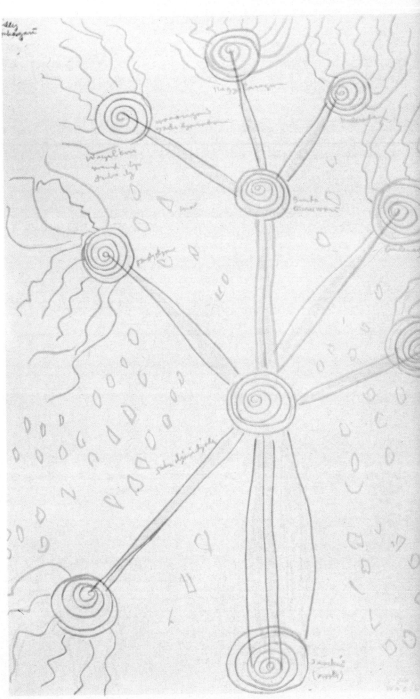

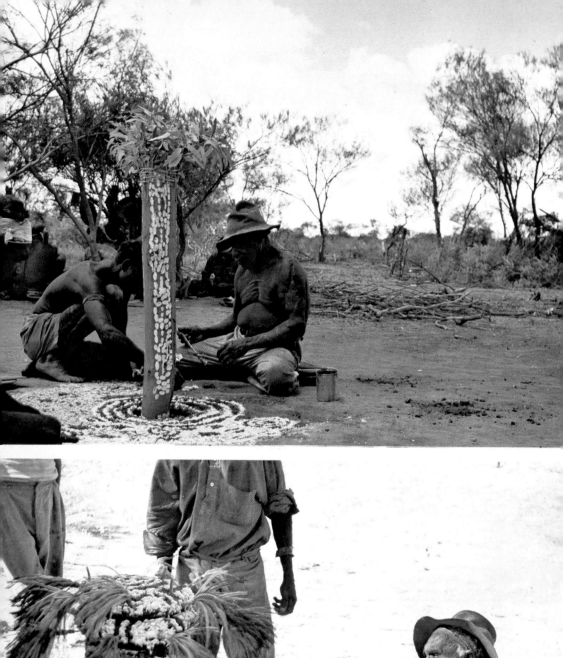
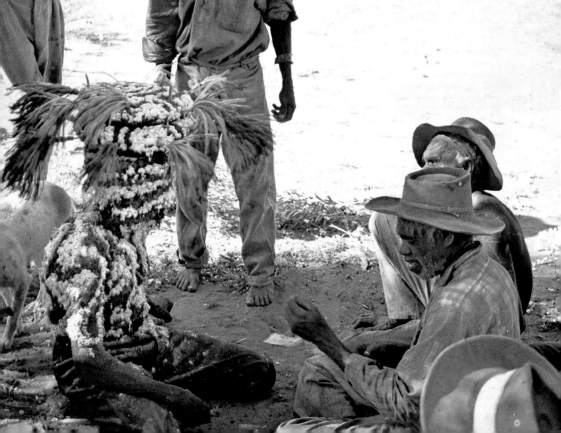

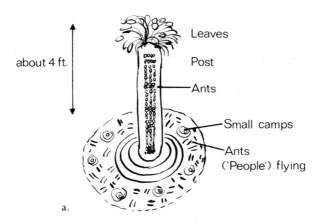

about 4 ft.

Leaves

Post

Ants

Small camps

Ants
('People') flying

a.

Fig. 6 a. Diagram of the post
and ground painting. The
details of the painting are
derived from a paper drawing
of it by a Walbiri man
b. Diagram of the hole and
suggested relation to concentric
circle when the circles which
line the hole are taken into
account

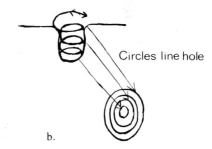

Circles line hole

b.

The straight lines joining the circle are the tails (also spears)
of the kangaroos, the paths they made travelling back to the
rock hole 'in order to go in'. Because the footprints indicate
direction, the figure shows that the Dreamings are going towards
the camp ('going in' rather than 'coming out'). In most cases,
however, direction cannot be 'read' from the graphs alone, but
knowledge of it depends upon extra-graphically supplied infor-
mation.

The drawing of Plate 3, a spiral, was used to explain the emer-
gence of a rain Dreaming, and is also a rain design. The informant
explained that the Dreaming 'came out' at the starting point of the
spiral, 'walked around' (*wariwabadja*) making his camp, and then
travelled away. Thus as he walked, the rain circled away from
the centre until finally he was on his way, leaving his home for-
ever.

In this example, there is no break between the extended path

line and the camp circle. More commonly, the line is a separat
unit joined to the circle peripheries; the ultimate connection c
the directional path line with the centre is nevertheless implici
since the latter is the absolute point of emergence or re-entry.

In Fig. 3 the spatial organization in terms of centre
peripheries-extension is used to convey more specialize
meanings. This figure was drawn in the sand as part of a
explanation of the causes of rain. (Later another man, seeing m
sketch of the drawing, suggested it was a design used as a san
painting in rain ceremonies.) The diagram illustrates Walbir
theory according to which rain is generated by rainbow snakes
who live inside the rock holes at many different sites.

At the very centre of the circle is a cluster of dots representin
pearl shells described as the 'spirit children' (*guruwalba*)[19] c
the snake. The medial circle is the snake coiled under the wate
of his rock hole camp; the children are inside his body. The peri
pheral circle is the rock hole at the bottom of which he is lying
The ray of lines extending from the circle peripheries is the rai
with the rain shells(/children) that the snake is sending out in al
directions. After this, rain returns into the earth, attracted bacl
(according to the informant) by the singing of rain songs.

It is notable that this causal explanation conforms to th
fundamental notion about the dynamics of life maintenance: th
rain does not merely come from the sky, but it emerges first fron
inside the ground, and then returning to it fertilizes the soil an
fills the rock holes.

In the diagram, the shell/children, or life elements, are place
at the very centre; they are then sent outside from this centre
Thus they travel from a position inside the body of the snak
(who is in turn inside the rock hole) to a position outside an
above the snake and the rock hole. If we plot these spatia
relations in terms of the circle, then successive rings signif
positions successively closer to the outside. Put in another way
the nesting of one circle inside another is used here to image th
position of inside or underneath (i.e. *ganindjara*) the item re
presented by the enclosing circle, as against outside or above i
(i.e. *gaŋgalani*).

These examples lead us to ask certain general questions per
taining to graphic structure. If the concentric circle(/spiral) is t
be regarded as an enclosure, then we must inquire further int
the utilization of this structural type in the wider graphic system
Secondly, we must direct more attention to the spatial 'logic' en
tailed in enclosing one item within another: for what sorts o
relationships in three-dimensional space can the enclosur
provide an equivalent in the two-dimensional, linear art, an
what principles underlie this equivalence?

The enclosure exemplified in the typical site circle of men's designs is actually a special form of a more general construction type widely used in Walbiri representation, and found in women's as well as men's usages. It consists of a circle with some other graphic element or elements enclosed within it; the latter may be other circles, but any graphic element can occur in this position if warranted by the narrative sense.

As I have pointed out, the circle can be used to refer to any class of items that 'fits' into the category of non-elongate, closed forms. This is also true, of course, of the circle functioning as an enclosure. Fig. 4 provides examples selected from my observations of men's and women's sand illustrations, and one from women's *yawalyu* designs. I shall comment first on certain enclosures referring directly to 'going in' which occur in the sand drawings of women's story telling.

Like all traditional Walbiri narratives these tales are believed to describe Dreamtime events. In the stereotypic finale, all the actors come together and go into the ground. The usual representation of this scene involves a number of lines drawn towards a circle to depict the paths of actors going into a hole (Fig. 4a), or into some object relevant to the story such as a fighting stick or a waterhole. Sometimes this circle is treated as an enclosure. In Fig. 4b a dead man is shown sitting inside a tree, and the other actors enter here. The spatial sense of the enclosure is that the dead man is surrounded and covered by the tree trunk. Similarly, the *yawalyu* design of Fig. 4g shows the children of the berry Dreaming inside the mother's body (the enclosing circles).

In Fig. 4c, however, the enclosure conveys a different spatial value. Here a concentric circle represents the breast of a murdered Dreamtime woman around which her son walks until finally he goes into the nipple (the central circle). The enclosed item is thus on the surface (or on top) of the enclosing object, and not inside it.

It should be noted that this use of the concentric circle to represent the breast is not an isolated one. In men's designs for female Dreamings the site circles generally depict the women's breasts as well as their camp sites.[20] The nipple, like the waterhole, is the source of life nourishment and both, it will be noted, are at the centre of the enclosure.

Fig. 4d, taken from a woman's sand story, represents a hill with an actor sitting on it.[21] The actor is not intended to be *ganindjara*, i.e. inside the surface of the hill, although as we have seen, this meaning could certainly be carried by exactly the same construction. It is only through extra-graphic factors of narrative context that we know the actors are sitting 'on' not 'under' the surface of the hill.

In contrast to the convex form of the hill, the objects

represented in Figs. 4e and f are concave, and the objects placed inside are at the bottom or 'in' the concavities. The nest, the wooden scoop, and the sand hollow are like the hole in this respect, but shallow rather than deep. Whether the circle refers to a convex or concave object cannot be 'read' from the graphic forms.

Still another spatial value of enclosure is suggested by Fig. 4h. The outer circle represents water running around a hill; of course, the hill is not 'on' the water but is merely ringed by it. So also the outer circles of Fig. 4i represent rings of people standing around a fire. In these cases, the circle does not represent a solid on whose surface the enclosed items are placed, or within which they lie; it functions merely as a boundary. This sort of meaning is carried to its extreme in the drawing of Fig. 4j where the circle does not represent any object, but only serves to indicate that the items within it are unified, or belong together as 'one country'. This unifying function of the circle is also implied in the more usual representational usages, since anything within the circle rather than outside it is bounded or contained by the one object. I have already noted the importance of this implication with respect to the site circle.

When the circle carries the sense of a ring, it need not be restricted to static objects but may sometimes express circular motion, as we have seen in the case of the site circle. As suggested in Figs. 4c and 4h, circling lines may also occasionally be used to express movement in the wider graphic system. The outer line of Fig. 4k represents rain falling around a berry tree. The informant (a woman) also personfied the rain as 'spirit children' who were dancing around the tree. The enclosure here would seem to carry more than one spatial value: on the one hand, the tree is engulfed by (covered by) the rain; on the other, the rain spirits ring the tree as they dance.

All these different spatial values of the enclosure are simply explained if we recognize that the spatial grammar with which we are dealing is strictly in accord with the rules of that two-dimensional country 'Flatland'. In 'Flatland', as Rudolf Arnheim (1954, p. 60) has pointed out:

The two dimensional units of the drawings are equivalents of solids and/or two-dimensional aspects of the outsides of solids depending on what is needed. The relationship between flatness and depth is undifferentiated, so that by purely visual means there is no way of telling whether a circular line stands for a ring, a disc, or a ball.[22]

Certain characteristics of the Walbiri use of enclosures follow from this principle. As we have seen, there is no graphic contrast

between spatial features like convexity and concavity, or between the representation of solids as opposed to an enclosing ring. An element placed inside the contour line could be 'read' as lying on or inside the surface of the object depending on context. If the object is concave, the item placed within the boundary is at the bottom of the concavity; if it is convex, the item could be on the surface, or inside it, as there is no graphic way of representing covering other than by the enclosing line itself.

When the enclosed item is supposed to be covered by the surface of the enclosure, the fact that it is visible in the drawing does not mean that the picture presents a kind of 'X-ray' view of the inside; as Arnheim (1954, pp. 59ff.) has rightly stressed, the line effectively covers the object. In the traditional Walbiri system enclosure is the basic solution to the problem of representing this sort of spatial relationship.

The structure of enclosure thus comprehends a range of possible spatial values; the selection of one or the other value in any given usage depends upon the nature of the object being depicted or on other factors of specific context. This visual ambiguity cannot be taken to indicate that the graphs are 'abstract' or in any sense 'non-pictorial'; on the contrary, it results from a recasting of the three-dimensional world into the spatial premisses, or organizational possibilities of two-dimensional, linear forms. Enclosure is a two-dimensional 'structural equivalent' of certain three-dimensional relationships, and its ambiguity derives from the limiting conditions of the media.

Let us consider the site circle in terms of this framework. As we have seen, the circle is typically conceptualized as a place consisting of a hole or waterhole with a surrounding camp. On the one hand, the enclosed item is simply a topographical feature on the surface of the country, and bounded (ringed) by the camp; on the other hand, the waterhole is a concave object with its bottom under the water, and below the surface of the country. It is a hole that penetrates the country.

If we construct a minimal concentric circle designating the outer boundary as the camp site and the inner one as the waterhole, then the space within the inner boundary, the very centre of the construction, is *ganindjara*: it is the bottom of the waterhole, the point under the surface of the country at which the Dreamings are localized before emergence or after re-entry.[23] In this sense, the outer circle represents the top and surface of the country (i.e. *gaŋgalani*) while the central circle is the bottom, inside the country.

On this view, the notion of a covering container holding the life sources is expressed in the concentric(/spiral) structure of the site circle. But this structure also conveys other spatial values

(that one object is on the surface of another, or that it is bounded by another) which are also relevant to the concept of the camp. We could 'read' the site circle in any of these ways, or in all these ways at once, but certainly the top(/outside)–bottom(/inside) notion is a critical one. I shall discuss this more fully later.

I wish to raise now one final problem regarding the representation of top and bottom in men's Dreaming designs. We can ask whether there is not some other principle in addition to enclosure through which the top and bottom of a single object can be represented in the designs. The contrast between the two representations of a tree in Fig. 5a and Plate 4 suggests that there is indeed an alternate solution.

Fig. 5a depicts the country of certain tree Dreamings. The camp where the men are sitting is *ganindjara*, in the roots of the tree. It is enclosed by a circular ring representing the leafy branches: here the enclosure serves to depict the top(/outside) and bottom(/inside) of the tree. Thus the tree is depicted on the model of a container.[24]

This solution does not directly show the vertical extension of the tree in space. In Plate 4, however, a tree is depicted in elevation: the trunk is a set of lines connected at one end to a circle depicting the roots and base of the tree, at the other to a circle depicting the leafy tops; side branches are also shown separately. It is as if the circles which were ranged one inside the other in the first drawing have been separated out and placed at either end of the trunk; and in addition, side branches have been separated out from the top central ones (Fig. 5b). Both types of construction represent the spatial relationships between the top and bottom of the tree, and depict the tree as a whole. It is important to note, however, that in Pl. 4 the tree (top and bottom) is depicted as an arrangement of separate camp sites and paths, while in Fig. 5a the parts of the tree are components of a single camp site. Of the two solutions, only the enclosure can combine the expression of the spatial relationship 'top–bottom' with the notions of a bounded place or a container.

CEREMONIAL
CONSTRUCTIONS

The visual formulation of 'coming out–going in' (outside–inside) is not confined to strictly two-dimensional graphic media, but occurs also in various visual constructions and enactments of men's ceremonial dramas. I shall comment briefly on a few examples here.

One type of ceremonial construction Walbiri make is a ground painting with a post standing in the centre of the painting. Figs. 4, 6, and Pl. 5 illustrate such a construction created for a *banba* ('increase') ceremony of a flying ant Dreaming. Workers

(*guruŋulu*) began the painting at the centre: a hole was dug and water poured on the ground. After blood had been rubbed on the wet soil, concentric circles of red-ochred fluff were laid around the sides of the hole and circling it on the surface of the ground. Additional graphic elements were added and white fluff attached to complete the design. The post was decorated with white dots representing numerous ants. Bloodwood leaves, which Walbiri always interpret in ritual contexts as 'life-giving' (*gudugulu*, child-having) were attached to its top, and it was placed in the hole. Men identified the post as the ant hill, while the hole (concentric circle) was their camp.

After completion of the construction, decorated dancers of the master patrilodge and moiety crouched on the sand painting beating the ground with leaves as they converged on the pole. As they shuffled inward the men clustered around them with ceremonial shouts of *wa! wa! wa!* When the dancers had come as close as possible to the post (and hole) their head-dresses were removed. (This always marks the end of the ceremonial embodiment of a Dreaming.)

Informants stated that the dancers shuffling on the ground painting were the ants crawling around their camp; when they moved towards the post they were going into the hole. Head-dresses were removed at the point when they were supposed to have entered it. Men associated the shuffling on the painting and movement towards the hole with multiplication of the ant species.

In this drama the centre of the circle is an actual hole, to which the elongate post (with the swarm of ants on it) is directly joined. Dancers converge on this focal centre 'going in'. This movement towards the centre (dying) is a procreative act. Since the hole is lined with circles, the concentric circle camp actually begins at the bottom of the hole and extends up to and along the surface. If we flattened the hole into a two-dimensional form (Fig. 6b), the innermost circle would be the very bottom, under the surface. Circling from the centre we are actually circling up to the outside; circling from the peripheries to the centre involves descent to the bottom of the hole.

The centre as an actual hole also occurs in certain circular head-dresses used in *banba* ceremonies. Before completion these constructions are a doughnut-like ring of mulga branches bound with hairstring. In the completed head-dress, however, the hole is covered and the entire surface decorated with concentric circles of red and white fluff.

If we wanted to make a simple, two-dimensional picture of the original mulga ring, we could obviously do so by means of a concentric arrangement consisting of two circles. The peripheral area (bounded by the outer and inner lines) is the solid ring, and

the central area (bounded by the inner line) is the hole. The drawing of the tree in Fig. 5 strongly suggests that the informant was conceptualizing the figure as a solid ring with a hole in the centre, and other paper drawings of site circles by Walbiri sometimes give this impression.

The explicit association between the ring and the camp site circle was brought to my attention in one instance during the preparation of a circular head-dress for a native cat ceremony. As the construction was being prepared, I drew the mulga ring in my notebook. Men who were sitting near me insisted that I attach the ring to a meander line representing the tail(/path) of the animal, and add footprints along the line going away from the ring. They explained that the head-dress was the camp or hole, and also called it *ŋami*, a deep-sided wooden scoop in which women carry water. They described the circle as the mother (*ŋamadinyanu*) of the path line, which was the son or child. Thus the son comes out of the circle – the mother, water-carrier and camp (cf. Pl. 1 and Fig. 2).

Plate 6 illustrates the dancer in a kangaroo mouse *banba* ceremony, who is wearing a circular head-dress from which lines of red fluff wind over his head and torso. The head-dress represents the hole (camp) of the kangaroo mouse, while the meandering lines are his tail or path. The mouse emerged from his hole and travelled along. Thus the dancer is 'encased' in a typical camp-track construction. Another type of construction where the circle-line model recurs is shown in Fig. 7, the plan of a ceremonial ground for the finale of a lengthy series of performances dramatizing the travels of a snake Dreaming.[25] The ground consisted of a large circular clearing surrounded by a low ridge of banked soil marking the boundary. Within this clearing was a shallow, circular depression some twelve feet in diameter; in its centre was a circular mound, and bloodwood leaves were placed on the mound. On the west the depression opened into an entranceway.

Two performances, one at night and one at dawn, were danced on this ground; women and children as well as men were present at both. In the night performance the dancers were *guruŋulu* (workers) rather than *gira* (masters) of the ceremony. Before the dancing began, women, children, and men gathered on the ceremonial ground, standing on the peripheral ring. Several dancers swung into the clearing from the east, circled south along this outer ring and entering into the entranceway circled briefly in the depression. As they danced, old women of the opposite patri-moiety clasping bloodwood leaves in their hands, stretched their arms out over the depression making a gesture that signified 'go in'. The atmosphere was one of intensity, and

women as well as men were aware that the performance drama-
tized the entry of the Dreamings into the ground.

In the dawn performance the dancers were the *gira* of the
Dreaming. When all was readied, bloodwood leaves were laid
briefly on the mound, and then taken off to be given to the
dancers. As before, men, women, and children gathered on the
peripheral ring. Three decorated dancers wearing squat box-like
head-dresses of the type called *bagali* knelt in the entranceway
and shuffling into the depression danced briefly towards the
centre; their head-dresses were then removed, signifying the
conclusion of this ceremonial cycle.

Women and children then left the ceremonial ground, but
men gathered around the mound on which the fluff-decorated
head-dresses had been laid. Young initiates (i.e. young men being
taught the ceremony) who were of the *gira* lodge and moiety
were brought to the centre, laid on the body of a *guruṇulu* and
rubbed with the head-dresses, so that some of the fluff came off
on their bodies.[26] (It will be recalled that the fluff is sometimes
likened to the generative powers, the *guruwari* of the Dreaming;
moreover, the designs themselves, made out of the fluff, are also
guruwari.)

In this ceremony the ground plan is equivalent to the concen-
tric circle with the line (the passageway) entering it. The central
mound clearly functions as the locus of life and death: the
dancers circle towards it going in, but on it rest the life-giving
leaves and the Dreamings' head-dresses expressive of continued
life. Here also the initiates are brought into contact with the
guruwari: the centre is the locus of intergenerational continuity,
where the Dreaming died.

During the performance only the Dreaming actors enter the
depression, while observers gather on the circle peripheries. (Cf.
the flying ant ceremony where performers danced on the ground
painting, while non-dancers clustered around them beyond the
edges of the painting.) If the centre expresses the position of the
Dreaming inside the ground, the peripheries express the outside
position of the living, the people of the present day, who are
yidjaru rather than *djugurba*. Contact at the centre between
initiates and *guruwari* juxtaposes the past, inside, with the
present, outside.

CIRCLE ENCLOSURE
AND LINE AS A
COSMIC MODEL:
SUMMARY

In this section I go beyond specific Walbiri interpretations to
suggest the general significance of the circle-line model. The
diagram (Fig. 8), is intended to summarize my points and to
indicate the way in which the circle-line model images the Walbiri
'world theory' built on the notion of 'coming out–going in'.

Fig. 7 Ceremonial ground for
finale of snake ceremony

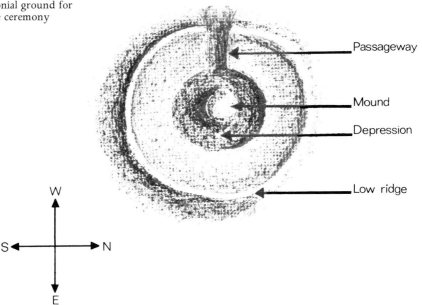

Passageway

Mound

Depression

Low ridge

W

S ← → N

E

Fig. 8 Circle and line as
cosmic model: summary

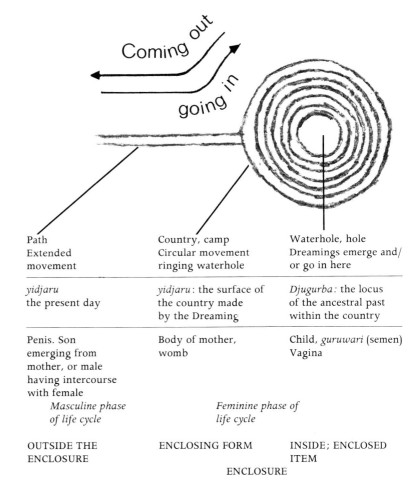

Coming out

going in

Path Extended movement	Country, camp Circular movement ringing waterhole	Waterhole, hole Dreamings emerge and/ or go in here
yidjaru the present day	*yidjaru*: the surface of the country made by the Dreaming	*Djugurba*: the locus of the ancestral past within the country
Penis. Son emerging from mother, or male having intercourse with female	Body of mother, womb	Child, *guruwari* (semen) Vagina
Masculine phase *of life cycle*	*Feminine phase of* *life cycle*	
OUTSIDE THE ENCLOSURE	ENCLOSING FORM	INSIDE; ENCLOSED ITEM
	ENCLOSURE	

As we have seen, the circle in its two senses of camp site or country and female body or 'mother' is a container: a visible form within which life is carried. Walbiri interpretations suggest the concentricity of the circle conveys the internal structure of the country or body. The essential contrast between centre and periphery is that the former is a hole or waterhole where the life sources are localized, while the latter is a solid enclosing form, i.e. the country or body, the container itself.

Because the enclosure as a general structural type can, in this system, depict more than one sort of spatial relationship, determination of the one intended in any given instance depends upon specific meaning and situational context. However, the relation between the hole or waterhole and the camp site is itself ambiguous, for the former mediates between the bottom or 'underneath part' of the country and the surface. On the one hand, the centre is the bottom of the hole, and therefore under the country; on the other, the centre is a visible topographical form on the surface of the country, ringed by the camp. We have to remember that the waterhole, like all topographical features, was created by the Dreamings, and functions as visible proof of their existence. But it also marks the point where the Dreaming exists hidden underground, or where he existed before emergence, before the waterhole was made.[27]

The same sort of double reading can be phrased in terms of the body. From one point of view the centre is inside the woman's body, while the peripheries are the bodily surface. In another sense, the centre is the vaginal hole through which entry is effected into the body in sexual intercourse and from which the child is born. The concentric structure seems to be aptly fitted to expressing the paradox that *djugurba* (the Dreaming) and *guruwari* – localized at the centre – are at once both hidden from view, and open and available.

The line conjoined to the circle peripheries is the path outside the boundaries of the place, moving either towards or away from it. It is masculine rather than feminine, and from one point of view, mobile in contrast to the static locality, since the latter is associated with sleep, rest, and death. While in one sense there is a simple opposition of circle and line, in another sense the two are parts of a paradigm: the line conveys directional, elongate mobility in space (straight or meandering depending on the type of path made by the Dreaming); the circle conveys circular movement showing the Dreaming moving within the locality (walking around making camp) rather than beyond it. Circling can also be understood as part of the process of 'coming out' or 'going in' when the Dreaming has not yet reached the extended path line, or has entered the boundaries of the place from the path.

As long as the Dreaming has a visible track (circular or elongate) he is outside the ground and can be 'followed' because he has physical presence. Both the concentric lines of the circle and the elongate ones of the extended path convey the existence of the Dreaming on the surface of the ground, alive and in motion. The path stops at the point where the Dreaming starts or ends, i.e. at the centre where all movement and surface existence disappear.

The contrast here is between the *guruwari* design itself, the entire track mark of the Dreaming, and the central point or area where the linear marks stop, or where the design itself ends. If we take this track as a kind of life-line, then as long as it is circular, the life cycle is within the female sphere, or in its feminine phase: inside the female or nourished by the female. The elongate section of the path is an assertion of the masculine life principle: it is the erect penis, the son coming out of the domain of feminine nurture into adulthood and sexual potency. Conversely, the life-line going back into the circle in sexual intercourse or death returns into the female phase or sphere of existence.

We can also look at the circle and line as a spatial model of the relationship between past (*djugurba*) and present (*yidjaru*). Indeed, it would seem to provide the traditional Walbiri model for imaging this relationship. The *guruwari* stored within the ground are the residue of the past and the dead; *djugurba* itself, in the persons of the Dreaming ancestors, exists today inside the ground covered over by the topography, i.e. by the visible realities of the *yidjaru* period. The circle, then, is the present day country with *djugurba* at the centre, hidden inside it. The enclosure shows *djugurba* under or at the bottom of *yidjaru*.

The extended line expresses the constant availability of *djugurba* to *yidjaru* through the coming out and going in cycle: the constant separation of life resources from the hidden insideness of the country. In effect, it says that there is movement from the past out and along the surface of the country and into the elongate path away from the dead. And it states equally the converse: return from *yidjaru* to *djugurba,* as when the Dreaming ceases to be physically embodied at the end of a ceremony, or the *guruwari* powers are released in death. So also the very concentricity of the circle seems to suggest the continuity between the bottom centre and the top peripheries of the country, between past and present.

It should be noted that this centre symbolism, unlike that of cosmic models in some other cultures, does not refer to the centre of the world *as a whole,* but only to a single place. Walbiri country consists of many such life centres linked together by

ancestral paths. There is no single locality that focalizes all the others. Walbiri do not really give conceptual shape to the world as a whole in the sense of a single, centralized structure, but conceive of it in terms of networks of places linked by paths. (Cf. Strehlow, 1964, p. 102.)

CONCLUSION In this paper my intention has been to suggest how a particular visual form widely used in one part of Walbiri iconography presents certain fundamental concepts of world order and thus provides an easily reproducible vehicle for their transmission over time. The primary focus of my analysis has been this visual form itself, in particular, certain positional relationships which it displays: centre *v.* periphery; inside *v.* outside; the conjunction of the two contrastive elements, circle and line. I have elucidated something of the symbolism of these positions by examining specific referential meanings Walbiri give to this visual arrangement in different contexts, and the relationship of the site circle to other circle enclosures utilized throughout the graphic art. Needless to say, I do not examine all the strands of meaning embedded in the circle-line figure.

Implicit in my approach is the assumption that analysis of the internal structure of visual forms as parts of larger visual systems (and by this I do not mean 'stylistic' analysis as it is currently practised, but rather analysis of the underlying rules showing us how a system 'works') is prerequisite to other approaches to the interpretation of form and meaning. In this I hold with the view expressed by Hymes (1971, p. 51) for myth — one that can be extended to the visual arts: we cannot 'assume that a purportedly universal theory, be it psychoanalytical . . . dialectical, or whatever, can go straight to the heart of a myth [read here 'visual art form'] before having considered its place in a genre structurally defined and functionally integrated in ways perhaps particular to the culture in question.'

One further point must be emphasized. I have been concerned with the circle-line figure as a spatial 'concept' which may be actualized in a range of concrete media and social contexts. That is, I have approached the problem largely from the point of view of *langue* rather than *parole*. From the perspective of the social process, however, the circle and line emerge in temporal activities and are parts of bodily behaviour. Thus during the construction of ceremonial objects or drawings in the sand, the extrinsically produced forms are meshed with the bodily behaviour of the producer. In sand drawing or painting, for example, the hand itself circles to produce the visual shape, and in ceremonial performances, as I have pointed out, the shapes may sometimes be acted out by the dancers' movements. In ceremonial also, the

contact between sacred objects or designs and the body is an important aspect of the activity: designs are painted on the body and ceremonial objects are handled or worn; sand paintings form the focus of bodily actions and are obliterated through the dancing.

This point serves to reinforce one implicit in my discussion: through the circle-line configuration the notions of 'world order' I have described are bound up with manipulative and tactile as well as visual perception, and thus embedded in immediate sense experience. Philosophical premisses about the macrocosmic order are continuously brought into the sense experience of the individual Walbiri man through the agency of this iconic symbolism. The symbols thus articulate the relationship between the individual or microcosm and the macrocosm, and through the immediacy of touch and sight bind the two together.

NOTES

1. By a *representation* I mean a communication with referential meaning in which the sign vehicle is a 'structural equivalent' for its referent. Put in another way: there is an element of likeness between the form of the vehicle and its referent; the relation between them is thus 'iconic' rather than 'arbitrary'. I use the term *iconography* to refer to a traditional system of visual representations whether developed within an oligo-literate civilization such as, for example, that of medieval Europe or of the ancient Maya; or within a relatively small scale non-literate society such as that of the Navaho, Kwakiutl, or Walbiri. All iconographies share certain fundamental structural features despite extensive stylistic differences. Most notably, all operate by means of relatively standardized visual vocabularies or elementary units (conveying, as in oral language, categories of varying degrees of generality), and have implicit rules of element combination. Although an iconography, as I consider it here, is materialized primarily in 'extra-somatic' media of two or three dimensions, it may also be given somatic form in dance or ritual enactment. The degree of 'spread' of a particular system over various possible media is, of course, a matter for empirical determination. As is well known, iconographies often serve to articulate underlying assumptions about the nature and structure of the universe; i.e. they can provide, as I point out, visual models for cosmic order. This sort of 'symbolic' meaning is also iconically patterned, as the term 'model' suggests. In the present study I am primarily concerned with this 'symbolic' function of iconographies, rather than simply with their referential (representational) aspects.

2. My research among the Walbiri was conducted over a period of eleven months between 1956 and 1958 at Yuendumu government settlement, Northern Territory, where primarily southern Walbiri were in residence. Field work was supported by a Fulbright grant and carried out under the auspices of the Australian National University.

3. Walbiri men sometimes used the term *djugurbanu* to refer to the ancestors, i.e. the actors in the narratives.

4. The notion of 'strength' carries the implication 'effective': each class of designs is thought to have a specific or generalized capacity – for example, aiding in the growth of a child – which is actualized when the design is ritually painted.

5. The number of basic, *regularly used* elements does not exceed about thirteen in any one genre of the art, but the elements vary somewhat in

the different genres, and moreover, coinage is always possible. There are also additional peripheral elements which occur less commonly.

6. In women's *yawalyu* designs, elements are sometimes combined in 'semi-decorative', non-representational arrangements, but the elements themselves still carry representational meanings.

7. There is a certain parallelism between visual categories of this type and some kinds of classifiers in oral languages, as for instance, the classificatory verb stems of Navaho (see Casagrande, 1960). Dr. Robert J. Smith (personal communication) has also suggested to me a parallel with Japanese 'counters' used to enumerate various classes of items. For example, certain elongate items such as pencils, roads, and paths may be enumerated with a single verbal counter, while spherical or lumpy solids are enumerated with another, etc.

8. The importance of this pattern of thinking in Australia – particularly in central Australia, but also in other areas – is amply documented in sources such as Roheim (1945), Strehlow (1947), and Warner (1937, Chapters 9–11). Roheim's study, with its neo-Freudian framework, remains to date the only attempt to provide a systematic interpretation of central Australian symbolism, notably that of the concentric circle and linear formations pervasive in the art and ritual of the area. In the present paper my aim is to show how 'coming out–going in' and its visual correlates provide a way of thinking and communicating about the nature of the cosmos. The sexual significance of 'coming out–going in' will become apparent in the course of discussion – Walbiri themselves are articulate about it – but this is only a part of the larger problem of cultural meaning and interpretation.

9. Pepper defines a 'world theory' as an attempt to define the basic structure of the world as a whole by means of a relational pattern drawn from a narrower domain or segment of the world.

10. However, some of the groundwork for this graphic model is certainly laid in the wider graphic system used by women as well as men. Compare in this respect the iconographic examples from women's story telling discussed below. In a work on Walbiri iconography currently in preparation I deal more fully with differences between men's and women's elaboration of the graphic system.

11. A number of my examples are taken from paper drawings made for me by Walbiri informants. Referential meanings given for the forms in each drawing, and for all other examples (sand drawings, ritual objects, etc.) are those obtained from informants.

12. Evidence for the following comments on Walbiri concepts of time, 'country', and 'physical embodiment' is presented in this earlier paper. The present study takes up from a different point of view some of the problems discussed there.

13. Other ways of phrasing this which I have heard are that the Dreaming 'gets up', i.e. 'awakens' (*yagurabura*), or that he must 'come' (*yanini*).

14. When the dancer quivers in the performance, fluff from the body decorations shakes off on to the ground. Two of my informants described this ritual quivering as 'throwing off' *(gidjini) guruwari*. See also Meggitt, 1962, p. 65. Spencer and Gillen (1904, p. 301) remark with reference to Warramunga *'intichiuma'* ceremonies: 'This shaking of the body . . . is done in imitation of the old ancestor. . . . The spirit individuals used to emanate from him [when he performed] just as the white down flies off from the bodies of the performers at the present day when they shake themselves.' On the sexual significance of ritual quivering and the direct association of fluff with impregnation see Roheim (1945, pp. 91, 97). There is little doubt that the ancestor's *guruwari* is his semen. The term seems to refer to the essence of male procreative power.

15. Cf. Meggitt's (1966, p. 135) description of Walbiri love magic ceremonies using these poles. He says: 'The poles represent the digging sticks, penes and clitores; the blood-soaked holes [in which the poles are standing] are

vulvas, vaginas, navels, bellies, wombs, breasts, waterholes and camp sites. . . .'

16. In addition to the occurrence of explicit interpretations differentiating centre and peripheries, there are some common modes of depicting the concentric circle in the paper drawings which suggest the differentiation. In a number of instances the central circular area is filled in, giving the impression of a circular item enclosed by several concentric circles, or of concentric circles bounding this item. In some other cases the central area is a relatively large circular space while the outer lines are placed closely together. In both sorts of depiction the centre is visually set off from the peripheral circles.

17. The unitary form of the circle-line figure seems to occur primarily where the line is a meander (i.e. an extended spiral form) so that it swings naturally out of the circle peripheries. It is a common feature of designs for the rain Dreaming where the meander is an important motif. In some paper drawings where the line was treated as a separate unit conjoined to the circle, my informants drew the line directly through the circle boundaries into the centre (cf. Fig. 1). Evidently, they were conceptualizing it as going in at this central position. In traditional technique, however, the lines would simply be joined to the peripheries, and thus would not break the circle boundaries. The point is that the meaning 'going into the centre' is conveyed by the conjunction of the line with the peripheries of the circle.

18. This is the well known figure of many Australian mythologies. In Walbiri thinking the snake's body is invested with the colours of the rainbow and the lightening, he has close associations with the rain Dreaming.

19. The *guruwalba* is a small child-like creature (male or female) who sits in the trees of Dreaming countries and throws a missile (e.g. a boomerang) injecting a woman with *guruwari* of the locality, and causing pregnancy. He is probably best understood as a personified form of ancestral generative powers.

20. One of my informants described ritual procedures used by men to aid in the growth of a young girl's breasts. According to his description, two small mounds were moulded in the sand and concentric circles in red and white fluff placed around them. The association of the concentric circle with the breast is especially prominent in connection with men's 'love magic' designs (*ilbindji*), but occurs also in other contexts. One man described the gesture sign for certain oval sacred boards (*djabanba* and *gunamani*) as representing the breast: he crooked the little finger and made circling motions with the hand. The little finger is the nipple; the circling, the breast. Cf. also n. 15 above.

21. Walbiri uses a locative suffix (-ŋga, -la) to express various relationships of position. For example, *bili-ŋga* (hill locative) could mean 'on', 'inside', or 'at' the hill depending on context.

22. In his otherwise excellent analysis of this problem, Arnheim unfortunately adopts an evolutionary viewpoint postulating that this particular two-dimensional technique for describing three-dimensional space 'is used mostly at very primitive levels' because of its 'ambiguity' (p. 160). This view is based on the western assumption that visual particularization is a more appropriate representational solution than generalization, and that a tradition will evolve out of generalization as it develops. It seems unlikely, however, that the degree of ambiguity of particular categories or constructions has broad, evolutionary implications for visual systems any more than it does for oral language systems.

23. The notion of the earth as a cover under which the Dreaming lies until he emerges making a waterhole is particularly well illustrated by the Northern Aranda bandicoot myth translated by Strehlow (1947, pp. 7ff.):

The gurra [bandicoot] ancestor – his name was Karora – was lying asleep, in everlasting night, at the very bottom of the soak Ilbalintja; as yet there was no water in it, but all was dry ground. Over him the soil . . . was over-grown with many grasses; and a great tnatantja [decorated pole] was

swaying above him. . . . At its root rested the head of Karora himself: from thence it mounted up towards the sky. . . . [When dawn began to break] the gurra ancestor was minded to rise. . . . He burst through the crust that had covered him; and the gaping hole that he left behind became the Ilbalintja soak. . . .

24. I avoid here such descriptions as 'bird's eye view' which imply that the solution is derived from a particular way of looking at the object, or that it shows us the object from a particular perspective. My implication is rather, that the solution derives from the *internal structure* of the representational system, and that we cannot automatically 'read off' from the structure a perspective from which the object is being viewed.

25. Circular ceremonial clearings of similar type are well known from other parts of Australia as well. Cf., for example, Mathews (1903); Stanner (1964, pp. 242 ff.).

26. As they rubbed the head-dresses on the *gira, guruŋulu* spit on them crying *po! po! po!*, a ritual expression of antagonism which also occurred in other sections of the ceremonial dramatization.

27. I do not mean to imply that Walbiri think of Dreaming ancestors as being localized *only* in the rock holes; rather, their idea seems to be simply that the Dreamings and *guruwari* are within the country. However, the hole or waterhole focalizes this notion of inside position since it is the locus of emergence and re-entry. Thus in the iconography the centre expresses the notion of this underground position.

REFERENCES

Arnheim, R., *Art and Visual Perception,* Berkeley, 1954.

Casagrande, J., 'On "Round Objects" a Navaho Covert Category', *VI^e Congrès des sciences anthropologiques et ethnologiques,* vol. 2, Paris, 1960, pp. 49–54.

Cunningham, C., 'Order in the Atoni House', *Bijdragen tot de Taal-, Land-, en Volkenkunde,* vol. 120, Leiden, 1964, pp. 34–68.

Fernandez, J., 'Principles of Opposition and Vitality in Fang aesthetics', *Journal of Aesthetics and Art Criticism,* vol. 25, no. 1, 1966, pp. 53–64.

Forge, A., 'Art and Environment in the Sepik', *Proceedings of the Royal Anthropological Institute for 1965,* 1966, pp. 23–32.

Hymes, D., 'The "Wife" who "goes out" like a Man: Reinterpretation of a Clackamas Chinook Myth' in P. and E. K. Maranda (eds.), *Structural Analysis of Oral Tradition,* Philadelphia, 1971.

Leach, E., Two essays concerning the symbolic representation of time, in *Rethinking Anthropology,* London, 1964.

Mathews, R., 'Aboriginal Bora held at Gundabloui in 1894', *Journal and Proceedings of the Royal Society of New South Wales for 1894,* 1903.

Meggitt, H., *Desert People,* Sydney, 1962.

——, 'Gadjari among the Walbiri Aborigines of Central Australia', *Oceania,* vol. 37, 1966, pp. 124–47.

Miller, R., 'Cultures as Religious Structures', *Proceedings of the 1964 Annual Spring Meeting of the American Ethnological Society,* Seattle, 1964.

Munn, N., 'Walbiri Graphic Signs: An Analysis', *American Anthropologist,* vol. 64, 1962, pp. 972–84.

——, 'Totemic Designs and Group Continuity in Walbiri Cosmology', in M. Reay (ed.), *Aborigines Now,* Sydney, 1964.

——, 'Visual Categories: An Approach to the Study of Representational Systems', *American Anthropologist,* vol. 68, 1966(1), pp. 936–50.

——, 'Graphic Narration in Desert Australia', Paper delivered at the sixty-fifth

annual meeting of the American Anthropological Association (mimeographed), 1966(2).

Pepper, S., *World Hypotheses,* Berkeley (first pub. 1942), 1961.

Roheim, G., *The Eternal Ones of the Dream,* New York, 1945.

Spencer, B. and F. Gillen, *The Northern Tribes of Central Australia,* London, 1904.

Stanner, W., 'On Aboriginal Religion', *Oceania Monograph II,* Sydney, 1964.

Strehlow, T., *Aranda Tradition,* Melbourne, 1947.

——, 'Commentary on the Magical Beliefs described in M. J. Barrett's "Walbiri Customs and Beliefs concerning Teeth"', *Mankind,* vol. 6, 1964, pp. 100–4.

Turner, V., 'Betwixt and Between: The Liminal Period in *rites de passage',* *Proceedings of the 1964 Annual Spring Meeting of the American Ethnological Society,* Seattle, 1964.

Warner, L., *A Black Civilization,* New York, 1937.

CHAPTER 12 Levels of Communication and
Problems of Taboo in the Appreciation
of Primitive Art

Edmund Leach

The problem which I posed to the seminar and to which I kept
returning was the question of how far our western appreciation
of works of primitive art is likely to be related to the intentions,
either conscious or unconscious, of the original artist or to the
responses which that artist's indigenous audience are likely to
record. It is undeniable that people of western culture do have
aesthetic responses to objects which are entirely alien to their
own, and some of us even claim to be able to make judgements of
value, saying that this object is 'better' *as a work of art* than that
one. But just what it is that we respond to in such cases is obscure.

As a test case I exhibited a photograph of an object – palpably
a human artefact – which was found in the central highlands of
New Guinea some years ago and is now the property of Mr. Philip
Goldman (Pl. 1). It is on record that this object was found in the
region now occupied by the Mae Enga tribe, but so far as is known
it is unique of its kind and no one is prepared to say just where it
came from in the first place or what it was used for or what it is
supposed to represent.[1] It was clear, however, that the photo-
graph of this object did communicate something to most
members of the seminar. Their reactions were very far from
neutral. Mr. Fagg in particular felt sure that it was 'good' of its
kind even if he did not know what that kind was, and Mr. Forge
who has handled the object also affirmed its fundamental
aesthetic merit. My own first crude interpretation of such judge-
ments was that we westerners must be attributing to the probos-
cis of the 'animal' a phallic interpretation, and though some
members of the seminar firmly rejected this suggestion, others
seemed to agree. As backing for my argument I used comparative
material from India and Polynesia to show that a particular string
of iconic equivalences occurs rather frequently in many different
contexts. This sequence may be represented by the equation:

deity = human phallus = totemic animal = human head = nose.

In any case, even without this wide-ranging comparative
evidence the data from New Guinea itself points in a similar
direction. Knowing what we do about Sepik river art and its
associated rituals no one could be surprised if Mr. Goldman's
'found object' eventually proved to be a totemic animal with a
nose which also serves as a phallic symbol. But the crux of my

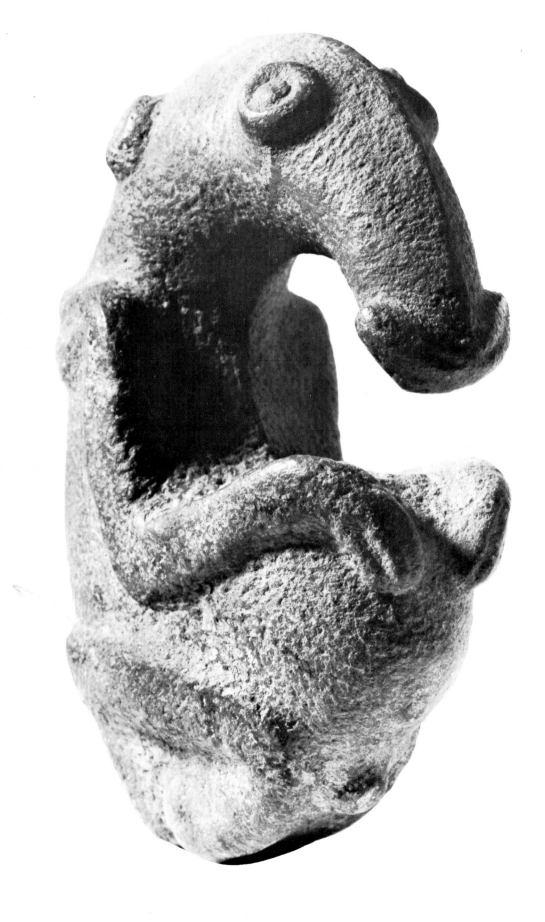

e object 20 cm. high.
n 1962 near the hamlet
idon-Pio, Yambu Clan
ry, Ambun Valley,
n Highlands, New
. Coll. Philip Goldman

argument was that at present any such interpretation must be pure guesswork. We do not as yet *know* anything at all about this object, and if some of us are prepared to attribute value to it, this value must derive from our prior prejudices; it cannot originate in the cultural background of the original maker. In effect then I was asserting that we can only judge such an object by treating it as if it were part of our own culture. Throughout the seminar I kept on affirming that art and society – however you define art – always form an integrated whole. Art is effective or communicative or whatever else it is *only* in terms of the cultural context in which it is observed.

Now this functionalist thesis that cultural things are meaningful only in their cultural context implies a notion of cultural cut-off. There must be a boundary to the cultural context outside which the object in question is *not* meaningful.

In that case, how is cross-cultural comparison possible at all? For in fact we do make cross-cultural aesthetic judgements all the time. How does this happen? There seem to me to be two kinds of problem here:

(i) If culture 'consists of messages' within the cultural context, how do we distinguish the cultural boundary?

(ii) If there are such things as cultural boundaries, how do some messages manage to get across the boundaries?

Part of the answer to both questions may lie in Dr. Munn's observation that iconic signals have multiple reference. In the case of the Walbiri, a diagram of concentric circles may signify a woman's vagina, or a waterhole, or a camp site, or a totemic location, or a gateway into the other world, and so on. So even if it is true that you have to be a Walbiri before this *whole* complex of ambiguous meaning becomes comprehensible, it may be that *bits* of the complex can communicate cross-culturally. It could be, for example, that those messages which are quite specific to particular cultures (e.g. Walbiri references to waterholes) cannot be transmitted cross-culturally, but that messages which refer to some attribute or part of the human animal as such are not culture bound.

Another part of the answer may depend on the fact that we have multiple senses. We still know very little about the actual mechanisms of perception, but it is plain that we apprehend the world by co-ordinating messages which we receive through our eyes simultaneously with those which we receive through our ears and our nose and our tongue and our sense of touch and so on. In the field of the plastic arts, objects always have tactile value as well as visual quality. Moreover we can judge what a thing looks like by feeling it in the dark, and we can judge what a thing feels like by looking at it. This, I think, is a point of quite

fundamental importance. When we try to distinguish 'art' from 'craft' we are always forced at some stage to come to terms with distinctions of the kind which in English we represent by the words *beautiful/ugly*. In the main such terms are culture bound but, in so far as they have cross-cultural significance, it is significance of a sexual kind. In all human societies men make qualitative distinctions regarding the attractiveness of women and they do so in terms of *visual* differentials. A beautiful woman is a woman who *looks* beautiful. But in fact men know women as objects to be touched and handled and smelled rather than to be seen. The visual description merely serves to suggest the underlying tactile quality. This capacity to use one sense (sight) to record impressions which ordinarily derive from another sense (touch) is, I suspect, a very basic attribute of aesthetic feeling. Where we distinguish a work of art from a work of craft we recognize that the artist is attempting, necessarily in vain, to impose on his material a degree of order higher than that which he can fully control. It is as if he wanted *both* to create a woman as a plastic visual object *and* as a tactile object generating sexual satisfaction. We know intellectually that this cannot be done, yet perhaps we can be sensitive to the failure of the attempt. How?

In attempting to answer that question in the discussions of the seminar I arrived at the formula that 'the special quality which we distinguish in a work of art, as distinct from a work of craft, is something which belongs to the *inter-categories* of sensation.' If the reader is to attach meaning to this formula I must go back and explain the particular theory of taboo which I expounded to the seminar.

A THEORY OF TABOO[2] I shall define taboo as prohibition by a cultural rule of some action which is possible for the human animal. For example, a Jew must not eat pork, a Hindu must not eat beef, we must not sleep with our sisters. Taboos of this kind can be said to be *explicit*. But there are also *implicit* taboos which are more deeply known by the human being and are adhered to with little or no conscious effort. For example, we Europeans have no formal rule against eating insects, we just do not eat them. Likewise many peoples have no formal rule against sex relations between a son and his mother, but nevertheless this kind of incest is extremely rare.

What is the function of taboo? Taboos serve to order the world. They achieve this end by forbidding ambiguity. Nature offers us a continuum between what is possible and what is impossible. Taboo cuts up the cake of experience into sharply defined chunks.

by separating categories. For example, it is important that each of us should be able to distinguish between 'food' and 'not-food'. Human beings cannot make such distinctions by 'instinct'. If we had no rules of taboo the edible and the inedible would merge in a quite arbitrary way, but in practice the existence of implicit and explicit taboos serves to keep 'food' and 'not-food' separate. The effect of prohibiting doubtful kinds of possible food is to define positively that which is quite unambiguously 'food'.

From another point of view taboo canalizes activity. In the case of eating, for example, it canalizes activity towards that which is 'proper food'. Likewise in the case of sexual outlet, taboos against masturbation, homosexuality, adultery, fornication, and incest leave as residual, and narrowly defined, the correct behaviour 'cohabitation with a spouse'.

Then again taboo serves to cut up time. Natural time is continuous; social time is discontinuous. The discontinuity is achieved by imposing taboo on the intervals between sections of legitimate or normal time. Ordinary workdays are separated by intervals which are holy days or holidays according to one's orientation. In this case the distinction between the normal and the abnormal is characterized *either* by the imposition of additional restrictions *or* by the relaxation of restrictions, but in every case abnormal time is marked by abnormal behaviour. It is the taboo on abnormality (ambiguity) which defines the normal.

Likewise taboo may serve to cut up territorial space. Localities of ordinary space are separated by smaller areas of sacred space, such as, for example, the 'no man's land' which separates the frontiers of continental countries. In our own society, church buildings illustrate this principle very well. As we proceed from the outside world to the holy of holies of a Christian church, we pass first through a cemetery which is a taboo area given over to the dead, and then into the nave which is a relatively secular area used by the lay congregation. But this secular area is separated from the high altar by a further tabooed zone – usually some kind of choir or sanctuary from which the ordinary congregation is excluded.

In all these cases the application of taboo has a complex effect. On the one hand, it serves to separate categories; on the other, it generates an emotional interest in the intervening object or time or space which is taboo. Our maximum attention becomes focused on the margin – the edge of that which is totally prohibited. Consideration of our western attitudes to female nudity illustrates this point. At the present time, in England and France, a woman is not nude in a legal sense provided she is (1) on a stage– that is to say, physically separated from the audience – and (2) the tips of her nipples and her vaginal slit are covered. These modern

Fig. 1

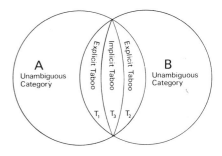

rules are extreme and minimal and focus attention explicitly on the ultimate source of sexual interest. In the course of the last four centuries European ideas on this subject have varied in the most extraordinary way, but at every stage, no matter how much of the human body has had to be covered to prevent censure, the sexual interest has always been generated by the outer edge of what remains visible. Victorian poets were enthusiastic about ankles; Renaissance poets about breasts; Arab poets about eyes. The most exciting part of a woman's anatomy is that which just can or cannot be seen. And the same argument, I maintain, applies to all spheres where taboo operates.

We can generalize this theory by a Venn diagram. If we have two categories A and B which overlap, then the overlap area is that which is the subject of taboo. Moreover within the overlap area we can further discriminate between an outer part which is explicit and an inner part which is implicit.

As an example, consider the taboos relating to incest and adultery in our own society. Let the categories of the Venn diagram be:

A: possible wife – 'unmarried woman who is not a close kinswoman'

B: wife – 'married woman who is not married to someone else'

T_1: sister – 'unmarried woman who is a close kinswoman'

T_2: other man's wife – 'married woman who is married to someone else'

T_3: mother – 'married woman who is also a close kinswoman'

The formal taboo affirms that: 'a man shall not have sex relations with a woman who is a close kinswoman or who is married to someone else.' In this formula the taboo against sex relations with the mother is doubly affirmed for she is *both* a close kinswoman *and* married to someone else. It, therefore, fits the theory that while incest with a sister and adultery with another man's wife are topics which recur repeatedly in English literature (i.e. the taboo is explicit but also fascinating) reference to the possibility of incest with the mother is very rare (fascination turns to horror and the taboo becomes implicit, i.e. 'sub-

conscious').

We arrive then at the generalization that taboo arouses excitement because it suggests a confusion of categories. My application of this theory to the field of art leads to the proposition that art tantalizes because it seems to the observer that it may be saying what may not be said. It is noticeable that the things which are commonly recognized as 'works of art' have nearly always been created quite explicitly for exhibition in taboo contexts on ritual occasions and in ritual places. Art suggests ideas which at those times and in those places must not be suggested. Put in another way, a work of art corresponds to our expectations, but it goes a little bit beyond into what is forbidden and unexpected.

If this argument has general validity then it should apply to art objects in the following way. Cultural objects, whatever their historical source, will tend to be fitted into 'sequences' in such a way that the continua of social space, social time, and social status are separated out into distinct unambiguous categories, and this will be achieved by imposing taboos on the intermediate sections of the continua. These 'inter-categories' will then acquire special value. They will appear 'ambiguous', 'interesting', 'mysterious', 'sacred', 'dangerous', 'sinful', 'exciting', and so on. One of the areas of experience where this process will operate is in the 'inter-categories of sensation'. As I have already pointed out, our awareness of the outside world is derived from 'messages' received on multiple channels through a variety of senses. The world would seem more orderly and less ambiguous if visual signals, tactile signals, smell signals, and so on were sharply distinguished, and it is very noticeable that we are especially prone to impose taboos on visual signals which arouse non-visual sensations . . . e.g. objects which suggest phallic symbolism. When subjected to taboo the phallic shapes retain their emotional potency, but we are inclined to deny that they are phallic.

In an earlier paper (Leach, 1958) I have drawn attention to the worldwide tendency to find ritual potentialities in the human head considered as a symbolic object, and I have argued that the underlying code contains universal elements. There is some degree of fit between this thesis and other arguments which derive from psycho-analytical theory (Berg, 1951).

The points which are particularly relevant here are that:

1. The human phallus is very widely employed as a symbol of deity.
2. The human head is very widely employed as a symbol of the phallus.
3. Head hair is then treated as an expression of 'sexuality'. For males 'hair' = 'semen', for females 'hair' = 'sexual avail-

ability'. Again and again we meet with the coding convention that 'cutting off the hair of the head' signifies the imposition of sexual restraint.

4. But 'sexuality' = 'potency' = 'power'. Political power is thus symbolized by ritual attention to the head of the ruler, and headgear tends to develop an elaborate code signifying positions in a hierarchy of status.

5. The coding develops out of two contrary principles. On the one hand, *emphasis* on the conical shape of the head or the elaboration of head hair serves to emphasize power . . . from this point of view the royal crowns of Europe have developed out of garlands placed around the head of victorious warriors. On the other hand, a hat can be thought of as a *cover* to the head and this expresses constraint on potency and sexuality.

In the seminar I exemplified this argument by drawing attention to the variety of headgear considered appropriate to various dignitaries of the Roman Catholic Church.

The dignity of Catholic ecclesiastics is compounded of several elements. The categories bishop, priest, deacon, monk, friar, nun are distinguished by the fact that the holders of these titles have separate roles to fill in the performance of religious rituals, but there are also a variety of offices which reflect a hierarchy of power in a secular administrative sense. Thus the Pope is Bishop of Rome, but he is also Sovereign Pontiff of the whole estate of the Church; and cardinals, whether they be bishops, priests, or deacons, are the Pope's administrative assistants in this latter sense. The traditional headgear reflects in a subtle way this conflicting overlap between saintliness and political authority. The tonsure, the mitre, the crown, the biretta, the tiara, and the

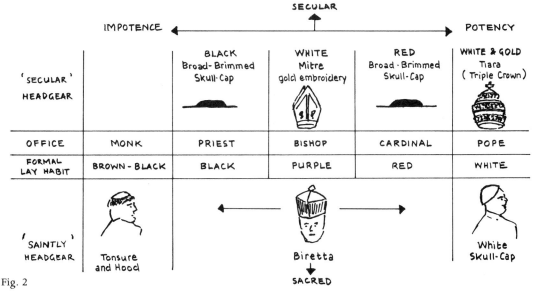

Fig. 2

cardinal's hat have had very varied histories, but they have now come to form a mutually consistent 'set' of objects in which the coding structure is easily recognizable (see Fig. 2).

We may distinguish:

1. The *tonsure* of the monk and the friar which expresses saintliness, asceticism, and the denial of sexuality;
2. The *broad brimmed black skull-cap* of the parish priest which likewise by flattening the top of the head, expresses a denial of sexuality and potency; but the impotence is secular rather than saintly;
3. The *cardinal's red hat,* of the same shape as (2) but red instead of black;
4. The white *papal tiara,* which is a phallic cone, garlanded by three golden crowns. This expressly signifies the power of the Pope as sovereign pontiff;
5. The *bishop's mitre*, likewise white and gold, likewise conical, but cleft down the middle – a kind of 'emasculated' version of the papal tiara.

Here we may note that, in terms of ecclesiastical authority, the bishop (5) is dominant over the priest (2) just as the Pope (4) is dominant over the cardinal (3).

The alternative headgear of priest, bishop, cardinal, and Pope is:

6. The *biretta* which is black for a priest, purple for a bishop, red for a cardinal, and white for the Pope. The biretta of the priest, bishop, and cardinal is a skull-cap on a stiff frame, historically related to the 'mortar-board' of English and American universities but, nowadays, the Pope wears a very plain white skull-cap which gives him the appearance of having a bald head. It is as if he were a fully tonsured monk.

The whole set of offices and symbols may be tabulated as follows (see also Fig. 2):

Category	1	2	5	3	4
Office	Friar	Priest	Bishop	Cardinal	Pope
Formal dress general colour	Brown	Black	Purple	Red	White
Tendency	← (sombre)			(bright) →	
Head-dress	Tonsure + Hood	Black Brimmed Hat or Black Biretta	White and Gold Mitre or Purple Biretta	Red Brimmed Hat or Red Biretta	White and Gold Tiara or White Skull-Cap
Tendency		← (religious merit)		(Secular power) →	

There is a cross-cutting opposition between 'secular potency' versus 'secular impotence' on the one hand (4:1) and 'sanctity' versus 'worldliness' on the other (1:4). The Pope's white skull-cap denotes his 'sanctity' whereas his tiara denotes his 'secular potency'.

This tabulation serves to emphasize the ambiguous status of the bishop. He fills a double office (i) in a hierarchy of saints and (ii) in a hierarchy of secular politicians; he is expected to be ascetic and potent at the same time. Given this contradiction of aims, it is surely not wholly irrelevant that the name of his peculiar hat should be derived from the Greek *mitra*: 'a headband worn by ancient Greek women, also a kind of head-dress common among Asiatics, considered by the Romans a mark of effeminacy when worn by men' (*O.E.D.* Art. 'mitre')?

ART AND THE
INTER-CATEGORIES OF
SENSATION

But what has all this got to do with the appreciation of art? Bishops' mitres can, on occasion, be works of art but this is not my point at all. I am simply trying to illustrate a mechanism of sensory apprehension. I want to show how the subliminal signals which we receive through our senses can be coded into sets. The case of the ecclesiastical hats illustrates this principle at a nearly explicit level. My thesis is that when we respond to a work of ark we are 'unconsciously' recognizing the existence of a comparable coded set of ambiguities in the object we are looking at.

In the particular case of the hats I am simply out to demonstrate that there is a consistency between the sexual ambiguity of the bishop's headgear and the other ambiguities in his total social position. The message system relies on a kind of punning which mixes up the notions of sexual potency and political potency and then plays games with the result: I am suggesting that this particular brand of punning is very common in art forms also.

My general proposition is that all true artists tend to devote their principal efforts to themes which contain elements of sensory ambiguity which are subject to taboo. This can be illustrated in all sorts of ways but one very obvious example is to be found in Christian religious art. In Christianity the symbol which stands out from all others as both supremely sacred (taboo) and supremely ambiguous is that of 'the Virgin mother of God'. We would all agree that many of the finest expressions of European art have resulted from attempts to express this manifestly impossible idea, but it is very striking that the most ravishingly 'successful' examples of this genre are those which introduce an element of forbidden sexuality into what purports to be a symbol of chaste maternal love. In Michelangelo's *Pieta*, for example, where the virgin bereaved mother and the dead son

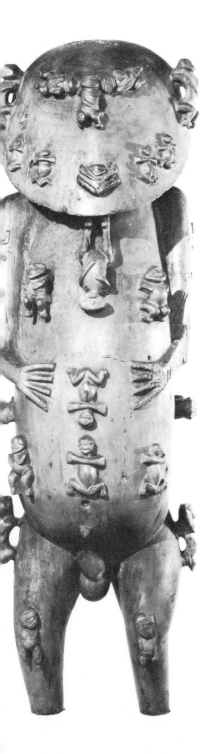
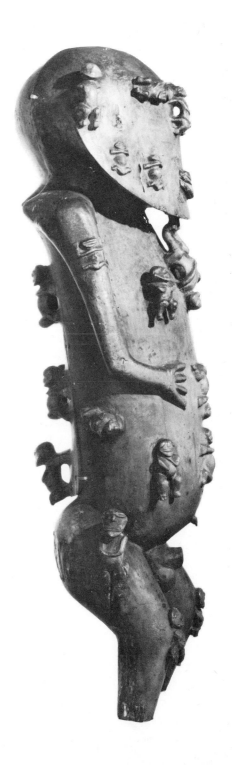

3 Carved wooden figure of
ngaroa from Rurutu,
ustral Islands. *By courtesy of
e Trustees of the British
useum, London*

are manifestly of about the same age our emotions are stirred by latent incestuous emotions of the most complex kind.

My hypothesis then is that when westerners affirm that some completely alien cultural product is a 'work of art' this is a response to the fact that elements in the iconography have touched off animal feelings which have been deeply repressed by taboo. These feelings, I believe, always stem from sensory confusion – they are a response to a mixture of messages composed of touch and smell and noise and movement and taste and sight. At the root of these complex sensations are the basic animal experiences of (a) sex (b) eating (c) dominance and submission. These experiences are the ones which bring the 'I' into *direct* contact with the 'other' which is outside the 'self'. Each one of us is constantly engaged, almost from birth, in a struggle to distinguish 'I' from 'other' while at the same time trying to ensure that 'I' does not become wholly isolated from 'other'. And this is where art comes in. It is the bridge that we need to save ourselves from schizophrenia.

The highly intellectualized arts of sophisticated societies both of the West and of the East contain many aesthetic components besides these trigger responses to our animal nature, and I do not wish to suggest for one moment that food and sex and interpersonal domination are the *only* factors which need to be looked for even in the art of 'primitive' peoples. My point is simply that it is such factors as these which are most easily recognized cross-culturally.

Plates 2 and 3 show aspects of a well known example of traditional Polynesian art. This carving of the deity Tangaroa originated in Rurutu but it has been in the British Museum since the early part of the nineteenth century. Not much is known about the associated cult activities but it is certain that Tangaroa had the attributes of an ancestral God-the-Father. This being so, a representation of Tangaroa in which human figures emerge from all over his body reflects a quite simple and easily understood iconographic convention. But this figure is not just 'an object from Polynesia'; it has always been regarded as an outstanding 'work of art'. Why? Why art? I believe that at least part of the answer must lie in the multiple layers of partly overt, partly disguised, expression of phallic ambiguity.

As may be seen the figure originally had an erect phallus; – it had already been emasculated, presumably under missionary influence, before it reached the British Museum. But the photographs show that this manifest sexuality is only one part of a much more subtle phallic theme. The handle of the detachable back also forms a kind of phallus emerging erect from above the buttocks and when viewed from the side the whole figure, with

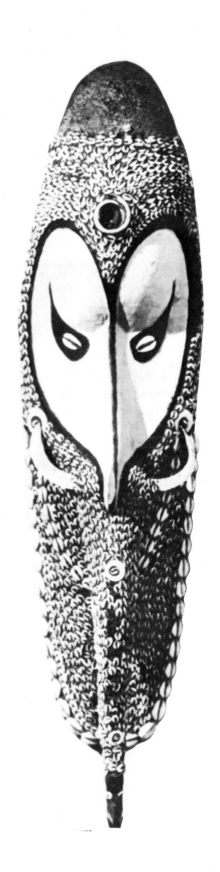

Mwai mask, from the
[Iat]mul. Bateson Coll., Museum
[of] Archaeology and
[Et]hnology, Cambridge

its elongated body and dish-shaped face acquires a very markedly phallic appearance. It is surely the ambiguous redundancy of this male sexual message which first catches our attention and makes us aware, in a barely conscious way, that here is something quite out of the ordinary.

Most emphatically I am not trying to make out that all aesthetic appreciation can be reduced to the recognition of disguised sexual symbolism. What I am discussing is the response to art *cross-culturally*. When we examine the products of exotic cultures the confusions which *first* fascinate us are those which have a physiological base, they are the confusions between male and female, between food and not food, between symbols of dominance and symbols of submission.

This is an enormously general proposition and I cannot possibly demonstrate that it is always true but I can, by illustration, show that it is probably sometimes true. For example, the Sepik mask illustrated in Plate 4 contains precisely these confusions. The mask is worn by boy initiates at puberty when participating in a dramatic performance in which they impersonate their semi-divine ancestors. The face is man-like but also pig-like, the nose, which is expressly phallic, is tipped with the representation of a totemic creature – the sago weevil – credited with powers of spontaneous generation.

If we go back from this to Plate 1 we still cannot say what the object is, but we can begin to understand why it is that this animal which is not an animal should arouse our aesthetic interest. And perhaps we can say a little more than that. Although we cannot identify this object we can feel certain that it contains a confusion of visual themes and that these confusions have led the artist to express the inexpressible with outstanding vigour. The theory I have advanced in this essay suggests a general explanation as to why artists all over the world so often find stimulus from the challenge of this kind of impossibility and why it is that we are partly responsive to the artists' endeavours even when we share little or nothing of his cultural experience.

NOTES

1. The head is reminiscent of an echidna, but the body appears anthropomorphic.
2. Other formulations of this theory are to be found in Leach, 1964, and Douglas, 1966.

REFERENCES

Berg, C., *The Unconscious Significance of Hair*, London, 1951.

Douglas, M., *Purity and Danger*, London, 1966.

Leach, E. R., 'Magical Hair', *The Journal of the Royal Anthropological Institute*, vol. 88, 1958, pp. 147–64.

——, 'Anthropological Aspects of Language: Animal Categories and Verbal Abuse', in E. H. Lenneberg (ed.), *New Directions and the Study of Language*, Boston, 1964.

Style, Grace, and Information
in Primitive Art

Gregory Bateson

INTRODUCTION
This paper consists of several still separate attempts to map a
theory associated with culture and the non-verbal arts. Since no
one of these attempts is completely successful, and since the
attempts do not as yet meet in the middle of the territory to be
mapped, it may be useful to state, in non-technical language,
what it is I am after.

Aldous Huxley used to say that the central problem for
humanity is the quest for *grace*. This word he used in what he
thought was the sense in which it is used in the New Testament.
He explained the word, however, in his own terms. He argued –
like Walt Whitman – that the communication and behaviour of
animals has a naïveté, a simplicity, which man has lost. Man's
behaviour is corrupted by deceit – even self-deceit – by purpose,
and by self-consciousness. As Aldous saw the matter, man has
lost the 'grace' which animals still have. In terms of this contrast,
Aldous argued that God resembles the animals rather than man:
ideally he is unable to deceive and incapable of internal con-
fusions. In the total scale of beings, therefore, man is as if dis-
placed sideways and lacks that grace which the animals have and
which God has.

I argue that art is a part of man's quest for grace; sometimes his
ecstasy in partial success, sometimes his rage and agony at failure.
I argue also that there are many species of grace within the major
genus; and also that there are many kinds of failure and frustra-
tion and departure from grace. No doubt each culture has its
characteristic species of grace towards which its artists strive,
and its own species of failure. Some cultures may foster a nega-
tive approach to this difficult integration, an avoidance of
complexity by crass preference either for total consciousness or
total unconsciousness. Their art is unlikely to be 'great'.

I shall argue that the problem of grace is fundamentally a
problem of integration and that what is to be integrated is the
diverse parts of the mind – especially those multiple levels of
which one extreme is called 'consciousness' and the other the
'unconscious'. For the attainment of grace, the reasons of the
heart must be integrated with the reasons of the reason.

In the previous chapter Edmund Leach presents in a compelling
form the question: how is it that the art of one culture can have
meaning or validity for critics raised in a different culture? My
answer would be that, if art is somehow expressive of something

like grace or psychic integration, then the *success* of this e
pression might well be recognizable across cultural barrie
The physical grace of cats is profoundly different from t
physical grace of horses, and yet a man who has the physic
grace of neither can evaluate that of both. And even when t
subject-matter of art is the frustration of integration, cros
cultural recognition of the products of this frustration is not t
surprising.

The central question is: in what form is information abou
psychic integration contained or coded in the work of art?

STYLE AND MEANING They say that 'every picture tells a story' and this generaliz
tion holds for most of art if we exclude 'mere' geometric orn
mentation. But I want precisely to avoid analysing the 'story
That aspect of the work of art which can most easily be reduce
to words – the *mythology* connected with the subject-matter –
not what I want to discuss. I shall not even mention the ur
conscious mythology of phallic symbolism, except at the en

I am concerned with what important psychic information
in the art object quite apart from what it may 'represent'. '*Le sty
est l'homme même*' (Buffon). What is implicit in style, material
composition, rhythm, skill, and so on? Clearly this subject-matte
will include geometrical ornamentation along with the con
position and stylistic aspects of more representational work
The lions in Trafalgar Square could have been eagles or bulldog
and still have carried the same (or similar) messages about empir
and about the cultural premises of nineteenth-century Englanc
And yet, how different might their message have been, had the
been made of wood! But representational*ism* as such is relevan
The extremely realistic horses and stags of Altamira are surel
not about the same cultural premises as the highly conventiona
ized black outlines of a later period. The *code* whereby perceive
objects or persons (or supernaturals) are transformed into woo
or paint is a source of information about the artist and hi
culture. It is the very rules of transformation that are of intere:
to me – not the message but the code.

My goal is not instrumental. I do not want to use the tran:
formation rules when discovered, to undo the transformation c
to 'decode' the message. To translate the art object into mytholog
and then examine the mythology would be only a neat way c
dodging or negating the problem of 'what is art?'. I ask, ther
not about the meaning of the encoded message but rather abou
the meaning of the code chosen. But still that most slippery wor
'meaning' must be defined. It will be convenient to defin
meaning in the most general possible way in the first instance
'Meaning' may be regarded as an approximate synonym o

pattern, redundancy, information, and 'restraint', within a paradigm of the following sort:

Any aggregate of events or objects (e.g. a sequence of phonemes, a painting or a frog or a culture) shall be said to contain 'redundancy' or 'pattern' if the aggregate can be divided in any way by a 'slash mark', such that an observer perceiving only what is on one side of the slash mark can *guess*, with better than random success, what is on the other side of the slash mark. We may say that what is on one side of the slash contains *information* or has *meaning* about what is on the other side. Or, in engineer's language, the aggregate contains 'redundancy'. Or, again, from the point of view of a cybernetic observer, the information available on one side of the slash will restrain (i.e. reduce the probability of) wrong guessing. Examples:

The letter T in a given location in a piece of written English prose proposes that the next letter is likely to be an H or an R or a vowel. It is possible to make a better than random guess across a slash which immediately follows the T. English spelling contains redundancy.

From a part of an English sentence, delimited by a slash, it is possible to guess at the syntactic structure of the remainder of the sentence. From a tree visible above ground, it is possible to guess at the existence of roots below ground. The top provides information about the bottom. From an arc of a *drawn* circle, it is possible to guess at the position of other parts of the circumference. (From the diameter of an *ideal* circle, it is possible to assert the length of the circumference. But this is a matter of truth within a tautological system.) From how the boss acted yesterday, it may be possible to guess how he will act today. From what I say, it may be possible to make predictions about how you will answer. My words contain meaning or information about your reply.

Telegraphist A has a written message on his pad and sends this message over wire to B, so that B now gets the same sequence of letters on his message pad. This transaction (or 'language game' in Wittgenstein's phrase) has created a redundant universe for an observer O. If O knows what was on A's pad, he can make a better than random guess at what is on B's pad.

The essence and *raison d'être* of communication is the creation of redundancy, meaning, pattern, predictability, information, and/or the reduction of the random by 'restraint'. It is, I believe, of prime importance to have a conceptual system which will force us to see the 'message' (e.g. the art object) as *both* itself internally patterned *and* itself a part of a larger patterned universe – the culture or some part of it.

The characteristics of objects of art are believed to be *about*, or

to be partly derived from, or determined by, other characteristics
of cultural and psychological systems. Our problem might there-
fore be oversimply represented by the diagram:

[Characteristics of art object/Characteristics of rest of culture]

where square brackets enclose the universe of relevance, and
where the oblique stroke represents a slash across which some
guessing is possible, in one direction or in both. The problem
then, is to spell out what sorts of relationships, correspondences
etc., cross or transcend this oblique stroke.

Consider the case in which I say to you 'it's raining' and you
guess that if you look out the window you will see raindrops
A similar diagram will serve:

[Characteristics of 'It's raining'/Perception of raindrops]

Notice, however, that this case is by no means simple. Only if
you know the *language* and have some trust in my veracity will
you be able to make a guess about the raindrops. In fact, few
people in this situation restrain themselves from seemingly
duplicating their information by looking out of the window. We
like to prove that our guesses are right, and that our friends are
honest. Still more important, *we like to test or verify the correctness
of our view of our relationship to others.*

This last point is non-trivial. It illustrates the necessarily
hierarchic structure of all communicational systems: the fact of
conformity or non-conformity (or indeed any other relationship
between parts of a patterned whole may itself be informative a
part of some still larger whole. The matter may be diagrammed
thus:

[('It's raining'/raindrops)/you–me relationship]

where redundancy across the slash mark within the smaller
universe enclosed in round brackets proposes (is a message
about) a redundancy in the larger universe enclosed in square
brackets. But the message 'It's raining' is itself conventionally
coded and internally patterned, so that several slash marks could
be drawn across the message indicating patterning within the
message itself. And the same is true of the rain. It too is patterned
and structured. From the direction of one drop, I could predict
the direction of others, and so on.

*But the slash marks across the verbal message 'It's raining' will
not correspond in any simple way to the slash marks across the
raindrops.* If, instead of a verbal message, I had given you

picture of the rain, some of the slashes on the picture would have corresponded with slashes on the perceived rain. This difference provides a neat formal criterion to separate the 'arbitrary' and digital coding characteristic of the verbal part of language from the *iconic* coding of depiction. But verbal description is often iconic in its larger structure. A scientist describing an earthworm might start at the head end and work down its length – thus producing a description iconic in its sequence and elongation. Here again we observe a hierarchic structuring, digital or verbal at one level and iconic at another.

LEVELS AND LOGICAL TYPES

'Levels' have been mentioned. It was noted: a. that the *combination* of the message 'It's raining' with the perception of raindrops can itself constitute a message about a universe of personal relations; and b. that when we change our focus of attention from smaller to larger units of message material, we may discover that a larger unit contains iconic coding though the smaller parts of which it was made are verbal: the verbal description of an earthworm may, as a whole be elongated.

The matter of levels now crops up in another form which is crucial for any epistemology of art:

The word 'know' is not merely ambiguous in covering both *connaître* (to know through the senses, to recognize, or perceive) and *savoir* (to know in the mind), but varies – actively shifts – in meaning for basic systemic reasons. Something of what we know through the senses can be re-coded to become knowledge in the mind.

'I know the way to Cambridge' might mean that I have studied the map and can give you directions. It might mean that I can recall details all along the route. It might mean that when driving that route I *recognize* many details even though I could recall only a few. It might mean that when driving to Cambridge I can trust to 'habit' to make me turn at the right points, without having to *think* where I am going, and so on.

In all cases, we deal with a redundancy or patterning of a quite complex sort:

[('I know . . .'/my mind)//the road]

and the difficulty is to determine the nature of the patterning within the round brackets or – to put the matter another way: what *parts* of the mind are redundant with the particular message about 'knowing'.

Last, there is a special form of 'knowing' which is usually regarded as adaptation rather than information. A shark is beautifully shaped for locomotion in water but the genome of the shark surely does not contain direct information about hydro-

dynamics. Rather the genome must be supposed to contain information or instructions which are the *complement* of hydrodynamics. Not hydrodynamics, but what hydrodynamics requires, has been built up in the shark's genome. Similarly a migratory bird perhaps does not know the way to its destination in any of the senses outlined above but the bird may contain the complementary instructions necessary to cause it to fly right.

Le coeur a ses raisons que la raison ne connaît point. It is this – the complex layering of consciousness and unconsciousness – that creates difficulty when we try to discuss art or ritual or mythology. The matter of *levels* of the mind has been discussed from many points of view at least four of which must be mentioned and woven into any scientific approach to art:

1. Samuel Butler's insistence that the better an organism 'knows' something, the less conscious it becomes of its knowledge, i.e. there is a process whereby knowledge (or 'habit' – whether of action, perception, or thought) sinks to deeper and deeper levels of the mind. This phenomenon which is central to Zen discipline (cf. Herrigel, *Zen in the Art of Archery*, London, 1953), is also relevant to all art and all skill.

2. Adalbert Ames' demonstrations that the conscious, three-dimensional visual images, which we make of that which we see, are made by processes involving mathematical premises of perspective, etc. of the use of which we are totally unconscious. Over these processes, we have no voluntary control. A drawing of a chair with the perspective of Van Gogh affronts the conscious expectations and, dimly, reminds the consciousness of what had been (unconsciously) taken for granted.

3. The Freudian (especially Fenichel's) theory of dreams as metaphors coded according to *primary process*. I shall consider style – neatness, boldness of contrast, etc. – as metaphoric and therefore as linked to those levels of the mind where primary process holds sway.

4. The Freudian view of the unconscious as the cellar or cupboard to which fearful and painful memories are consigned by a process of repression.

Classical Freudian theory assumed that dreams were a *secondary* product, created by 'dream work'. Material, unacceptable to conscious thought, was supposedly translated into the metaphoric idiom of primary process to avoid waking the dreamer. And this may be true of those items of information which are held in the unconscious by the process of repression. As we have seen, however, many other sorts of information are inaccessible to conscious inspection including most of the premises of mammalian interaction. It would seem to me sensible to think of these items as existing *primarily* in the idiom

of primary process, only with difficulty to be translated into 'rational' terms. In other words, I believe that much of early Freudian theory was upside down. At that time many thinkers regarded conscious reason as normal and self-explanatory while the unconscious was regarded as mysterious, needing proof, and needing explanation. Repression was the explanation, and the unconscious was filled with thoughts which could have been conscious but which repression and dream work had distorted. Today we think of consciousness as the mysterious, and of the computational methods of the unconscious, e.g. primary process, as continually active, necessary, and all-embracing.

These considerations are especially relevant in any attempt to derive a theory of art or poetry. Poetry is not a sort of distorted and decorated prose but rather prose is poetry which has been stripped down and pinned to a Procrustean bed of logic. The computer men who would programme the translation of languages sometimes forget this fact about the primary nature of language. To try to construct a machine to translate the art of one culture into the art of another would be equally silly.

Allegory, at best a distasteful sort of art, is an inversion of the normal creative process. Typically an abstract relation, e.g. between truth and justice, is first conceived in rational terms. The relationship is then metaphorized and dolled up to look like a product of primary process. The abstractions are personified and made to participate in a pseudo-myth, and so on. Much advertising art is allegorical in this sense, that the creative process is inverted.

In the cliché system of Anglo-Saxons, it is commonly assumed that it would be somehow better if what is unconscious were made conscious. Freud, even, is said to have said, 'Where id was, there ego shall be,' as though such an increase in conscious knowledge and control would be both possible and, of course, an improvement. This view is the product of an almost totally distorted epistemology and a totally distorted view of what sort of thing a man, or any other organism, is.

Of the four sorts of unconsciousness listed above, it is very clear that the first three are necessary. Consciousness, for obvious mechanical reasons,[1] must always be limited to a rather small fraction of mental process. If useful at all, it must therefore be husbanded. The unconsciousness associated with habit is an economy both of thought and of consciousness; and the same is true of the inaccessibility of the processes of perception. The conscious organism does not require (for pragmatic purposes) to know *how* it perceives – only to know *what* it perceives. (To suggest that we might operate without a foundation in primary process would be to suggest that the human brain ought to be

differently structured.) Of the four types, only the Freudian cupboard for skeletons is perhaps undesirable and could be obviated. But there may still be advantages in keeping the skeleton off the dining-room table.

In truth, our life is such that its unconscious components are continuously present in all their multiple forms. It follows that in our relationships we continuously exchange messages about these unconscious materials, and it becomes important also to exchange meta-messages by which we tell each other what order and species of unconsciousness (or consciousness) attaches to our messages.

In a merely pragmatic way, this is important because the orders of truth are different for different sorts of messages. In so far as a message is conscious and voluntary, it could be deceitful. I can tell you the cat is on the mat when in fact she is not there. I can tell you 'I love you' when in fact I do not. But discourse about relationship is commonly accompanied by a mass of semi-voluntary kinesic and autonomic signals which provide a more trustworthy comment on the verbal message. Similarly, with skill, the fact of skill indicates the presence of large unconscious components in the performance.

It thus becomes relevant to look at any work of art with the question: What components of this message material had what orders of unconsciousness (or consciousness) for the artist? And this question, I believe, the sensitive critic usually asks, though perhaps not consciously. Art becomes, in this sense, an exercise in communicating about the species of unconsciousness. Or, if you prefer it, a sort of play behaviour whose function is, amongst other things, to practise and make more perfect communication of this kind.

I am indebted to Anthony Forge for a quotation from Isadora Duncan: 'If I could tell you what it meant, there would be no point in dancing it.' Her statement is ambiguous. In terms of the rather vulgar premises of our culture, we would translate the statement to mean: 'There would then be no point in dancing it, because I could tell it to you, quicker and with less ambiguity, in words.' This interpretation goes along with the silly idea that it would be a good thing to be conscious of everything of which we are unconscious.

But there is another possible meaning of Isadora Duncan's remark: if the message were the sort of message that could be communicated in words, there would be no point in dancing it, but it is not that sort of message. It is, in fact, precisely the sort of message which would be falsified if communicated in words, because the use of words (other than poetry) would imply that this is a fully conscious and voluntary message, and this would

be simply untrue.

I believe that what Isadora Duncan or any artist is trying to communicate is more like: 'This is a particular sort of partly unconscious message. Let us engage in this particular sort of partly unconscious communication.' Or perhaps: 'This is a message about the interface between conscious and unconscious.' The message of *skill* of any kind must always be of this kind. The sensations and qualities of skill can never be put in words and yet the fact of skill is conscious.

The artist's dilemma is of a peculiar sort. He must practise in order to perform the craft components of his job. But to practise has always a double effect. It makes him, on the one hand, more able to do whatever it is he is attempting; and, on the other hand, by the phenomenon of habit formation, it makes him less aware of how he does it. If his attempt is to communicate about the unconscious components of his performance, then it follows that he is on a sort of moving stairway about whose position he is trying to communicate but whose movement is itself a function of his efforts to communicate. Clearly, his task is impossible but, as has been remarked, some people do it very prettily.

PRIMARY PROCESS 'The heart has its *reasons* which the reason does not perceive at all.' Among Anglo-Saxons, it is rather usual to think of the 'reasons' of the heart or of the unconscious as inchoate forces or pushes or heavings – what Freud called '*Trieben*'. To Pascal, a Frenchman, the matter was rather different, and he no doubt thought of the reasons of the heart as a body of logic or computation as precise and complex as the reasons of consciousness.

(I have noticed that Anglo-Saxon anthropologists sometimes mis-understand the writings of Claude Lévi-Strauss for precisely this reason. They say he emphasizes too much the intellect and ignores the 'feelings'. The truth is that he assumes that the heart has precise algorithms.)

These algorithms of the heart, or as they say, of the unconscious, are, however, coded and organized in a manner totally different from the algorithms of language. And since a great deal of conscious thought is structured in terms of the logics of language, the algorithms of the unconscious are doubly inaccessible. It is not only that the conscious mind has poor access to this material, but also the fact that when such access is achieved, e.g. in dreams, art, poetry, religion, intoxication, and the like, there is still a formidable problem of translation. This is usually expressed in Freudian language by saying that the operations of the unconscious are structured in terms of *primary process,* while the thoughts of consciousness (especially verbalized thoughts) are expressed in *secondary process.* Nobody, to my

knowledge, knows anything about secondary process. But it is ordinarily assumed that everybody knows all about it, so I shall not attempt to describe secondary process in any detail, assuming that you know as much about it as I.

Primary process is characterized (e.g. by Fenichel) as lacking negatives, lacking tense, lacking in any identification of linguistic mood (i.e. no identification of indicative, subjunctive, optative, etc.) and metaphorical. These characterizations are based upon the experience of psycho-analysts, who must interpret dreams and the patterns of free association.

It is also true that the subject-matter of primary process discourse is different from the subject-matter of language and consciousness. Consciousness talks about things or persons, and attaches predicates to the specific things or persons which have been mentioned. In primary process the things or persons are usually not identified and the focus of the discourse is upon the *relationships* which are asserted to obtain between them. This is really only another way of saying that the discourse of primary process is metaphoric. A metaphor retains unchanged the relationship which it illustrates, while substituting other things or persons for the relata. In a simile, the fact that a metaphor is being used is marked by the insertion of the words 'as if' or 'like'. In primary process (as in art) there are no markers to indicate to the conscious mind that the message material is metaphoric. (For a schizophrenic, it is a major step towards a more conventional sanity when he can frame his schizophrenic utterances or the comments of his voices in an 'as if' terminology.)

The focus of 'relationship' is, however, somewhat more narrow than would be indicated merely by saying that primary process material is metaphoric and does not identify the specific relata. The subject-matter of dream and other primary process material is, in fact, relationship in the more narrow sense of relationship between self and other persons or between self and the environment.

Anglo-Saxons who are uncomfortable with the idea that feelings and emotions are the outward signs of precise and complex algorithms, usually have to be told that these matters, the relationship between self and others, and the relationship between self and environment are, in fact, the subject-matter of what are called 'feelings' – love, hate, fear, confidence, anxiety, hostility, etc. It is unfortunate that these abstractions referring to *patterns* of relationship have received names, which are usually handled in ways that assume that the 'feelings' are mainly characterized by quantity rather than by precise pattern. This is one of the nonsensical contributions of psychology to a distorted epistemology.

Be all that as it may, for our present purposes it is important to note that the characteristics of primary process as described above are the inevitable characteristics of any communicational system between organisms who must use only iconic communication. This same limitation is characteristic of the artist and of the dreamer and of the pre-human mammal or bird. (The communication of insects is, perhaps, another matter.) In iconic communication, there is no tense, no simple negative, no modal marker. The absence of simple negatives is of especial interest because it often forces organisms *into saying the opposite of what they mean in order to get across the proposition that they mean the opposite of what they say.*

Two dogs approach each other and need to exchange the message: 'We are *not* going to fight.' But the only way in which fight can be mentioned in iconic communication is by the showing of fangs. It is then necessary for the dogs to discover that this mention of fight was, in fact, only exploratory. They must, therefore, explore what the showing of fangs means. They therefore engage in a brawl; discover that neither ultimately intends to kill the other; and, after that, they can be friends. (Consider the peace-making ceremonials of the Andaman islanders. Consider also the functions of inverted statement or sarcasm, and other sorts of humour in dream, art, and mythology.)

In general, the discourse of animals is concerned with relationship either between self and other or self and environment. In neither case is it necessary to identify the relata. Animal A tells B about his relationship with B and he tells C about his relationship with C. Animal A does not have to tell animal C about his relationship with B. Always the relata are perceptibly present to illustrate the discourse, and always the discourse is iconic in the sense of being composed of part actions ('intention movements') which mention the whole action which is being mentioned. Even when the cat asks you for milk, she cannot mention the object which she wants (unless it be perceptibly present). She says, 'Mama, Mama', and you are supposed from this invocation of dependency to guess that it is milk that she requires.

All this indicates that primary process thoughts and the communication of such thoughts to others are, in an evolutionary sense, more archaic than the more conscious operations of language, etc. This has implications for the whole economics and dynamic structure of the mind. Samuel Butler was perhaps first to point out that that which we know best is that of which we are least conscious, i.e. that the process of habit formation is a sinking of knowledge down to less conscious and more archaic levels. The unconscious contains not only the painful matters which consciousness prefers not to inspect but also many matters which

are so familiar that we do not need to inspect them. Habit, therefore, is a major economy of conscious thought. We can do things without consciously thinking about them. The skill of an artist or rather his demonstration of a skill becomes a message *about* these parts of his unconsciousness. (But not perhaps a message *from* the unconscious.)

But the matter is not quite so simple. Some types of knowledge can conveniently be sunk to unconscious levels but other types must be kept on the surface. Broadly, we can afford to sink those sorts of knowledge which continue to be true regardless of changes in the environment, but we must maintain in an accessible place all those controls of behaviour which must be modified for every instance. The lion can sink into his unconscious the proposition that zebras are his natural prey but in dealing with any particular zebra he must be able to modify the movements of his attack to fit with the particular terrain and the particular evasive tactics of the particular zebra.

The economics of the system, in fact, pushes organisms towards sinking into the unconscious those generalities of relationship which remain permanently true and towards keeping within the conscious the pragmatics of particular instances.

The premisses may, economically, be sunk but particular conclusions must be conscious. But the 'sinking', though economical, is still done at a price – the price of inaccessibility. Since the level to which things are sunk is characterized by iconic algorithms and metaphor, it becomes difficult for the organism to examine the matrix out of which his conscious conclusions spring. Conversely, we may note that what is *common* to a particular statement and a corresponding metaphor is of a generality appropriate for sinking.

QUANTITATIVE LIMITS
OF CONSCIOUSNESS

A very brief consideration of the problem shows that it is not conceivably possible for any system to be totally conscious. Suppose that on the screen of consciousness there are reports from many parts of the total mind, and consider the addition to consciousness of those reports necessary to cover what is, at a given stage of evolution, not already covered. This addition will involve a very great increase in the circuit structure of the brain but still will not achieve total coverage. The next step will be to cover the processes and events occurring in the circuit structure which we have just added, and so on. Clearly, the problem is insoluble and every next step in the approach to total consciousness will involve a great increase in the circuitry required.

It follows that all organisms must be content with rather little consciousness and that if consciousness has any useful functions whatever (which has never been demonstrated but is probably

true), then *economy* in consciousness will be of the first import-
ance. No organism can afford to be conscious of matters with
which it could deal at unconscious levels. This is the economy
achieved by habit formation.

QUALITATIVE LIMITS It is, of course, true for the TV set that a satisfactory picture
OF CONSCIOUSNESS on the screen is an indication that many parts of the machine are
working as they should; and similar considerations apply to the
'screen' of consciousness. But what is provided is only a very
indirect report of the working of all those parts. If the TV suffers
from a blown tube, or the man from a stroke, *effects* of this
pathology may be evident enough on the screen or to conscious-
ness, but diagnosis must still be done by an expert.

This matter has bearings upon the nature of art. The TV which
gives a distorted or otherwise imperfect picture is, in a sense,
communicating about its unconscious pathologies – exhibiting
its symptoms and one may ask whether some artists are not
doing something similar. But this still won't do.

It is sometimes said that the distortions of art (say Van Gogh's
'Chair') are directly representative of what the artist '*sees*'. If such
statements refer to 'seeing' in the simplest physical sense (e.g.
remediable with spectacles), I presume that they are nonsense. If
Van Gogh could only see the chair in that wild way, his eyes
would not serve properly to guide him in the very accurate
placing of paint on canvas. And, conversely, a photographically
accurate representation of the chair on the canvas would also be
seen by Van Gogh in the wild way. He would see no need to
distort the painting.

But suppose we say that the artist is painting today what he
saw yesterday – or that he is painting what he somehow knows
that he *might* see. 'I see as well as you do – but do you realize that
this other way of seeing a chair exists as a human potentiality?
And that that potentiality is always in you and in me?' Is he
exhibiting symptoms which he *might* have, because the whole
spectrum of psychopathology is possible for us all?

Intoxication by alcohol or drugs may help us to see a distorted
world, and these distortions may be fascinating in that we
recognize the distortions as *ours*. *In vino pars veritatis*. We can
be humbled or aggrandized by realizing that this too is a *part*
of the human self, a *part* of Truth. But intoxication does not
increase skill – at best it may release skill previously acquired.

Without skill is no art.

Consider the case of the man who goes to the blackboard – or
to the side of his cave – and draws, freehand, a perfect reindeer
in its posture of threat. He cannot *tell* you about the drawing of
the reindeer ('If he could, there would be no point in drawing it').

'Do you know that this perfect way of seeing – and drawing – a reindeer exists as a human potentiality?' The consummate skill of the draftsman validates the artist's message about his relation ship to the animal – his empathy.

(They say the Altamira things were made for sympathetic hunting magic. But magic only needs the crudest sort of representations. The scrawled arrows which deface the beautiful reindeer may have been magical – perhaps a vulgar attempt to murder the artist, like moustaches scrawled on the Mona Lisa.)

THE CORRECTIVE
NATURE OF ART

It was noted above that consciousness is necessarily selective and partial, i.e. that the content of consciousness is, at best, a small part of truth about the self. But if this part be *selected* in any systematic manner, it is certain that the partial truths of consciousness will be, in aggregate, a distortion of the truth of some larger whole.

In the case of an iceberg we may guess, from what is above surface, what sort of stuff is below; but we cannot make the same sort of extrapolation from the content of consciousness. It is not merely the selectivity of preference, whereby the skeletons accumulate in the Freudian unconscious, that makes such extrapolation unsound. Such a selection by preference would only promote optimism.

What is serious is the cross-cutting of the circuitry of the mind. If, as we must believe, the total mind is an integrated network (of propositions, images, processes, neural pathology, or what have you – according to what scientific language you prefer to use), and if the content of consciousness is only a sampling of different parts and localities in this network; then, inevitably, the conscious view of the network as a whole is a monstrous denial of the *integration* of that whole. From the cutting of consciousness, what appears above the surface is *arcs* of circuits instead of either the complete circuits or the larger complete circuits of circuits. What the unaided consciousness (unaided by art, dreams, and the like) can never appreciate is the *systemic* nature of mind.

This notion can conveniently be illustrated by an analogy: the living human body is a complex, cybernetically integrated system. This system has been studied by scientists – mostly medical men – for many years. What they now know about the body may aptly be compared with what the unaided consciousness knows about the mind. Being doctors, they had purposes: to cure this and that. Their research efforts were therefore focused (as attention focuses the consciousness) upon those short trains of causality which they could manipulate, by means of drugs or other intervention, to correct more or less specific and

identifiable states or symptoms. Whenever they discovered an effective 'cure' for something, research in that area ceased and attention was directed elsewhere. We can now prevent polio but nobody knows much more about the systemic aspects of that fascinating disease. Research on it has ceased or is, at best, confined to improving the vaccines.

But a bag of tricks for curing or preventing a list of specified diseases provides no overall *wisdom*. The ecology and population dynamics of the species has been disrupted; parasites have been made immune to antibiotics; the relationship between mother and neonate has been almost destroyed; and so on. Characteristically, errors occur wherever the altered causal chain is part of some large or small circuit structure or system. And the remainder of our technology (of which medical science is only a part) bids fair to disrupt the rest of our ecology.

The point, however, which I am trying to make in this paper is not an attack on medical science, but a demonstration of an inevitable fact: that mere purposive rationality unaided by such phenomena as art, religion, dream, and the like is necessarily pathogenic and destructive of life; and that its virulence springs specifically from the circumstance that life depends upon interlocking *circuits* of contingency, while consciousness can see only such short arcs of such circuits as human purpose may direct. In a word, the unaided consciousness must always involve man in the sort of stupidity of which evolution was guilty when she urged upon the dinosaurs the common-sense values of an armaments race. She, inevitably, realized her mistake a few million years later and wiped them out.

Unaided consciousness must always tend towards hate; not only because it is good common-sense to exterminate the other fellow, but for the more profound reason that, seeing only arcs of circuits, the individual is continually surprised and necessarily angered when his hard-headed policies return to plague the inventor.

If you use D.D.T. to kill insects, you may succeed in reducing the insect population so far that the insectivores will starve. You will then have to use more D.D.T. than before to kill the insects which the birds no longer eat. More probably, you will kill off the birds in the first round when they eat the poisoned insects. If the D.D.T. kills off the dogs, you will have to have more police to keep down the burglars. The burglars will become better armed and more cunning . . . and so on. That is the sort of world we live in – a world of circuit structures – and love can survive only if wisdom (i.e. a sense or recognition of the fact of circuitry) has an effective voice.

What has been said so far proposes questions about any

particular work of art somewhat different from those which have been conventionally asked by anthropologists. The 'culture and personality' school, for example, has traditionally used pieces of art or ritual as samples or probes to reveal particular psychological themes or states.

The question has been: Does the art tell us about what sort of person made it? But if art, as suggested above, has a positive function in maintaining what I called 'wisdom', i.e. in correcting a too purposive view of life and making the view more systemic, then the question to be asked of the given work of art becomes: What sorts of correction in the direction of wisdom would be achieved by creating or viewing this work of art? The question becomes dynamic rather than static.

ANALYSIS OF A
BALINESE PAINTING

Turning now from the consideration of epistemology to a specific work of art, we note first what is most general and most obvious. With almost no exceptions, the behaviours called art or their products (also called art) have two characteristics: they require or exhibit *skill* and they contain redundancy or pattern. But those two characteristics are not separate: the skill is first in maintaining and then in modulating the redundancies.

The matter is perhaps most clear where the skill is that of the journeyman and the redundancy is of comparatively low order. For example, in the Balinese painting (Pl. 1, by Ida Bagus Djati Sura of the village of Batuan, 1937[2]), skill of a certain elementary but highly disciplined sort was exercised or practised in the background of foliage. The redundancies to be achieved involve rather uniform and rhythmical repetition of leaf forms, but this redundancy is, so to speak, fragile. It would be broken or interrupted by smudges or irregularities of size or tone in the painting of the successive leaves.

When a Batuan artist looks at the work of another, one of the first things he examines is the technique of the leafy background. The leaves are first drawn, in free outline in pencil; then each outline is tightly redefined with pen and china ink. When this has been done for all the leaves, the artist begins to paint with brush and brick ink. Each leaf is covered with a pale wash. When these washes are dry, each leaf receives a smaller concentric wash and after this another still smaller and so on. The final result is a leaf with an almost white rim inside the inked outline, and successive steps of darker and darker colour towards the centre of the leaf. A 'good' picture has up to five or six such successive washes on every leaf. (This particular painting is not very 'good' in this sense. The leaves are done in only three or four steps.) The skill and the patterning so far discussed depend upon muscular rote and muscular accuracy – achieving the

1 *The Start of a Cremation Procession.* By Ida Bagus Djati Sura of Batuan, Bali, 1937

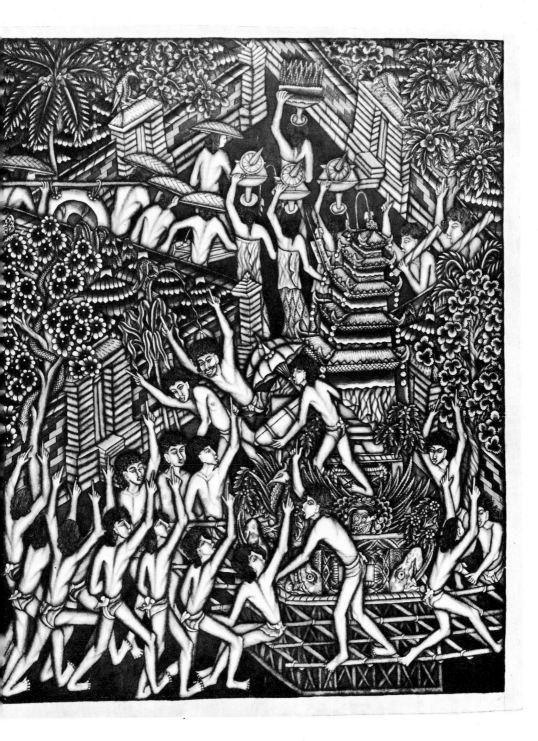

2 Ida Bagus Djati Sura of
Batuan, Bali

perhaps not negligible artistic level of a well laid-out field of
turnips.

I was watching a very gifted American carpenter-architect at
work on the woodwork of a house he had designed. I commented
on the sureness and accuracy of each step. He said: 'Oh, that.
That's only like using a typewriter. You have to be able to do that
without thinking.' But on top of this level of redundancy is
another. The uniformity of the lower level redundancy must be
modulated to give higher orders of redundancy. The leaves in
one area must be *different* from the leaves in another area and
these *differences* must be, in some way, mutually redundant.
they must be part of a larger pattern. Indeed, the function and
necessity of the first level control is precisely to make the second
level possible. The perceiver of the work of art must receive
information that the artist *can* paint a uniform area of leaves
because without this information, he will not be able to accept
as significant, the variations in that uniformity. Only the violinist
who can control the quality of his notes can use variations of that
quality for musical purposes.

This principle is basic and accounts, I suggest, for the almost
universal linkage in aesthetics between skill and pattern. The
exceptions – e.g. the cult of natural landscapes, 'found objects'

ink blots, scattergrams, and the works of Jackson Pollock – seem to exemplify the same rule in reverse. In these cases, a larger patterning seems to propose the illusion that the details must have been controlled. Intermediate cases also occur: e.g. in Balinese carving, the natural grain of the wood is rather frequently used to suggest details of the form or surface of the subject. In these cases, the skill lies not in the draftsmanship of the details, but in the artist's placement of his design within the three-dimensional structure of the wood. A special 'effect' is achieved, not by the mere representationalism, but by the perceiver's partial awareness that a physical system *other* than that of draftsmanship has contributed to determine his perception.

We now turn to more complex matters, still concentrating attention upon the most obvious and elementary.

COMPOSITION 1. The delineation of leaves and other forms does not reach to the edge of the picture but shades off into darkness so that almost all around the rectangle there is a band of undifferentiated dark pigment. In other words, the picture is framed within its own fade-out. We are allowed to feel that the matter is in some sense 'out of this world'; and this in spite of the fact that the scene depicted is familiar – the starting out of a cremation procession.

2. The picture is *filled*. The composition leaves no open spaces. Not only is none of the paper left unpainted but no considerable area is left in uniform wash. The largest such areas are the very dark patches at the bottom between the legs of the men.

To occidental eyes this gives an effect of 'fussiness'. To psychiatric eyes, the effect is of 'anxiety' or 'compulsivity'. We are all familiar with the strange look of those letters from cranks, who feel that they must fill the page.

3. But before trying too fast to diagnose or evaluate, we have to note that the composition of the lower half of the picture, apart from this filling of background space, is turbulent. Not merely a depiction of active figures, but a swirling composition mounting upwards and closed off by the contrasting direction of the gestures of the men at the top of the pyramid.

The upper half of the picture, in contrast, is serene. Indeed, the effect of the perfectly balanced women with offerings on their heads is so serene that, at first glance, it appears that the men with musical instruments must surely be sitting. (They are supposed to be moving in procession.)

But this compositional structure is the reverse of the usual occidental. We expect the lower part of a picture to be the more stable and expect to see action and movement in the upper part – if anywhere.

4. At this point, it is appropriate to examine the picture as a

sexual pun and, in this connection, the internal evidence fo
sexual reference is at least as strong as it is in the case of th
Tangaroa figure discussed by Leach (Chapter 12). All you hav
to do is to set your mind in the correct posture and you will see a
enormous phallic object (the cremation tower) with tw
elephants' heads at the base. This object must pass through
narrow entrance into a serene courtyard and thence onward an
upward through a still more narrow passageway. Around th
base of the phallic object you see a turbulent mass of homunculi
a crowd in which

> Was none who would be foremost
> To lead such dire attack;
> But those behind cried 'Forward!'
> And those before cried 'Back!'

And if you are so minded, you will find that Macaulay's poen
about how Horatius kept the bridge is no less sexual than th
present picture. The game of sexual interpretation is easy if you
want to play it. No doubt the snake in the tree to the left of th
picture could also be woven into the sexual story.

It is still possible, however, that something is added to ou
understanding of a work of art by the hypothesis that the
subject-matter is double: that the picture represents both the
start of a cremation procession and a phallus with vagina. With
a little imagination, we could also see the picture as a symbolic
representation of Balinese social organization in which the
smooth relations of etiquette and gaiety metaphorically cover
the turbulence of passion. And, of course, 'Horatius' is very
evidently an idealized myth of nineteenth-century imperial
England.

It is probably an error to think of dream, myth, and art as
being about any one matter other than relationship. As was
mentioned earlier, dream is metaphoric and is not particularly
about the relata mentioned in the dream. In the conventional
interpretation of dream, another set of relata, often sexual, is
substituted for the set in the dream. But perhaps by doing this
we only create another dream. There indeed is no *a priori* reason
for supposing that the sexual relata are any more primary or basic
than any other set.[3]

In general, artists are very unwilling to accept interpretations
of this sort, and it is not clear that their objection is to the sexual
nature of the interpretation. Rather, it seems that rigid focusing
upon any single set of relata destroys for the artist the more
profound significance of the work. If the picture were *only* about
sex or *only* about social organization, it would be trivial. It is

non-trivial or profound precisely because it is about sex *and* social organization *and* cremation, *and* other things. In a word, it is only about relationship and not about *any* identifiable relata.

5. It is appropriate then to ask how the artist has handled the identification of his subject-matter within the picture. We note first that the cremation tower which occupies almost one third of the area of the picture is almost invisible. It does not stand out against its background as it should if the artist wanted to assert unequivocally 'this is a cremation'. Notably also, the coffin, which might be expected to be a focal point, is appropriately placed just below the centre but, even so, does not catch the eye. In fact, the artist has inserted details which label the picture as a cremation scene but these details become almost whimsical asides, like the snake and the little birds in the trees. The women are carrying the ritually correct offerings on their heads, and two men appropriately bring bamboo containers of palm toddy, but these details, too, are only whimsically added. The artist plays down the subject identification and thereby gives major stress to the contrast between the turbulent and the serene mentioned in section 3 above.

6. In sum, it is my opinion that the crux of the picture is the interwoven contrast between the serene and the turbulent. And a similar contrast or combination was also present, as we have seen, in the painting of the leaves. There too, an exuberant freedom was overlaid by precision.

In terms of this conclusion, I can now attempt an answer to the question posed above: What sorts of correction, in the direction of systemic wisdom, could be achieved by creating or viewing this work of art? In final analysis, the picture can be seen as an affirmation that to choose either turbulence or serenity as a human purpose would be a vulgar error. The conceiving and creating of the picture must have provided an experience which exposed this error. The unity and integration of the picture assert that neither of these contrasting poles can be chosen to the exclusion of the other, because the poles are mutually dependent. This profound and general truth is simultaneously asserted for the fields of sex, social organization, and death.

NOTES

1. Consider the impossibility of constructing a television set which would report upon its screen *all* the workings of its component parts, including especially those parts concerned in this reporting.
2. Three photographs of this artist at work have been published in G. Bateson and M. Mead, *Balinese Character,* New York, 1942, Pl. 23.
3. Cf. Gregory Bateson, 'Sex and Culture', *Annals of the New York Academy of Sciences,* vol. XLVII, 9 May 1947, art. 5, pp. 647–60.

Talking about Art and Primitive Society[1]

W. T. Jones

This paper differs from the other contributions to this volume in being entirely *ex post facto*. Since I am an expert neither on art nor on primitive societies, I went to Burg Wartenstein as an observer, not as a contributor. If, in the course of the conference discussions, I gradually became something of a participant, that, I take it, is a change in role often experienced by anthropologists. Indeed, my role at the conference – at least as I have come to perceive it – came to be that of an amateur anthropologist, conducting participant-observation in an amateurish way. I found myself in the midst of a small society much of whose behaviour was strange to me; I tried to make sense of what I observed. This paper records the results of this attempt at sense-making.

The behaviour that I observed and tried to make sense of was talk. This is a second way in which my paper differs from the others in this volume. They are concerned with art in primitive societies; mine is concerned with talk-about-art-in-primitive-societies. Thus mine may be characterized as a 'meta-approach'. What is the justification for such an indirect approach?

All talk about art – or about anything else, for that matter – presupposes a conceptual scheme of some sort, sometimes largely unconscious, in the mind of the talker. Two talkers succeed in communicating only to the extent that they share a conceptual scheme, a map of the world. So far as their conceptual schemes differ, they locate the 'same' things in different regions of their maps and their efforts to communicate are frustrated – a common occurrence at conferences where people of diverse backgrounds and training try to exchange ideas. Talk-about-talk has the function of directing the various talkers' attention to differences in their underlying conceptual schemes and so enables them to communicate more successfully.

This claim is made for a meta-approach generally – not specifically for this paper. As regards the paper, I can say only that some of the talk that I observed puzzled me; I managed to make sense of this talk, at least for myself, in the ways I shall describe. To the extent that the talk at this conference was not atypical of anthropological discussions of art, and to the extent that my analysis makes sense for others as well as to myself, this paper may serve a modest, but useful, purpose.

What, then, puzzled me about the conference discussions?

Not the factual information conveyed. Though I was ignorant of the Sepik River people and the Walbiri, I was not *puzzled* by what I heard about them. No, what puzzled me was talk about the difference between art and craft; about whether there is, or can be, a society without art; about what 'minimal' art is; about whether 'found art' is art; about the difference between 'true' art and fakes; about the relation between art and language, between art and taboo. Much of this talk seemed to me inconclusive, and I became convinced that its inconclusiveness was due to implicit disagreements about the nature of art. Accordingly, I propose to try to bring these implicit disagreements to the surface; making them explicit will show how the various participants came to map the same factual information in different ways.

A REMARK ABOUT
DEFINITIONS: PLATO'S
AVIARY

It is not surprising that the conference tried to avoid the question, 'What is art?'. Discussions of definitions are usually sterile, or worse. Yet how can one talk sensibly about something without knowing what it is one is talking about? Or, rather, how can one communicate effectively about art with someone who has mapped art on to a very different map from ours? Every member of the conference actually had a definition of art – even though he was reluctant to put it into words and might have had difficulty in doing so had he tried. And it was differences among these partly unconscious, but nevertheless operative, definitions that caused such implicit disagreements as those I have listed above.

The reason why discussions of definitions are so often sterile is that they are usually conducted within the framework of a Platonic metaphysics. There is an assumption that a definition specifies some characteristic (one of Plato's forms?) which all objects named by that name share. Thus it is assumed that there must be some feature (or features) that all art objects share, in virtue of which they are art objects. According to this view, to formulate the 'correct' definition is to ascertain this feature. It is as if there were an aviary full of all sorts of birds, one of which is 'art'; people suppose that their job, as definers, is to reach carefully inside the aviary and extract the right bird. Many people are unconsciously influenced by this analogy, even while verbally disowning it.

But if we attend to the world around us, we do not find self-identical features repeated again and again in each of a number of objects. For instance, we do not find a single, self-identical colour, 'red', repeated absolutely unchanged in fire trucks, roses, toy balloons, and lipsticks. Rather, there are a very large number of more or less similar tones, or shades. Usually, we attend to them so marginally that we lump them together, but if we happen

to look at them carefully, we discover a spectrum of tones, each one of which differs slightly from its neighbours. Some of these tones everyone would describe as red; about others people might disagree. Of a particular tone, for example, one individual might say, 'Well, that's certainly a bit bluish, but to me it's more reddish than bluish.' Accordingly, he would include it among the reds. Another individual looking at the same tone might say, 'No; that's distinctly purple', and so exclude it from the reds.

Or, to take another example, suppose it is a question of distinguishing between sofas and chairs. One of the distinguishing features is width of seat. Suppose we are looking at two pieces of furniture which are otherwise very similar – same sorts of arms, back, and legs. But one of these pieces of furniture has a very wide seat and the other has a very narrow one. Everybody will call the former a sofa and the latter a chair. But how narrow must the seat be for us to resist calling it a sofa and for us to want to call it a chair? People will differ about this, as they differ about whether a particular tone is reddish blue or bluish red.

We can think of pieces of furniture, similar in other respects, as being arrayed in an order with respect to width of seat, from the widest seat of all to the narrowest. I shall call the ordering principle, or rule, in terms of which any such array is formed a 'dimension'. Thus in the present example, the dimension being used is the width-of-seat dimension. We use – or may use – different dimensions for arraying the same objects.

This suggests thinking of the act of defining, not as reaching into an aviary, but as first choosing a dimension and then making a cut in the array that has been formed in accordance with this dimension. Disputes can arise at either of these stages. People may differ about what dimension to use: some people think of width of seat as the leading characteristic of sofas and array pieces of furniture in accordance with this dimension; others think of shape of back as the leading characteristic and array the furniture according to this dimension. Again, even those who use the same dimension may make the cut at different points, depending on their differing interests as definers. The dispute between Freud and his Viennese critics over the definition of hysteria is a well-known example.[2] There was an array of patients manifesting symptoms; each patient had his own individual set of symptoms which differed more or less from the symptoms of every other patient. At one end of this array were patients whose behaviour was such that 'everybody' (i.e. both Freud and his critics) called these patients hysterics; at the other end of the array were patients whose behaviour was such that 'nobody' called them hysterics. In the middle there were patients whose behaviour Freud believed to be sufficiently similar to

those of the clear cases of hysteria to warrant calling them hysterics too. But where Freud concentrated on the similarities, his critics concentrated on the dissimilarities; they therefore lumped these individuals in the class of non-hysterics. The disagreement was about what was more important – the similarity or the dissimilarity. The facts were stipulated: Freud did not deny that the disputed cases were dissimilar to the clear cases – the disputed cases were all men; the clear cases were women. But to Freud the sex dissimilarity was inconsequential, whereas to his critics it was crucial. Thus Freud and his critics made the cut between hysteria and non-hysteria at different points, and the points at which they made their cuts reflect their commitment to very different theories about the nature of mental illness.

Here is another example: we can think of the set of all salt-cellars, for instance, as ordered in an array from the small paper containers that are turned out in great quantity for distribution with meals served on airplanes to (say) the Cellini salt-cellar now in the Kunsthistorisches Museum. 'Everybody' agrees that the latter is an art object – after all, it is famous and displayed in a museum. 'Everybody' agrees that the former are not art objects but utility objects. In the middle of this dimension are salt-cellars which some people will call art objects and which other people will call utility objects. It is my intention in this paper to show that the implicit disagreements at the conference arose because (1) participants ordered art objects in accordance with several different dimensions, and because (2) even those participants who used the same dimension made their cuts at different points.

A MODEL FOR TALKING ABOUT TALK-ABOUT-ART-AND-PRIMITIVE-SOCIETY

An art object is a product, i.e. the result of some sort of process. Therefore, before I formulate the dimensions on which I propose to locate the various implicit (but operational) definitions of art which underlay the conference discussions, I shall say something generally about the process (or activity) of constructing (or making) things. For this purpose I shall utilize a model which I have found useful in dealing with perception.[3] According to this view, perception is a process in which a foreground is interpreted by means of what I call a background. An elementary example is as follows: suppose two men, I_1 and I_2, are walking at night through the ruins of an old castle. I_1 believes in ghosts and is aware of reports that the castle is haunted; I_2 is unaware of these reports and in any case disbelieves in ghosts. At some point in their walk, where I_2 sees moonlight falling on a wall, I_1 may see the ghost of a former owner. In this example, the foreground is a differential luminescence in the perceptual fields of both walkers; the background is a complex of beliefs, generalizations, and

memories (variously charged). The perceptual object (moonbeam, ghost) is a product. Given the same foreground (F), the perceptual object (O) varies with differences in background (B). Thus

$$B_1 \, x \, F \longrightarrow O_1$$
$$B_2 \, x \, F \longrightarrow O_2$$

In this example I_1 and I_2 see different things – each has constructed an object from materials in the perceptual field of both. I_1 and I_2 may now agree to settle their difference by such procedures as 'going a little closer', 'reaching out and trying to touch', or 'appealing to a third party'. That is, despite the differences mentioned, B_1 and B_2 may contain similar elements – for instance, a belief in the importance of agreement and also in the value of scientific objectivity. It may be, however, that I_1's belief in ghosts is more highly charged than his belief in scientific method. If so, I_1 may continue to see a ghost, and he may 'justify' this by reconsidering the reach-out-and-touch procedure: since ghosts are intangible, failing to touch does not falsify his perception. Thus we can read back from differences perceived in O to differences in B. If I_1 sees a ghost we infer that his background structure contains the belief, 'Ghosts exist'. If he continues to see a ghost, despite I_2's protests that it is only a moonbeam, we infer that this belief is very highly charged, and so on.

This is elementary, but it is perhaps enough for present purposes. Transition from perception to production can be made in the following way. Often we do not merely confront a foreground visually or aurally. Often we also manipulate it physically. The outcome of such a process of manipulation is a product:

$$B \, x \, M \longrightarrow P$$

where B is again background, M is some material that is being manipulated ('shaped') in accordance with beliefs contained in B, and P is the finished product, the outcome of the manipulative process.

M may be a piece of wood or clay; but M may also be my body: I construct a gesture (say, thumbing a ride) by moving my arm and hand in certain ways. I am able to construct this gesture because my B contains information about the 'meaning' of this sort of movement of arm and hand. Now the prescription for the ride-thumbing gesture has more or less precise limits: if I vary too much in the way I construct my gesture it may be taken by an observer to 'mean' something else. Variation too far in one direction may cause it to be perceived as a pointing; variation too far in another direction may cause it to be perceived as an ob-

scenity. (Note that in bringing in an observer, we introduce another perceptual process. What the observer perceives is a function of his F and his B. His F is not a ride-thumbing gesture – it is the physical movement of my hand and arm, as I make my ride-thumbing gesture in accordance with a prescription in my B. He perceives a ride-thumbing gesture, if he perceives one, only because his B contains information of the same type as that contained in the prescription by which I made my ride-thumbing gesture.)

But, though the prescription for the ride-thumbing gesture sets limits for the physical movements, several degrees of freedom exist. The actual gesture that I construct is not determined entirely by the prescription; the prescription is too loose to specify the exact shape of my gesture. Hence B contains other elements which affect the finished gesture that I actually make. For instance, some people are characteristically jerky in their gestures; others make smooth gestures. Further, a man's unconscious preference for jerkiness (or, alternatively, for smoothness) may very well affect not only the way he makes the ride-thumbing gesture, but many other products which he constructs out of very diverse materials (not merely bodily movements) and in accordance with all sorts of different prescriptions.

To generalize: I have already said that B contains beliefs, generalizations, and attitudes. We now see that B also contains prescriptions for manipulating people and things in certain ways. These prescriptions vary greatly in respect to the specificity of the instructions they contain, but even the most specific are still loose enough to allow other elements in B to influence the outcome, i.e. the finished product. Further, we may think of B itself organized into hierarchies, or levels, of beliefs and prescriptions. Deep levels in B have been laid down ('learned') early in life, are relatively stable, and are relatively unconscious. Upper levels in B are less stable and more readily accessible to consciousness. I have also spoken of charges (positive or negative) on elements in B. Some elements are ambivalent, i.e. are both positively and negatively charged. We may suppose that elements deep in B are likely to be more highly charged than those in the upper levels, and perhaps more frequently ambivalent. Again, elements in B at all levels are in dynamic interaction, and there are feedbacks from P to B (for instance, if my ride-thumbing gesture fails to secure me a ride, I may revise the prescription for ride-thumbing contained in my B).

These refinements of the model need not detain us here, but let us note that products issuing from any regions of B that are highly charged (either positively or negatively) will have features

that distinguish them from products issuing from otherwise similar regions of B that are less highly charged. Suppose the existence of a prescription (contained in a number of different Bs) to issue warnings about fires. Suppose, further, that two individuals, I_1 and I_2, have Bs that contain this prescription. If I_1 and I_2 are both observing the same event and I_1 exclaims 'Fire!' while I_2 says, 'That house is on fire', we infer that I_1 is more concerned about the fire than is I_2. Given stronger charges on the prescription in B_1 than those on the 'same' prescription in B_2, the (verbal) products will be different – B_1 yields an abrupt, mono-syllabic, emphatic product; B_2 yields an ordinary assertion. Further, products that issue from regions of B that are ambivalently charged (both positively and negatively charged) will be characteristically patterned. I shall return to this later.

The products of the process we have been describing are obviously enormously varied. Some of them are intended by their producers to be art objects; others are not so intended, for whether or not a given product is intended to be an art object depends on the prescription contained in the producer's background structure. Further, whether or not a given product is perceived (by an outside observer) to be an art object is a function of that observer's background structure, just as whether or not a luminescent region in the perceptual field is perceived as a ghost is a function of the perceiver's background structure.

Though the producer's intention and the observer's perceptions may on occasion coincide, intentions and perceptions are independent variables: an object intended by its producer as an art object may be perceived by an outside observer as not being an art object; a product not intended as an art object by its producer may nevertheless be perceived as one by the observer. Intentions and perceptions diverge to the degree to which the observer is an 'outsider', that is, to the degree to which his background structure differs from the background structure of the producer. If their background structures differ markedly, they are likely to make the cut between art and non-art at very different points. In this paper, I am discussing the judgements, not of producers, but of observers, specifically the judgements of conference participants. Thus we have a rather complicated model

where B_1 is the background of some individual producer in some

primitive society (say, a particular Walbiri) and B_2 and B_3 are the backgrounds of individual participants at the conference. B_1's P (the object which he produced out of material, M) is an F for B_2 and B_3. O_2 and O_3 are the more or less different assessments of P (F) made by two participants at the conference whose background structures (including their beliefs about art) differ in certain respects. It is extremely important to bear these distinctions in mind – both the distinction between P and O, and the distinction between one O and another O.

I now return to the notion of dimensionality. A dimension, D, is a principle, or rule, in terms of which objects are, or may be, ordered. Not all background structures contain identical dimensions; even when the elements are the same they may be ordered in different ways, i.e. along different dimensions. Further, different dimensions become operative in different circumstances and for different purposes. Given primitive producers instead of sophisticated observers, or given other observers (economists instead of anthropologists), doubtless other dimensions would have been used, and implicit disagreements would have occurred at different points. But, given the purpose of the conference and the backgrounds of the participants, it is a matter of empirical fact, I think, that the following dimensions were employed:

1. the *Utility* dimension;
2. the *Information* dimension;

and 3. the *Expression* dimension.

The utility dimension provides an array of products ranging from those that are primarily utilitarian – e.g. the paper salt-cellars on dinner trays in airplanes – to those that are only incidentally utilitarian – e.g. the Cellini salt-cellar. The information dimension provides another array of products, from those that are primarily informational – e.g. a research paper on art and primitive society – to those that are only incidentally informational – e.g. an automobile, which may convey information about the income of its owner, but does so only incidentally to providing him with transportation, and so on.

Now of course I do not mean that every participant had actually worked out any of these arrays in detail. Rather, I am suggesting that these dimensions were in the background structure of every participant at the conference, and that each participant used one or the other of them as his primary organizing principle, or orientation. I also hold that differences among participants with respect to which of the dimensions was primary caused those implicit disagreements to which reference has already been made.

To take an analogous case: instead of considering the set of all

products of human activity, let us consider the set of all applicants for the job of policeman. We find that applicants who are accepted in one city are rejected in another. By studying the individuals in question we can read back to the different dimensions which have been used by the police commissioners who select the candidates. Analogously, products which were acceptable to one participant (i.e. perceived by him as art objects) were rejected by another participant (perceived by him as not being art objects). Here too we can read back to differences in the dimensions used. In the policeman case, the whole set of applicants for jobs as policemen can be thought of as having places on an array according to height; they will also have places on an array according to their readiness to pay a 'kickback' to the police commissioner; they will all have places on an array according to I.Q. But a given applicant will have different neighbours on these three arrays; he will be higher up on the one array and lower down on another. His 'acceptability' to a given police commissioner will depend on which dimension that commissioner takes as primary, and on where along the array constituted by this dimension the commissioner makes his cut. Different police commissioners use different arrays; even those using the same dimension may make their cuts at different points. This is why an applicant who gets a job in one city may be rejected in another. Further, we should note an important difference between the array according to readiness to pay kickbacks and the arrays according to height and I.Q. Height and I.Q. are relatively objective measures – any two commissioners using these dimensions will end up with much the same rank orderings. But readiness to pay a kickback is a more subjective ordering principle. Commissioners for whom the kickback dimension is primary may estimate applicants' readiness to pay kickbacks quite differently. Hence even if they make their cut on this array at the same point (say, $500), one commissioner may reject applicants that the other accepts.

To return from this analogy to the question of art, the dimensions that are relevant to our implicit disagreements about art are more like the kickback dimension than like the height or the I.Q. dimensions. Hence disagreements over whether a particular product is or is not an art object may result from: (1) differences regarding which dimension is primary – for instance, some participants put primary emphasis on the information dimension, others regarded it as only subordinate; (2) differences in the way participants array products on the same primary dimension – the locus assigned to a given product is affected by the value which the participant attached to other, for him secondary, dimensions; (3) differences in the places at which cuts are made.

These variations may be represented schematically in the following way:

To simplify the diagram we have considered only the loci assigned to three products α, β, and γ by four individuals, I_1, I_2, I_3, and I_4. I_1 arrays these three products on D_1; I_2 arrays them on D_2. I_3 and I_4 use the same dimension, D_3, but differ in their rank orderings, because I_3 takes D_1 into account and I_4 regards D_1 as irrelevant. Since most people probably make their cuts over segments of an array, rather than at a single point, cuts are represented as fuzzy bands, not as sharp edges.

So much for the general, I shall now try to bring this discussion down to specific cases by describing the dimensions I have enumerated.

ORDERING IN TERMS OF THE UTILITY DIMENSION

The distinction between what is regarded as merely' useful and what is somehow art appears to go very deep in our own culture. It is not surprising, therefore, that it turned up at the conference. There was general agreement, for instance, that headrests, *tapa* beaters, stools, and canoes are utilitarian objects. And there was general agreement that Gola and Kilenge masks and the funerary terracottas produced by the Kwahu of Ghana

are art objects. If the Iatmul dwellings are primarily utilitaria
structures, the faces on their facades are art objects. It is not at a
easy, however, to formulate the dimension, or ordering principl
that underlay these agreements. For some participants it migl
be stated in the following way: many products are clearly instru
mental to men's traffic with nature and with other men; they ar
designed with their intended utility in mind. Yet there ai
objects which, though they may also be utilitarian, have som
thing about them that lifts them out of the category of the *mere.*
useful. For instance, more time and effort may have been spel
on their production than was necessary to satisfy the utilitaria
purpose. Thus most Tikopia headrests are merely headrest
nothing more. A headrest with legs may be better, i.e. mol
utilitarian, than a solid block of wood because it is lighter an
easier to move around. Whittling away at a block to lighten it
therefore a utilitarian act. But if whittling is carried farther (ho·
far?) so that a delicate shape (how delicate?) is achieved, we see
to feel we are justified in calling this headrest an art object. This
especially the case if the carved headrest is more fragile than th
solid kind, and to that extent, actually dysfunctional.

Perhaps the most obvious evidence of this kind of 'goin
beyond' utility, which I take to have been the chief mark of ai
objects for some participants, is the presence of ornament an
decoration. House-posts are structural architectural elements an
so utilitarian; carving a house-post in the shape of an animal o
bird adds nothing to the strength of the house. Hence a carve
house-post is an art object. So also for funerary terracotta
canoes, *tapa* runners, and the like.

Observers (by no means limited to participants at the cor
ference) for whom this is the primary dimension take as thei
paradigm of an art object something 'obviously' artistic, som
thing only marginally utilitarian, like the Cellini salt-cellar (
(in conference terms) the Ashanti golden stool. Then othe
objects are arrayed in an order that reflects the degree to whic
they are felt to exemplify the paradigm's characteristics. T
array objects in this way is to use the utility dimension as a
ordering principle. Participants for whom this was the primar
dimension thought about the study of art chiefly in terms (
describing, as accurately as possible, the 'beyond-utility
features of objects. Examples of such beyond-utility features ar
patterns painted or incised on the surface of such utility objec
as canoes or headrests. The first step in the study of art (fro·
this point of view) is to set up descriptive categories in terms (
which the various beyond-utility features can be classified, fc
instance in terms of colour or of shape. Once the beyond-utilit
features are discriminated in these ways, the approach may b

either comparative or historical, or both. The discriminated patterns are thought of as stylistic features, and a student may seek to show how styles (conceived in this way) evolve through time and how one style influences another. But perhaps the primary concern of participants for whom this dimension was primary was to identify ('verify') individual art objects by locating them within the context of a style, just as the Cellini salt-cellar is located by characterizing it as 'sixteenth-century Italian'. It was for these participants that the problem of 'fakes' was of critical importance. One distinguishes a genuine art object from a fake on the basis of whether the object possesses or lacks the proper style characteristics, i.e. those of the 'period' to which the object claims to belong. Obviously the more firmly established the style characteristics of a given period, the easier it is to detect a fake. Since style characteristics are by no means so well established for primitive art as for western art, the problem of detecting fakes is correspondingly more acute.

My impression is that there were no participants who did not take this dimension into some account. Everyone agreed that the decorations on canoes, body painting, and Gola masks came within the scope of the conference. Further, everyone was concerned with the empirical description and classification of what I have called 'stylistic features' – which I take to be the leading mark of reliance on this dimension. Without such basic agreement, communication could not have occurred. But though everyone was interested in style (conceived in this way), different participants handled these components in very different ways. This is true because for some participants this utility dimension was only secondary to other dimensions which I shall now examine.

ORDERING IN TERMS THE INFORMATION DIMENSION

All products whatever convey some information, however meagre. This follows from the fact that every product stands in a contextual relation to other things. For instance, although an automobile is not *designed* (as is a research paper) to convey information, it may nevertheless convey information about the economic status of its owner or about the level of technological development in the country in which it is manufactured. To the extent that inference is possible from the product to this kind of context, the product functions as a symbol, even though the producer may not have intended this symbolic reference when he constructed this product.

Information was a primary dimension for some participants; for others it seemed almost irrelevant. But those for whom it was primary differed among themselves both regarding the kinds of information held to be important and regarding where cuts were

to be made. Among those who used this dimension, and wer
therefore primarily concerned with the informational aspect c
art, some were chiefly interested in information regarding th
belief systems of the producers of the objects in question. Other
were chiefly interested in information about the society of th
producers – for instance, about the social role of the producer
i.e. of the artists.

Another consideration of importance, affecting how object
were arrayed on this dimension, was a difference of opinio
regarding the relevance or lack of relevance of the producer'
intent to provide information of any sort, whether about hi
beliefs or about the structure and institutions of his society
Consider any product whatever. We can ask, was it designe
primarily as a message, or does it convey information onl
incidentally? Granted that Walbiri sand drawings convey to th
anthropologist much information about Walbiri beliefs that th
Walbiri do not intend to convey; nevertheless a sand paintin
is a message and functions as such, for the Walbiri as well as fc
the anthropologist. Thus it is possible to take the concept of
message as the paradigm for arraying objects on this informatio
dimension. Let us think of the ratio (M-ratio) between th
message-function of a given product and the sum of all tha
product's message and other functions. M-ratio is high in th
case of a Walbiri sand painting; it is minimal in a Tikopia headres
It is possible, then, taking objects like sand paintings as th
paradigm, to array objects on the information dimension wit
respect to their M-ratio. Then the cut between what is art an
what is not art will be made in terms of a law of diminishin
returns – at some point the content of the message an objec
contains will seem too meagre to make it worthwhile calling th
object art.

But those for whom information is the primary dimensio
may be interested in information *per se*, not specifically i
messages. Thus a *tapa* runner conveys information about th
economy of its Polynesian producers; a Gola mask convey
information about the political system of the Gola. It happen
that the mask also conveys information (to the anthropologis
about the belief system of the Gola and the runner convey
information about changes in the value system of the Polynesian
just as the Walbiri sand painting conveys information about th
belief and value systems of the Walbiri. But anyone who take
the *tapa* runner or the mask as a paradigm will obtain an arra
on this dimension very different from the array obtained b
using the Walbiri sand paintings as a paradigm, for the runne
and the mask are not messages: information must be inferre
from them, not read off directly. (The distinction is similar t

that between reading off the message contained in a typed letter and inferring from the quality of the typing something about the secretarial skill of the typist.) To put this differently, what may be called the I-ratio (ratio of information conveyed to all functions) of objects is by no means identical with their M-ratio.

Two variables that affect how arrays are made on this dimension have now been mentioned: (1) the difference between participants primarily interested in belief systems and those primarily interested in social structure, and (2) the difference between those primarily interested in message-conveyed information and those interested in information *per se*. These variables are theoretically independent, but in particular cases one may reinforce the other. For instance, in primitive societies there are relatively few messages about social structure; therefore those interested in messages are likely to focus their attention on belief systems. Further, since messages are perhaps the best (though not the exclusive) source of information about belief systems those interested in belief systems are likely to take messages as their paradigm, rather than masks or *tapa* runners.

ORDERING IN TERMS OF THE EXPRESSION DIMENSION

To distinguish between information and expression is important, but it is also difficult, since the latter term, especially, is used in a variety of ways. Consider the following sentences:

(1) Her hair is red.
(2) Her hair is Titian red.
(3) Her hair is a dirty red.
(4) He is a dirty red!
(5) He is a member of the Central Committee of the Communist Party.
(6) But where the ship's huge shadow lay
The charmèd water burnt alway
A still and awful red.

I shall now introduce three terms – (i) 'content', (ii) 'designative symbol', and (iii) 'expressive symbol' – whose meaning these sentences are designed to illustrate. Content is the information a symbol conveys. Thus sentences (1), (2), and (3) have roughly the same content; all three are about the colour of a particular woman's hair, but (2) and (3) convey more content (information) than does (1) since they specify the colour in more detail. (4) and (5) have another content; they convey information (but in very different amounts) about some man's political affiliation. What is the content of (6)? This is not easy to ascertain. Perhaps someone will say that (6) is about a ship and its shadow, as (1), (2), and (3) are about a woman and her hair. But this is far from a complete analysis, and to give a more adequate account I now turn to the distinction between designative and expressive symbols. A

symbol is designative (in my terminology) if it conveys its information in a relatively neutral and factual way; it is expressive if it is more charged with emotion and feeling. Thus, for instance, (1) and (5) are relatively designative symbols, while (2), (3), and (4) are relatively expressive symbols.

I say 'relatively' because I hold that no symbol is ever purely designative or purely expressive. Every symbol is a mix, or blend, of designative and expressive components, and the mix varies from one symbol to another. For instance, though (1) is almost neutral, it is not entirely neutral for every speaker and every listener has some attitude towards the colour red. (2) is less neutral, for while 'Titian' designates a tone of red, identifiable as occupying a particular locus in the spectrum, 'Titian' also brings into play complex effects associated with Titian's paintings. (3) is still less neutral: like 'Titian', 'dirty' is an identifiable shade of red – we know which red the speaker is attributing to the woman's hair. But no one would be likely to call a shade 'dirty' who liked that shade. (4) is even more highly charged: it tells us little about the political affiliations of the man being characterized; rather, it strongly conveys the speaker's attitude towards him. (5) is relatively neutral again.

This brings us to (6). It is true that (6) is about some fictitious ship's shadow in the same way that (3) is about some presumably real woman's hair. But it is not merely that the information (6) conveys about its subject is minimal, as the information that (3) conveys about its subject is minimal. For, first, the primary subject of (6) is not the ship and its shadow; it is the Ancient Mariner, his crime, and his repentance. Second, what is said about this content is said expressively, not designatively. Finally, whereas (3) – and of course (4) as well – simply ejaculates, or discharges, feeling, (6) organizes and focuses feeling about the Mariner's crime (primary content) by means of the image of ship and shadow (explicit content). To put this differently, whereas the expressive element in (3) and (4) is presumably unintended (the speakers probably believe themselves to be describing the woman's hair and the man's political affiliations), the expressive element in (6) is intentional – Coleridge has deliberately chosen the monosyllabic 'still' and the drawn-out, initial vowel sound in 'awful' to reinforce the affect already attached to red, thereby producing an impression of loneliness and terror.

It is important, then, to see that content can be conveyed in symbolism that is primarily expressive as well as in symbolism that is primarily designative. Consider (4) and (5) again. Both sentences may be said to be about the same subject – so-and-so's political affiliation, though the information conveyed in (4) is fragmentary as compared with the information conveyed in (5).

Doubtless someone will want to maintain that (4) conveys information, not about the political beliefs of the ostensible subject, but about the political prejudices of the speaker. This is a possible way of speaking, but I think it is likely to be confusing. I prefer to say that (4) *expresses* (rather than conveys information about) the political beliefs of the speaker. In this way we can distinguish (4) from 'I am a member of the Central Committee of the Communist Party' which conveys information about the speaker's political beliefs, but does so in primarily designative, rather than in primarily expressive, symbolism.

I fear that these distinctions have been tedious, but they are, I think, necessary. Let us now apply them to the implicit disagreements that I detected in the conference discussions. I have already indicated that the participants seemed to me to differ greatly with respect to the kinds of information they were interested in. Thus some were chiefly interested in information about the structure of the societies whose art they described; others were primarily interested in the religious or the sexual beliefs and attitudes of these societies. But these differences amongst participants were further complicated by a differential preference either for designative or for expressive symbolism.

An example may be helpful. Suppose that a number of psychologists are all interested in some man's political beliefs. Some of these psychologists may rely for evidence chiefly on explicit statements by the man in question (such as the statement 'I am a member of the Central Committee of the Communist Party'); others may distrust this kind of evidence (designative symbolism, in my terminology) and prefer to base their conclusions on such expressive symbolism as the man's dreams or the doodles that he makes while attending meetings of the Central Committee. It is doubtless true that no psychologist would rely wholly on evidence of the designative sort to the exclusion of any expressive symbolism, or on expressive symbolism to the exclusion of designative. Nevertheless it would be possible, I think, to form an array of psychologists with respect to their attitude towards expressive symbolism, from those who have a deep interest in such evidence to those who have little interest in such evidence; similarly as regards the participants in our conference with respect to the kinds of objects which they accepted as being 'representative', or 'typical', art objects. Just as a psychoanalyst attends to evidence that a behaviourist would ignore as unreliable, so participants with a strong interest in expression tended to concentrate their attention on objects that other participants regarded as atypical or only marginally interesting.

Participants with a strong interest in expression arrayed products in an order very different from that of those primarily

interested in information, and they made their cuts at different points. It is important in this connection to recall that every product is to some extent, however slight, an expressive symbol. A product inevitably conveys information because we can make inferences from it to its social or economic context; it is also inevitably expressive because we are never completely neutral towards that context; we have an attitude towards all that we know or infer. Consider, for instance, the non-verbal symbol of thumbing a ride. This symbol may be regarded as primarily designative, but it is also expressive of the attitude of the ride-thumber. Think of the different ways in which two people, one tired and pessimistic about his chances of getting a ride and the other optimistic, make the 'same' ride-thumbing gesture. Within the parameters that define the ride-thumbing gesture, there are, I have said, several degrees of freedom; hence the specific shape of the actual gesture is not determined exclusively by the prescription for ride-thumbing. We can now say that what determines the specific shape of the gesture within those parameters is affect. This is why the gesture is always to some degree expressive.

Different products vary greatly in respect to their capacity to carry affect, to be expressive. We can indeed establish a rough scale representing the ratio of expressive function (E-ratio) to the sum of all functions and we can order products accordingly. Compare a children's game, for instance, hide-and-go-seek, with football. The rules of the latter are much more restrictive than the rules of the former. Accordingly, children's games are much more expressive than football. Yet the latter is not unexpressive: it is possible to talk about the different styles of football players, conceiving these styles as typical and suggestive ways of handling the ball, ways that result from differences in affect. It is possible, indeed, to talk about a life style, that is the pattern that, stemming from and expressive of attitudes deep in a man's background structure, characterizes all of his behaviour. To think about style in this frame of reference is clearly very different from thinking about it as the surface details – those 'beyond-utility' features – that distinguish art objects from merely utilitarian objects. Yet ornament and decoration, which are primary in the latter way of thinking about style, may also be of interest to those for whom the expressive dimension is primary. For ornament and decoration may be perceived not merely as external marks (designative symbols) by which historians learn to discriminate the art of one society or of one epoch from another. These marks may also be perceived as revealing, through their different configurations, the personalities of the artists who produce them (expressive symbolism).

Thus, depending on their varying interests in information or in expression, participants thought about the same features of art objects in quite different ways, and even though these different interests did not always become explicit, they none the less affected the ways in which the discussions developed.

This is not the only implicit disagreement to which it is possible to point. If we take the information dimension (interpreted in terms of messages) as primary, we are likely to adopt some such product as a Walbiri sand painting as our paradigm. If we take the information dimension (interpreted in terms of information *per se*) as primary, we are likely to adopt some such product as a *tapa* runner as our paradigm. If, however, we take expression as the primary dimension, we are likely to focus on some such product as a Gola mask or an Abelam painting as our paradigm. Such objects certainly convey information – for instance, about the social role of the artist. And some participants were clearly primarily interested in information of this sort. But Gola masks and Abelam façade paintings convey this information in symbolism that is primarily expressive. Because they do so, they express the emotions and feelings of the artist at the same time that they convey information about social structure – just as 'Her hair is a dirty red' both conveys information about some woman's hair and also expresses the speaker's attitude towards that colour and possibly towards the woman as well. Some participants were clearly more interested in the speaker's attitude (as it were) than they were in the colour of the woman's hair. Accordingly, these participants focused their attention on art objects which seemed to reveal the personality dynamics of the artist or of his society.

In saying that masks or façade paintings might be taken as the paradigm by those for whom the expressive dimension was primary, I do not intend to exclude *tapa* runners or sand paintings, for, as I have said, all products *to some extent* function expressively. But observers for whom the expressive dimension is primary will focus on different features of the masks and of the sand paintings. Of central importance for the former will not be what can be learned about belief systems, still less what can be learned about social structure. Rather, it will be what can be learned about the producer's personality dynamics, with its complex pattern of attitudes. Thus, for those who take expression as the primary dimension, the paradigm is a symptom. Indeed, the art object is perceived by these participants essentially as a set of symptoms revealing the inner, psychic state of the producer. Further, it is not every psychic state of the producer that interests those who use this dimension. There is a tendency to concentrate on clinical symptoms and hence to be especially interested in

those features of art objects that seem to reveal inner tensions or conflicts.

To summarize this part of my discussion: I believe that all participants started out from a somewhat vague, but roughly agreed-on notion of which of the various products of primitive societies are, and which are not, art. This distinction was drawn in the following way: products that have some function are utilitarian objects; those that are non-functional (or that serve a function only marginally) are art objects. This notion of the nature of art was doubtless determined in part by what primitive peoples call art (in their languages, as the participants understood these languages) but also in part by what looked like art to the participants, in terms of the participants' own western, non-primitive background structures. Thus the commonsensical starting point was ornamental and decorative patterns and designs – what I have called the stylistic, or 'beyond-utility', features of objects. From this core of agreement about what is art in primitive societies differences now developed, depending on whether the participants were primarily interested in the history of styles or in the 'meaning' (variously understood) of style. To adopt Merton's terminology about manifest and latent functions, we might say that participants for whom one of the other two dimensions was primary re-interpreted the distinction between functional and non-functional products as a distinction between products that have a manifest function and those that have a latent function. Re-interpreting art in this way added to its importance in the eyes of these participants. It gave art a significance ('meaning') which it lacked when it was perceived simply in terms of beyond-utility features. For instance, those who took the information dimension as primary felt that the critical question regarding ornament and decoration was not, 'What is the style (in the descriptive, classificatory sense)?' but, 'What information can be learned from this style about the beliefs and social structures of the producers?' Accordingly, they came to make the cut between art and non-art, not simply at the point where the beyond-utility features of objects have become useful, but at the point where the information content of the objects in question has become marginal.

Similarly, as regards those who took the expressive dimension as primary: these participants made the cut between art and non-art on the basis of a judgement of the extent to which the product is expressive in addition to being non-utilitarian; ornament and decoration were important to them only to the extent that they felt the observable style characteristics had diagnostic value – to the extent, that is, that ornament and decoration are expressive of the underlying personality structure

of the producers.

Another point: participants differed regarding the importance they attributed to conscious intention on the part of producers. Those who took messages as the paradigm held that intention is a prime category: this follows because of course the product is not a message unless its producer intended it to convey information. Those who were interested in information *per se* largely ignored the question of the producer's intention: what mattered to them was the quantity of significant information they could infer regarding the social context in which the object was produced. In contrast, those for whom expression was primary were inclined to play down conscious intention, because they were interested in aspects of personality that tend to be unconscious. For them, therefore, intention was not merely an irrelevant category; it was almost a red herring.

SOME ADDITIONAL IMPLICIT DISAGREEMENTS

Finally, I shall deal, much more briefly, with a few other implicit disagreements that arose during the conference.

As regards the relation between art and taboo: those for whom either utility or information was the primary dimension tended not to see this relation as a critical problem. It was, not surprisingly, important only for those who concentrated their attention on the expression dimension. For my part, I would interpret taboo as a projection on to a certain range of products of strong and ambivalent charges deep in what I call the background structure (B). I suggest that all products connected with such ambivalent regions in B may well have characteristic patterns (i.e. observable stylistic features). But I would not want to *identify* art objects with those having just these features.

Second, as regards minimal art: minimal art can now be defined as consisting of those objects that are in the region where a cut is made. Above the cut are objects that one is sure are art objects; below are those objects that one perceives as obviously not art; in the region of the cut are those about which one is dubious. It follows that minimal art for I_1 will differ from minimal art for I_2, depending on which dimensions are used and where the cuts are made.

Is there a society without art? Once again, this depends on what dimension is taken to be primary. There may be societies in which there are no non-utilitarian products at all (or those in which there are only marginally non-utilitarian products). But some of these objects may be serving important latent functions, e.g. expressing and discharging affect that has accumulated in the background structures of the producers. To this extent there would be art objects in these societies, even though the objects might not have the look of art objects. That is, they might not

have ornamental or decorative detail that 'goes beyond' the merely useful.

Is 'found art' art? Since the model I have introduced presupposes production, and since by definition found art is not produced, I would seemingly have to say that found art is not art. But natural objects, which have not been manipulated in any way by man, may none the less have shapes similar to those which men have manipulated in the interest of expression (or information). Then, by association, such found objects would come in the course of time to acquire both an expressive and an information function. Since natural objects are more likely to function (by association, of course) as expressive symbols than as information symbols, participants for whom the expression dimension is primary would be more likely to be interested in found art than would participants for whom information or utility is the primary dimension.

The question of the appeal of found art leads directly to another question of great interest, raised several times at the conference but never discussed systematically. How far can the art of one society be meaningful for a different society? One of the advantages of our model is that it now becomes possible to translate this into a question that is easier to deal with. In general, a symbol will have identity of meaning for I_1 and I_2 to the extent that I_1's background is similar to I_2's. Hence an art object produced by I_1 will be meaningful to I_2 in the way it is meaningful to I_1 providing that I_1 and I_2 have similar Bs. Consider first found art. Found art appeals, if it does appeal, because this found object happens to have the same sorts of formal characteristics (shape, etc.) it would have had, had it actually been produced according to a prescription. Since the found object is the result of a 'natural' process, not the product of any interpretative process at all, the question of communication – of similarity of background structure – does not arise. Now, as regards the art of a different society, it is clear that the art may appeal, and appeal greatly, yet it may not evoke responses at all similar to the responses it evokes in members of the producer's own society. It is quite possible that a great deal of misunderstanding – of failure to communicate – may occur. For instance, what is read by the anthropologist as 'mere' decoration may be read as a message in the producer's society, and so on.

To what extent, if any, are the background structures of different societies similar? This is an empirical question; and though it is difficult, it ought to be answerable. It is possible, for instance, that all background structures have certain common features. For instance, if I lack such-and-such information which is specific to one sort of society, I cannot read a particular gesture

as the ride-thumbing gesture it is read as in the producer's society. Yet, without this information, I may read it as graceful or ugly. Such responses, because they stem from very deep levels in B, may be transcultural. Thus, if sexual taboos occur in all societies it is possible that objects in which taboos are expressed will be read in similar ways by members of societies that differ greatly in other respects.

But it is not necessary to assume that all men start out with certain common elements in their Bs. By participant observation, members of one culture can in the course of time acquire large numbers of elements which they once lacked and so come to share the Bs of members of a different society. Such a process is not different in kind from the process that goes on within a society as children learn the Bs of their elders. Indeed, there is only a degree-difference between the inter-cultural situation and the intra-cultural situation. On the other hand, even within the same culture there are always differences in B from one individual to another. Hence it is a question of how much communication occurs, not a question of whether the art of one society 'can be' meaningful to another. No matter how different two societies may be, the art of one can to some extent become meaningful to the other, assuming the possibility of interaction, feedback, and self-correction.

I shall conclude with a question that was not raised at the conference. Where is the model that I have been working with? Answer: in my background structure. It has helped me to make sense of the talk about art and primitive society that I heard at the conference. I hope that the model may be helpful to the participants and to other readers of this volume. A major problem for this conference – and for most conferences – is that participants have different funds of information, different interests, different vocabularies, and different approaches to the study of the 'same' subject. It is essential, then, for participants to become sufficiently aware of these and other elements in their background structures to be able to articulate them. If this happens, what had been a handicap – difference in background structure – becomes an advantage, an incentive to enlarge one's own view of the field of inquiry by incorporating the perspectives of those whose outlook is different.

NOTES

1. I am much indebted to G. Bateson, Stephen A. Erickson, A. Forge, Charles Leslie, George Park, and Hortense Powdermaker for helpful comments.
2. See Ernest Jones, *The Life and Work of Sigmund Freud*, vol. I, New York, 1953, p. 231.
3. I have described this model in *The Sciences and the Humanities*, Berkeley, 1965, and in 'World Views their Nature and their Function', *Current Anthropology*, 13, 1, 79–109.

Index of Authors, Artists, and Authorities

Italic references indicate pages on which illustrations appear.

Index of Subjects